3DTotal Publishing

3DTOTALPUBLISHING

3DS MAX
PROJECTS

A detailed guide to modeling, texturing,
rigging, animation and lighting

3DS MAX
PROJECTS

A detailed guide to modeling, texturing,
rigging, animation and lighting

3DTOTAL**PUBLISHING**

3DTOTAL PUBLISHING

Correspondence: publishing@3dtotal.com
Website: www.3dtotalpublishing.com

First published in the United Kingdom, 2014, by 3dtotal Publishing.

Paperback ISBN: 9781909414051

Printing and binding: Everbest Printing (China)
www.everbest.com

Junior Editor: Emalee Beddoes
Proofreaders: Lynette Clee, Adam J. Smith
Technical Proofreader: Jahirul Amin
Lead Designer: Imogen Williams
Designers: Matthew Lewis, Jonathan Ingram

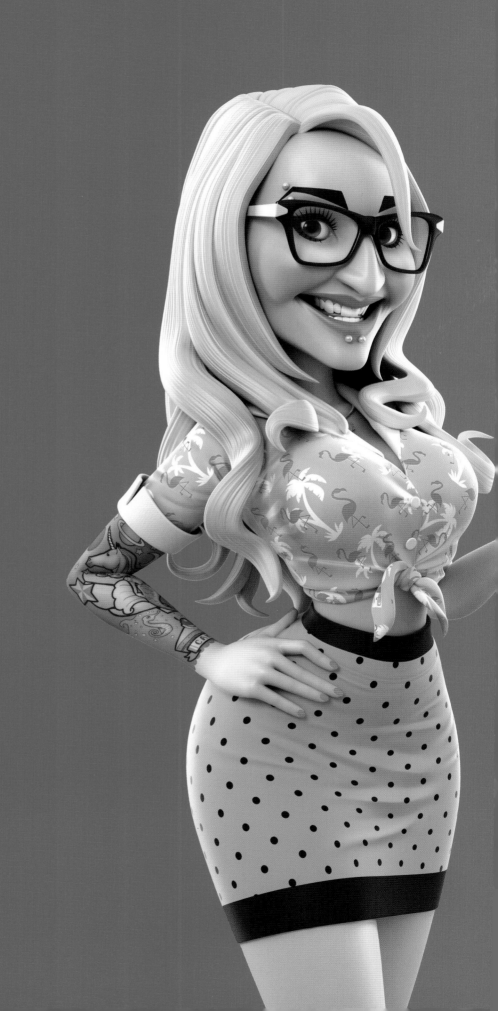

CONTENTS

AUTODESK 3DS MAX
IS ONE OF THE MOST COMPREHENSIVE SOFTWARE PACKAGES A 3D ARTIST COULD ASK FOR, AND IS SUBSEQUENTLY ONE OF THE INDUSTRY'S MOST-USED TOOLS...

Created in the wake of the Atari, 3ds Max has its origins in 3D Studio, which was released way back in 1988. Since then, the software has gone from strength to strength and has been used in some of the world's most iconic films, from *The Italian Job* to the *Harry Potter* franchise.

Mastering 3ds Max is essential for any aspiring 3D artist but it's not always an easy ride. *3ds Max Projects: A detailed guide to modeling, texturing, rigging, animation and lighting* has been written to ease the tricky journey from eager experimentation to technically literate, fully-fledged portfolio pieces.

Ideal for those fairly new to 3ds Max as well as experienced artists looking to brush up on basic techniques and theory, *3ds Max Projects* outlines some of the key skills involved in mastering 3D. 11 experienced industry professionals will guide you through their pipelines for various processes in 3ds Max in order to help you develop your own artworks and acquire your own skill set.

As characters are such a huge part of the 3D world, we begin by learning how to model and texture a character directly from a 2D concept, before discovering how to rig and animate your new model. To perfect your character

design skills, you can also discover that the processes behind developing characters for portfolio images with Andrew Hickinbottom, as well as learning the complex and essential skills of topology with Diego Maia.

We then take an in-depth look into even more industry-standard workflows, including creating atmospheric lighting, blending 3D and photography, modeling vehicles and mastering particle effects.

3ds Max has incredible integrative potential and a number of the artists in *3ds Max Projects* also explain how they incorporate other software into their pipelines, including ZBrush, Softimage, Mudbox, Silo, RealFlow, Wings3D, V-Ray, Photoshop and After Effects. If you haven't tried some of these tools, you'll find that most manufacturers offer free trial versions to help get you started.

So whether you're developing your own 3D specialism or exercising your muscles as a generalist, we hope *3ds Max Projects* will help you to develop your skills, refine your own workflow and inspire you to create a portfolio filled with amazing artwork!

Emalee Beddoes, Junior Editor

Some of our *3ds Max Projects* tutors have kindly supplied, where appropriate, free resources to accompany the projects for you to download and follow along with their teachings.

All you need to do to access the free resources is visit www.3dtotalpublishing.com. Under the Resources section you will find information on how to download your complimentary files.

Simply look out for the Free Resources logo that appears on projects in this book where there are files available for you to download.

FREE RESOURCES
Download your free resource pack for this project
www.3dtotalpublishing.com

Tutorials range from step-by-step modelling, rigging lighting and more, to looser and more technique-based projects, allowing you to grow throughout the book as you develop skills and gain confidence...

INTRODUCTION TO CHARACTER CREATION

By Dmitry Shareyko
and Seid Tursic

LEARN HOW TO DEVELOP CHARACTERS FROM 2D CONCEPTS INTO 3D MODELS READY FOR RIGGING AND ANIMATION

Translating 2D designs into workable 3D characters is a key skill for 3D artists, and it can take time to hone the technical and observational skills needed to get them just right.

This in-depth guide by Dmitry Shareyko and Seid Tursic will take you through the process of creating a 3D model using Denis Zilber's fantastic *Loan Shark*

concept as a point of study. Firstly, Dmitry will describe the modeling stages of bringing the character to life, before Seid develops the model with texturing, lighting and finishing touches to create the perfect likeness.

This project is a complete guide to character creation, covering the entire process so you can master your craft.

FREE RESOURCES

Download your free resource pack for this project

www.3dtotalpublishing.com

INTRODUCTION TO CHARACTER CREATION
MODELING YOUR CHARACTER

BY DMITRY SHAREYKO

In the following chapters, I will reveal the process of creating a character using 3ds Max and Photoshop. The character will be based on a great sketch by Denis Zilber (www.deniszilber. com), entitled *Loan Shark* (Fig.01).

This project is divided into eight chapters. We will work through the stages of creating a 3D image, covering: preparation, modeling, mapping, texturing, lighting, rendering, and finally post-production.

Since we won't be making a low-poly game character (we'll create more complex renders), we don't need to limit ourselves when it comes to polygons and textures. The only limit we'll be sticking to is that everything will be handled using 3ds Max and Photoshop only, without any third-party programs in the mix.

Note: I usually find that using different programs and plug-ins for characters can be helpful. These will often make the working process easier and quicker. So once you've mastered 3ds Max, look out for new processes to incorporate into your workflow; install scripts and plug-ins and try to find new approaches to your projects. Keep experimenting!

I always encourage the use of hotkeys as much as possible. I will put hotkey references in brackets for those commands that are assigned to hotkeys by default.. For all the other frequently used commands, you will need to assign hotkeys manually and apply them, instead of wasting time looking for them in different menus. Hotkeys can be assigned

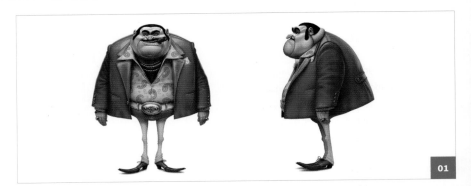

01

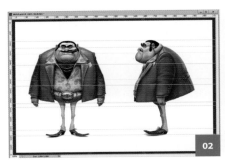

02

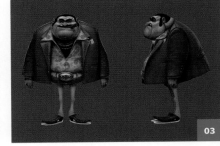

03

" Try to apply hotkeys as much as possible "

in Photoshop using Edit > Keyboard Shortcuts and in 3ds Max using Menu > Customize > Customize User Interface > Keyboard.

PREPARATION

When modeling the head, creating reference image planes is optional. I usually model by eye without an underlying sketch, but if you need to re-create the sketch accurately then a 'studio' setup will make it easier. This involves using a readymade sketch that consists of two views – face and profile – on a white background. The image can be downloaded from **www.3dtotalpublishing.com/resources.html**.

First of all we have to prepare the image for use in 3ds Max. Our so-called 'studio', in this case, is two perpendicular reference planes in the 3ds Max viewport with the image of the character. We will focus on this while modeling.

First, open the sketch in Photoshop and with the help of the guidelines, check that the face coincides with the profile. Turn on the ruler display (View > Rulers or Ctrl + R) and drag the guides from the horizontal ruler into key points of the image. As we can see, the sketch is perfect. Apart from a few details, the projections correlate well, so there is no need to correct it (Fig.02).

If the views hadn't matched, we would have had to tweak them using Lasso (L), Transform (Ctrl + T), Liquify (Ctrl + Shift + X) and Puppet Warp (Edit > Puppet Warp) in Photoshop.

Once the images are in place, we don't need the Guides anymore, so we can turn off this display. Go to View > Show > Guides, or press Ctrl + ;.

We can now reduce the brightness of the image and make the background more neutral, as the white objects/grid won't be clearly seen against the white background during the modelling process in 3ds Max.

To reduce the brightness of an image in Photoshop, open Image > Adjustments > Brightness/Contrast. I use Brightness -70 and Contrast -25.

Select the background of the image using the Magic Wand tool (W) with the Tolerance set to 20 and Contiguous set to Off. Then go to Image > Adjustments > Hue/Saturation (Ctrl + U) and lower the Lightness to -70.

We could also crop extra space of the image using the Crop tool (C), but it is not obligatory. This is the final stage of preparing the sketch for modeling (Fig.03) and now we can start up 3ds Max.

With 3ds Max now open, let us first check the current units of measurements (Customize > Unit Setup). The correct size of the model is important if you wish to export it to a game engine, for example. It is also crucial when you set the lights and render in 3ds Max. You can set the values as shown in Fig.04.

In the front perspective viewport, create a primitive plane with the width and length values indicated by our sketch (1,000 x 600 pixels, so create a plane at 100 x 60cm).

Apply the values: Length Segs: 1; Width Segs: 1; and make sure Generate Mapping Coords is on. In the Name and Color section rollout, change the name of the object to 'front'. Then convert this Plane to an Editable Poly (QM transform > Convert To > Convert to Editable Poly) (Fig.05).

Note: QM – Quad Menu is a menu that is opened by clicking on the right-mouse button in the 3ds Max viewport.

Now let's add the sketch to this plane as a texture. With this marked plane, go to Material

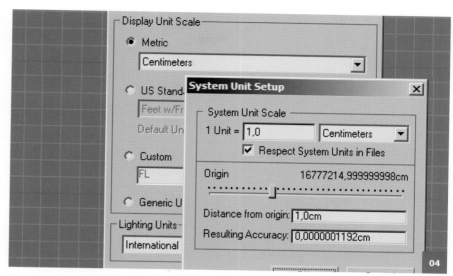

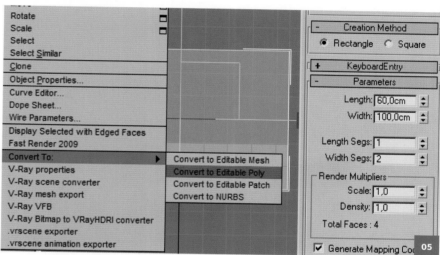

Editor (M), choose the first material slot and then select Assign Material to Selection and Show Standard Map in Viewport. In the Self-Illumination counter, apply 100.

In order to apply the sketch, click the small square button near the Diffuse slot. In the Material/Map Browser window, choose Bitmap and specify the image path (Fig.06).

We can apply the same method to introduce textures to our readymade model in the future. We should now see our sketch on the plane.

It's time to divide the plane into two parts and rotate one of them 90 degrees. As we previously converted our model to Editable Poly, we can edit it with the help of this modifier at any of the following sub-object levels: Vertex (hotkey 1), Edge (hotkey 2), Border (hotkey 3), Polygon (hotkey 4) and Element (hotkey 5).

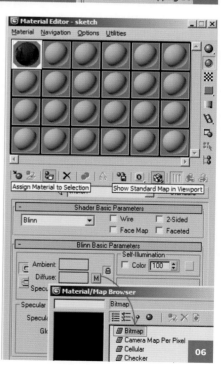

To separate part of the object, select the polygons and click on the Detach button in the Edit Geometry rollout (Fig.07). In the Detach window you can give a new name to the object; in this case I use 'Side'.

Now we have to decrease the size of the two new planes by cropping the unnecessary gray space around the character. To do this, first turn on Preserve UVs. You need to apply this to make sure that the texture does not deform as you resize the planes.

At the sub-object's level of editing, select the edges of each plane and move them to the center using the Select and Move (W) tool. Once done, select the object side and turn it using the Select and Rotate (E) tool. In order to turn it by 90 degrees to the right, turn on Angle Snap Toggle (A). We can see how our planes should look in Fig.08.

Note: You can also click the right mouse button on Select and Move, Select and Rotate and Select and Uniform Scale. When you select these, a new window will open where you can type the numerical parameters of such transformations.

You need this tool to insert the object precisely in the center of coordinates or to turn it to a definite angle. When you click the right mouse button, an Angle Snap Toggle window will appear where you can set the snap parameters.

The last stage of the studio preparation is to fit the size of the reference planes to the actual size of the character.

According to the sketch he is short and chubby. So let's assume he is 160cm tall to give us something to work to. In the center of the coordinates, create a primitive box that is 160cm high and of any length and width.

Next, match the scale of our reference planes to the box. Translate the side image plane so the legs of the character stand at the zero point on the Z axis. In order to change the size of the reference planes, use Uniform Scale (R). Delete the box after this so we can begin modeling (Fig.09).

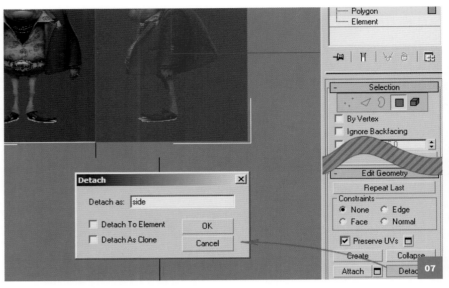

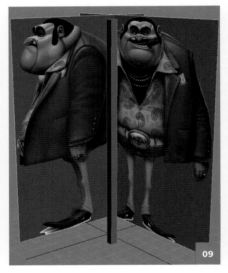

MODELING

We will create different parts of the character using geometric primitives in 3ds Max (such as Box, Plane, Sphere, Cylinder and so on). We will then convert them into Editable Polys to allow us to edit parts of the character further.

We will progress from easy to more complex techniques by starting the modeling with the least amount of polygons. We will then complicate the geometry of our character by adding edge loops and polygons, and towards the end we will apply a TurboSmooth modifier to achieve a smooth-looking model.

As an example: first create a box in the center of our coordinates, sized 50 x 50 x 50cm and with 1 x 1 x 1 segments for the length, width and height (Fig.10).

Note: It's important to create objects in the center of your coordinates or move them there using the Move (W) tool. We will talk about this more later.

After this, convert the box to an Editable Poly and choose the TurboSmooth modifier from the Modifier List, using Iterations: 3 (Fig.11). Try turning the Isoline Display on and off. This is a useful parameter, as when enabled, 3ds Max only displays isolines – the object's original edges – before smoothing, so it gives a less-cluttered display.

Note: With the help of the light-bulb box opposite the modifier's name, you may turn this function on or off. To see how the modifier works you have to move on to the modifier's stack while the modifier is still turned on.

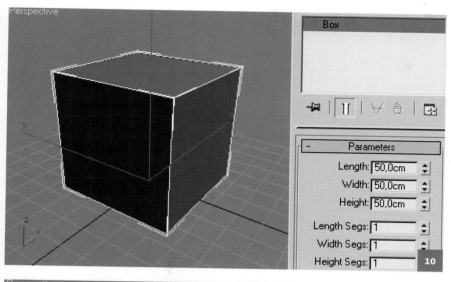

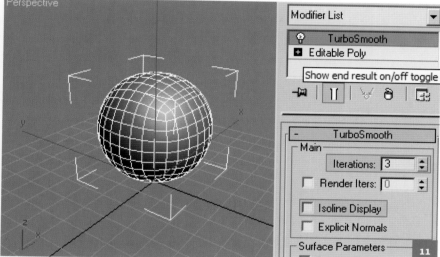

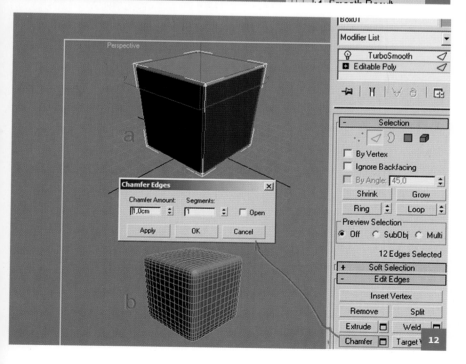

> **Practise changing the Chamfer Amount and Segments settings, and try to understand how the TurboSmooth tool works**

The Show end result on/off toggle button is useful when we want to see the actions of all the active modifiers that are situated higher than the modifier in the stack. For example, we may edit our model in Editable Poly while at the same time viewing the model as a subdivided mesh.

As we can see when we turn on TurboSmooth, our object is too smooth, and so loses its cube shape (by almost turning into a sphere) (Fig.12). To improve this, on the Editable Poly modifier Go to Edge sub-object level and select all the edges of the cube. Apply a Chamfer and set the Amount to 1cm and the Segments to 1 (a). Here you can see the result of turning on TurboSmooth (b).

Practise changing the Chamfer Amount and Segments settings, and try to understand how the TurboSmooth tool works.

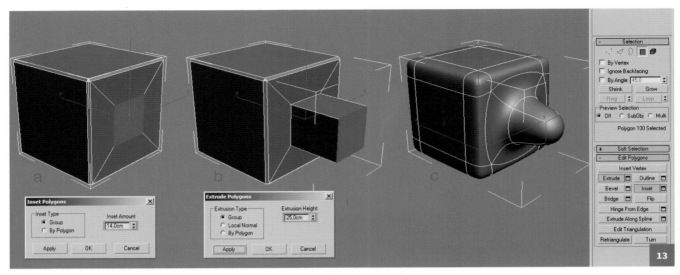

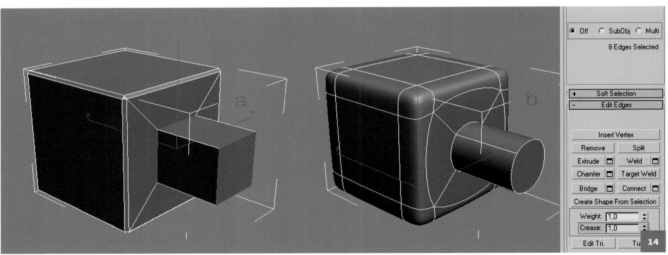

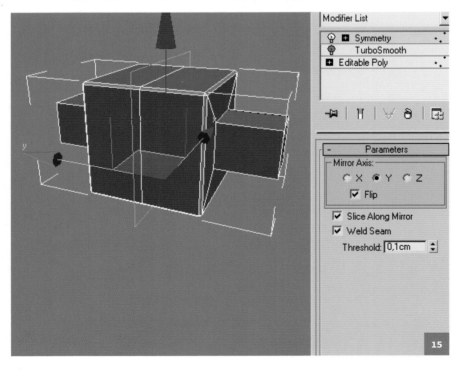

Another way to sharpen the planes is to apply Edit Edges > Crease (Fig.13). Select one of the side polygons of the cube and apply Inset with an Inset Amount of 14cm (a). Without deselecting the cube area, apply Extrude with an Extrusion Height of 25cm (b). Turn TurboSmooth on and see the results of the modeling (c).

Now select the edges, as shown in Fig.14 (a), increase the Crease value to 1.0 and turn on the TurboSmooth again to view the results (b).

As we can see, this has created sharp planes on our smooth object. Try changing the Crease volume and watching to see how the TurboSmooth changes.

Now let's apply the Symmetry modifier to our previously created object. Add it on the top of Editable Poly and TurboSmooth on

the Modifier list. This will allow us to model only half of the object. The second half is then mirrored using this modifier. Experiment with the Mirror Axis parameter to see how the results affect the mesh. (Fig.15).

Note: The order of modifiers can be changed simply with drag and drop.

Now we have mastered the modeling of simple objects, we can carry on and tackle the more difficult – and most interesting – part of our character: the head.

First we'll model the form without details and apply the minimum number of polygons. We will then add extra edge loops where needed to add further detail to the model. Then we can smooth the model using TurboSmooth.

Let's start with a primitive box (36 x 38 x 16cm) with two segments for each of the sides. Convert this box to an Editable Poly, delete the polygons on the left half of the box (these will be created using the Symmetry modifier), and the four ground polygons (marked blue) (Fig.16)

Let's now shape the box to look like a brainpan. Apply the Symmetry modifier, then add and turn off TurboSmooth (with the following values: Iterations: 2; Isoline Display: on). We will build the rest of the head through a series of edge extrusions (you may sometimes see me refer to this as 'copy the edges')

To do this, set the sub-object level to Edge or Border, select specific edges (those edges that belong to only one polygon), hold down the Shift keyboard modifier and use the Move tool to extrude (copy) extra edges.

It's easier if you turn on the See-Through option (QM Transform > Object Properties > See-Through, or hotkeys Alt + X) when you edit the object. It makes the edited model half-transparent so you can see your studio behind it (Fig.17).

Note: We add the TurboSmooth modifier, but turn it off. While modeling you will have to turn it on constantly or use the Show end result on/off toggle in order to see how the model looks with smoothing mode on. This is really important because the smoothed model may vary from the unsmoothed one, and from the sketch too.

> **" After extruding we have two polygons left and their angles have to be joined "**

So we will model the head without taking asymmetrical parts into account (we will add them at the very end). The approximate direction of extruding is shown in Fig.18, but there is actually no order of priority. After extruding we have two polygons left and their angles have to be joined (see red circle).

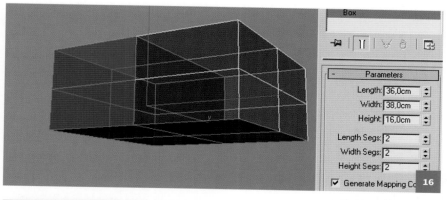

16

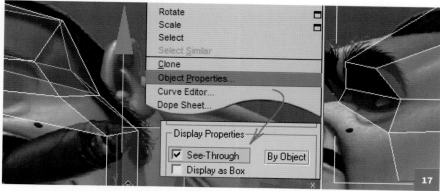

17

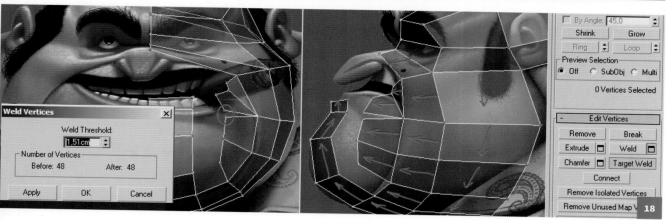

18

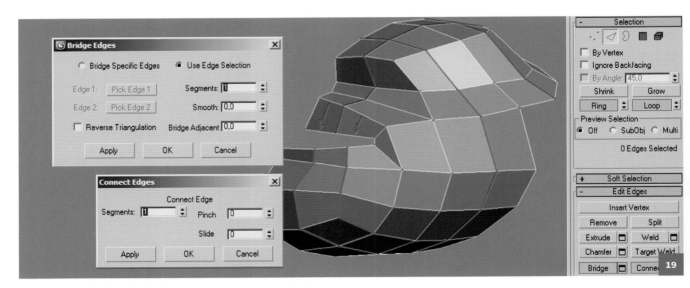

We can use the Weld tool or Target Weld tool to do this. First, select the right vertices and push the small button near the Weld square. In the window that appears, put those values in Weld Threshold to join the vertices. Alternatively, you could push the Target Weld button, select one vertex and drag it to the other in order to weld them. We will use these tools when we need to join a few vertices on the model.

Using the Bridge function next, join the two parts of the lower jawbone. At Edge sub-object level, select the edges shown in blue and then push the small square button near Edit Edges > Bridge.

In the opened dialog window we can see the parameters (which are in figures). The results of the polygons are shown in blue (Fig.19). We then continue to build the shape of the object by extruding new polygons out of existing ones.

We also add some edge loops – these are marked red in **Fig.19**. To do this, select the edge perpendicular to the one we want to add the edge loop to, push the Ring button (this expands an edge selection by selecting all edges parallel to the selected edge), then push the Connect button.

If you click on the small rectangular button to the right of Connect, a dialogue window will appear; this is where you may set such parameters as the quantity of added edge loops, the distance between them and their displacement from the center.

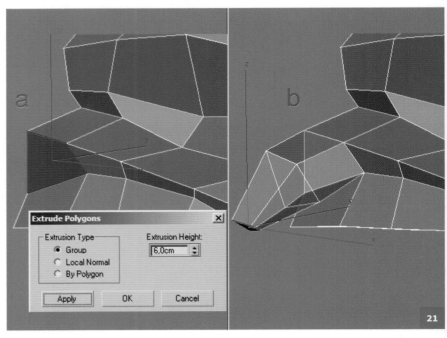

We will also have to apply the Loop button, which expands the selection as far as possible, in alignment with the selected edges.

Using the Cut tool, add a few more edge loops. In order to do this, push the Edit Geometry > Cut button and add loops by pushing the Edges or Vertices buttons in turn (Fig.20).

After this, take some time to push and pull the vertices to match the reference images. Edges marked with the red color show ones we have added, and those with blue edges show those that we have deleted. We also need to delete the polygons marked in blue. This is the place where we will put the model's ear. In order to delete the edges, select them by pushing Backspace on the keyboard. To delete the polygons, select them in the same way and push the Delete button.

Note: Through the editing process of the model grid, it's comfortable to change regimes in Edit Geometry > Constraints. This lets you apply existing geometry to constrain sub-object transformation. You will have to switch frequently between Constraints None-Edge, which can be done with the help of the hotkeys Shift + X.

Let's now model the base of the nose for our character. Select the polygon where you want to start the tip of the nose (Fig.21). Then apply Extrude twice (with an Extrusion Height of 6cm) (a). Next, edit the shape of the tip of the node and delete the inner polygons that have been created by the extrusions on the inside of the nose, as shown in Fig.21 (b).

Add an extra edge loop around the eye by selecting the four polygons where the eyeball will sit (Fig.22) (a) and then apply an Inset with an Inset Amount of 1.5cm (b). Then rework the vertices to form the character more faithfully (c).

We continue to build the head by modeling the back of the head and extruding out the top of the chest from the bottom of the jaw, leaving a place for the ear (Fig.23). Polygons marked blue appear as a result of using Bridge for the edges marked blue.

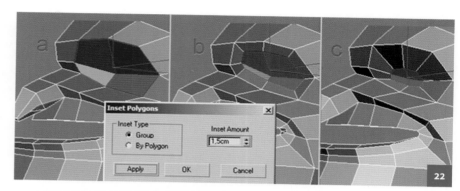

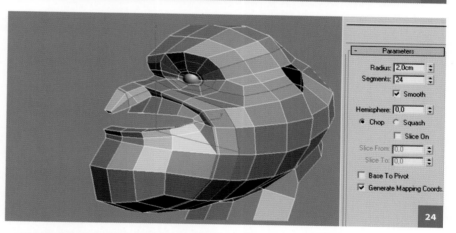

We add a few adjustments to the edge loops and a sphere primitive, which will be used as a left eye for our character. Let's name this 'eye-L' and set parameters for it (see Fig.24 for those).

At this point, take time to push and pull the vertices to get closer to the reference. For example, to match the reference you'll need to add some bagginess beneath the eyes (Fig.25).

Now select all the polygons inside the eye pit, apply Extrude with a value of Height: 1.5cm and Extrusion Type: Group. After this, push Collapse (Ctrl + C), which will make all the marked polygons become one vertex in the center of the marked area. Select all the edges of the eye pit 'orb' and apply Chamfer with a Chamfer Amount of 0.05cm and Segments set to 1 (Fig.26).

Note: Collapse can be applied to selected polygons, edges and vertices.

Using Backspace, delete a few edges in the corner of the mouth (Fig.27) (a). Now add a few new edge loops around the eyes, mouth and nose. Then for those edges that are marked blue, apply Collapse again (b).

Note: Pay attention to the vertex that is circled in red. It forms a pentagonal polygon, which shouldn't be seen in the final model (only triangles and quadrangles are allowed). We will try to fix this while modeling the hair area.

Let's work on the nostrils now. In order to make it easier, let's hide all the polygons that are not connected to the nose or the nasolabial fold. Select all the polygons that need to be seen and go Edit Geometry > Hide Unselected. You will need to use the Hide Selected and Unhide All to bring the complete mesh back into view. While here, you can add a new edge loop to the nose, which has been highlighted in red in Fig.28.

Now let's select the edges as shown in Fig.29 and push the Edit Edges > Split button (a). After this a cut will appear, replacing those edges, and we will be able to edit them separately (b).

Select four opposite edges (marked in blue) of the cut in the grid, and use Bridge to close it. Set the value of the parameters as shown in Fig.30.

Now we can add a few edge loops. For edges marked blue, apply Collapse (Fig.31) (a). After transferring vertexes, adjust the shape of the objects (b). You will need to pay particular attention to the edge loop that goes out of the visible field of work here. This is not gone, but rather just moves

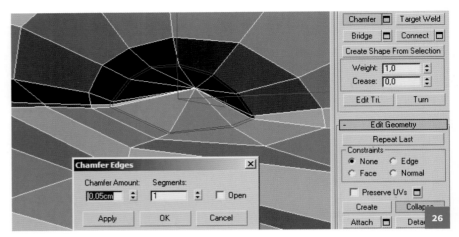

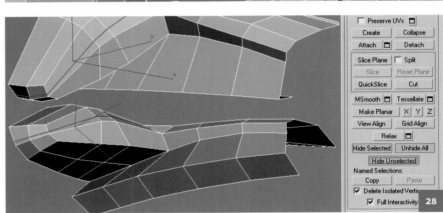

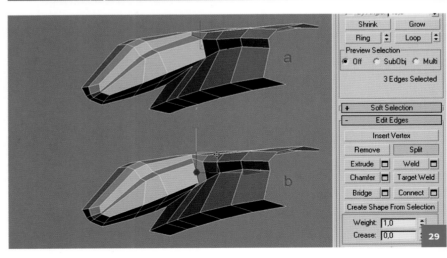

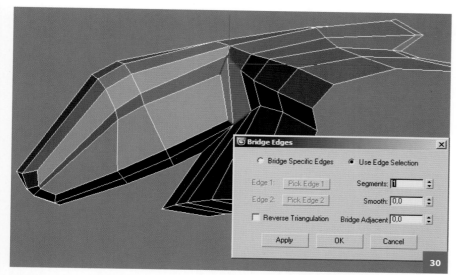

further around the mouth. You will have a chance to review it later on in the project.

Note: Don't forget to switch on TurboSmooth and check how the model looks when it is in use.

It's time to finish the nostrils now. First, select the four polygons at the bottom part of the nose, and then apply Inset with an Inset Amount value of 0.7cm (Fig.32) (a). After this, extrude with an Extrusion Height of 0.7cm (b), and edit the shape of the resulting crevice (c).

We are done with the nose now and can start work on the chin of the character. Apply Cut tools to do that, and add some new edge loops (Fig.33) (a). After this, we can edit the resulting mesh (b).

Now we can edit the topology of the model. We can see some long polygons near the eye that don't shape it well and aren't really smooth enough (Fig.34) (a). Delete the edges that form them using Backspace (b), and form some new topology with the Cut tool. Finally, edit the location of new vertices (c).

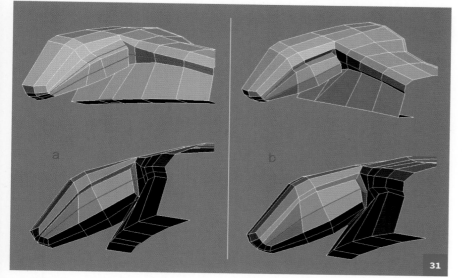

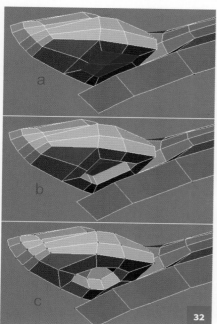

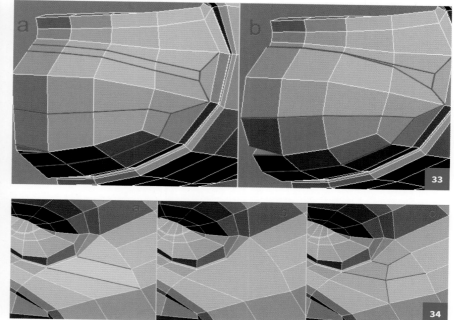

Let's go to the eyebrows and hair area of the character. First, we're going to model the base for the eyebrows. Select the polygons where the eyebrows have to be located (Fig.35) (a) and apply Bevel with the following settings: Height: 0.8cm, Outline Amount: -0.3cm and Bevel Type: Group. After that, just edit the position of the vertices to match the reference (b).

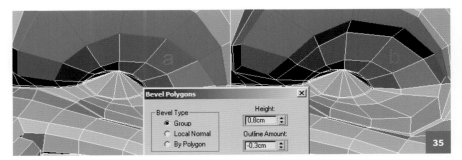

Move onto the hair area: using the Cut tool add a few new edges. Then apply Collapse to the two edges and the polygon, as shown (Fig.36).

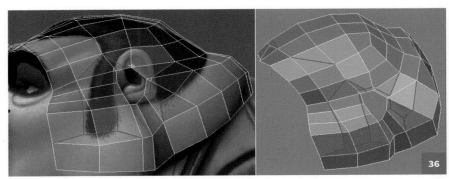

Now edit the contour of the hair so that it coincides with the sketch more (you can do this by switching from Edit Geometry > Constraints to Edge or Face), and then delete those with edges marked in blue using Backspace (Fig.37) (a). Let's add one more edge loop above the ear (b).

Select all the polygons in places where hair grows and apply Bevel with these settings: Height: 1.0cm, Outline Amount: 0.8cm and Bevel Type: Local Normal (Fig.38) (a). Notice that using Bevel has also created polygons in the axis of the symmetry line, and so when we turn Symmetry on a parting will appear in the hair. Don't forget to delete these polygons (marked blue), and transfer the marked vertices to the center of the coordinates along the X axis (b).

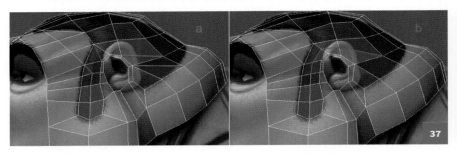

Now when we move the vertices we can finally shape the hair (Fig.39). Select the edges along the hairline in front and above the ear (a), and apply Chamfer to them with a Chamfer Amount of 0.2cm and Segments of 1. Then with two edges and one polygon marked blue, apply Collapse (b). We have now finished working with the hair.

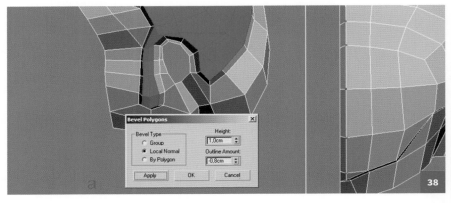

Let's model the ear of our character next. To do this, create a primitive plane in the right-hand view window, with the values shown in Fig.40. Then convert it to an Editable Poly.

By using a 'copying edges' method, we can create a flat pattern for our future external ear. We get two blue polygons by selecting the blue edges and using Bridge with a Segment value of 2 (Fig.41) (a).

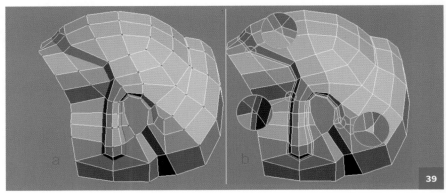

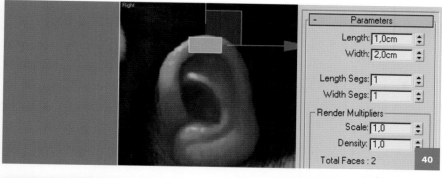

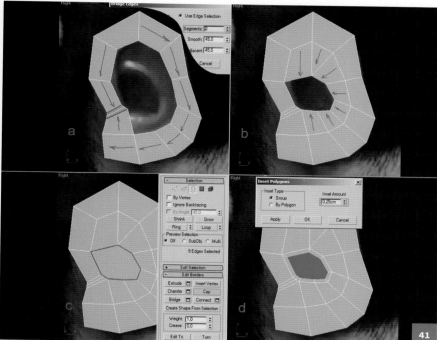

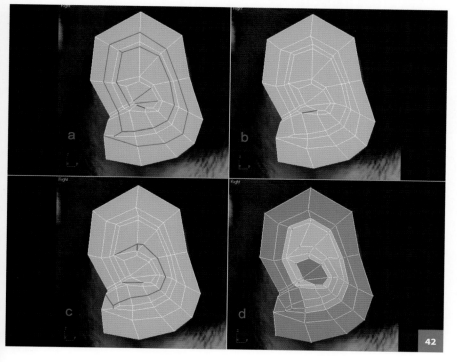

Do the same actions again in order to make the inner part of the ear using Weld or Target Weld if necessary (b). Now go to the Border sub-object level and select all inner edges as the image shows (c). Then apply Edit Borders > Cap to the marked area; this will create one large poly-angular polygon of these edges. Let's select this polygon and apply Inset with an Inset Amount of 0.25cm (d).

Now edit the position of the vertices, apply the Cut tool to add some new edge loops, and then apply Collapse to the edges marked blue (Fig.42) (a). The pattern for the ear has to look as it's shown in the image (b). We now have to delete the edge marked blue using the Backspace key.

What we've created so far is a plane without depth. It is simply a pattern we will apply to shape the ear by relocating the vertices along the X axis. But before adding volume, we need to add a few edges, and delete the blue edge again (c).

In d, I have marked directions for further editing. Drag the vertices in the blue area inwards; we will drag those in red away from us, and the green gradient means that there is a gradual transition between red and gray areas in this place. (This division into four areas is rather conditional and is used to illustrate further actions only).

So by moving vertices of the model along the X axis using the Move tool, we can start to edit the shape of the external ear. Don't forget to constantly compare your model to the front and side reference planes.

We have to move the regions together now, as shown in **Fig.42**. It is easier to apply an FFD (Free-Form Deformation) modifier to do this. Select those polygons that we want to edit (in the red area). Then choose FFD 2 x 2 x 2 modifier in the Modifier list (to find this list, select the small cross (x) near the name and choose Control Points.

The FFD modifier allows us to affect an entire region using its cage, rather than having to edit each individual vertex of the model. This can effectively save a lot of time (Fig.43).

Click the right-hand mouse button on the name of the FFD modifier in the stack and choose Collapse To in the Context menu. We will get back to editing an Editable Poly afterwards.

Ensure that you have added shape in this region of the ear (Fig.44) (a). Work on it from all views and check the results using the TurboSmooth modifier (b). The fourth black version is the view from the back to see the changes clearly.

Let's make our ear thicker. Start by selecting all the edges that follow the contour of the ear and extrude the edges, as shown in Fig.45. In order to create the blue polygon, apply Bridge (a).

Now we will model the back of the ear. To do this, extrude the edges inwards and apply Weld where the geometry is disconnected (b). We shouldn't forget to check how the whole model looks with TurboSmooth turned on, too.

We can stop modeling the ear now. Let's join it to the head. If there is a TurboSmooth modifier in the stack of modifiers, or any other modifiers are turned on, delete them or turn them off. In order to delete a modifier you use the same Context menu that you opened for Collapse To. You only have to choose the Delete command from the lists of options.

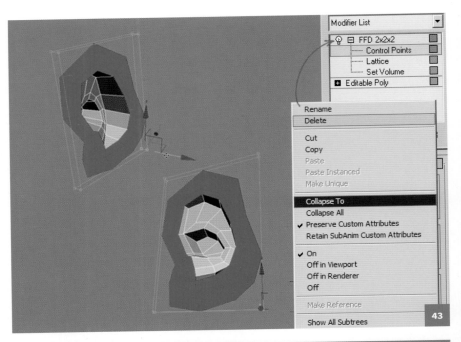

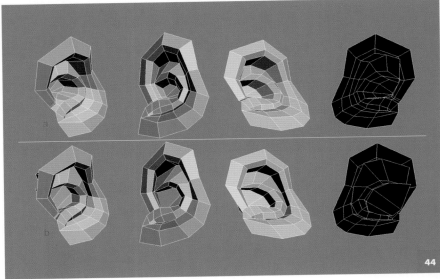

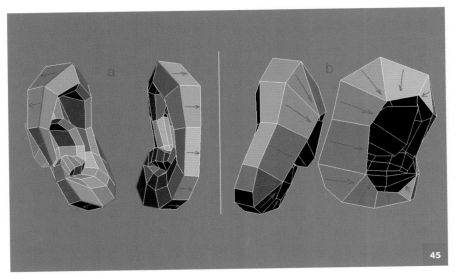

Now we can get back to the head editing process. In the Edit Geometry rollout, click the Attach button and choose the previously created ear (we will make the ear a sub-object for the head and then we will be able to edit them together). If you push the small button near Attach you will see the window with the list of objects in order to add to them.

Using the Move tool, adjust the vertices of the ear holes and head hole so that they match each other. After that, select these vertices and join them using Weld with a Threshold value of 0.2 (Fig.46). To demonstrate it clearly in this image, I've hidden all the geometry.

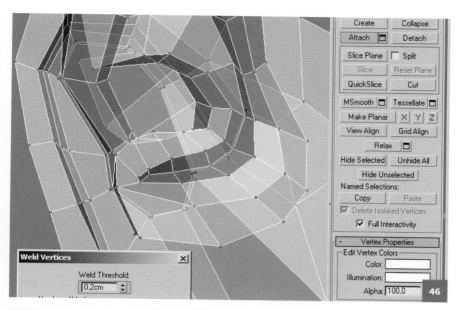

" The FFD modifier allows us to affect an entire region using its cage, rather than having to edit each individual vertex of the model "

Now let's model teeth for our character. In the right-hand panel window, create two box primitives with the parameters shown in Fig.47. Place them in the position of the upper front tooth. One box will be used as part of the gum and the other is for the tooth.

Convert these boxes to Editable Poly and then edit them one by one (Fig.48). Use the following process: delete all of the polygons that are marked in dark blue (a); move the vertices to give the tooth a regular shape (b); for Box01, select the polygons as shown in the image and apply Inset with an Inset Amount of 0.2cm (c); and finally, use Attach and add the blue Box02 (d).

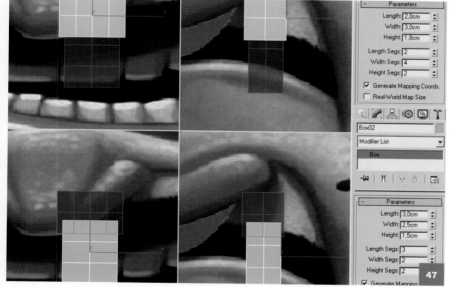

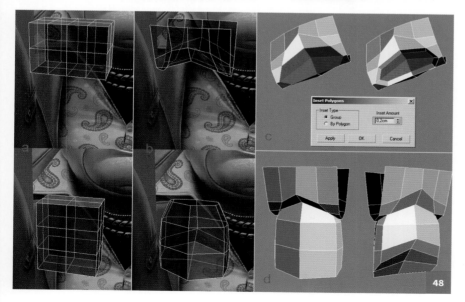

Now that we have made a pattern for one tooth, we can multiply it so that we can then use it elsewhere. In order to do this, select the tooth in the front window and move it along the X axis holding the Shift button. The Clone Options window will appear, where you can put the number of teeth you need to copy. Make eight copies and also note the type of copying – Copy (Fig.49) (a).

Select the first tooth and using the Attach tool, join all the other teeth with it. Select the vertices by the edges of the gum near every tooth, and then using the Weld tool, join them into one sub-object (b).

If we compare them, we can see that all the teeth are the same. Because of this, use the Move and Scale tool to edit their shapes. Also add four polygons into the edge of the gums (marked blue) (Fig.50).

Now select the model of the teeth and turn on Hierarchy > Pivot > Affect Pivot Only. This will allow you to pivot on the base point of the model without moving the whole model. This helps us guarantee the correct placement of modifiers in the next step.

Bend the teeth so that they take the shape of the mouth, and apply the Symmetry modifier to them in order to create the second half.

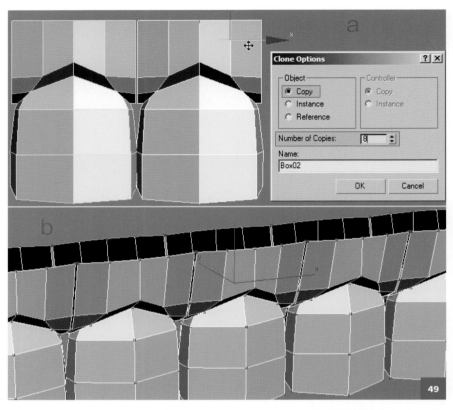

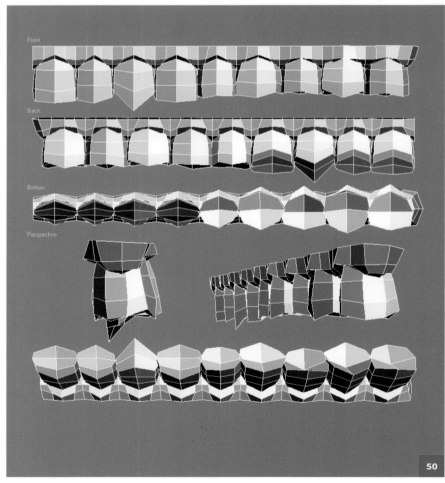

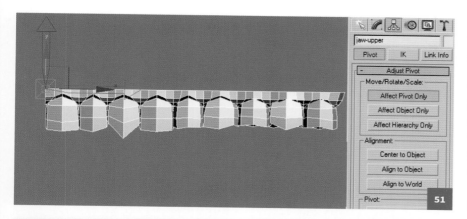

51

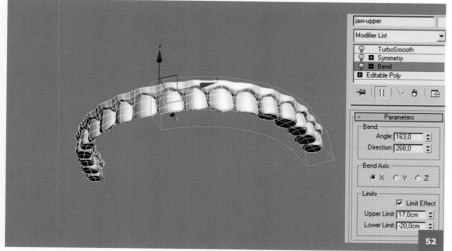

52

Place the pivot the way shown in Fig.51 and then turn off Affect Pivot Only. This is the stage where I rename the model 'jaw-upper'.

Now we can add Bend modifiers from the Modifier List to the modifiers stack (parameters are shown in Fig.52), and apply Symmetry and TurboSmooth (with the following parameters: Iterations 2 and Isoline Display on). As a result, we get a readymade row of upper teeth.

" The row of lower teeth should be different from the upper row, so mirror the upper row and edit its shape "

The row of lower teeth should be different from the upper row, so mirror the upper row and edit its shape. To mirror the upper teeth, use command MM (Main Menu) > Tools > Mirror and set the parameters as shown in Fig.53.

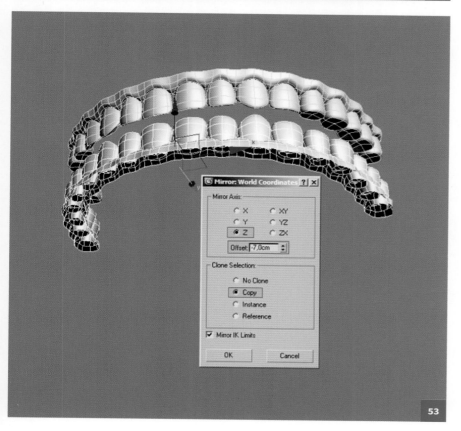

53

Also change the name of the lower jaw to 'jaw-lower'. Edit the shape of teeth, as before. Simply go to Editable Poly and adjust the sizes and proportions so that they look like lower teeth.

Fig.54 shows the jaw we have created so far (with the Smoothing tool turned on). You can also see that I have relocated and turned the jaw slightly to coincide with the sketch.

Let's get back to editing the head and add asymmetry to the mouth of character. We have to add an Edit Poly modifier between TurboSmooth and Symmetry – we will add asymmetry in that, not in the Editable Poly of the model. This turns off all the asymmetric geometry and gets us back to the initial version.

So by moving vertices using the Move tool we can change the shape of mouth as shown in Fig.55 (a). I've also added

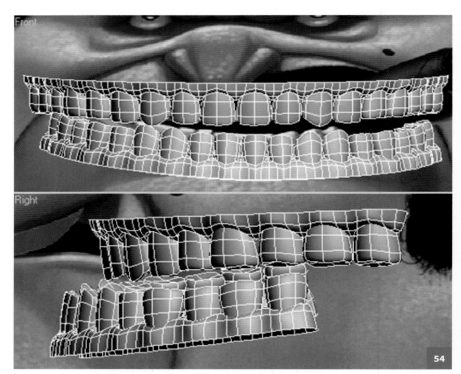

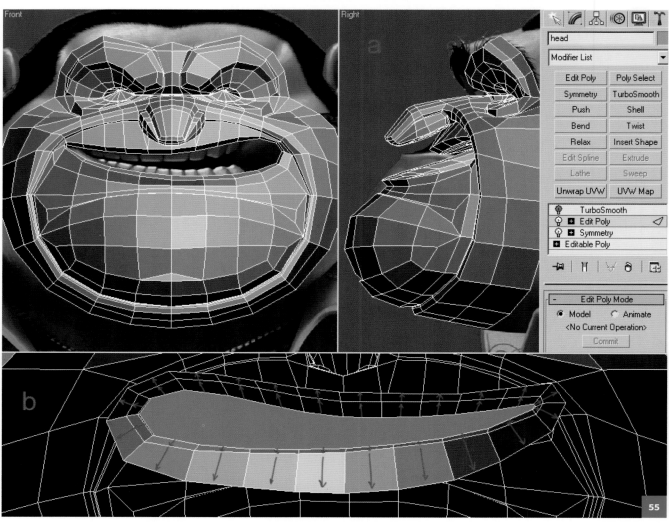

geometry inside the mouth to make it easier to make smooth lips (b).

Finally, we can create a cigar using a Cylinder primitive. Use a Cylinder with the parameters shown in Fig.56 (a). Convert it to an Editable Poly, and then apply and turn off TurboSmooth (with values of the following: Iterations: 2, Isoline Display: on). Finally, add some new edge loops and edit the position of the vertices (b).

Now select two dodecagonal polygons at the edges of the cylinder, use the Inset tool with each of them at each section (with a small amount as the Inset value) and then press Collapse. As a result we will divide these two polygons into 24 triangular ones (marked in blue in c).

Now select the uppermost and lowermost edges of the new polygons (marked in red in

c) and use Chamfer with a Chamfer Amount of 0.35cm. Edit the grid of the model, as shown in d, then turn the cigar around and place it into the mouth of the character.

We have now finished creating the head; we will go on to creating the body next. Our final model can be seen in Fig.57, with Smoothing turned on.

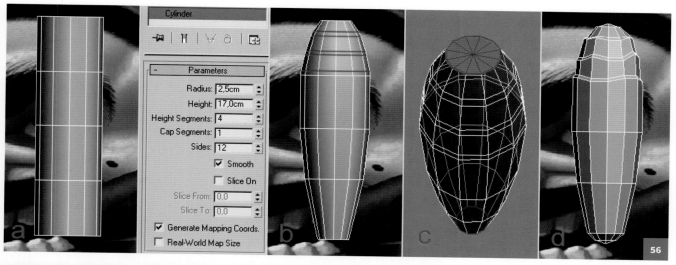

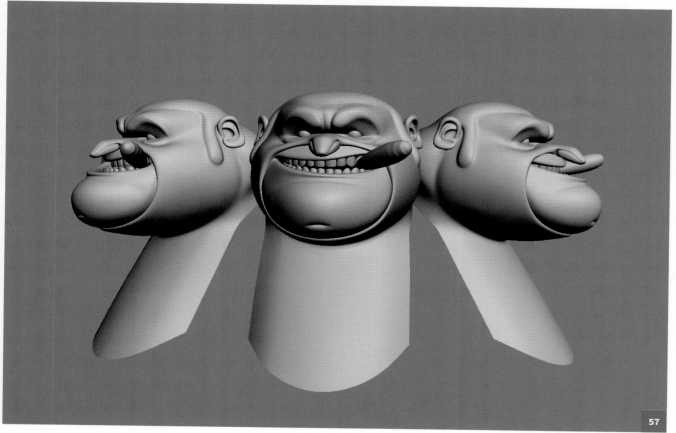

INTRODUCTION TO CHARACTER CREATION
ADDING DETAIL

BY DMITRY SHAREYKO

In this second chapter of the project, we will model the body and the hands. I won't show where the buttons are situated in the 3ds Max interface anymore as we have seen this in the first chapter. Instead, I will focus on the process and the value for the parameters used.

We can start with the jacket of the character. First, create a primitive box with the parameters: 50 x 50 x 50cm, with the Segments 3 x 4 x 2 (Length x Width x Height), which will be converted to an Editable Poly.

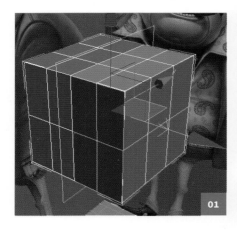

Select the polygons on the side that will be replaced with the Symmetry modifier (marked blue) and delete them by pushing the Delete key on the keyboard (Fig.01).

Note: This time we don't add Symmetry and TurboSmooth modifiers to the stack at this stage; we will do it later. I'll explain why further on in the project.

Moving between sub-object levels and using the Move, Rotate and Scale tools, shape the

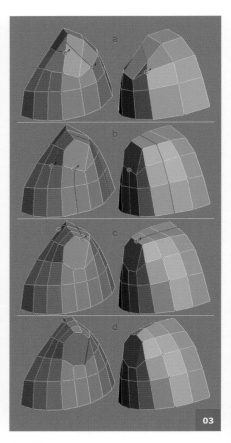

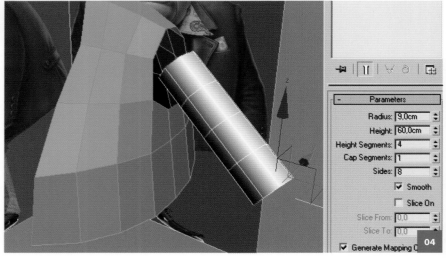

Parameters

Radius:	9,0cm
Height:	60,0cm
Height Segments:	4
Cap Segments:	1
Sides:	8

☑ Smooth
☐ Slice On
Slice From: 0,0
Slice To: 0,0
☑ Generate Mapping C

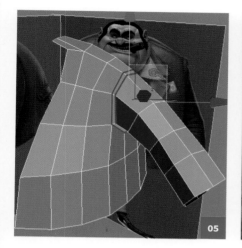

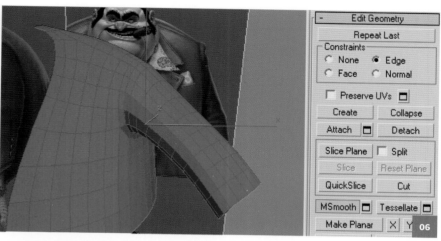

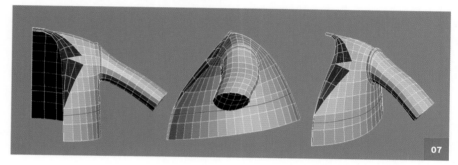

box to look like a jacket (without sleeves for now). Also delete any unnecessary polygons from the lower part of the model – these are marked in blue (Fig.02).

As you can see, using the current amount of polygons is not enough to shape the jacket, especially in the upper part of the shoulders. Add necessary edges using the Cut tool while fixing the shape of the model as you progress (Fig.03). Edges that we add are marked red, and edges we need to delete are marked blue (Backspace). The octagonal polygon (marked blue) we can also delete – this is the hole we need to add sleeves to.

It's time to add the base for future sleeves. Use a primitive cylinder set with the parameters shown in Fig.04.

Note: Notice that we will model the hands at 45 degrees from the body. This is done to avoid problems with the rigging and skinning of our character.

Now we can get back to editing the jacket. Using the Attach command, join the cylinder to the jacket. We can shape it to look like the sleeve by relocating vertices and deleting polygons from both edges of the cylinder. Connect the sleeve to the jacket using the Bridge tool as illustrated in Fig.05.

Let's add the main details to the jacket. At the moment, the base model doesn't really have enough polygons to do that yet, so we need to select all the polygons and use the MSmooth (MeshSmooth) command with the

default parameter value (Fig.06). As a result we add one iteration of model smoothing.

We now have enough geometry to add details. We're going to start by creating the collar. Select the relevant edges for the collar, extrude them outwards and shape them to resemble the highlighted blue polygons in Fig.07.

Now it's time to model the cuffs. First select the edges, as Fig.08 shows, and apply Split to it (a). Then extrude the edges to create the start of the cuff (b). Using the Connect and Cut tools, add a few edge loops (c). We add the edges at this stage in order to create a seam along the perimeter of the main elements.

Using the Cut tool, add one more edge loop around the sleeve joint and edges. This will form the base for the pocket (Fig.09).

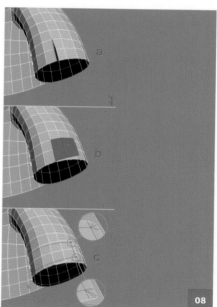

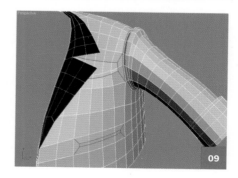

In the end, using the Connect and Cut tools, add a few more edge loops (needed for seams) to the collar and the lower part of jacket, as shown in Fig.10.

Now it's time to add thickness to the material of the jacket. On top of the Editable Poly object, add the Symmetry modifier to the stack of modifiers with standard parameters. Then add the Shell modifier with the parameters shown in Fig.11.

After this, convert the object to an Editable Poly again, and delete those polygons made by the Symmetry modifier (marked blue).

We can use this trick to get regular topology on the axis of symmetry while adding a Shell modifier. If we added the Shell modifier to half of the jacket, we would create artefacts at the axis of symmetry while smoothing it. That's why we didn't add smoothing to the model at the beginning of this technique.

Now we can add Symmetry modifiers on top of the Editable Poly (leave the parameters set to their default values) and add TurboSmooth (Iterations set to 2 and Isoline Display on).

Finally, we can take care of the seams. Select the edges along the seams and then use Extrude (to the edges only – not the polygons) with Extrusion Height set to -0.3cm and Extrusion Base Width set to 0.15cm.

Let's look at this process using an example of the cut in the collar (Fig.12). If you turn on the TurboSmooth modifier now you will see that the seam is indistinct (a). To avoid this, we can use the Chamfer and the Target Weld tools to adjust the topology around the corners (b). This creates the effect shown in c.

We now need to look at the newly created seam. To avoid the appearance of unnecessary polygons around the joined edges, apply Weld to the vertices (d).

Continue to add seams around the perimeter of the jacket and, after turning on Symmetry and smoothing, you can see a much better result (Fig.13).

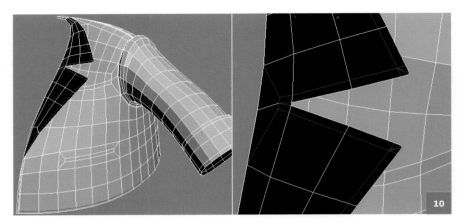

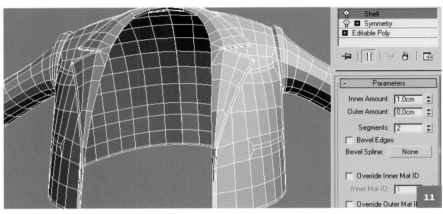

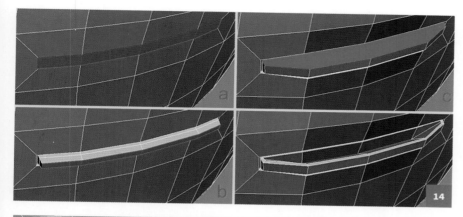

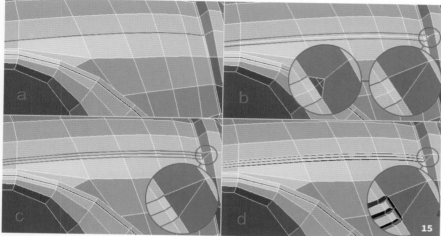

Now we need to add the pockets and the seam across the back and the shoulders. In order to model the lower pocket, select the polygons as shown in Fig.14 (a), and apply Bevel three times with the following values (b):

• Height -0.3cm and Outline Amount -0.15cm
• Height 0.5cm and Outline Amount -0.12cm
• Height 0.8cm and Outline Amount -0.18cm

Fix the shape and select eight polygons (c), apply the Inset tool, apply the Inset tool with an Inset Amount value of 0.35cm, and finally move the two marked vertices lower in order to create depth (d).

We can use the same modeling technique to create the upper pocket.

Now we can work on the seam on the back. First, select the edges, as shown in Fig.15 (a), delete the extra vertices that have appeared where the shoulder seam meets the sleeve seam, and apply Chamfer with a Chamfer Amount of 0.65cm and 2 Segments (b).

Then select the edges, as seen in c, and apply Extrude with an Extrusion Height of 0.2cm and Extrusion Base Width of 0.15cm. In the angles of the seam, two triangles and two pentagons appear, which result in an artifact when you use Smoothing. We can delete this by applying Collapse to their common edge (d).

The handkerchief in the upper pocket will be created using a box primitive with two segments to each side. Position its vertices, as the sketch shows, and delete the polygons on three of its four sides (Fig.16) (a). This will give us a 50-50 folded fabric.

Apply the Shell modifier to the handkerchief with an Inner Amount of 0.4cm, Outer Amount of 0.4cm and with 2 Segments. On top of that, add the TurboSmooth modifier (with Iterations set to 2, and Isoline Display turned on) (b).

In order to finish the jacket, we need to create the buttons and the buttonholes for them. We use a cylinder primitive to create buttons with Radius set to 1.4cm, Height to 0.6cm, Number of Segments in Height to 1 and 12

sides (Fig.17) (a). We then convert it to an Editable Poly, and select the polygons' edges.

After that, apply Inset to them one by one (with an Inset Amount of 0.7cm), Extrude (Extrusion Height of -0.25cm) Insert and Collapse (b). Select the edges as shown in Fig.17 and apply Chamfer (Chamfer Amount set to 0.05cm) (c). Add the TurboSmooth modifier to the stack with the following parameters: Iterations set to 2 and Isoline Display turned on.

Now let's model the stitching. For this, we need to use splines. First, choose Create > Shapes > Line in the menu and create a line in the shape of the stitching; pass it through the button (d).

Add a Sweep modifier to this spline with the following parameters: Built-In Section: Cylinder; Interpolations Steps: 1; and Radius: 0.1cm (e). We convert our stitching to an Editable Poly and delete its edges. Now go to edit the button and add the thread using the Attach command.

We will create buttonholes using a plane with the following parameters: Number of Segments in the Length set to 3 and Width to 4 (Fig.18) (a). We then convert the plane to an Editable Poly, delete two inner polygons, and shape the others to look regular (b).

We apply a Shell modifier (Inner Amount: 0.2cm, Outer Amount: 0.2cm, Segments: 1) and TurboSmooth (Iterations: 2, Isoline Display: on); step c shows the result.

Now we place the buttons on the jacket. The final look of the jacket is shown in Fig.19.

We can create the shirt next. The sleeve of the shirt is a simple cylinder with deleted edges (Fig.20) (a). To this cylinder we apply a Shell modifier (Inner Amount of 0.5cm, Outer Amount of 0.5cm, Segments: 2), Symmetry (parameters by default) and TurboSmooth (Iterations set to 2 and turn Isoline Display on) (b).

In order to create the front part of the shirt, we can use a plane primitive and create the section of the shirt that is visible by once again using the method of copying edges (Fig.21) (a). We can also add polygon loops along the perimeter of the belt at this stage (b).

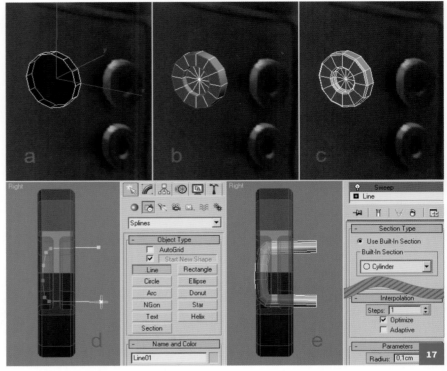

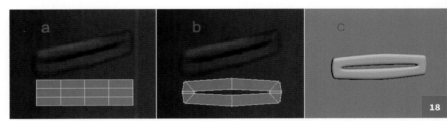

19

18

" The sleeve of the shirt is a simple cylinder with deleted edges "

These polygons will be visible if the character is to be deformed. But on the other hand, if you're creating a character for a render only, then you won't need to worry about that.

20

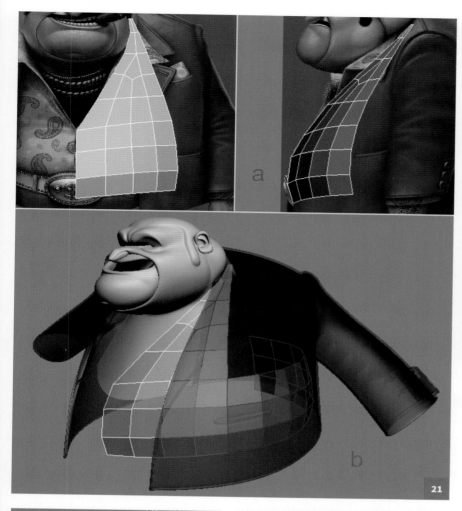

a

b

21

22

23

24

25

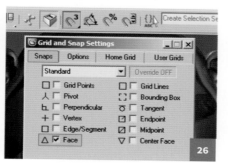

26

Using the method of extruding edges, we model the collar (Fig.22). Add edges marked red to get sharper angles when smoothing this area.

By using the Cut and Connect tools, we can add edge loops later for seams in the same way we did for the jacket of our character (Fig.23).

As we did with the jacket, we can now add thickness and seams to the shirt. This is what we get as a result (Fig.24).

Now we just need to add buttons and tuck one part of the shirt under the other. First, duplicate the buttons that we created for the jacket. Then use the Collapse tool from the Symmetry modifier to tuck one part of the shirt under the other (the stack should only have Editable Poly and TurboSmooth modifier left). Then all you need to do is just rework the vertices to get a cleaner mesh (Fig.25).

Now let's model the chains on the neck. First use a line and create three splines around the neck; they will be our directions to follow for chain bending. It's easier to do this if you turn on Snap to Surface, the 3D Snaps Toggle and then choose Face in the settings. The Grid and Snap Settings window may be opened by clicking the right mouse button on the 3D Snaps Toggle (Fig.26).

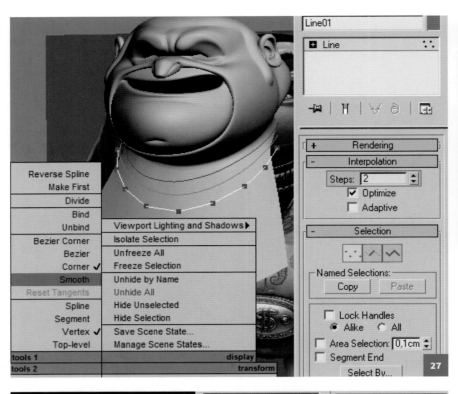

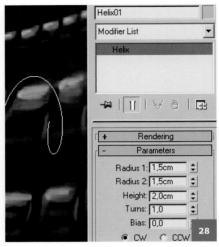

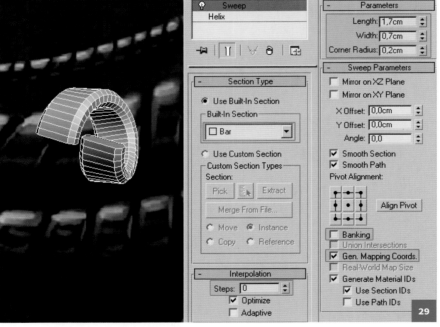

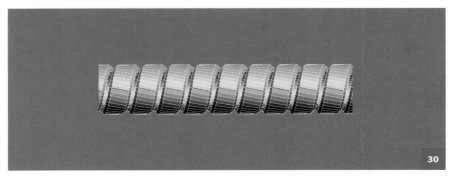

Now we will need to move the splines from the neck a little as chains have thickness and so will sit a little further away from the body.

Move to the Spline Vertex editing window, select all the points and apply QM tools 1 > Smooth. This is so we convert marked vertices from a Corner type to a Smooth type, and get a smoother curve as a result. In the Interpolation scroll, lower the Steps value from 6 to 2, thereby lessening the number of points which appear between two key areas (Fig.27).

Now let's create the chain itself. We can use the same method that we used to create the teeth by creating an individual link, duplicating it and then merging the links together. From the Create menu > Shapes, choose Helix and allocate the parameters, as shown in Fig.28.

After that, apply a Sweep modifier with Built-In Section set to Bar, Interpolation Steps to 0, Length to 1.7cm, Width to 0.7cm, Corner Radius to 0.2cm, and Banking turned off. It is important to remember to turn on Gen. Mapping Coords (Fig.29). (I find that I forget to do this almost all the time and torture myself making the unwrap later!)

We can now convert the object to an Editable Poly and delete the two-edged polygons.

Clone the object by choosing Clone Options > Copy in the dialog window and allocating the number 80. Select one of the clones and using Attach, connect other clones to this one (Fig.30).

Now we have to select all the links along the chain and apply Weld with a Weld Threshold of 0.07cm. Selecting this amount manually is hard, though, so we can try using a little technique to get it done more quickly…

Go to the level of editing called Border and press Ctrl + A to select all the links. As we have deleted all the front polygons in every part of the chain already, we will select all the edges at the points where the links need to join. Now press Ctrl on the keyboard and go to the level of editing called Vertex – all the points will be marked automatically. Now we can apply Weld to them.

So now we have guiding splines and the chain, we have to next bend these splines to contour the shape of the chain. This is fairly easy; we just create four copies of the chain (we will need the fourth one later to do the bracelet for the right arm).

Select them one by one and apply the PathDeform (WSM) modifier. After that, select the Pick Path button inside PathDeform and choose the appropriate spline. Then select the Move to Path button and our object moves to the chosen spline and bends according to the shape of this spline.

It may happen that the object won't shape correctly according to the spline, but will bend perpendicularly. In this case, a group of switchers on the Path Deform Axis will help. To change the size of an object proportionally, we can apply Select and Uniform Scale.

The settings of the modifier can change the following (Fig.31):

- **Percent:** moves the object along the gizmo path based on a percentage of the path length.

- **Stretch:** scales the object along the gizmo path, using the object's pivot point as the base of the scale.

- **Rotation:** rotates the object around the gizmo path.

- **Twist:** this twists the object around the path. The twist angle is based on the rotation of one

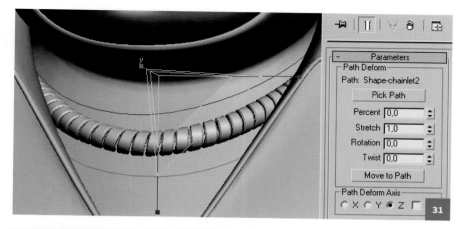

end of the overall length of the path. Typically, the deformed object takes up only a portion of the path, so the effect can be subtle.

Let's move to a harder part now: modeling the hands. This is rather complicated, but I won't apply new techniques; we'll use what we've already learned. I will only show figures of the stages to go through without re-explanations.

First, we create the initial form of hands with the help of a box primitive (I have modeled the hand in a downwards pose and will then drag it into position) (Fig.32).

Increase the number of polygons, as shown in Fig.33, and then add in some extra details to the shape (Fig.34).

You can now add a few edge loops, and delete some of the polygons to create a place for the thumb to hang (Fig.35).

Now create a base for where the fingers will be inserted. Fig.36 shows how I have created 10 edges in the section for the thumb, and eight edges for each of the fingers.

Instead of modeling every finger separately, we will make one and then resize it to create the form and size of every finger. I find it easier to start modeling a finger using a Cylinder primitive with a side volume of eight (Fig.37).

With the first finger ready, we just need to copy and resize it to create the others. Then, with the help of Attach, join it to the hand and use Weld to connect the necessary vertices (Fig.38). Do the same with all the other fingers – except for the thumb, at this stage.

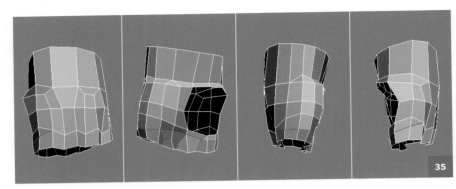

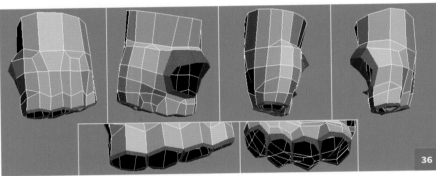

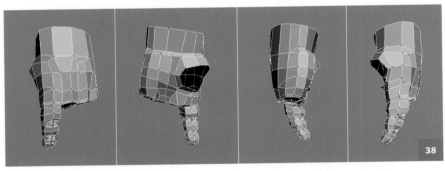

The thumb is different from other fingers, so I'll show how to deal with this separately (Fig.39).

As you can see, we need to delete wrinkles at one of the joints and change the geometry of the base of the thumb to make it look more believable. You should remember that the number of edges binding the thumb to the hand is not 8 but 10. Now we can join it.

To wrap up work on the hand we just need to add a few edge loops to emphasize the forms of the joints, wrists and wrinkles on the palms (Fig.40).

Now let's drag the hand into position and apply a TurboSmooth modifier on it, with the usual values (Fig.41).

Now we only lack fingernails, rings and a bracelet on the right hand of the character to complete this stage of the modelling.

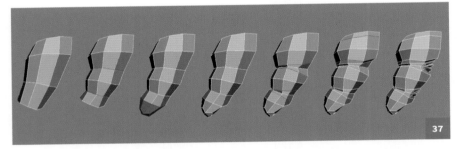

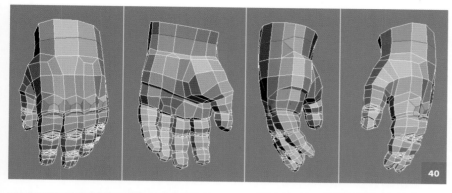

Fingernails can be created using a primitive plane. Apply Bend (with an Angle setting of 75 degrees), Shell (with Segments set to 2) and TurboSmooth to it (Fig.42). Then just copy it to put the nails on the fingers.

I won't talk too much about the techniques involved in making a bracelet, as we can simply follow the same steps involved when we created the chains (Fig.43).

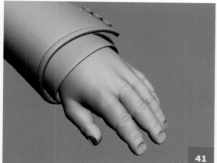

In order to create rings we will use a cylinder primitive (with a Radius of 2.5cm, Height of 2.4cm, Height Segments of 4, Cap Segments of 2, and Sides set to 16) (Fig.44) (a). Delete all the central polygons and shape the others. The ring on the middle finger is now ready (b).

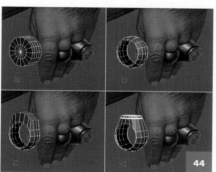

In order to create the ring on the ring finger, duplicate the current ring, then apply Bevel (Height set to 1.4cm, and Outline Amount to -0.3cm) and add the ring to the projection on the top (c). Finally, fix the form of the ring and add some details to it (d).

You can see our current model in Fig.45. We will finish modeling the character in the next part by adding a belt, legs and shoes.

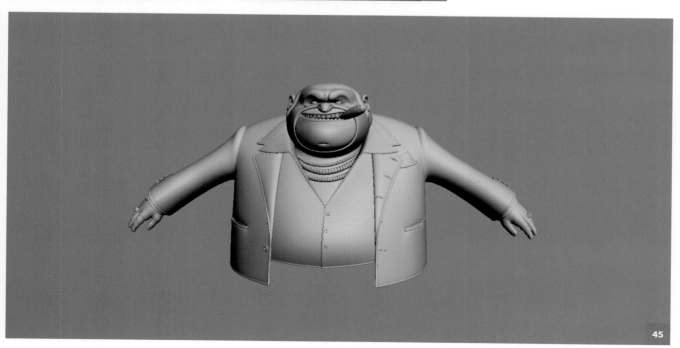

INTRODUCTION TO CHARACTER CREATION
MODELING BELTS AND BOOTS

BY DMITRY SHAREYKO

We're now moving onto creating the bottom half of our model: the legs, belt and shoes - which are actually much easier to model than the head and torso, so you should fly through this third chapter!

To create the legs we'll start with the trousers using two primitives (Fig.01):

• Box (L x W x H: 25 x 95 x 95cm, and L x W x H Segs: 2 x 4 x 4) – for the pelvic area.

• Cylinder (Radius 5cm, Height 50cm, Height Segments 6 and Sides 8) – for the legs.

Remove the polygons highlighted in blue from the box and convert the box to an Editable Poly. Then apply the TurboSmooth modifier (Iterations: 2, Isoline Display: on) and Symmetry. Convert the cylinder into an Editable Poly, remove its ends and attach it to the box using the Attach command.

Next, we'll connect the primitives (Fig.02). Adjust the position of the vertices and delete the blue edges (a), then add some edge loops on the box (b). Delete the polygons marked in blue and, using Weld, connect the box and cylinder.

Now add edge loops to obtain a more uniform mesh and, of course, follow the silhouette of the reference (Fig.03). Also at this stage create a portion of the inside of the trouser leg and the waist (two polygon loops) so as to avoid visible open edges.

Add a few more edge loops to create the appearance of folds in the trousers (Fig.04).

04

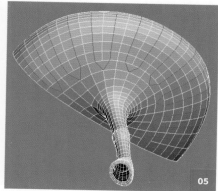

05

06

07

Next we can create the pockets. There are currently not enough polygons in the region to create them, so we have two possibilities. The first way is to use MSmooth, which means that each polygon is divided into four, and the result is then smoothed. But this feature has one major drawback: we will not return to the original mesh (well, we can – with some plug-ins or manually – but it's difficult to do).

The second option is to use the model modifier, TurboSmooth (Iterations: 1, Isoline Display: off – it is very important not to forget to turn the Isoline Display off), and then the Edit Poly modifier before continuing to edit the model. This way we will always have the option of disabling these two modifiers and getting the original model back.

So, using the latter method, we see that the model has become denser, but the pockets of the polygons are still quite stretched, which creates artefacts when smoothing. Add some edge loops (marked in red) to obtain more or less square polygons in the right places (Fig.05).

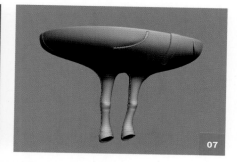

08

Make a template for the future pocket with the Cut instrument (Fig.06) (a). Then, in exactly the same way as we did for the pockets of the jacket, model the pocket of the pants. Select the polygons, as shown (b), apply Inset (Amount 0.15cm), and then Bevel three times with the following values (c):

• Height -0.13cm and Outline Amount -0.1cm

• Height 0.4cm and Outline Amount -0.04cm

• Height 0.4cm and Outline Amount -0.1cm

Modify the form a little and select 14 polygons (d). Apply Inset (value of 0.12cm), and put down the two inner ribs below to form a recess (e).

We can create the fly and make the seams in exactly the same way as we did with the jacket. As a result, the smoothed model should look something like Fig.07.

Let's make the belt next. Select the edge loop around the perimeter of the pants and use the command: Create Shape From Selection (Fig.08).

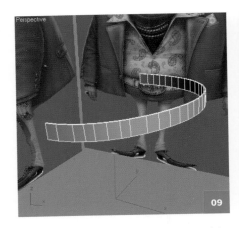

Now we have got extra splines in the area of the pockets and side seams – which were formed as a result of the previous command – and we need to delete them. To do this, apply a Sweep modifier with the following values: Built-In-Section: Bar; Length: 0.55cm; and Width: 7.8cm (Fig.09). You will need to adjust the position of the vertices of the splines a little.

Convert the object to an Editable Poly and add some auxiliary edge loops to it so that the smoothed model has sharp corners on the edges of the belt. Apply the Symmetry and TurboSmooth modifiers with the usual values (Fig.10).

Select two edge loops (as shown) and apply Create Shape From Selection. We'll need the resulting spline later when adding rivets to the belt (Fig.11)

Now we can start to model the buckle on the strap. To create the basic form of the object, go to Create > Shapes > Ellipse and apply the values shown in Fig.12.

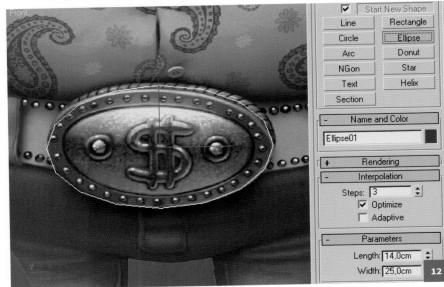

Convert the ellipse to an Editable Poly (Fig.13). The result is a single polygon with 16 ribs. Use the Insert and Cut tools to divide this polygon into smaller quadrangles (a). Apply the Shell modifier with Outline Amount: 2cm and Segments: 2 (b). Then convert the object to an Editable Poly and give the inside of the buckle a more convex form. Finally, add some auxiliary edge loops and apply the TurboSmooth, and also Symmetry modifiers (c).

To create rivets on the perimeter, do not forget to highlight the edge loop and apply Create Shape From Selection (Fig.14).

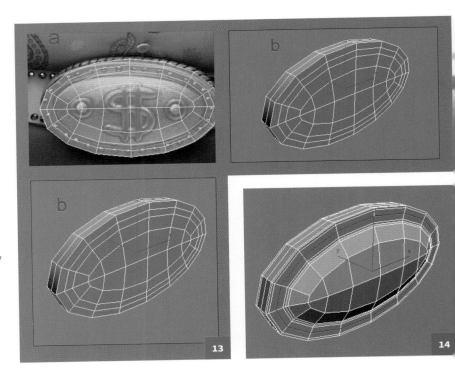

15

Now we need to design a dollar sign to finish off the belt. To do this, start with a primitive plane and extrude the edges outwards to model a flat dollar sign (Fig.15) (a).

Select all the polygons and apply Extrude with an Extrusion Height of 0.2cm, and Bevel with a Height of 0.4cm and an Outline Amount of -0.2cm (b). Finally, you can add the auxiliary edges for a realistic smoothing effect (c).

16

We will make the two big rivets on the sides of the dollar using a sphere primitive (Create > Standard Primitives > Sphere) with parameters as shown Fig.16.

Convert the object to an Editable Poly and, using the Extrude and Chamfer tools, add a ledge at the base. The result should look as shown in Fig.17. Auxiliary edges are highlighted in red, and necessary to hold the form when the object is smoothed.

17

18

The twisted pattern on the rim of the buckle will be made in the same way that we created the chains and bracelet in the previous chapter. With the help of Create Shape From Selection, apply Guideway and Path Deform (WSM) Fig.18.

To complete the work on the belt, we need to add small studs on the buckle and the belt.

First of all we need to make a rivet. To do this, simply create a half sphere with the following parameters: Radius: 0.6cm; Segments: 8; and Hemisphere: 0.5. Now run the Tools > Align > Spacing Tool. In the window that opens, you must specify the spline on which we will copy the rivets and the number of copies. You must also include Follow so that the copy is correctly aligned relatively to the spline (Fig.19). We are not interested in other copy settings now. Finally, make the rivets on the strap in exactly the same way.

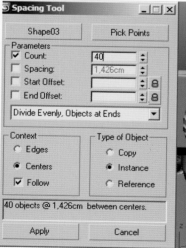

19

43

"To create the character's shoes, create a primitive plane on its side, convert it to an Editable Poly and, by extruding edges, model the profile of the boot"

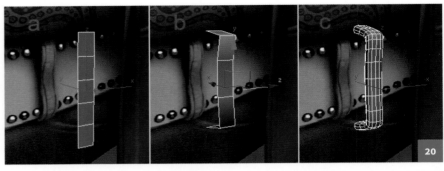

Now we need to add carriers to the trousers (Fig.20). To do this, create an elongated plane with five segments in height (a), bend it into the strap shape (b), and apply the Shell and TurboSmooth modifiers (c).

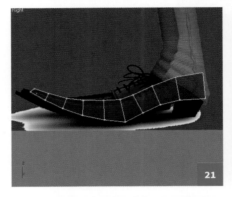

To create the character's shoes, create a primitive plane on its side, convert it to an Editable Poly and, by extruding edges, model the profile of the boot (Fig.21).

Apply the Shell modifier to the profile we've got with an Outer Amount of 3 (Fig.22) (a). Transfer the object to Editable Poly again, add a cross-section (as shown) and delete the polygons on the axis of the symmetry, marked in blue (b).

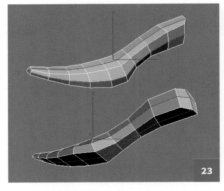
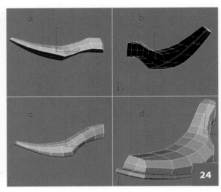

Give the object a shoe-like shape and add a few extra edge loops to get it closer to matching the reference (Fig.23). After this, set the reference point model (pivot) so that it is on the shoe's axis of symmetry, and apply Symmetry and TurboSmooth modifiers with the same values as in the previous cases.

Now select all of the polygons on the sole and apply Extrude with an Extrusion Height of 0.4cm and Extrusion Type of Local Normal (Fig.24) (a). Delete the polygons that were formed on the axis of symmetry (b), select the polygons as shown in the image (c) and again apply Extrude with the same parameters. Finally, select edges on the perimeter of the sole and apply Chamfer with a Chamfer Amount of 0.07cm (d).

Now we can add the heel (Fig.25). Use the primitive box with dimensions (L x W x H: 5.5 x 5 x 7cm and L x W x H Segs: 3 x 2 x 2) (a). Delete the upper polygons and then tilt it by the FFD modifier 2 x 2 x 2 (b). add some extra edge loops at the back to create the shape of the heel and apply Chamfer to the ribs (which must have sharp corners) (c). Now the heel is ready, you can apply TurboSmooth to it.

We can then create the side leather inserts with holes for the laces. This is simple: to create a plane that goes over the surface of the shoe's back and sides, simply highlight the necessary shoe polygons, use the Detach command with the Detach as Clone parameter and then edit the newly created object. Make sure that opposite each hole is a vertex formed by the intersection of the horizontal and

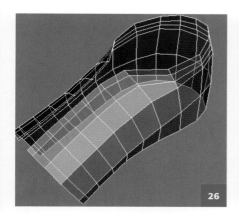

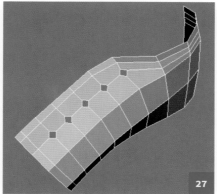

vertical edge loops (Fig.26). After this, select these same vertices and apply Chamfer to them with a small value. Finally, remove the polygon in the center of each hole (Fig.27).

If you apply smoothing to the model now you will see irregularities, as there are five hexagonal polygons near the holes. You can fix this by adding a few edges, as shown in Fig.28.

Now it is possible to adjust the thickness of the shoe using the Shell modifier (Outer Amount: 0.3cm and Segments: 2). In order to create seams, select the ribs, as shown in the image, and apply Extrude with an Extrusion Height of -0.1cm and Extrusion Base Width of 0.08cm (Fig.29).

Finally, add the laces by creating them using the Line object and adding volume with the Sweep modifier using the following values: Built-In-Section: Cylinder; Interpolation Steps: 1; and Radius: 0.25cm (Fig.30).

As I mentioned at the start of this chapter, the legs, belt and boots are by far the easiest parts of the character in terms of modelling. Fig.31 shows our progress so far – which also marks the end of my contribution to this project!

The following chapters in this Introduction to character creation project will be led by Seid Tursic, who will cover techniques for preparing UV maps, painting textures, producing shaders and maps, and perfecting and compositing the character.

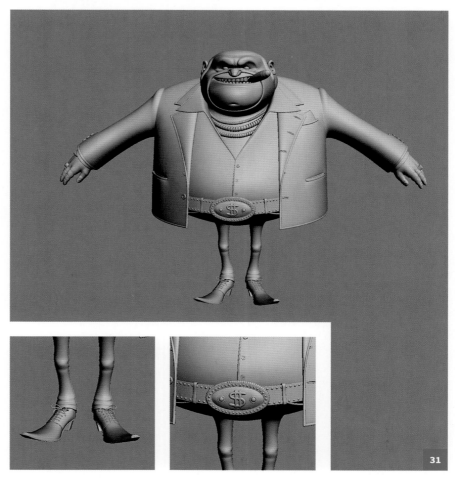

INTRODUCTION TO CHARACTER CREATION
PREPARING UV MAPS

BY SEID TURSIC

It's now time to tackle the texturing of our stylized character. I will begin by outlining workflows to extract the UV maps and preparing a good foundation for texturing.

I am going to explain and prepare the UVs for the texture maps. I use two different ways to extract the UVs here: one way is with the Unwrap UVW modifier in 3ds Max and the other with the ZBrush UV Master plug-in. If I want more control over the UV layout, I usually work inside 3ds Max where I can move every single vertex of the UV cage.

I prefer this workflow on complicated areas, particularly when texturing organic objects. On some important parts of the character, we want to have 'proper' UVs rather than computer-generated ones.

Let's start with the 3ds Max Unwrap UVW modifier workflow (Fig.01). We will first make the UVs for the jacket, as it looks like the most complex object on the character and we want to have full control over this.

Select the jacket object, and hide all the other objects to have a clear view if you prefer. We have to delete the TurboSmooth modifier and collapse the symmetry and other editable modifiers to have only the raw object.

Choose Unwrap UVW modifier from the Modifier List, which is located almost at the bottom of the list (a). After applying the modifier, click Open UV Editor (b). As you can see, the UVs are messed up with a high number of green lines on the model, which represent the broken edges on the UVs.

Next, we will have to place the green lines on hidden spots of the model or on the side which is not visible.

Note: The fewer polygons and geometry you have on your model, the easier the Unwrap process will be.

To edit the UVs (Fig.02), first, select the faces in the Unwrap UVW modifier stack (a). Before making a section on the model, deselect the Ignore Backfacing option (b) so we can select every back-facing polygon on the model.

Select the whole of the jacket, when everything is part of the selection, go and check the Planar Map in the Projection stack (c) and immediately check the View Align button underneath it.

The sleeve will now be visible in the UV Editor screen. Press the Planar Map to accept the selection and move the selected sleeve in the UV Editor to the side, which is now an extracted UV object.

Time to switch to the Edges in the Unwrap UVW stack (Fig.03) (a).

Select one edge on the sleeve on the displayed spot (b); this spot is not always visible and makes the perfect place to apply a cut on the UVs. Check the Loop UV button in the Editor (c) and make a cut with the Break button (d).

If done correctly, a green line will be visible on the edge loop throughout the length of the sleeve.

Note: Always place the UV seams and cuts on hidden and less visible spots.

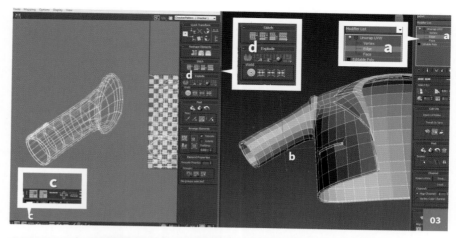

As the whole jacket has geometry on both sides, we need to extract the inner side of the UV geometry from the outer shell (Fig.04). I found the perfect spot for this example but keep in mind that every single object is unique and has its own solutions.

In this case, select the two edges (a, b) and click the Loop: XY Edges button (c) in the Edge Selection rollout. Use Break again (d) to split the edges in the same way as we did in the previous step.

Now we have to clean the UV parts of the sleeves to work on (Fig.05).

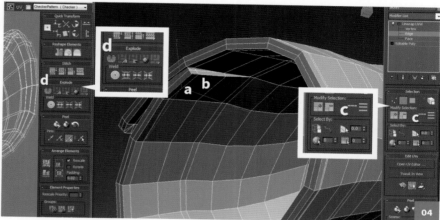

Switch to the Move Selected Subtools button in the UV Editor (a), tick Select By Element UV (b) and click on any UV edge in the UV Editor. Move one part of the sleeve's UV next to the other (c).

Now we have a solid ground to work further on the UVs, we can fully concentrate on the UVs inside the UV Editor. First, select Vertex from the Unwrap UVW stack (a). This is now the perfect situation to make use of the great Relax tool (Fig.06). This tool is located in the UV Editor Tool menu (b).

First, select any part of the sleeve's UV; in this case I select the important outer part (c). Hit Start Relax (d) in the small Relax Window. You will notice some kind of simulation taking place, which is stretching the whole UVs to a single flat area. Feel free to increase the Iteration and Amount sliders to speed up the simulation (e). Also make use of the different Relax options in the Relax menu, but avoid switching to Relax by Centers. The result is good, but still not perfect...

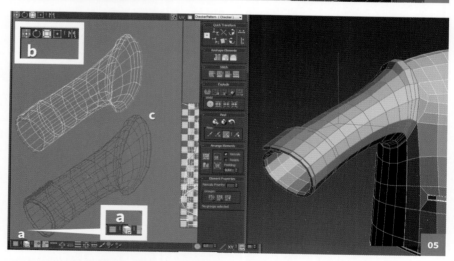

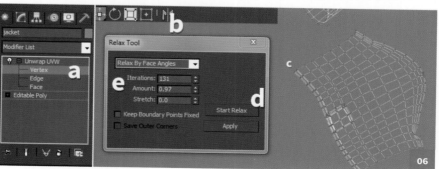

At this point, we only have one small issue, commonly referred to as overlapping UVs. In the red circle in Fig.07, you can see that one small part is overlapping on top of another. If we leave it we could run into serious problems later when applying textures or generating displacement maps.

Let's find a solution for this with the Soft Selection tool inside the UV Editor. Check it and increase the slider to about 20. Let's also limit the Soft Selection by 3 edges and select some of the vertices on the upper UV part.

Now, move the vertices under the influence of Soft Selection to the side (Fig.08). You can switch Soft Selection on and off until you get the small part of the vertices arranged.

This is the not-so-fun part of the process and there is no way around it. Move the single vertices until you get something similar to what is shown. By moving the vertices around we can fix any small overlapping issues; if there are bigger overlapping areas we will need to cut smaller UV pieces and use the Relax tool a lot, though it really depends on the geometry of the model.

Note: If you run across some really complex geometry, feel free to cut smaller UV tiles. It is better to have more seams rather than suffering stretched-out textures.

Using the same methods and the Relax tool, go on and finish the inner part of the sleeves (Fig.09). Always ensure you have evenly distributed vertices and faces. The Relax tool will be working on your side, but it needs preparation to work correctly. If something is out of reach for the tools, just adjust the points manually.

Now, if want to check if the UV is done correctly, open the Material Editor (shortcut key M) (a) and apply any material to the jacket. Then click the small button next to the Diffuse slot (b), apply the Checker map (c), and set the tiling to 20.

Now check the Show Shaded Material in Viewport button (d) to get the result on the screen (Fig.10). As you can see, the checker

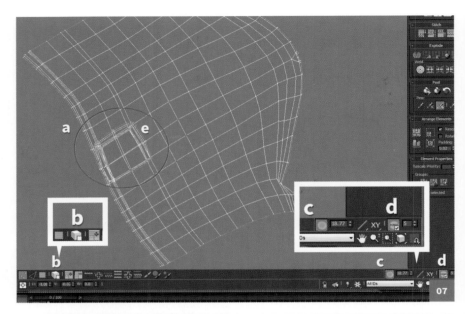

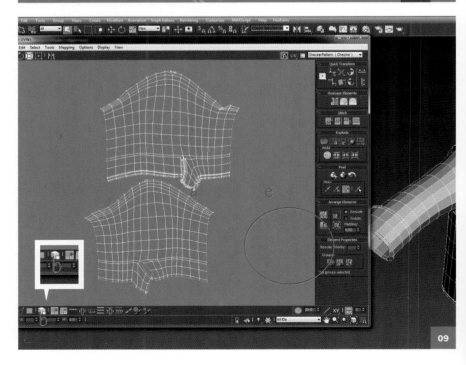

tiles are evenly distributed over the sleeve, which represents the actual texture for now. Feel free to rotate around the model from different angles. Some spots may be a little stretched – usually around the manually adjusted area – but it should be just good enough if kept to a minimum.

Now it's time to proceed to the other parts of the jacket (Fig.11). Select all the faces of the jacket collar (a) – don't forget to select the inner faces. Use the same methods described in the previous steps (b).

Now apply the Planar map and make an edge loop on the sides of the collar (c) and split it with the Break tool (d). We should now have two separate tiles on which we can apply the life-saving Relax tool (e).

" Place the seams where they will be hidden from view and make sure you check for stretching using the checker map "

Using the same methods, you can finish the rest of the jacket now (a, b).

As you can see in Fig.12, I place the cuts on the actual seams of the jacket. The goal is to have big UV spaces where we can paint our texture maps. Remember, though, that the fewer seams we have, the better our model will look.

Place the seams where they will be hidden from view and make sure you check for stretching using the checker map.

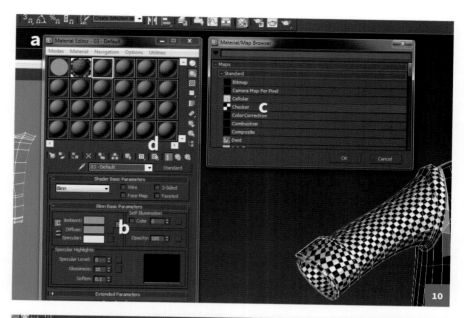

10

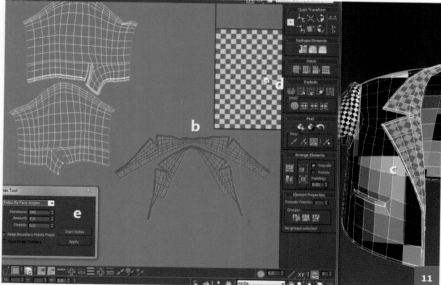

11

12

Take your time and place the UV pieces inside the UV frame (Fig.13).

I scale down the non-visible UV tiles, so they don't take up too much space in the valuable UV frame. Always keep the texture maps in mind: Where do you want to paint the textures? How much detail do you want to paint? What size are the textures? What parts are hidden and don't require any textures or much UV space? And so on.

As promised, it's now time to show another method for getting UVs for texturing (Fig.14). I use this method a lot for simple objects but let's demonstrate it on the portrait of the character. It sounds like a one-click show but that's not the case, because we have some control and want to use all the possibilities this tool offers for even better results.

First, collapse the Symmetry modifiers; delete TurboSmooth and export the head as an OBJ file.

Now, jump into the digital-sculpting software, ZBrush. Newer versions of ZBrush have the UV Master plug-in installed; if you have an older version, you can find the plug-in at **www.pixologic.com**. Import the head into ZBrush (Fig.15) (a) and enter Edit mode (b). Find the ZBrush plug-in menu (c), scroll down and open the UV Master rollout (d).

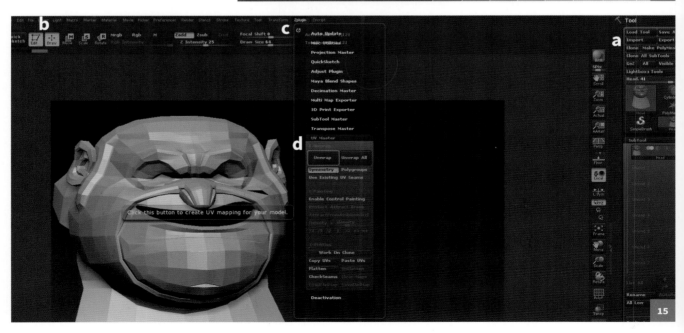

Basically, all you need to do is hit the Unwrap button – and voilà! It should give you decent results for texturing with proper UVs. We can do more still, though, so let's explore some of the basic options.

Since the UV Master will randomly place the UV seams and cuts across the model, we have to protect the important areas (Fig.16). We also have to avoid having seams in the middle of the face, since we could later get some strange results while texturing and shading.

To do this, activate the Enable Control Painting mode (a) and press the Protect sub-options. This enables us to paint over the important areas of the model and protect it from seams and cuts. Go on and paint over the face and also catch the ears in Active mode (b). You don't have to select any brushes or color here, as Active mode will take care of everything.

Now go back to the UV Master menu and select the Attract option (Fig.17). Rotate to the back of the head and put the Attract blue paint on the surface of the rear, which is usually not visible. We will attract the UV seams to this area and leave all the other areas protected. Hit Unwrap again and you should now have a very good base to start texturing.

As you can see in Fig.18, I paint the areas around the eyes, nose and mouth to have a reference on the displayed UV map in the lower right-hand corner.

UV Master places the seams around the areas we want and has left the front of the face protected from any seams. As we had the Symmetry option turned on, the resulting UV map is symmetrical.

This explains some basic and advanced methods for unwrapping the models. Now you can use all of the before-mentioned steps to finish and Unwrap all the other parts of the character. You can use any of the explained methods but feel free to experiment with additional tools and options not mentioned.

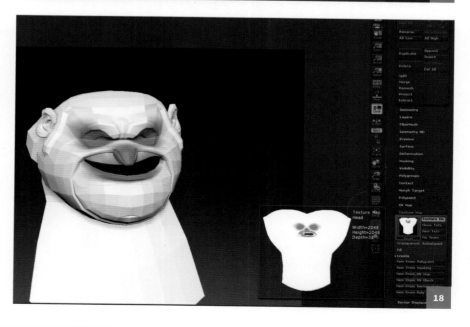

INTRODUCTION TO CHARACTER CREATION
PAINTING TEXTURES

BY SEID TURSIC

In this part of the project, we will go through the process of painting and generating textures for our character.

There are a number of different ways to create textures, but we will go with some proven examples that I frequently use and which are also really fast and artist-friendly. As an artist, you want to get your creativity flowing without interruption.

Luckily, we have a wide variety of different and useful tools that offer us a lot of freedom and opportunity. The most common tools I use for creating textures are Photoshop and ZBrush together with 3ds Max. Let's take a look at the concept again (Fig.01).

Looking at the 2D image, we can simplify structures and a wide variety of different materials with nice use of color and texture. This is the kind of character I like to work on most, as it's more fun than hard work. We have to re-create skin materials, leather, metal and simple fabrics. We also have a burning cigar with cool-looking textures to create.

First import the head OBJ file into ZBrush (Fig.02) (a). If you'd like to know more about this, take a look back at the previous part of the project where we created the UVs for the head in ZBrush. Don't forget to finish all the UVs first before thinking about the textures – this is very important to get right, before we start painting.

Go on and store a Morph Target (b). As we will be subdividing the object, which can change the base model a bit, the Morph Target allows us to get back to the

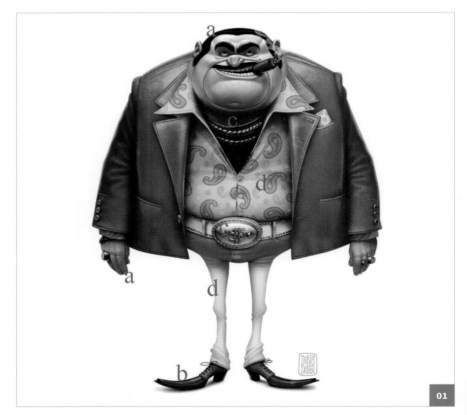

01

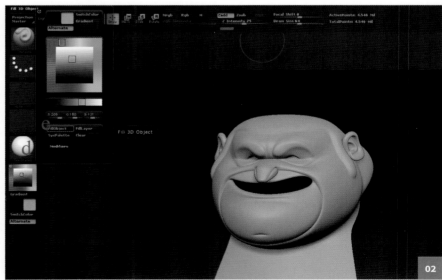

02

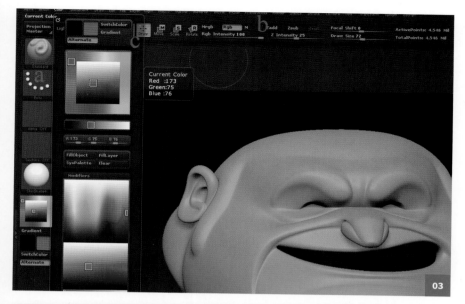

03

04

05

main unchanged base model if we need to export it again in its original state.

Now divide (c) the model to SDiv level 07 under the Geometry Tool menu. This should give us enough polygons to paint on. This process is called PolyPainting.

Switch to the SkinShade04 material (d) and fill the object (e) with a color close to the skin color on the concept. This is the usual starting point for PolyPainting.

To set up the brushes (Fig.03), leave the default Standard brush with default dots stroke and no Alpha selected (a). Then select the RGB mode and turn off Zadd (b).

Now we have everything prepared to apply layers of paint onto the model. We want to start by blocking basic skin colors on the face, so we select tone of red (c). Now it feels like we're about to paint on a canvas, but in this case, we'll paint on the model itself.

As you can see in Fig.04, I quickly apply basic skin-tone colors on the model. Feel free to adjust the size of the brush by hitting the S shortcut key (a) and also X, the keyboard shortcut for X symmetry.

Even if we have a great concept with all the information included, feel free to use extra reference images or real-life studies as you progress. Look around you and you will notice that every object has more than just one color or structure. Texturing is even more complex than modeling or sculpting, as you can ruin a good modeling job with the use of bad colors or texturing. So be careful, but also feel free to experiment. Since all digital tools have a back-up function, you can't really do anything wrong. Feel free to explore new methods.

Now let's go back and zoom in. In the Brush Strokes menu (Fig.05), switch to Spray (a). Lower the Color slider amount but increase the Flow amount (b) and select Alpha 47, which is a small dot. After clicking on the Color Menu, hold and drag the pointer to the model to pick a color from the object. Now start painting again on the head. This is a fast and easy way to add foundational skin details.

Go all the way around the head and add skin details with the stroke options and different alphas (Fig.06).

Feel free to experiment with the different Strokes (a). Combined with the various alphas available you can get some amazing brushes that can speed up the whole process. Even with only few settings you can get good results.

Now import the eyes and teeth and paint over them. We can leave the eyebrows and the mustache for the moment as we will be adding some hair and fur in 3ds Max later on. We are getting closer to the concept now…

To export our painted diffuse color map (Fig.07), go to the Multi Map Exporter in the ZPlugin menu, select the 4,096 map size, leave everything else by default and click on Create All Maps (a). Here you can see the color map of his face (b). It will be the first and most important map when creating shaders later on.

I will also show you later how we can create great-looking specular/bump maps in ZBrush. We can also add further details in Photoshop of course, but first let's finish the other objects, before moving on.

As you can see in the concept, the character's shirt has some decoration on it. We will use Photoshop to create a black-and-white image of this pattern and use it as an Alpha in ZBrush (Fig.08).

In Photoshop, create a new document with about 1,024 x 1,024 pixels. Cut out the concept and place the decoration in the frame to use as a guideline (a). Follow the lines with the Pen Tool (b) and re-create the shape of the design.

By right-clicking (Fig.09), you can find the handy Stroke Path menu (a), which enables you to place brushstrokes along the path of the lines. Use it with different brush settings to place different kinds of strokes.

Make some circles on different layers and make copies of them to place around the design. You can use any method you are comfortable with for this – you can even draw out everything with your graphics tablet.

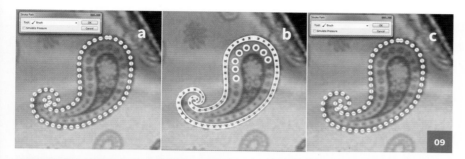

09

When you are close to the original concept, save your image as a PSD (Photoshop) file.

In ZBrush again, import the unwrapped shirt object and store the Morph Target before dividing (Fig.10).

Subdivide the shirt up to 12,000,000 active polygons, as we can then store all of the information and small details of the alpha map on the shirt. Select the FastShader material (a), go again to RGB mode (b) and select the DragRect brush stroke in the Strokes menu (c).

10

Now let's go to the Alpha window (d) and import the PSD file of the pattern that we re-created from the concept. You should now have something like a stencil for your texture work.

Now just drag and drop the alphas (Fig.11) onto the shirt, following the placements on the concept closely (b). Don't forget to select a similar red color (a). When you have placed all the red parts of the pattern how you want it, select a green color and stamp smaller versions onto the shirt to improve the pattern. You can also make a small flower alpha to add to the design, if you want to.

11

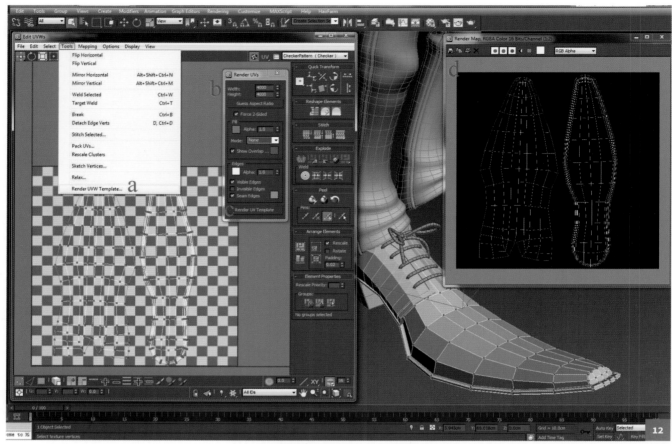

You can now can export this color texture for later use on various maps. With the help of this texture we will create a blend material to add further realism and details to the shirt.

In 3ds Max, open the UV Editor of your unwrapped object – in this case the shoe (Fig.12). In the Tools Menu find the Render UVW Template option (a) and adjust the size of your map (b); I use 4,000 x 4,000 for this texture. It's important to have a big map size to work on in Photoshop. The more important the object is, the bigger it should be.

Render the UV template (c); a new window should pop up. Now save this image as a PNG (d), or any other file type that stores the image alpha information.

Open the saved UV Template in Photoshop (Fig.13). Rename the UV layer as 'UV' (a), then create a new layer for the background and fill it with black (b). Set the UV layer above all others and set the Opacity of the layer to about 20% (c). Now find some good texture reference images for leather that we can use.

Don't look for the color of the leather, since we will be adjusting it with color layers. I strongly recommend using **www.cgtextures.com** where you have a daily limit to download good quality textures, once you've created a free account.

First make a new layer (the color layer) and using paint red and brown underneath the UVs (Fig.14). The red color is for the red leather of the shoes and the brown will be the color of the shoe's sole (a).

When you've found good matching leather textures, make a selection and place it on top of the red color layer (b). If the leather texture has color information, just reduce the Hue/Saturation of this layer to make a black-and-white leather texture. Place the layer on top of the color layer and select the Multiply mode for the leather layer. This should give us a good red leather texture later on. Follow the same workflow and add some dirt textures for the shoe sole – but don't exaggerate it too much.

To test our textures, we can go back to 3ds Max and view the color maps on the objects (Fig.15). Place the color maps in the Diffuse slots of the Materials Applied to the textured objects. I think it's looking fine right now, but we will enhance it more in future chapters by adding different shaders and materials.

Let's move on to the cigar now. I will explain a third workflow for creating textures, this time, with the help of the ZBrush Spotlight feature (Fig.16). I will assume you are now comfortable with importing the objects for texturing and preparing everything, so we'll get stuck in.

In the Texture menu, import a simple paper texture, similar to the one in the concept (a). After selecting the imported texture (b), hit the Add to Spotlight button. Once you've done that, the texture should appear on the screen with reduced opacity.

We are now in Spotlight mode, which gives you a great advantage when creating various textures (Fig.17). It's very easy to use. For example, you can drag the picture around, adjust some of its parameters on the wheel, and so on. For now, find the Spotlight Radius on the wheel and increase it by holding and rotating it to the right. Next hit the Z shortcut key on the keyboard.

" Spotlight mode gives you a great advantage when creating various textures "

The texture should now disappear from the screen but it should be partly visible while moving the brush pointer across your model (Fig.18).

In the active RGB mode of the brush, place strokes across the model. The brush should be able to transfer the textures from the image directly onto the model. You can now finish the whole cigar, while rotating around the model. We can paint the other details with different brushes.

Use the Standard brush with the Freehand Strokes now, together with Alpha 08, and draw the front side of the cigar with a very dark color (Fig.19).

With the same brush, you can continue to paint on the cigar. Feel free to change the colors and start detailing until you are satisfied with the results (Fig.20). This method is very simple and it should be used on simple objects. It might look kind of flat, so we will create better-looking cigar effects later, while doing the shading.

18

19

20

INTRODUCTION TO CHARACTER CREATION
PRODUCING SHADERS AND MAPS

BY SEID TURSIC

It's time to start producing some good materials and shaders for our character now. I will also show you how to create some additional maps for the materials.

We will use 3ds Max to create a render scene for our material testing, and also V-Ray (**www.chaosgroup.com**) to render, as it's a fast and easy-to-use render engine that offers nice shaders for different kinds of materials.

Let's quickly go through the basic scene setup. First, assign V-Ray in the Render Setup menu. We then have to adjust the linear gamma workflow for better visual results (Fig.01).

In the Rendering menu (a) select Gamma/LUT Setup and go on with the Gamma 2.2 settings, as shown (b). Also, don't forget to go into the V-Ray: Color Mapping options in the Render setup menu (c) and adjust the Gamma to complete the linear workflow set up.

In the Material editor select a VRayMtl (d) and assign it to the whole character by leaving a gray diffuse color on it.

We also need to go and adjust some basic rendering settings for our test renders. I usually work through the shading process with some good test render settings, so I can get a good overview of the shading results (Fig.02). If you have a lower-end computer, feel free to reduce some of the settings or resolution, although these should be just fine.

In the V-Ray tab in the Render Setup menu enable the built-in Frame buffer (a). Set the Image Sampler (Antialiasing) options to

01

02

03

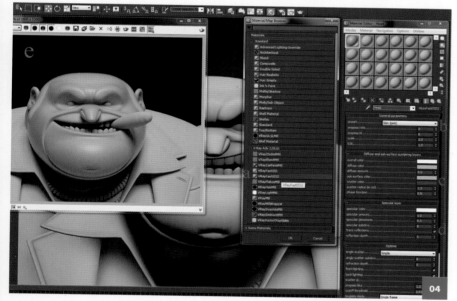

04

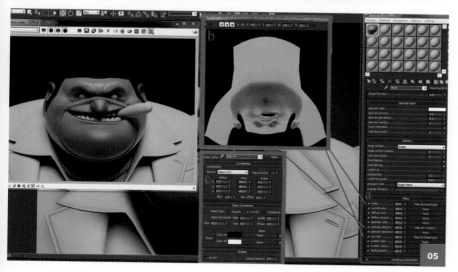

05

Adaptive subdivision and VRaySincFilter (b, c). We will use Indirect Illumination (d) with Irradiance map and Light cache. We will also turn on the Ambient Occlusion option. I usually start with a resolution of 1,600 x 1,200 pixels and adjust it further later (e).

The last step in preparing the scene for shading work is to place a VRayLight above the character and a simple plane for the ground (Fig.03). Place a camera in front of the character and hit F9 for the first test render. This setup should give a good overview of all the shading and materials applied.

Zoom in and create a new camera displaying his face, since it's the first thing that we want to texture – and the most important part of a character is its face, of course (Fig.04).

I will now explain how to manage a believable skin material for a cartoon character, but this advice also applies when creating realistic portraits, too. Select the VrayFastSSS2 material (a) and apply it to the character's head. This material is the best choice when creating a skin material in V-Ray. It offers great control and produces some very good results.

We can now go through the parameters shown here in this image. In the General parameters rollout (b), I usually start with the skin (pink) preset. Set the prepass rate to 0 to get good results. If you own decent hardware you can even go up to 1 or 2, but this should be just fine for us now, and it will keep the render time low. Set the scale to 2, which will affect all the other parameters by multiplying it by two.

I won't explain all the parameters here, as creating the perfect skin material is a science in itself, but feel free to experiment with these material parameters (c). Don't forget to tick the Trace Reflection option (d) in the Specular layer rollout for more realistic reflections, though.

Hit F9 for the first test render. The result is a good start, but now let's add the maps that we painted before to add more variation to the skin material. We could make a large number of different maps to enhance the skin shader, but here we will try to use only our painted texture and still achieve a satisfying result (Fig.05).

In the maps rollout (a), place our painted texture (b) in the SSS color field. I tweak the map a bit inside Photoshop first to correct some colors and reduce the saturation of it. Use the same map or copy the SSS color map to the bump field. The same map will be used for the bumps on the face, since it has many small painted details. Also reduce the blur amount of the bump map in the image parameters for a sharper, noisy bump result. Instead of painting a specular map, let's use the procedural noise map (c). Set it to Fractal, increase the XYZ tiling to 300 and set the overall output amount to 2 to increase the general reflection effect of the map.

Make a new test render and watch the new effect taking place with the help of the maps. Feel free to tweak the maps and materials in any way you like.

Let's now jump to the eyebrows and the hair. This part is very important and can be handled easily with the standard Hair And Fur modifier in 3ds Max (Fig.06). Select the head polygons for the eyebrows and his mustache (a) and Shift + Move to clone the polygons. Select the new objects, go to the Modifier stack and add the Hair And Fur modifier (b).

We can now style the hair (Fig.07) (a) in the styling rollout. I use only hairbrush and hair-cut tool (b) to get it done. There is a slider underneath the brush function to adjust the size of the brush. We don't want to complicate it too much, so just follow the flow of the polygons and refer to the original concept.

Fig.08 shows all the parameters for the characters eyebrows and mustache. The most important areas are the General (a) and Material (b) parameters. We have a wide range of other possibilities here but I just tweak the colors and specular a touch to match the original concept artwork.

Before hitting Render again, we need to go to the Rendering menu and find the Effects submenu. In the Hair Rendering Options set the Hairs to mr prim to be able to render the hairs with V-Ray. This will get it pretty close to the concept.

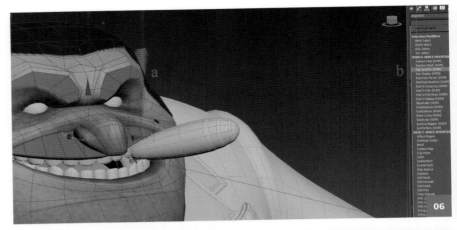

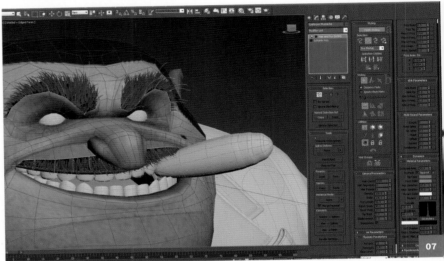

Finish the rest of the hair on his head with all the same tools and brushes. Because the hair on his head is pretty much straight, you'll want to set the flyaway parameters of the Hair and Fur to zero to achieve the effect that you're looking for.

Jump to his teeth next. We need to create a V-Ray Blend Material to add dirt in-between his teeth (Fig.09). In the Material Editor, create a new VRayBlendMtl material, then in the Base material slot place a VRayFastSSS2 (a) material with yellow colors to represent the teeth.

For the first Coat material just use a simple VRayMtl material (b) with all the sliders set to black. In the slot underneath the blend amount, select a VRayDirt map and swap the occluded/unoccluded colors. We don't have to paint every object's texture map to get good results; sometimes the different shaders just will do just fine.

The eyes will add so much depth to the character so we need to be careful here. The most important parts of the eye are the pupil, cornea, iris and the white area. We can model every part individually but we can also achieve good results with this method (Fig.10) (d).

Basically the outer space consists of a reflective glass (b) material, as you can see, which will reflect the area around the eye and add specularity. The inner part, with the iris texture, is a VRayFastSSS2 material (c) with a red subsurface color that will add softness to the eyes without any reflection.

The cigar is quite simple to texture, but let's go a bit further and add some additional details (Fig.11). I've modeled some burnt paper for the tip of the cigar (a). We'll keep it simple, so a dark gray material color for this should do the trick.

Apply the painted cigar texture to the main object (b) and create a basic VRayMtl material with a glossy effect on it.

Now we will create a blend material to add some glow effects onto the cigar (Fig.12). Simply use Photoshop to create a blend map (a) from our painted texture map. By adjusting the levels on the texture map, we can make the bright yellows become white areas, which will be the blend area for the new light material.

Create a new V-Ray blend material (b) and place the cigar material into the base slot. For the coat material (c) we will select the VRayLightMtl material and adjust its parameters a little. Take care to turn on Direct Illumination so the light has an effect on the surrounding objects. In the blend amount, just place the newly created blend map.

The shirt is quite simple and we will again make use of the V-Ray blend material here (Fig.13). For the base material, use a simple reflective material with the painted pattern texture map. The coat material will be a less reflective and glossy map with the same textures. The blend map created from the texture map will be used as the blend amount map and it will affect only the pattern, making it less reflective. This is a good way to add variation to textures and materials.

Also use a fabric texture to add some small details on the painted pattern shirt texture. In Photoshop, simply place a desaturated fabric texture layer on top of the base color layer and use the Overlay blending mode.

For the jacket we will use only the procedural maps in 3ds Max, as they are quite powerful and very helpful in many situations. The most important part is to match the colors of the jacket and the right reflections.

Place a gradient map for the color and a dent procedural map for the reflections to add some variations (Fig.14). There are no objects in real life that have perfect reflections and it is most important to keep this in mind while creating simple shaders, especially for cartoon characters, which tend to be very minimalistic.

Apply a gold material to his necklaces and a silver metallic material for his belt accessories. Some hair on his chest can also be created in the same way that we made his eyebrows (Fig.15).

Back to the leather again now. This time, let's use our textures that we created in Photoshop for his shoes. Let's go ahead again with simple VRayMtl material and place the maps in the corresponding material slots. Try to match the reflections (Fig.16).

" It's very important to have a raw render matching the concept artwork as close as possible "

Be aware that we will render some passes in the final chapter of this section, together with some specular and reflection passes to use in the compositing work at the end. We will have some further control over most of the aspects of the rendered objects. Nonetheless, it's very important to have a raw render matching the concept artwork as close as possible.

To hide the geometry used as the base for the hair – in this case the hair on his hands – select the hair geometry and add an Edit Poly modifier under the Hair And Fur modifier (Fig.17). Select all the polygons and find the Hide Selected button. This should hide all the geometry and only the hair will be visible in the rendered image.

Fig.18 shows a small preview of the fully textured character. In the final chapter, we'll tackle the rendering and compositing stages to perfect a character illustration.

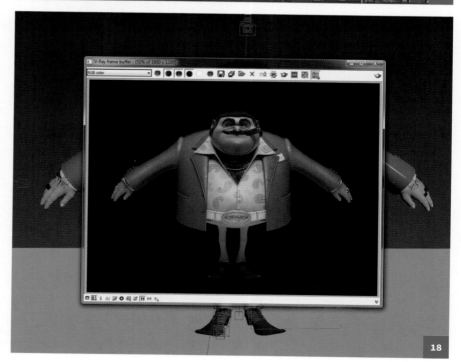

65

INTRODUCTION TO CHARACTER CREATION
PERFECTING AND COMPOSITING

BY SEID TURSIC

In the last chapter of this section, we will go through some basic compositing methods to create a simple presentation image of our character. This last step is very important; it can enhance your presentation or ruin it completely.

There are many good characters with bad presentation out there, and even some examples of unfinished characters with great presentation that has saved the whole artwork. So let's begin by preparing the whole scene for rendering. We need to get some parameters to reasonable numbers first.

Go through the basic parameters (Fig.01). In the Output Size parameters we need to adjust the settings to match the high-resolution image that we need for the final render. We will also set the Render Output with a PNG file format.

For a good quality render with low noise intensity, we need to take a closer look at the Image Sampler options. These settings can increase the render time but also reduce the noise and sharpen edges around the Alpha Channels. We will also increase some of the Indirect Illumination settings, the Irradiance map and Light cache. This should give us a good quality render overall and solid base layers for the compositing work in Photoshop later on.

We will render the character separately from the background to have the best possible control over the image (Fig.02). For this we will create a basic environment. I simply make a plane object and extrude some edges to create a ground and wall behind the character.

03

04

05

We need to create a matte material next. For this, let's use the VrayMtlWrapper material (a) and adjust some of its settings. I select the Matter Surface option (b) and add the shadows to be included in the alpha channel. Alpha contribution should be set to -1.0.

The next step is to set the Object ID on all the different objects (Fig.03). Since we will be rendering the Object ID pass this will enable us to select the various objects in Photoshop and adjust it manually. Select any object, in this case the jacket, right-click somewhere on the screen and find the Object Properties (a) in the popup menu.

Leave all the settings as default: we only need the Object ID parameters (b). Set any number in the jacket Object ID; this will later be our ID number or color for the jacket. For every important object, set a different ID number; for example, the background is set to 1, jacket to 2, face to 3, hands to 4, and so on. Don't use too many ID numbers. Since we don't need control over any small object in the scene, just set it correctly for the basic objects.

Switch to the Render Elements tab in the Render Setup menu now (Fig.04). We need to activate some render elements by adding them to the active list (a). The most important are the specular, reflection and the ID elements, but feel free to add additional elements and experiment with them later on, too. Since we are using the built-in Frame Buffer, the render elements seem to be disabled, but it will render them correctly – just leave it as default. Some other elements – the ZDepth element, for example – need some additional tweaking in the parameters. All you need to do here is adjust the corresponding distances. The output folder will be the same as the base image.

Now, before we start collecting the render passes, let's create an additional pass: the Ambient Occlusion pass (Fig.05). Even if you have turned on the Ambient Occlusion option in the V-Ray render settings, it's good to have some additional control. Select a new material and apply a VrayLightMtl material to it (a).

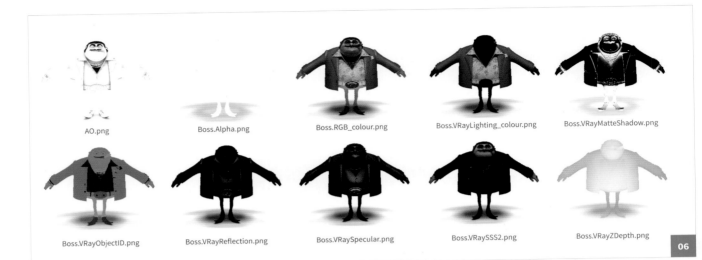

AO.png Boss.Alpha.png Boss.RGB_colour.png Boss.VRayLighting_colour.png Boss.VRayMatteShadow.png

Boss.VRayObjectID.png Boss.VRayReflection.png Boss.VRaySpecular.png Boss.VRaySSS2.png Boss.VRayZDepth.png

06

Leave everything by default and place a VRayDirt material (c) in its color slot (b). I have increased the subdivisions to 32 to get a smoother transition; by leaving lower values we get noisier effects. Now in the V-Ray:: Global switches render settings, go and put your new material in the Override mtl slot.

We now have everything together in one place, and we're able to adjust many aspects of the image manually and get some nice-looking results out of it (Fig.06). We could skip some of the passes, but it's always better to have more of them at the beginning.

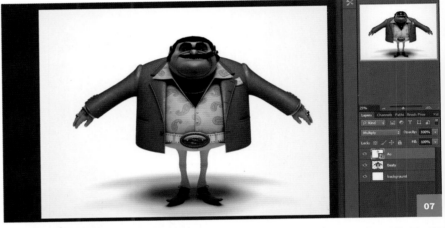

07

Open the beauty render in Photoshop (Fig.07). Create a new layer (Ctrl + Shift + N) and place it underneath the beauty layer. This will be our white background layer, similar to that in the concept artwork. I also place the Ambient Occlusion layer on top of the beauty layer and used the Multiply blending mode. You can adjust the strength of the Ambient Occlusion (AO) layer with the Levels in the Image > Adjustments options or just reduce or increase the opacity of the layer.

Place the specular and reflection passes on top of the layers and select the Linear Dodge blending mode (Fig.08). Feel free to adjust the Levels of the layers manually to get the desired results. I lower the opacity of the reflection layer to 40% to reduce the overall effect.

We want to add an adjustment layer on top of the beauty pass and increase the saturation of the image, as the colors on

08

> " The VRaySSS2 pass can be very helpful in perfecting the character's skin. I usually use it with the Screen mode to add some more highlights, or the Pin Light mode to add shadows on some areas "

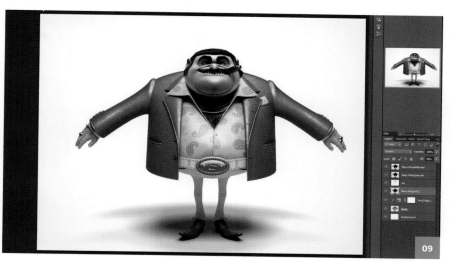

the concept are much more intense than those on the rendered image. To do this, click on the small circle adjustment layer button (a) and select Hue/Saturation. In the menu, increase the Saturation by +20 (b).

The VRaySSS2 pass can be helpful in perfecting the character's skin. I usually use it with the Screen mode to add some more highlights, or the Pin Light mode to add shadows on some areas (Fig.09). Playing around with the Curves or Levels offers you enough control to achieve incredible results. I use the Screen mode and reduce the layer opacity to decrease the overall effects, since it was a bit too strong.

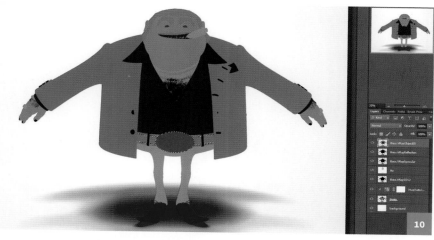

We can use the Object ID elements to correct certain areas (Fig.10). Let's try it out on the character's belt. Since there is a small difference in color on the concept artwork, let's use this pass to do some minor color corrections. Place the Object ID layer on top of the other layers. Use the Magic Wand Tool to select the metal object material of the belt; it should be fairly easy with the ID element pass. Once you've selected it, turn of the Object ID layer and with the active point selection, go down and select the beauty layer.

Now go to the Color Balance options under Image > Adjustments. Adjusting the colors, we can easily match those in the concept (Fig.11). We can use this method on any other layer and adjust every aspect of the image as we see fit.

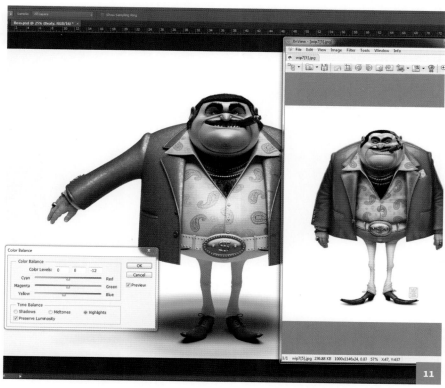

Using almost the same method next, we can strengthen up the reflection on his face. Select the Object ID of his head, switch to the reflection layer and use Levels to increase the positive values of the image and increase the strength of the reflection in this area (Fig.12). Now it should be looking very close to the original artwork.

Let's use our ZDepth layer to add some depth of field to the image (Fig.13). This will blur the hard edges on the character slightly. First we need to adjust it a little. Open the ZDepth layer in another file and invert the whole image. Using Levels, we can control how much of the image will be affected. Since I usually want to blur the edges, the ZDepth layer should have white areas on the edges and black areas on the front of the character. When it's ready, insure the ZDepth layer is active, then press Ctrl + A to select it and Ctrl + C to select or copy the ZDepth information. Switch back to the character.

Re-select the beauty layer, go to the channels and press Shift + Ctrl + V to paste the ZDepth on the alpha channel (Fig.14) (a). On the active beauty layer, go to the Lens Blur tab in the Filter menu of Photoshop (b). Then in Depth Map Source, select Alpha channel. By

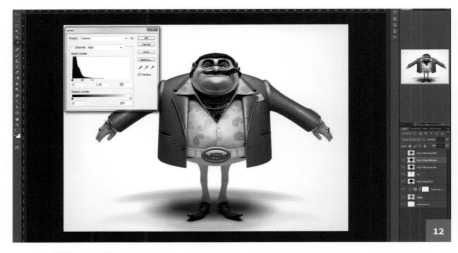

adjusting the Blur Focal Distance and Radius we can create a simple depth-of-field effect on the character. Don't exaggerate it too much, since it should only be very slightly visible.

This should complete this section of the project, as we are very close to the original artwork now (Fig.15). We could also collapse all the layers and add some additional final color correction to the whole image, but it is not necessary, and I am pretty pleased with its current state.

This method is simple and gives you plenty of freedom to do as you like with the image. We can also add layers on top and paint some additional details if it is going to be a polished illustration (Fig.16). The choice is yours!

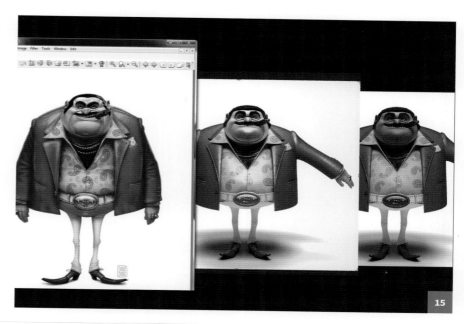

15

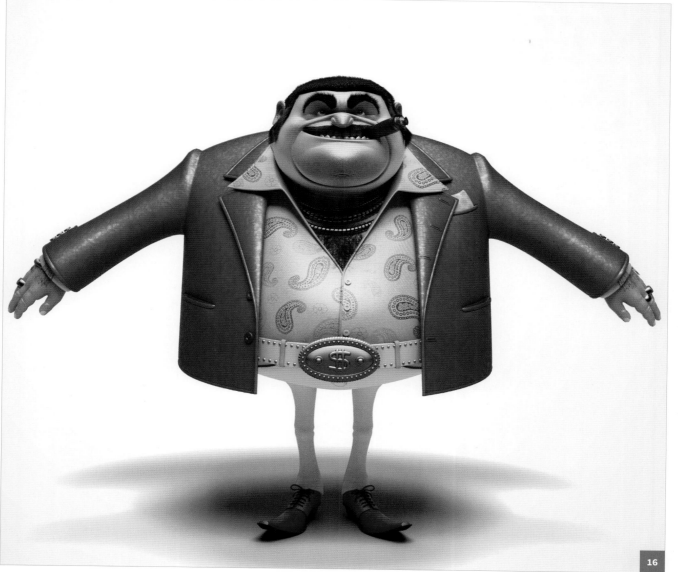

16

INTRODUCTION TO CHARACTER RIGGING

By Jahirul Amin

LEARN HOW TO SUCCESSFULLY RIG CHARACTER MODELS IN ORDER TO CREATE REALISTIC-LOOKING ANIMATIONS

In this project, Jahirul Amin reveals the processes necessary to create a rig that mirrors the physical constraints of the human body in preparation for animating a stylized character.

This comprehensive step-by-step guide runs through how to introduce

bones and controls, rig each significant area of the body – as well as elements of the clothes – before skinning and adding morph targets.

Jahirul helpfully breaks down each stage, making light work of complex tasks, such as creating bone chains and controls.

INTRODUCTION TO CHARACTER RIGGING
BONES AND CONTROLS

BY JAHIRUL AMIN

To begin the rigging section of this project, we will be taking the loan shark character and adding the skeleton and control structure to allow for deformation.

Before jumping straight into 3ds Max and creating bones left, right and centre, I first of all make sure I take time to plan out what the rig will need to do and also find out how the animator likes to animate.

My first port of call was to have a quick chat with Fernando Herrera who will be using the rig for the animation in the next chapter. By opening up the communication lines, I can quickly answer some of these questions.

So, what did I find out? Well, I discovered that Fernando would prefer an IK (Inverse Kinematics) spine, have the ability to switch between FK (Forward Kinematics) and IK for the arms and the legs, and also some minor control over the face and the cloth elements. With this information, I can now start planning out the rig, firstly making sure it ticks all the boxes for the animator, and then adding any bells and whistles on top.

As we go through the creation of the rig, it will be important that we follow a few guidelines to add consistency to the asset. Firstly, naming conventions – all bones, curves, geometry and so on will be suffixed. This will make it easier to organize our hierarchies and make our objects more manageable.

Next, we have to make sure the rig can be returned to the default position by zeroing out the controls. All Flexion (narrowing the

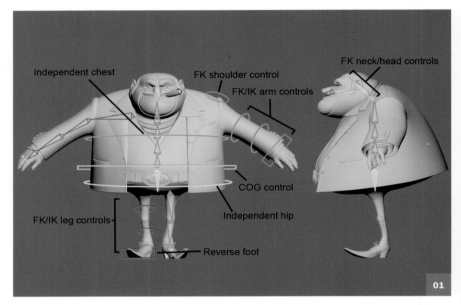

01

distance between bones) will be handled by positive Z rotation. All extension (increasing the distance between bones) will be handled by negative Z rotation. By doing this, the animator should be able understand how the articulation of the rig affects the animation curves in the graph editor.

Before we look at the techniques in any detail, I would like to explain that, in my mind, it's important that skills learned in one package can be transferred to other packages, so you don't find yourself bound to one software. The methodology used here is designed to allow you to take core principles and apply them to the package(s) of your choice.

Moving on to the process itself, the first thing I like to do is take an image of the model from the front and the side view and create a draw-over of where I intend to create the joints and the type of controls needed. This free-flow planning process enables me to get a feel for

> **" In my mind, it's important that skills learned in one package can be transferred to other packages, so you don't find yourself bound to one software "**

how the rig is going to look, but also allows me to quickly generate ideas concerning colour coding, bone placement and so on (Fig.01)

BONE CREATION

I want to spend a couple of steps running through how I approach bone creation and setting up controls. Open up scene file step01. max (which can be downloaded free from

www.3dtotalpublishing.com/resources.html),
and you should find two polygon cubes, which I
have labelled as spineA_GEO and spineB_GEO.
Go to Animation > Bone Tools to open up the
main bone creation and editing toolset. Check
Create Bones and in the front view (you may
want to go into wireframe mode here by hitting
F3); first click around the base of the two cubes,
then in the middle and finally at the tip.

Click on the RMB (right mouse button) to
come out of the tool. You will now see a small
bone nub (useful for attaching IK handles)
has also been created at the tip of the chain.
Go to Graph Editors > New Schematic View
and you will see the newly created bone
hierarchy as well as the two cubes in the
scene. I tend to also do the majority of my
parenting or basic hierarchy editing within
this window (Fig.02). Rename the bones
from root to tip: 'spineA_JNT', 'spineB_JNT'
and 'spineEnd_JNT'. I usually add the
suffix '_JNT' (joint) for all bone objects.

JOINT FLEXION/ EXTENSION

Once the joints are in place, select all the
joints, hold Alt and the RMB and go to
Freeze Transform. I always make sure that
they are orientated to my preference, so
positive Z rotation creates flexion, and
negative Z rotation creates extension. Rotate
Y deals with abduction and adduction and
rotate X deals with twisting (Fig.03).

Set the Reference Coordinate System (RCS)
to Gimbal and set the pivot mode to Use
Pivot Point Center. Select the two bones
and rotate them forward and you should
see that the movement is being driven by
the Y axis. To correct this, in the Bone Tools
panel, enable Bone Edit Mode. Switch the
RCS to Local mode (my preferred setting for
editing bone orientation) and either manually
rotate spineA_JN or enter a value of 90 into
the X channel. Uncheck Bone Edit Mode
and Freeze Transform the bones again.

When you rotate the bones now, the forward
motion should be performed by positive
Z rotation. It's important that you check
every bone at the creation stage as you

go – and by every bone, I mean *every* bone
in the chain. Finding out later that the odd
bone has not been orientated correctly will
cause you a major headache. Now you can
parent the geometry to its relevant bone
and do a final test to check the rotations.

CREATING CONTROLS

Now that we have some bones in place
and correctly orientated, let's add some
controls. For each control, we will create a

small hierarchy using two Point Helpers. The
top helper in the hierarchy will be used to
position and orient the control to match the
correct bone. The next helper will be used for
adding an extra level of control through the
use of the Reaction Manager – the usefulness
of which will be evident when we set up
the finger controls. Finally, at the bottom
of the hierarchy will live the animation
control (a Spline shape) that is selectable
in the viewport by the animator (Fig.04).

05

First, create a Circle by going Create > Shapes > Circle or through the Create tab in the Command Panel. Make sure it is at the World center and rename the circle spineA_CTRL. Now create two Point Helpers and make sure they are also at the World center. Rename the first Helper 'spineA_CTRL_OFFSET' and in the Modify tab, set its Display to Cross.

Rename the second Helper 'spineB_CTRL_REAC' and set its Display to Box. Now turn on Connect and parent spineA_CTRL under spineA_CTRL_REAC and parent spineA_CTRL_REAC under spineA_CTRL_OFFSET. Then select spineA_CTRL_OFFSET, hit the Align tool and select spineA_JNT.

When the Align Selection window pops up, be sure to check all the position and the orientation boxes and hit Apply (Fig.05). The control hierarchy should snap into place. Repeat the same steps for spineB_JNT.

You've probably noticed that the controls could do with some editing to make them more easily selectable. The last thing you should do is directly manipulate the shape as this will destroy the manner in which we positioned the control. So select the control curve,

06

hold down the RMB and go to Convert To > Editable Spline. Now either in Vertex, Segment or Spline mode, you can edit the shape and position it to suit your needs without affecting its transform properties (Fig.06).

Next we need to constrain the bones to each control. Select spineA_JNT and go Animation > Constraints > Orientation Constraint

and select spineA_CTRL. Do the same for spineB_JNT. If you rotate spineA_CTRL, you will probably notice that the results are slightly odd. To correct this, we will need our control structure to mimic the parent-child relationship of our bones.

Simply parent spineB_CTRL_OFFSET under spineA_CTRL and all should now be fine.

USING FINS AND COLOR CODING

In the Bone Tools window, open up the Fin Adjustment Tools. For the majority of the joints I create, I like to enable Side Fins and Back Fins. Although, they have no influence on skinning, they do give a clear indication of the orientation of the bones. You can also use the Size attributes to make one set of fins smaller than the other, making it easier to tell between Side and Back Fins.

Finally, I like to add some color to the bones to differentiate those of the left-hand side from those of the right-hand side. The right-hand bones I color red, the left I color green, the center joints are a combination of blue (spine), yellow (hips) and orange (neck and head) (Fig.07).

You may feel that creating controls in this manner is a long-winded process. However, what we have now are correctly placed controls that give us two levels of control and can also be easily returned to the default position. The technique employed here can also be applied to other CG packages allowing you to develop transferable skills (Fig.08).

INTRODUCTION TO CHARACTER RIGGING
CREATING THE TORSO RIG

BY JAHIRUL AMIN

Before creating any bones, I like to take my draw-over sketch and use it to define how I cut up the model. The reasons for cutting up the model are firstly to create a low-res version of the rig that can be animated in real-time, and secondly to test out the pivot position of the bones early on. By simply parenting the chopped-up body parts to the bones, we can quickly get an idea of how the character will move without having to deal with any skinning.

Open the step06.max scene file (download from www.3dtotalpublishing.com/resources. html), which consists of the final model created by Dmitry Shareyko in the character creation section. In the Manage Layers window, create a new layer and add the all the elements of the model to that layer. Rename the layer 'GEO_highRes_layer'. Next, duplicate the model by hitting Ctrl + V, making sure to set the Clone Options > Object to Copy. Create a new layer called 'GEO_loRes_layer' and add the duplicated objects to that layer.

For all the parts that will make up the low-resolution rig, you will need to go through and first delete the TurboSmooth modifier that exists to keeps things quick. So do this before you go any further.

To break up the model, go into Polygon mode, select a set of polygons and hit Detach, which you will find under Edit Geometry. I tend to do this pretty early throughout the whole model but you can wait until you have placed some bones and use them to define how you break up the model, if you prefer to work in that order.

Same length

01

CREATING THE SPINE BONES

In the left view of the step06.max scene file, create a three-bone chain (with a bone nub) and label them from root to tip: 'spineA_IK_JNT', 'spineB_IK_JNT', 'spineC_IK_JNT' and 'spineEnd_IK_JN'. I like to draw the chain from around the belly button to around the base of where the nipples would be.

I also make the bones of equal length by activating Bone Edit Mode, switching to

" By creating a straight spine, as opposed to an S-shaped one, we can create a clean twisting action through one rotational axis "

Gimbal mode and popping a value of 12 into the translate-X of spineB_IK_JNT, spineC_IK_JNT and spineEnd_IK_JNT (Fig.01). Don't worry if this looks a little short for the spine, as we'll be adding an extra joint later on for the upper chest region.

Anatomically, the human spine has 24 bones, is S-shaped and is at the back of the torso. You'll notice that on my chain it has been placed in the center of the geometry and is pretty straight. The reason for this is two-fold: firstly, we are trying to mimic the movement of the spine, not replicate it 100 percent. Secondly, by creating a straight spine, as opposed to an S-shaped one, we can create a clean twisting action through one rotational axis.

It's worth experimenting at this stage, so parent some geometry to the joints and see what works for you. Make sure to go through the bones and orient them correctly as mentioned in the previous steps.

ADDING THE CHEST AND HIP BONE

Now, we are going to add two extra bones: one for the hip and one for the chest. First open up the Grid and Snap Settings and enable Pivot snapping. Using the Bone Tool, Pivot snap from the end of the spineEnd_JNT to the base of the neck, and then rename this bone 'chest_IK_JNT' and the nub 'chestEnd_IK_JNT'.

For the hip bone, pivot snap from spineA_JNT downwards. Again, check the orientation of the bones and remember to Freeze Transform. Once all the bones are created, pop them into a new layer called 'JNT_layer' (Fig.02).

CREATE A HIP AND CHEST CONTROL

Follow Create > Shapes > Circle and then rename it 'chest_IK_CTRL' and place it at the world center. Set the Grid and Snap Settings to Grid to do this, or simply plug a value of 0, 0, 0 into the Transform Type-In boxes.

Create two Helper objects – one a box and the other a cube. Rename the box helper 'chest_IK_CTRL_REAC' and the cross 'chest_IK_CTRL_OFFSET'. Make sure both the Helper objects are also at the world center.

Parent chest_IK_CTRL under chest_IK_CTRL_REAC, and chest_IK_CTRL_REAC under chest_IK_CTRL_OFFSET. Select all three and use the Align Tool to match their position and orientation to chest_IK_JNT.

Use Freeze Transform so we can easily get back to this position using Transform To Zero. Finally, we need to constrain the chest_IK_JNT to the control. To do this, select chest_IK_jnt and go Animation > Constraints > Position Constraint and then select chest_IK_CTRL.

Do the same again, only this time use the Orientation Constraint. Now test to see if the control drives the bone and then repeat the step for the hip control. Remember that if you would like to edit the control shape, convert it to an Editable Spline and do so in Component mode (Fig.03).

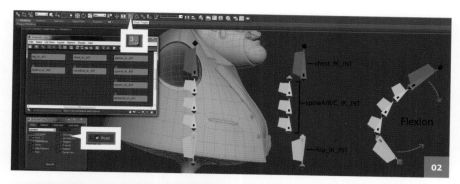

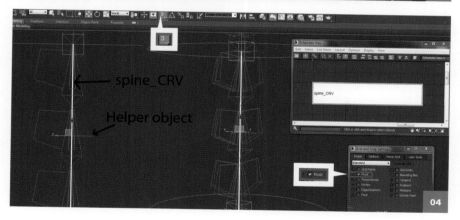

SPINE CURVE

I next want to create a line to drive the IK spine. The line will consist of three points: one at the base (hip_IK_CTRL), one at the center and one at the tip (chest_IK_CTRL). We can use Pivot snapping for the base and the tip but we need to approach the mid-point position in a different manner.

To do this, create a Point Helper object and Position Constrain it to both the hip_IK_CTRL and the chest_IK_CTRL. As both objects will have a 50/50 influence over the helper, it will be positioned perfectly in the middle (Fig.04).

Next, enable Pivot mode in the Grid and Snap Settings and follow Create > Shapes > Line. Set the Initial Type to Smooth under the Creation Method and make three clicks using hip_IK_CTRL, the Helper and chest_IK_CTRL to snap to. Rename the line 'spine_CRV' and delete the Helper object that we used.

BINDING THE CURVE TO THE CONTROLS

Create two new Helper objects and set their display to Box. Rename them 'spineRoot_IK_BIND' and 'spineEnd_IK_BIND', and use the Align Tool to match their

position and orientation to hip_IK_CTRL and chest_IK_CTRL, respectively.

Next, select spine_CRV and add a Skin modifier to it. Under the Parameters for the modifier, click Bones > Add and when the Select Bones window pops up, select both _BIND objects.

Finally, parent spineRoot_IK_BIND under hip_IK_CTRL and spineEnd_IK_BIND under chest_IK_CTRL. You should now be able to translate and rotate the two controls, and the spine_CRV should be affected (Fig.05).

CONNECTING BONES TO THE CURVE

Create four Helper objects (boxes) and rename them 'spineA_path_HELP', 'spineB_path_HELP', 'spineC_path_HELP' and 'spineD_path_HELP'. Align spineA_path_HELP to hip_IK_CTRL and parent it under the control, also.

For the other helpers, Path Constrain them to the spine_CRV. To do this, select spineB_path_HELP and go Animation > Constraints > Path Constraint, and then select spine_CRV.

With the helper still selected, go into the Motion tab in the Command Panel and scroll down to Path Options under Path Parameters. Set the % Along Path to 33.33 and the helper should pop into the correct place. Repeat the same step for spineC_path_HELP and spineD_path_HELP, but making sure to edit the % Along Path to 66.66 and 100 to position them correctly (Fig.06).

Now we need to have the bones follow the positions of the Helper objects. To do this, Position constrain each bone to its relevant helper. First select spineA_IK_JNT and go Animation > Constrain > Position Constraint and select spineA_path_HELP. Do the same for spineB_IK_JNT, spineC_IK_JNT and spineEnd_IK_JNT to spineB_path_HELP, spineC_path_HELP and spineD_path_HELP, respectively.

If you rotate the hip or chest control, the bones now separate. To fix this, use the LookAt Constraints: Select spineA_IK_JNT and go to Animation > Constraint > LookAt Constraint, and select spineB_path_HELP (Fig.07).

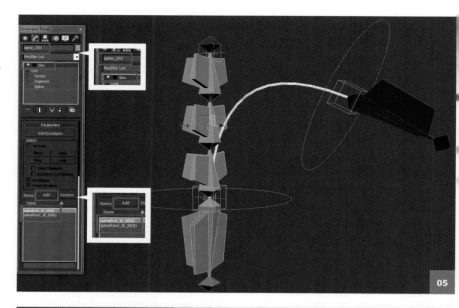

05

spineD_path_HELP

spineC_path_HELP

spineB_path_HELP

spineA_path_HELP

06

To fix the initial flipping, go into the Motion panel, check Rotation and make these changes: set the Viewline Length to 0, the Source Axis to Y and turn on Flip, and aligned to Upnode Axis to Y. Create a LookAt Constraint for spineB_IK_JNT to spineC_path_HELP, and spineC_IK_JNT to spineD_path_HELP.

ADDING TWIST TO THE SPINE

Create five Helper objects and set the Display Parameters to both Cross and Box. Rename them 'spineA_upNode_HELP', 'spineLower_upNode_HELP', 'spineB_upNode_HELP', 'spineUpper_upNode_HELP' and 'spineC_upNode_HELP'. We'll now move on to position them, which we'll do with one Helper at a time so it is clear. First, select

spineA_upNode_HELP and Position constrain it to both spineA_IK_jnt and spineB_IK_jnt. Select spineLower_upNode_HELP and Position constrain it to spineB_path_HELP.

Select spineB_upNode_HELP and Position constrain it to both spineB_IK_jnt and spineC_IK_jnt. Next, select spineUpper_upNode_HELP and Position constrain it to spineC_path_HELP. Finally, select spineC_upNode_HELP and Position constrain it to spineC_IK_jnt and spineEnd_IK_jnt. When all five are in place, select them and go to Freeze Transform to get rid of the constraints used to position them. Select them all and translate them back in the left view to sit behind the spine bones (Fig.08).

07

08

Now for some parenting. Parent both spineA_ upNode_HELP and spineLower_upNode_HELP under spineRoot_IK_BIND. Parent spineB_ upNode_HELP under hip_IK_JNT. Then parent both spineC_upNode_HELP and spineUpper_ upNode_HELP under spineEnd_IK_BIND.

Now Position constrain spineB_upNode_HELP under both spineUpper_upNode_HELP and spineLower_upNode_HELP. Now go to the LookAt Constraint for spineA_IK_jnt in the Modify tab and scroll down to Select Upnode. Disable World, hit None and then select spineA_upNode_HELP. When the bone flips out, edit the Source Axis to Z and the aligned to Upnode Axis to Z.

Go to the LookAt Constraint for spineC_IK_JNT and select spineC_upNode_HELP as the Upnode, and again, update the Source Axis and the aligned to Upnode Axis. For spineB_IK_JNT, it's a little different…

Set spineB_upNode_HELP as its Upnode for the LookAt constraint but then set the Upnode Control to LookAt and leave the Source Axis on Y. You should now be able to flex, twist and create side to side motion in the spine (Fig.09).

INDEPENDENT HIP CONTROL

To allow for independent motion in the hip without affecting the spine bones, we will need to add an extra bone, an extra control and to edit the hierarchy slightly. Start by selecting the hip_IK_JNT and hitting Ctrl + V to duplicate it. Make sure to set the mode to Copy and rename it 'hipLower_JNT' and 'hipLowerEnd_JNT' for the nub. Edit the size of the fins to make it easily selectable and then parent it under 'hip_IK_JNT'.

09

Now select hip_IK_CTRL_OFFSET, hip_IK_
CTRL_REAC and hip_IK_CTRL, and hit Ctrl +
V to duplicate the entire control hierarchy.
Update the name from hip_IK_CTRL to
'hipLower_CTRL' for all three. Parent hipLower_
CTRL_OFFSET under hip_IK_CTRL and edit the
shape in Component mode to make it easily
selectable; I have slightly reduced it. Lastly,
select hipLower_JNT and go to Animation
> Constraint > Orientation Constraint, and
then select hipLower_CTRL (Fig.10).

To make your controls easier to see or select, in the Modify tab you can turn on Enable In Viewport, which you will find under the Rendering options. Then edit the Thickness to your liking. Do be aware that this will make the rig heavier to use, though.

INDEPENDENT CHEST CONTROL

To manipulate the chest independently, we don't need an extra bone, just an extra control and some re-wiring. First select chest_IK_CTRL_OFFSET, chest_IK_CTRL_REAC and chest_IK_CTRL, and duplicate them. Update the name from chest_IK_CTRL to 'spine_CTRL', and in Component mode, slightly translate it up.

Parent spine_CTRL_OFFSET under chest_IK_CTRL. Then select chest_IK_JNT and in the Motion tab, delete the current Position and Orientation constraint. With the bone still selected, Position and Orientation constrain it to the newly created spine_CTRL (Fig.11).

CREATING THE COG CONTROL

The final control that we need to create is the COG (Center of Gravity) control. This will be the main driver to translate the character around the 3D space. For this control, I decide to give it a cross-like look to differentiate it from the other controls.

First enable Grid in the Grid and Snap Settings and then use a Line with the Initial Type set to Corner to draw out the shape. Rename it 'cog_CTRL' and, as we have done with all the controls, center it in world space and then create the two Helper objects to accompany it. Then use the Align tool to match the position and orientation of cog_CTRL_OFFSET to hip_IK_JNT (Fig.12).

EDITING THE CONTROL SHAPES AND TIDING UP

The last thing to do is re-work the control shapes so they are easily selectable, and then tidy up a few loose ends in the current rig. Start by turning on the visibility of the model and, one by one, go through each control and edit its shape in Component mode so it fits around the character. It's worth color-coding the controls also; I tend to match them to the color

of the bones. Next, parent spineA_path_HELP under hipLower_JNT. Parent spineA_IK_JNT, chest_IK_JNT, hip_IK_JNT, spine_CRV, spineB_path_HELP, spineC_path_HELP and spineD_path_HELP under cog_CTRL.

Create three new Helper objects and place them in the World center. Rename them 'back_GRP', 'chest_GRP' and 'hip_GRP'. Parent chest_IK_CTRL_OFFSET under chest_GRP and hip_IK_CTRL_OFFSET under hip_GRP.

Parent both chest_GRP and hip_GRP under back_GRP, and finally parent back_GRP under cog_CTRL. I also parent some geometry to the relevant bones to test out the current rig (Fig.13).

INTRODUCTION TO CHARACTER RIGGING
CREATING THE NECK AND HEAD RIG

BY JAHIRUL AMIN

In the Left view, turn on Pivot snapping and, starting from chestEnd_JNT, create a two-bone chain and a nub. Rename the bones from root to tip: 'neck_JNT', 'head_JNT' and 'headEnd_JNT'. Then go through and check the orientation for each bone and Freeze Transform.

For each bone, create a control using a circle shape and name them 'neck_CTRL' and 'head_CTRL'. Make sure to create the two extra Helper objects for each control and name them accordingly. Once the control hierarchies have been created, use the Align Tool to position and orient the _OFFSET helper of each control to its relevant bone (Fig.01).

CONSTRAINING THE BONES TO THE CONTROLS

Once the controls are in place, select neck_JNT and go to Animation > Constraints > Orientation Constraint and select neck_CTRL. Also orient constrain head_JNT to head_CTRL.

Next, select neck_JNT once more and go to Animation > Constraints > Position Constraint and connect that to neck_CTRL. To re-create the FK behavior of the bones through the controls, parent head_CTRL_OFFSET under neck_CTRL.

To connect the neck to the torso, parent neck_CTRL_OFFSET under spine_CTRL. Parent some geometry to the bones to test out the current setup (Fig.02). To finish off the head, add some space-switching capabilities.

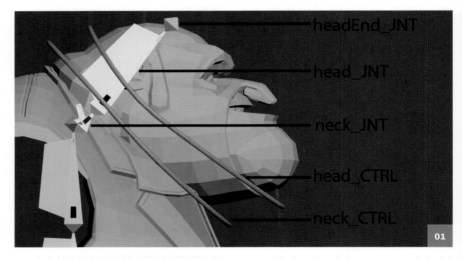

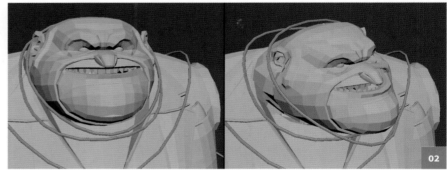

USING HELPER OBJECTS FOR SPACE SWITCHING

Create four Helper objects and give them all a Cross display. Rename them 'head_world_CON', 'head_hip_CON', 'head_chest_CON' and 'head_neck_CON'. Use the Align Tool to match their positions and orientation to head_JNT.

Select head_CTRL and go to Animation > Parameter Editor or hit Alt + 1. When the window pops up, change the Parameter Type to Array, the UI Type to DropDownList and the Name to headOrient. Scroll down to Array and create four Item names, one at a time, and hit Add Item. The items being: neck, chest, hip and world. Once these are set, hit Add at the top of the window and you should find a new Custom Attribute menu in the Modify tab (Fig.03).

THE REACTION NODE COMES INTO PLAY

Select head_CTRL_REAC and go to Animation > Constraints > Orientation Constraint and select head_neck_CON. In the Modify tab, scroll down to Orientation Constraint and hit Add Orientation Target.

Select head_chest_CON, head_hip_CON and head_world_CON to add them to the list. Next, parent head_neck_CON under neck_CTRL. Parent head_chest_CON under chest_IK_CTRL. Parent head_hip_CON under cog_CTRL, and leave head_world_CON as it is (Fig.04).

REACTION MANAGER

Go to Animation > Reaction Manager and when the window pops up, hit the Add Master (green cross) icon and select head_CTRL. A small window should pop up; to load the attribute into the Reaction Manager follow this path: Object (Editable Spline) > Custom_Attributes > headOrient. Next, hit Add Slave (gray cross) and select head_CTRL_REAC. When the window pops up, follow it like so: Transform > Rotation > Orientation Constraint > Orientation Weight 0. Weight 0 will be head_neck_CON.

Repeat the step to add Weight 1 (head_chest_CON2), Weight 2 (head_hip_CON), and Weight 3 (head_world_CON), as Slave objects, too. You'll notice that every time we add a new Slave, a new State is created at the bottom

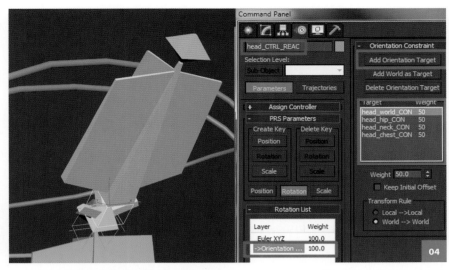

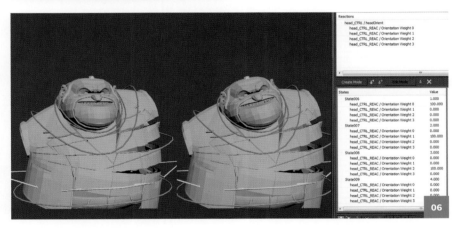

half of the Reaction Manager window. Delete all of the new states to begin with so we can re-create them to our needs (Fig.05).

CREATING STATES AND CONTROLLING WEIGHTS

Select head_CTRL/headOrient from the Reactions menu and hit Create State. When the State is created, set the Value for Orientation Weight 0 to 100 and set the Value for Orientation Weight 1, 2 and 3 to 0. Select head_CTRL/headOrient and create another State. This time, change the Value for the State

to 2 and set the Value for Orientation Weight 1 to 100 and the remaining three Weights to 0.

Repeat the step twice more for Orientation Weight 2 and 3, making sure to update the Value of the State and also the Orientation Weights. We can now define how the head follows the body by changing our headOrient attribute (Fig.06).

INTRODUCTION TO CHARACTER RIGGING
CREATING THE FK AND IK ARM SETUP

BY JAHIRUL AMIN

To create the shoulder and bone control, in the Front view create a single bone with a nub for the left-hand side of the character. Rename the bone 'l_shoulder_JNT' and the nub 'l_shoulderEnd_JNT'. Then go through and check the orientation of each bone and Freeze Transform.

For the shoulder bone, create a control using a circle shape and call it 'l_shoulder_CTRL'. Make sure that you create the two extra Helper objects for each control and name them accordingly. Once the control hierarchies have been created, use the Align Tool to position and orient the _OFFSET Helper to l_shoulder_JNT. Lastly, position and orient constrain the bone to the control and then parent l_shoulder_CTRL_OFFSET under spine_CTRL (Fig.01).

CREATING THE ARM BONES

Turn on Pivot snapping and create a two-bone chain starting from l_shoulderEnd_JNT, hitting the elbow region and ending at the wrist. Rename the bones 'l_upperArm_JNT', 'l_lowerArm_JNT' and the bone nub 'l_armEnd_JNT'.

Make sure you check the placement of the bones from every angle and then fix the orientation so positive Rotate Z gives you Flexion. To create the FK/IK setup, duplicate the entire chain twice so you have three sets of bones sitting one on top of the other. Rename the first chain of bones to end with '_FK_JNT' and the second set with '_IK_JNT' (Fig.02).

CREATING THE FK/IK SWITCH

First of all, parent l_upperArm_JNT, l_upperArm_FK_JNT and l_upperArm_IK_JNT under l_shoulderEnd_JNT. Now we need a control that houses switches to allow the animator to go between FK and IK. You can use whatever shape you would like but I suggest creating a shape that is easily identifiable as the switch.

To do this, I use the Line Tool with grid-snapping turned on to create a control that resembles the letters FKIK. Once it is ready, rename it 'FKIK_CTRL', position it behind the character and then parent it under the cog_CTRL. With the FKIK_CTRL selected, go into the Hierarchy tab in the Command Panel. In the Link Info tab, check all the boxes for Move, Rotate and Scale in the Locks section. Fig.03 shows the FKIK switch, parented to the cog_CTRL and its transforms locked off.

SWITCH ATTRIBUTES AND CONSTRAINTS

With the FKIK_CTRL selected, go to Animation > Parameter Editor. Set the Parameter Type to Float and the UI Type to Spinner. Name it 'l_arm_FKIK' and set the Range From 0 To 10.

Add three more attributes with the same settings. Name them 'r_arm_FKIK', 'l_leg_FKIK' and 'r_leg_FKIK'. Next select l_upperArm_JNT, then go to Animation > Constraints > Orientation Constrain and select l_upperArm_FK_JNT. On the newly created constraint, click Add Orientation Target and select l_upperArm_IK_JNT. Orient constrain l_lowerArm_JNT to both l_lowerArm_IK_JNT and l_lowerArm_IK_JNT (Fig.04).

SETTING FK/IK WITH THE REACTION MANAGER

Go to Animation > Reaction Manager and hit Add Master. Select the FKIK-CTRL and follow it like so: Object (Line) > Custom_Attribute > l_arm_FKIK. Hit Add Slave and then select l_upperArm_JNT and follow it like so: Transform > Rotation > Orientation Constraint > Orientation Weight 0. Also add Orientation Weight 1 of l_upperArm_JNT as a

03

04

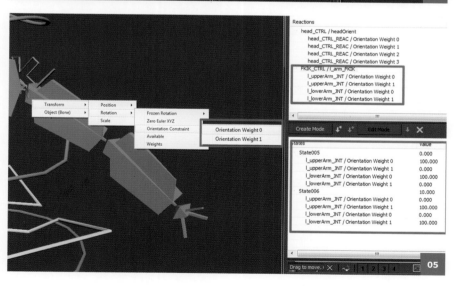

05

Slave and then both Orientation Weights for lowerArm_JNT. Delete any states that would have been created and create two new states, both containing all four Orientation Weights.

The first state will give us FK when the l_arm_FKIK switch is set to 0. Set the Value

of the State to 0, both Orientation Weight 0s (FK) to 100 and the Orientation Weight 1s (IK) to 0. For the second state, set the Value to 10, both Orientation Weight 0s to 0 and both Orientation Weight 1s to 100. Our original set of bones will now be driven by either set through or Custom Attribute (Fig.05).

CONTROLLING THE FK ARM

Create a spline circle and rename it 'l_upperArm_FK_CTRL', and also create the two Helper objects (_REAC and _OFFSET) for the control hierarchy. Use the Align Tool to match their orientation and positions to l_upperArm_FK_JNT. Now create a control for the l_lowerArm_FK_JNT in the same manner.

Once both controls are in place, aligned and Freeze Transform has been applied, parent l_lowerArm_FK_CTRL under l_upperArm_FK_CTRL and then parent l_upperArm_FK_CTRL_OFFSET under l_shoulder_CTRL. Lastly, orient constrain l_upperArm_FK_JNT to l_upperArm_FK_CTRL and l_lowerArm_FK_JNT to l_lowerArm_FK_CTRL (Fig.06).

ADDING IK

Hide the original arm chain and the FK chain so we are only working with the IK set. Select l_upperArm_IK_JNT and go Animation > IK Solvers > IK Limb Solver and then select l_armEnd_IK_JNT. Rename the IK handle 'l_arm_IK' and then use a Spline Line and grid-snapping to create a box for the control. Rename this 'l_arm_IK_CTRL', along with two Helper objects.

Once the control has been set up, use the Align Tool to match its position and orientation to l_arm_IK. Freeze Transform the control and then parent l_arm_IK under l_arm_IK_CTRL. With the control selected, go to Animation > Parameter Editor and add a new attribute with the following settings: Parameter Type > Float, UI Type > Spinner, Name > elbowSwivel and Range: -360 to 360.

Now go to Animation > Wire Parameters > Parameter Wire Dialog. Select l_arm_IK_CTRL, refresh the left-hand side and under Custom_Attributes, highlight elbowSwivel:Bezier Float. Select l_arm_IK, refresh the right-hand side and under Transform : IKChainControl, highlight Swivel Angle : Float Wire. Make sure the control direction is set from left to right and in the right-hand expression window type 'DegToRad(elbowSwivel)'. You can see the Custom Attribute of l_arm_IK_CTRL driving the Swivel angle of the l_arm_IK in Fig.07.

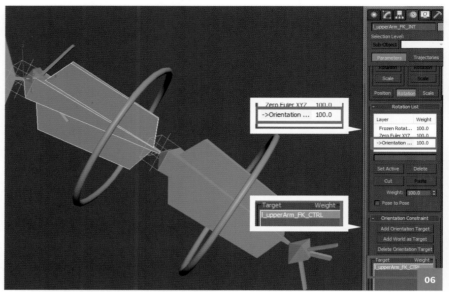

MIRRORING BONES

To mirror bones in 3ds Max, I tend to use the following method: with the Move tool active, set the RCS to Global, select the entire bone chain you wish to mirror, and hit the Mirror tool in the Bone Tools window.

Next, set the Mirror Axis to X, the Bone Axis to Flip to Y and hit OK. Select the root bone from the original chain and jot down its Global position in Translate-X. Copy that value onto the Translate-X for the mirrored root bone, but put a negative in front of it, too. The bone chain should pop into the correct place.

To fix the orientation of the mirrored bones to match the original set, select the root bone and go into the Hierarchy tab in the Command Panel. Set the mode to Pivot and enable Affect Pivot Only. Set your Rotate tool to Local and plug a value of 180 into the Rotate Y channel. Finally, Freeze Transform the mirrored set of bones and you should be good to go (Fig.08).

USING LAYERS

I like to use layers often to allow me to quickly show or hide elements within the scene, and also to group objects together so I can easily find them. You can also Freeze objects, therefore making them un-selectable, which is very useful if you want to stop elements of the rig being selectable – or worse, deleted. It's a neat way to keep your scene tidy, so I encourage you to create a few layers and start organizing your objects (Fig.09).

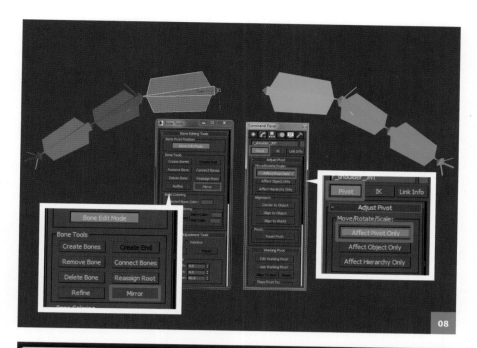

89

INTRODUCTION TO CHARACTER RIGGING
RIGGING THE HANDS

BY JAHIRUL AMIN

Now we move on to what is considered the second-most expressive part of the body (after the face): the hands. Start by enabling Pivot snapping and create a single bone (plus the nub) starting from the l_armEnd_JNT and ending at the end of the palm. Rename the bone 'l_palm_JNT' and the nub 'l_palmEnd_JNT'.

As we have done for every bone created, check the orientation and then go to Freeze Transform. For each finger, create a four-bone chain, although be sure to note that the thumb will only need *three* bones. Start the chain from where the metacarpal bone would originate for each finger and then add a bone for each of the phalanges. I like to add the metacarpal bones as it allows for greater posing of the hand, especially when creating a nice arc in the knuckles when the hand forms a fist. Out of habit, I've also left the nubs, but you can delete these if you like (Fig.01).

> ❝ I like to add the metacarpal bones as it allows for greater posing of the hand, especially when creating a nice arc in the knuckles when the hand forms a fist ❞

Bone nubs

01

02

NAMING AND ORIENTATION

Rename the bones from root to tip with the following suffixes: 'FingRoot_JNT', 'FingA_JNT', 'FingB_JNT', '_FingC_JNT' and 'FingEnd_JNT'. The root bone for the index finger would be 'l_indexFingRoot_JNT', the middle phalanx for the ring finger would be 'l_ringFingB_JNT' and the bone nub for the middle finger would be called 'l_middleFingEnd_JNT', and so on (Fig.02).

Now go through and check the orientation of each bone. This is very important – especially for the thumb. We want to have the ability to create a fist by simply using the Rotate Z axis for all the bones together.

Take some time to make sure this is done well. Again, Freeze Transform all the bones when you are happy with the results and parent some geometry to the finger bones so you can test them out.

CREATING HAND AND FINGER CONTROLS

Before creating any controls, quickly select all the finger root bones and parent them under l_palm_JNT. For the palm control, I decided to use an Arc that you will find under Create > Shapes. Rename the control 'l_palm_CTRL', and make sure to create the control hierarchy with the Helper objects and rename them appropriately.

Use the Align Tool to match the orientation and position of l_palm_CTRL_offset to l_palm_JNT, and then position and orient constrain l_palm_JNT to l_palm_ctrl.

For the finger controls, I decided to use the Line tool to create a custom shape. Rename each control to match the naming convention of the bone that it will control, and then align the controls to the bones so they are in the correct position and have the correct orientation. Once this has been completed, use Freeze Transform (Fig.03).

CREATING THE CONTROL HIERARCHY AND CONSTRAINING

We now need our controls to mimic the FK behavior of the bones. For each finger, parent the l_#FingC_CTRL_OFFSET under l_#FingB_CTRL. Parent l_#FingB_CTRL_OFFSET under l_#FingA_CTRL. Parent l_#FingA_CTRL_OFFSET under l_#FingRoot_CTRL, and finally l_#FingRoot_CTRL under l_palm_CTRL. Then orient constrain each bone to its relevant control. Create a Helper object, rename it 'hands_RIG_GRP' and parent l_hand_CTRL_OFFSET and l_palm_JNT under it (Fig.04).

CONNECTING THE HAND TO THE ARM

Create two new Helper objects and set their Displays to Cross. Rename them 'l_hand_FK_CON' and 'l_hand_IK_CON'. Use the Align Tool to match their positions and orientation to l_hand_JNT. Parent l_hand_FK_CON under l_lowerArm_FK_CTRL and l_hand_IK_CON under l_arm_IK_CTRL.

Next, select l_hand_CTRL_OFFSET and go to Animation > Constraints > Orientation Constraint and then select l_hand_FK_CON. Under the settings for the constraint, hit Add Orientation Target and select l_hand_IK_CON.

Next, as we did for the FK/IK switch for the arms, use the Reaction Manager to set the Orientation Weight to follow either the FK or the IK chain. Select l_hand_CTRL_OFFSET once more and go to Animation > Constraints > Position Constraint and select l_armEnd_JNT (Fig.05).

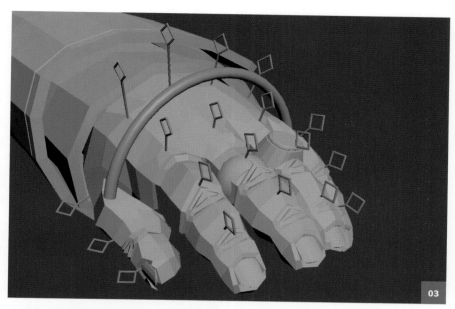

03

04

05

CREATE THE CUSTOM FINGER CONTROL

Currently, we can rotate each digit to manipulate the fingers. This is great for refining and making small yet detailed changes, but it isn't great for making quick broad poses. So let's create a control to house spinner attributes that allow for this.

Here, we will really take advantage of the REAC helpers that we have put into every control. First we need the control. Use the Line tool with the Initial Type set to Smooth and in the Front view, create a shape that looks like a hand. Rename the shape l_fingers_CTRL, position it by the hand and then parent it under l_hand_CTRL. Go into the Hierarchy tab and in Link Info enable the Locks for all the Move, Rotate and Scale boxes (Fig.06).

CREATE THE ATTRIBUTES

With l_fingers_CTRL selected, go to Animation > Parameter Editor. Create the following attributes: thumbCurl, indexCurl, middleCurl, ringCurl, pinkyCurl, thumbSpread, indexSpread, middleSpread, ringSpread and pinkySpread. Set each attribute to have a Parameter Type of Float, UI Type of Spinner and a Range From -10 To 10 (Fig.07).

ADDING FINGER CURLING

Next, open up the Reaction Manager. Hit Add Master and select l_fingers_CTRL. When the window pops up, go to Object (Line) > Custom_Attributes > thumbCurl. Then hit Add Slave and select l_thumbRoot_CTRL_REAC. When the window pops up go to: Transform > Rotation > Zero Euler XYZ > Z Rotation.

Also add l_thumbA_CTRL_REAC and l_thumbB_CTRL_REAC with the same settings. Create three new States for this attribute and leave the first State as it is. This will be the default pose. Set the Value for the second State to 10 and pop a value of around 10 for the root bone and 40 for thumbs A and B.

You'll need to experiment to find what works for you to create the thumb curl. For the third State, set the Value to -10, then -10 for the root bone, and finally -20 for the two other

bones. You should now be able to use the thumbCurl attribute on the l_fingers_CTRL to curl and hyperextend the thumb. Repeat the same steps for the remaining fingers and remember to make sure it is the REAC node you are linking up to (Fig.08)

ADDING FINGER SPREADING

For all the finger spread attributes, I follow the same method as previously mentioned, only when I select the Slave object, I use the following: Transform > Rotation > Zero Euler XYZ > Y Rotation.

I set the State with a Value of 10 to equal abduction of the fingers (away from the middle finger) and the State with a value of -10 to equal adduction (rotating towards the middle finger). Once you have repeated this step for all the fingers, you should now be able

to quickly pose with the Spinner attributes and then work on top by grabbing onto the animation controls in the viewport (Fig.09).

GROUPING REGIONS TOGETHER

I mentioned previously that I like to use the layers to control the visibility of bones, controls and so on, to keep the scene organized. As well as this, I also like to keep the rig as tidy as possible, so should someone else need to look at it and fix an issue, they could hopefully deconstruct it pretty easily.

To ensure this, I use Helper objects and then parent all the relevant parts of a particular region under that. For example, I created a Helper Object (Cross), renamed it 'hands_RIG_GRP' and then parented l_hand_CTRL_OFFSET and l_palm_jnt under it. Should another rigger or animator need to find an element

that belongs to the hand rig, they could quickly navigate to this part of the rig.

Create groups for the torso, neck, arms and later on for the legs and feet (Fig.10).

ADDING LOCKS

Many of the controls we set up will perform a particular function; for example, the finger controls should only be rotated, the IK spine controls should only be rotated and translated, and the IK arm controls should only be translated. To make sure the animator doesn't use them in any other way than that desired, I recommend that you use the Locks available in the Hierarchy > Link Info tab (Fig.11).

INTRODUCTION TO CHARACTER RIGGING
RIGGING THE LEGS AND FEET

BY JAHIRUL AMIN

To create the leg bones, in the Right view, use the Bone Tools to create four bones and a nub: firstly starting around the hip, then the knee, the ankle, ball and ending at the tip of the shoe. Rename the bones: 'l_upperLeg_JNT', 'l_lowerLeg_JNT', 'l_ankle_JNT', 'l_ball_JNT' and 'l_toeEnd_JNT'.

Check the orientation of the bones, make sure that the legs are sitting within the geometry from every angle, and then use Freeze Transform. Duplicate the bone chain twice and, like we did for the arms, rename the first set of duplicated bones to end with '_FK_JNT' and the second set to end with '_IK_JNT' (Fig.01)

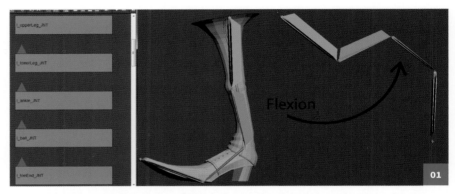

CONSTRAINTS AND FK CONTROLS

As with the arms, orient constrain each bone from the original set to both its FK and IK counterpart. Then use the Reaction Manager again to control the weights of the constraints to be driven by the correct attribute on the FKIK_CTRL. As we did for the FK arm chain, create controls for each of the FK leg bones by creating a control hierarchy that mimics the behavior of the bones.

04

Then select l_lowerLegIK_JNT and in the Bone Tools window, hit Create End.

Rename the newly created nub l_legEnd_IK_JNT. With l_upperLeg_IK_JNT selected, go to Animation > IK Solvers > IK Limb Solver and select l_legEnd_IK_JNT. Rename the IK 'l_leg_IK'.

Now select l_ankle_IK_JNT and go to Animation > IK Solver > HI Solver and select l_ball_IK_JNT. Rename the IK 'l_ball_IK'. Finally, select l_ball_IK_JNT and go to Animation > IK Solver > HI Solver and select l_toeEnd_IK_JNT. Rename the final IK 'l_toe_IK' (Fig.03).

CREATE AN IK FOOT CONTROL

As I did when creating the IK arm control, I used a Line tool to draw out a cube for the IK leg control. Once you have your shape, rename it 'l_leg_IK_CTRL' and create the control hierarchy using Helper objects, as we have done throughout this project. When the control is ready, use the Align Tool to match its orientation and position to l_leg_IK. You can now use the Parameter Editor to add the following attributes to l_leg_IK_CTRL with the following settings:

• footRoll, heelPivot, toePivot, toeFlap, sideToSide and heelRollOffset should all have a Range From -10 To 10.

• ballRollOffset, toeLiftTipOffset and toeLiftFloorOffset are all to have a Range From 0 To 10.

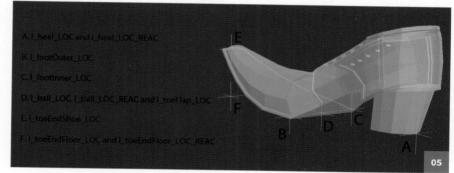

A. l_heel_LOC and l_heel_LOC_REAC

B. l_footOuter_LOC

C. l_footInner_LOC

D. l_ball_LOC, l_ball_LOC_REAC and l_toeFlap_LOC

E. l_toeEndShoe_LOC

F. l_toeEndFloor_LOC and l_toeEndFloor_LOC_REAC

05

• Set the kneeSwivel Range From -360 To 360.

All of the attributes should be of Parameter Type Float with a UI Type of Spinner (Fig.04).

CREATING THE REVERSE FOOT HELPERS

To create the reverse foot setup, we will use many Helper (cross) objects placed around the foot to allow for pivoting from that position. We'll go through these one by one so it will hopefully be clear where to place them. So create the first Helper and call it 'l_heel_LOC', and then use the snapping tools to position to the back heel of the shoe where it touches the floor. Orient it slightly so it also matches the angle of the foot. Duplicate the helper, leave it where it is and call it 'l_heel_LOC_REAC'.

Create another Helper, position it at the widest part on the outside of the foot and rename it 'l_footOuter_LOC'. Again, orientate it so it matches the angle of the foot. Duplicate that Helper, rename it 'l_footInner_LOC' and translate it so it's on the widest part of the inside of the foot.

Create a new Helper, position it at the ball of the foot and orientate it so it matches the angle of the foot. Rename it 'l_ball_LOC', then duplicate it twice and rename the duplicates 'l_ball_LOC_REAC' and 'l_toeFlap_LOC'.

Create a new Helper, position it at the tip of the toe and orientate it to match the angle of the foot. Rename it 'l_toeEndShoe_LOC' and duplicate twice. Rename the duplicates 'l_toeEndFloor_LOC' and 'l_toeEndFloor_LOC_REAC'. Position both so they're level with the floor. Select all of the Helpers and Freeze Transform them (Fig.05).

CREATING THE REVERSE FOOT HIERARCHY

Now to create the hierarchy to get the reverse foot working. First parent l_ankle_IK_JNT under l_leg_IK. Parent l_leg_IK under l_ball_LOC, and then l_ball_LOC under l_ball_LOC_REAC.

Next, take l_toe_IK and parent it under l_toeFlap_LOC. Select l_toeFlap_LOC, l_ball_LOC_REAC and l_ball_IK, and parent all three under l_toeEndFloor_LOC.

Now parent l_toeEndFloor_LOC under l_toeEndFloor_LOC_REAC and then l_toeEndFloor_LOC_REAC2 under l_toeEndShoe_LOC.

Parent l_toeEndShoe_LOC2 under l_footInner_LOC and then l_footInner_LOC under _footOuter_LOC. l_footOuter_LOC goes under l_heel_LOC and then l_heel_LOC goes under l_heel_LOC_REAC.

Lastly, parent l_heel_LOC_REAC under l_leg_IK_CTRL… Phew! You can see the hierarchy in Fig.06.

CONNECTING THE HELPER OBJECTS WITH THE FOOT CONTROL

Before connecting the Helper objects to the attributes we set up on the foot control, go through and rotate each one to find out which axis will be helpful, and also the type of movement that is created.

The reason why in some places we have more than one Helper – for example, at the heel and ball of the foot – is so we can get all the movement needed to create a walk/run cycle with one attribute (footRoll), but still create an offset on top or even animate with three independent Spinner attributes if desired. This is just to give a bit more flexibility to the animator and doesn't force him to animate in a particular way (Fig.07).

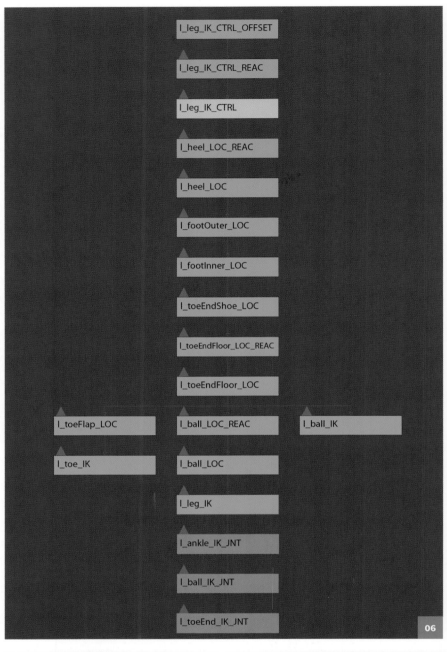

06

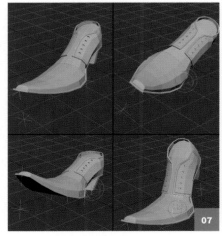

07

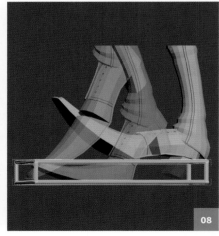

08

CREATING THE FOOT ROLL

Open up the Reaction Manager and hit Add Master. Select l_leg_IK_CTRL and follow it like so: Object (Editable Spline) > Custom_Attribute > footRoll. Hit Add Slave and select l_heel_LOC_REAC and when the window pops up, follow it like so: Transform > Rotation > Zero Euler XYZ > X Rotation.

Also add the X Rotation of l_ball_LOC_REAC and l_toeEndFloor_LOC_REAC as Slave objects. Now create a new State with all three Helper objects included and leave it as it is – this is our default State.

Create a new State with the same objects. Set the Value to -10 and then set the X Rotation for the l_heel_LOC_REAC to -20. Leave the other two objects as they are right now. Create another State, and this time set the Value to 5. Set the X Rotation for l_ball_LOC_REAC to 35 and the other two Helpers to 0. Lastly, you'll need to create a new State and set the Value to 10. Set the X Rotation for l_toesEndFloor_LOC_REAC to 40 and the other two to 0.

You should now be able to use the footRoll attribute on the foot control to pivot the foot back onto the heel, roll the foot onto the ball and then raise the foot onto the toe (Fig.08).

FINISH OF THE REVERSE FOOT AND ADDING KNEE SWIVEL

Following the same method of loading a Master and then the Slave object, go through and connect the remaining Helper objects to the foot control attributes.

Once they are all done, the last thing we need to do is add the knee swivel. To do this we'll use the same method we used for the elbow swivel. Go to Animation > Wire Parameters > Parameter Wire Dialog.

Select l_leg_IK_CTRL, refresh the left-hand side and under Custom_Attributes, highlight kneeSwivel:Bezier Float. Select l_leg_IK, refresh the right-hand side and under Transform: IKChainControl, highlight Swivel Angle:Float Wire. Make sure the control direction is set from

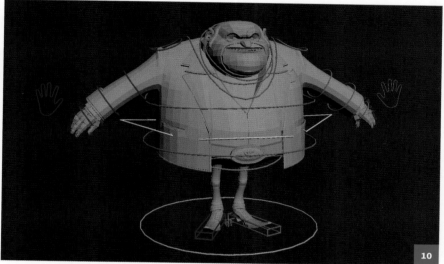

left to right and in the right-hand expression window type, 'DegToRad(kneeSwivel)' (Fig.09).

CREATING A GLOBAL SRT CONTROL

We've got the bulk of our major rig complete, so let's quickly create the Global SRT control. This control will be used to position and orientate the character so he is facing in the correct direction at the start of a shot.

Create a circle and rename it 'global_SRT_CTRL'. Position it at the world center, convert it to an Editable Spline and then in Component mode, scale the shape so it surrounds the character. Create the _REAC and _OFFSET Helper objects and build the control hierarchy. Once complete, all the elements of the rig will be parented below this control (Fig.10).

USING A CONTROL FOR ELBOW AND KNEE SWIVEL

I've set up the rig to use Custom Attributes to drive the elbow and knee control. This is

to reduce the amount of controls on-screen. However, some people prefer to be able to grab a visible control, so should you prefer that method, feel free to create a control, position it and then select the IK Solver you wish to connect it to. Scroll down to IK Solver Properties and under IK Solver Plane, hit Pick Target and select the control.

ADDING LOCKS

Many of the controls we set up will perform a particular function. Remember: to make sure the animator doesn't use them in undesirable ways, be sure to use the Locks available in the Hierarchy > Link Info tab.

INTRODUCTION TO CHARACTER RIGGING
RIGGING THE FACE AND CLOTH CONTROLS

BY JAHIRUL AMIN

To get the natural arc when opening the jaw, I opt to use a bone as opposed to morph targets. While I'm there, I also decide to pop a couple of bones into his big nose and also his ears. This was just to allow some subtle movement to the face, should the animator need it.

For the jaw, in the Left view, create a two-bone chain that mimics the shape of the human jaw and a bone nub, starting from just below the ear. I'm aware that the human jaw is only one bone – the mandible – but I like to try and get my CG bones to resemble it visually.

All the rotation will still happen from the root bone, as the human jaw articulates from around that point. Rename the bones, from root to tip: 'jawA_JNT', 'jawB_JNT' and 'jawEnd_JNT' (Fig.01).

CREATING THE NOSE AND EAR BONES

In the Left view, create a two-bone chain for the nose. Rename the bones, from root to tip: 'noseA_JNT', 'noseB_JNT', and 'noseEnd_JNT'. For the ear bone, in the Perspective view, use Vertex snapping to create a single bone with a nub. Rename the bone 'l_ear_JNT' and the nub 'l_earEnd_JNT'.

Take all the new bones and then go through and fix their orientation. You can then use Freeze Transform. Once complete, select all the root bones from each chain and parent them under a Helper object; name that object 'face_RIG_GRP' (Fig.02).

CREATING THE CONTROLS FOR THE FACE

The controls for the face are created in the same manner that all the FK controls have been created so far. I use a custom shape, similar to that of the finger controls, and simply create control hierarchies with Helper objects and use the Align Tool to position them.

Once in place, I position and orient constraint the relevant bone to the controls, and then take all the _CTRL_OFFSET Helpers and parent them under head_CTRL (Fig.03).

I decided to rig the cigar in the same manner. To add further expression to the face, we'll come back and add some morph targets driven by custom controls.

CREATING THE CLOTH CONTROLS

As the jacket is pretty loose and the character has some rather large collars adorning his outfit, I decide to pop some Helper objects in to allow for deformation in these regions. I also decided that, instead of popping bones in there and then creating controls for them, I would lighten the rig by simply skinning the Helper objects to the cloth.

Create a Helper (box) and rename it 'l_jacketA1_CTRL'. Duplicate it and change its Display Type to a cross and rename it 'l_jacketA1_CTRL_OFFSET'. (We'll forget about the REAC helpers for this stage, also).

With both at the world center, parent l_jacketA1_CTRL under l_jacketA1_CTRL_OFFSET. Take l_jacketA1_CTRL_OFFSET and

Vertex snap it to the front left-hand side of the jacket and then orient it slightly to match the angle of the vertex normal.

Once in place, use Freeze Transform and then duplicate the entire control hierarchy, replacing the A1 with 'A2'. Reduce it down slightly and duplicate it once again. Rename the hierarchy to end with 'A3'.

Once in place, parent the A3_CTRL_OFFSET under A2_CTRL and then the A2_CTRL_OFFSET under A2_CTRL. Continue to build the controls in the same manner so they go all the way around the character (Fig.04).

ADD THE COLLAR AND LAPEL CONTROLS

As we did for the bottom of the jacket, create controls for the shirt collar and the jacket lapel in the same way. Currently, the root for each control is not connected to the main rig. You can connect them now, but I actually found

some tweaking was needed later on so they follow the correct control. For now, parent all the controls of the lower jacket to the hip_IK_CTRL and the collar and lapel controls to chest_IK_CTRL. This is just temporary until the skinning has been completed (Fig.05).

INTRODUCTION TO CHARACTER RIGGING
SKINNING AND ADDING MORPH TARGETS

BY JAHIRUL AMIN

At this stage, I think we're ready to start skinning. But before doing so, I always like to test out the rig by creating a quick pose test or a simple walk cycle. This allows you to see if the rig is solid or if there are any issues that need to be fixed first. Since we have the low-resolution geometry attached, we should be able to spot anomalies very easily (Fig.01).

> " The manner in which I approach skinning is to first make some broad strokes and then start refining down "

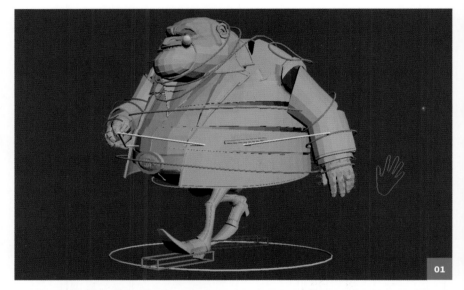

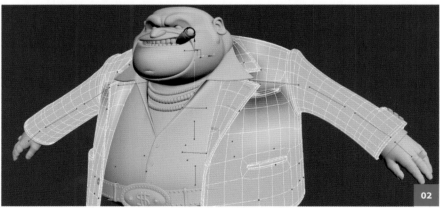

SKINNING WORKFLOW

Rather than showing you how to skin on the character, I think it will be easier to explain a good workflow on a simpler model: the trusty cylinder. I've placed a couple of bones in the cylinder to mimic an arm or a leg. They are called, from root to tip, 'root_JNT', 'mid_JNT' and 'end_JNT'. The manner in which I approach skinning is to first make some broad strokes and then start refining down.

To begin with, I allow each bone to have 100-percent influence on all of the vertices surrounding it. Then I pose the limbs. I usually do this in FK mode so I can manipulate one axis at a time, and animate the posing by setting some keys on the timeline. At this stage, I will start pushing and pulling the weights using the Weight Tool. I tend not to use the Envelope capsules as I find them pretty cumbersome and painful to use, but if you like them, work in your preferred manner (Fig.02).

MIRROR SKIN WEIGHTS

If a character is symmetrical, we can take full advantage of the Mirror Parameter options. The character we have here does have some asymmetry in places, but the Mirror tool still does a pretty good job; some minor tweaking is needed to fix the areas where it struggles to mirror over. Once you have painted the weights of one side (I tend to paint the character's left-hand side), enable Mirror Mode in the Skin modifier, set the Mirror Plane to X and hit Paste Blue to Green Verts (Fig.03).

The model I received had a TurboSmooth modifier already applied to the mesh. Make sure you get rid of this before adding the Skin modifier. Once the Skin

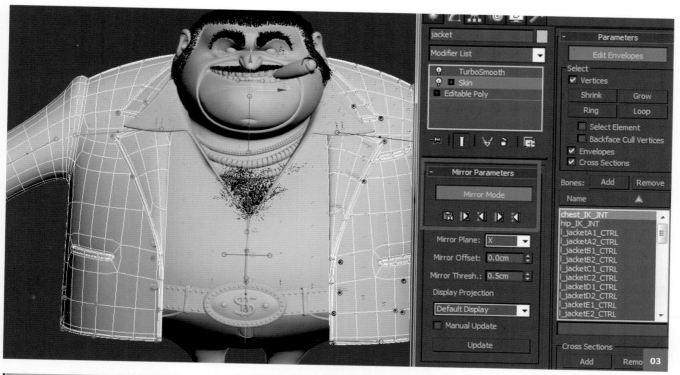

03

04

modifier is applied, just pop it back on so
it lives at the top of the stack (Fig.04).

ATTACHING THE
MESH TO THE BONES

First, select the geometry (the cylinder)
and in the Modifier tab, add a Skin Modifier.
In the Parameters, next to Bones, hit Add.
When the Select Bones window pops
up, select root_JNT and mid_JNT.

Here, we don't need the nub, so when you
skin the hand geometry to the finger bones,
exclude the nubs as we won't be orientating
from those points. You can now orient the
bones to deform the cylinder (Fig.05).

05

By default, on a simple object, the deformation isn't too bad, but let's presume this is a more complicated model so I can demonstrate my general workflow…

BLOCKING OUT THE WEIGHTS

Select the Skin modifier and scroll to the Display menu. As we won't be using the Envelope capsules, enable Show No Envelopes, so that they're hidden.

Now comes the blocking. Make sure Edit Envelopes and Vertices are turned on. Select the vertices of the top half, make sure root_JNT is selected in the Bones window, scroll down to Weight Properties, and plug a value of 1 into the Abs. Effect box. Select the lower half of the vertices, and with the mid_JNT highlighted, also plug a value of 1 into the Abs. Effect box. The vertices at the top are now fully assigned to root_JNT and the vertices at the bottom to mid_JNT (Fig.06).

ADD POSES AND REFINE

Select mid_JNT and set a key at the starting position. Step five frames forward, rotate the bone and set another key. The results will be rough due to our initial blocking, but we will fix that next.

Go back to the Skin modifier and turn on Weight Tool to bring up the editing window. Select the vertices around the inside of the bend (elbow/knee), select root_JNT from the lower box, and hit the + button beside the Set Weight to start adding influence to the selected vertices (Fig.07).

Use the timeline to scrub through the animation to see the effects during deformation. By using this method we can start giving influence to some vertices and taking from others in a clean, non-destructive manner. It may seem like a painful process, but this method allows you to have full control over skinning, rather than relying on the software. Take the skinning as far as possible, and should you need extra fixes, we can use corrective shapes on top.

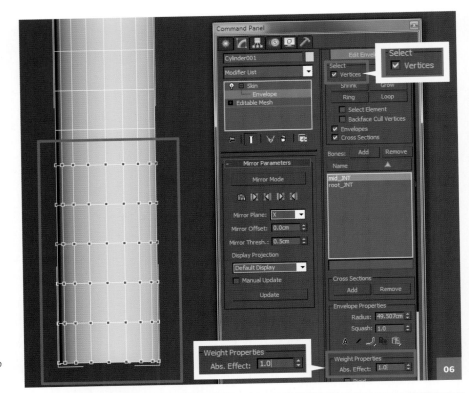

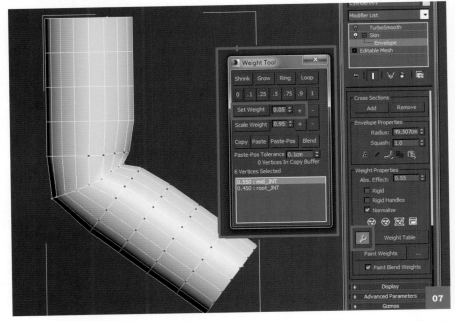

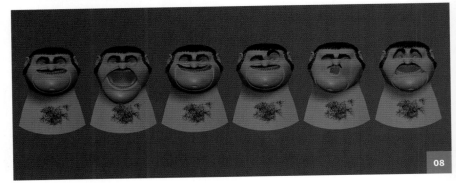

The current model is broken into many parts, so take each part, add a Skin modifier and then the bones needed in that region. Go through the blocking, posing and refining stages and you should be able to skin him pretty quickly.

ADDING FACE SHAPES

To add some further character to the Loan Shark, I thought it best to add controls to be able to manipulate his expressions. To do this, I use a combination of 3ds Max and Mudbox.

By exporting the head into Mudbox, I found I could quickly generate a series of facial poses that I could then bring back into 3ds Max. If you wish, you could stick to 3ds Max and do the same thing: just duplicate the head, create the expressions an apply them using a Morpher modifier. I just find it easier to push and pull using the sculpting tools in Mudbox.

If you are looking into developing a full-feature face, I recommend you have a look at the research of Dr. Paul Ekman and FACS (Facial Action Coding System). For the face of our character, I will add controls that allow for brow-raising and lowering, mouth-widening and narrowing, mouth-raising and lowering, and blinking and widening of eyelids (Fig.08).

CREATING THE FACE SHAPES

First select the head geometry and disable the TurboSmooth modifier so we get the lowest-resolution head. Then go Application Menu (File) > Export > Export Selected and save the head as an OBJ file.

Load the head into Mudbox and create a new sculpt layer. Rename the layer 'l_browInner_up' and then use the Move tool to start pushing the brow up. Create a new layer and call it 'l_browMid_up', and then raise the middle of the left brow in that layer. Create a third sculpt layer, rename it 'l_browOuter_up' and raise the outer portion of the left brow. You can use the weighting for each layer to see how they work independently, as well as together (Fig.09).

It's very useful to get an idea of how the many shapes of the face will work in conjunction with one another. Once you have a range of face shapes all created on separate

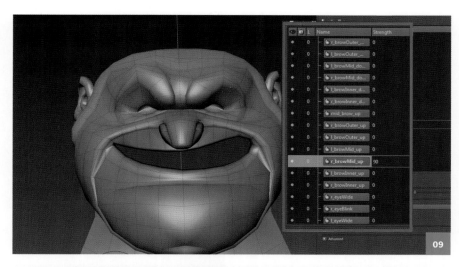

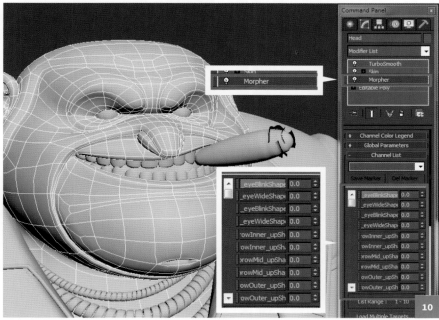

layers, turn them all up to 100%, select the head and export out as an FBX file.

BRING IT BACK INTO 3DS MAX

When you are back in 3ds Max, go to the Application Menu (File) > Import and select the FBX file saved out from Mudbox. Leave the settings as they are when the Import screen pops up, and then hit OK.

3ds Max will automatically add a Morpher modifier to the Head stack and load in all the shapes created in Mudbox. The face may look a little squished at first, but this is due to the fact that all the shapes have a strength of 100. Simply go in and take them all to 0. You will also need to edit the Modifier stack so

the deformation happens correctly. Simply drop the Morpher modifier below the Skin modifier. Currently, the animator will need to come into the Morpher modifier to animate the face, which isn't ideal, so let's allow for a facial control setup that they can grab in the Viewport and manipulate (Fig.10).

CREATING CONTROLS TO DRIVE THE MORPH SHAPES

The controls that used to drive the morph targets are Helper (box) objects. They're positioned around the regions of the face that the morph shapes would drive. Each control has an _OFFSET Helper added for positioning, and the transforms frozen.

11

The naming of each control is determined by the morphs it will drive; for example, l_inner_brow_CTRL will drive the morph shapes l_browInner_up and l_browInner_down (Fig.11).

USING THE REACTION MANAGER TO DRIVE THE MORPHS

Open up the Reaction Manager and hit Add Master. Select l_inner_brow_CTRL and follow the pop-up window like so: Transform > Position > Y Position.

Hit Add Slave and select the head geometry and follow the pop-up window like so: Modified Object > Modified Object > Morpher > l_browInner_up. Add l_browInner_down as a Slave object, also.

Create a new State and leave this as the default pose. Create another State and set the State Value to 2, the l_browInner_up to 100 and l_browInner_down at 0. Create a third State and set it to -2. Set the l_browInner_up to 0 and l_browInner_down to 100. Repeat this step for all the controls and the morph targets with each control, going from positive 2 to negative 2.

To stop the controls from flying away from the face, using the Hierarchy tab, I set locks so they were limited to Move only two units up and down in the Y-axis. Some controls, such as those at the corner of the mouth, could move up and down two units as well as side to side by two units. Also lock the rotate and scale attributes (Fig.12).

RIGGING THE EYES

The last part of the rig that I want to focus on is the eyes. As the model I received had the eyes slightly off center, I decided to rotate them slightly so they look straight ahead. This makes things simpler when connecting them to the controls by using LookAt Constraints.

12

13

14

15

In the Left view, create a bone from the center of the eye, towards the iris and ending at the outer edge. Rename the bone 'l_eye_JNT' and the bone nub 'l_eyeEnd_JNT'. Orient the bone – although it's not really necessary and is simply force of habit on my part – and then Freeze Transform. Select both eye parts – the outer and the inner portions – and add a Skin modifier. In the Skin Parameters, hit Add and select l_eye_JNT. To connect the eyes to the head, simply parent l_eye_JNT under head_JNT (Fig.13).

CREATING THE EYE CONTROLS

Use the Line tool to create a shape that resembles a cross. Place it in the world center and rename it 'l_eye_CTRL'. Create the _REAC and _OFFSET Helpers to accompany it. Use the Align tool to match l_eye_CTRL_OFFSET to the position and orientation of l_eye_JNT. Once it pops into place, in Local mode, translate it on the X axis so it sits in front of the geometry. Then do the same for the right eye.

Once you have both controls in place, create
a large, square-like control to surround both
eye controls. This will allow you to carry both
eyes together, while also manipulating each
individual eye by using the cross controls.
Call the new control 'eyes_CTRL' and create
the control hierarchy, as per usual.

To position the control, use the Align Tool
to match the position and orientation of
l_eye_CTRL and then zero it out on the X axis
so that it is centered. Parent both l_eye_CTRL
and r_eye_CTRL under eyes_CTRL (Fig.14).

CONSTRAINING THE BONES TO THE CONTROLS

Next select l_eye_JNT, go to Animation
> Constraints > LookAt Constraint and
select l_eye_CTRL. Repeat the step for the
right eye and then translate the controls
around to see if the eyes follow (Fig.15).

Once complete, you can either parent eyes_
CTRL_OFFSET under head_CTRL or leave it as
it is so it's independent of the head movement.
If you want to, you could use the REAC Helper
to control when it should or should not follow
the head in the same manner in which we
created the space switching of the head.

BITS AND BOBS

There are a few loose ends that need to be
set up to complete the rig. Here is a quick
summary of how I will approach them.
Firstly, I need to tackle the hair, brows and
the mustache. The hair on his head is easy
to solve. Since no shape change occurs in
that region, we can simply parent the hair
under head_JNT, or skin it to that bone.

The brows and the mustache need to deform
with the face, though, so how can we solve
that? Well, I use a Skin Wrap modifier: simply
add the Head geometry into the Parameters for
the modifier and you should be good to go.

Next we need to allow the teeth to open
and close with the mouth. To do this, I
apply a Skin modifier and add head_JNT
and jawA_JNT as influence objects. A bit of
weight painting should do the trick to have
them follow the jaw opening correctly.

16

17

The model didn't have an interior mouth cavity,
which looked a bit odd when the mouth was
open, so I quickly model this and skin it to the
same bones. I also skin the fingernails to the
finger bones to follow the fingers, but I simply
parent the jewelry under the closest bone.

Finally, for the buttons and the buttonholes,
I use a combination of either adding a
Skin modifier or using the Attachment
Constraint. It's generally a case of
experimenting and seeing which tool is
best for the job. You can see the rigging for
these extra elements shown in Fig.16.

FINISHING UP

At this stage, the rig should be close to
sending off to the animator. Before doing
so, go through it with a fine-toothed comb.

Check that the controls orient correctly.
Add layers to allow for showing and hiding
controls, and locking for those elements
that you wish not to be touched.

Go through and be thorough with your
naming conventions. Create groups to
keep the rig organized. All this and more
should be looked at before signing off.

The final rig can be seen in Fig.17. When
you are happy and you've sent it off to the
animator, let them take it for a test drive and be
prepared to make minor changes if need be.

INTRODUCTION TO CHARACTER ANIMATION

By Fernando Herrera

LEARN HOW TO PLAN A SIMPLE ANIMATION AND ANIMATE A CHARACTER TO BRING YOUR SCENES TO LIFE

Animation is a subtle and complex art. In this project, Fernando Herrera talks us through the theories and processes that will help you master this skill to create a smooth and believable scene using the character modeled and rigged in earlier projects.

Fernando will share his detailed industry proven techniques, explaining a variety of character interactions, from movements and gestures to prop interaction.

You'll also find videos to help illustrate the process at **www.3dtotalpublishing.com**.

FREE RESOURCES

www.3dtotalpublishing.com

Download your free resource pack for this project

INTRODUCTION TO CHARACTER ANIMATION
THE 12 PRINCIPLES OF ANIMATION

BY FERNANDO HERRERA

In this section of the project, we will talk about the animation process. The workflow we will learn in these chapters can also be applied to other 3D software as well.

We are using Denis Zilber's *Loan Shark* concept again, which looks a bit like a mob guy, or something (Fig.01). We are going to do a body mechanics shot in 3ds Max and I'll be explaining the process every step of the way.

If you look at the character you will see his proportions are very exaggerated and cartoon-like. This doesn't mean we can totally ignore realism in our animation, though. Even cartoon animation is grounded in the real world – we can bend and ignore rules, but what we are trying to capture is caricaturized movement.

Even much exaggerated animations, like Tex Avery's shorts, still reference elements of real life, which is why we relate to it so much. To do this we will have to exercise a high level of observation, by looking at the real world and making our own version of it in 3D.

Before we can start, we need to know what animation is. Essentially, animation is creating an optical illusion that something is in movement – and in our case, with a character, also alive. To do this, we must understand how the human body works and the basic laws of physics. It sounds boring, but don't worry, it doesn't involve any calculus – plus once you get the hang of it, it's actually quite straightforward and fun.

As character animators, we create the illusion of life (which, by no coincidence,

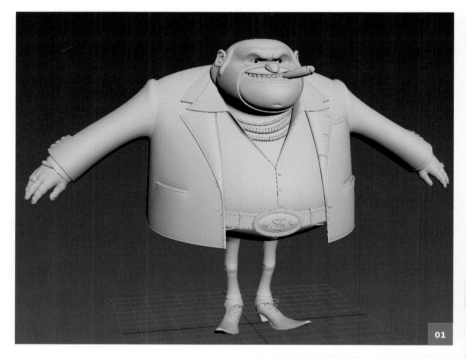

01

is also the title of one of the best-known books on the subject) and to achieve this we must prepare accordingly.

Animation is not a very technical process, if looking at it from a software knowledge point of view – anyone can place a key and play with a rig. What really makes good character animation is the understanding of body mechanics, acting, and a solid workflow to translate it into animation.

TECHNIQUE

The way we think of animation is the same in every medium, so the workflow I'll describe in this project is based on traditional hand-drawn animation, but focuses on digital software. I'll try to balance the right amount of help we're going to get from software interpolation and what we're going to build ourselves.

SQUASH

NORMAL

STRETCH

02

We will talk about each stage of the process: planning, blocking, spline, and polishing. I'll quickly summarize what each process is as well, so you know what I am talking about when I mention one of them.

03

- **Planning:** You'll need to plan your shot before even opening up 3ds Max.

- **Blocking:** Build your poses, timing, acceleration and everything that your shot is going to have. At this stage, we don't have software interpolation (interpolation is the automatic animation calculated by the software between two keyframes).

- **Spline:** Start using the software interpolations and controlling them to better suit your animation.

- **Polishing:** Polish contacts, spacing (the visual space between each pose), timing, arcs, and every little thing that will turn a good shot into a great one.

I can't really go on to teach anything about animation without first mentioning the 12 principles of animation. These principles were gathered by classic Disney animators Ollie Johnston and Frank Thomas through experience and observation of the real world.

The list expresses and summarizes very well what we should think about when animating characters. It's not exactly a list of rules, because animation has no rules (that's the beauty of it) but it is more a list of principles, as the name would suggest.

SQUASH AND STRETCH

Every material has a certain amount of malleability. When we watch super slow-motion videos of objects or the body in motion

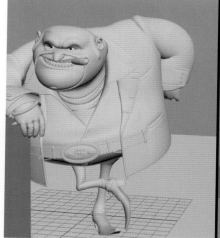

04

we can notice a lot of shape changing. Even if we can't perceive it with the naked eye, we certainly feel the elasticity (Fig.02).

In character animation, it's very important to take that to heart in order to make your character feel organic and fleshy. This principle is directly connected with exaggeration; we are taking a characteristic that exists in nature and exaggerating it to our favor. It's important that we note that when we are squashing or stretching we are not changing the volume.

ANTICIPATION

Anticipation is deeply connected to how the body mechanics and muscles work. To generate force, you need to build energy beforehand. It's like a coil: to make it jump, it needs to be compressed first. The same happens to our body and muscles. To jump, you need crouch, building potential energy in

your legs - otherwise the movement would be impossible. To make something feel alive and believable, we need to anticipate movements, because that's how our bodies work (Fig.03).

STAGING

Staging is a relation between posing and the camera. Cameras and cinematography are a language on their own that require a lot of study to fully understand – which is something I really recommend to animators.

The camera is the spectator's window to the animation. We need to think about the best way we can show something to them, otherwise much of the effort on all the other aspects of animation can be wasted on bad reading. By staging a character in a shot you have to think of what the spectator is seeing. Good staging can bring dynamic and clarity to a shot (Fig.04).

The reason posing is so connected to staging is because we pose to the camera, so the way we pose it affects the staging and clarity of everything.

STRAIGHT-AHEAD AND POSE-TO-POSE

This refers to the two approaches we have in animation. Pose-to-pose is an organized approach, where you start from the most important poses then figure out the transitions between them. Straight, on the other hand, is a more fluid and dynamic way of working, where you start from frame one, and go on animating each transition till the end of a shot.

Each one has its pros and cons. Pose-to-pose can result in great readable poses; however, it can become too stiff. The straight-ahead approach has an organic and natural effect but can also become unpredictable and result in poses that are difficult to read. The principle is that we should try and make the best of each one and use both at their best.

FOLLOW-THROUGH, DRAG AND OVERLAPPING ACTION

These principles rely on physics and the way joints and weighting works. Follow-through basically means inertia: something that is in motion tends to keep its movement. A pendulum, for example, will continue to move in the direction the base was going even after you've stopped the base moving (Fig.05).

Drag is the opposite of follow through. Keeping with the example of a pendulum; as the base begins to accelerate, the pendulum will drag behind. If something is stationary, it will tend to keep stationary, so it resists and delays from the base (Fig.06).

Overlapping action is a concept whereby the parts of our body tend to move at different rates, with varied timing. It really makes sense, since each body part has its own mass.

EASE IN AND EASE OUT

Easing in and out refers to acceleration and deceleration – organic movements tend to ease in and out. This is directly linked with

body mechanics, as the human body always tries to move in efficient ways; starting or stopping a movement very abruptly requires lots of energy. Take a moment and try to move your arm abruptly with no little movements in preparation – it is near impossible and becomes like a robot impression.

ARCS

Everything in nature tends to move in arcs – even inanimate objects. If you observe any human motion you will be able to track arcs at various points of the body. Applying this principle to animation creates a sense of real, organic movement. This probably happens because of how our bodies are built – a series of joints connected to each other – and when you rotate a joint, the movement follows an arc along the extremity of the movement.

If we look at inanimate objects, we can see the laws of physics working on them. A bouncing ball arcs because of gravity, inertia and so on. So we can conclude that the arcs that affect our bodies are a combination of body mechanics and of the laws of physics acting upon them (Fig.07).

SECONDARY ACTION

Secondary actions are something that support the main action. For example, a person talking to another will often touch their own face, pick up an object or scratch their arm, for example. It's yet another way to give life to characters, and highlight their idiosyncrasies.

TIMING

Timing is the amount of time (frames) a movement lasts for. In animation, this can make all the difference, making a character look alert or sleepy, or making a movement feel realistic or floaty.

Timing variation is also very important for the organic feel we want to capture, as the body parts all move at different rates.

EXAGGERATION

Exaggeration is a great tool that we can use to give character to movement. We can add extra exaggeration to create a more cartoon-like feel or hold back for a more realistic approach.

You can often use exaggeration to emphasize specific elements in a shot. Exaggeration can be applied to movement amplitude, timing, or even using a pause to generate comedic effects. Exaggeration is linked to all of the other principles of animation and we always have to keep it in mind.

SOLID DRAWING

In traditional animation, this principle means that an animator must be a good artist and cherish his skills to make the drawing feel alive, because the drawing in itself is the medium. With computer-generated animation, the importance of this principle remains – even if we don't need to draw anything. You still need to ensure that the default rig has a personality and looks alive. When looking at the pose and facial expressions that we've created, we should be given the impression of a solid image, clearly telling the story – the same as a drawing in traditional animation.

APPEAL

This is a very wide concept that we can apply to anything in our world. Appeal relates to our ability to make something relate to the spectator and interest an audience. This principle also relates to the others, and we will need to keep it in mind throughout the animation process.

This is a very hard concept to grasp and it won't come through studying just animation alone. A good understanding of drawing, modeling,

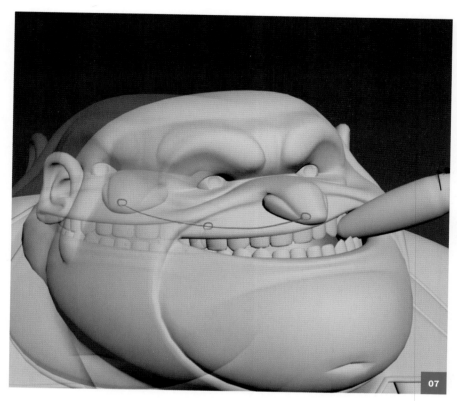

07

anatomy and cinematography will help, but there's certainly not a specific way to learn about appeal – some people have an innate talent for it, while others learn throughout their careers. One thing is for sure, though: experience will always make you better.

FEEDBACK

Animation is a team effort; if you look at the credits of any animated production, you will notice a lot of people are involved. For animators, like all the other creative careers, it is very important to look for feedback from other artists. The animation process is long, so it is very common for you to get tired and miss something. A fresh look from someone you trust is always very valuable when you want to achieve the best quality you can.

Even people outside of the industry may have interesting input to offer, as they will be watching your animation as a spectator and not as a fellow artist. Good feedback can also help you realize if a joke is working or if the idea isn't clear, and so on.

In theory, this all sounds perfect, but you will realize that hearing criticism is also hard; it's like someone telling you that your baby

"The animation process is long, so it is very common for you to get tired and miss something. A fresh look from someone you trust is always very valuable when you want to achieve the best quality you can"

is ugly. You have to learn how to respond well to critics and turn it into something positive. You will also have to filter a lot and find out what makes sense and what doesn't. Find people that you trust and who give you valuable input – don't just look for positive feedback and compliments only. You won't learn anything that way.

INTRODUCTION TO CHARACTER ANIMATION
PLANNING YOUR SCENE

BY FERNANDO HERRERA

Animating a shot is not a sprint; it's a marathon, and as such requires patience. A movement we can easily do with our bodies – like jump or pick up a box from the ground – in a few moments can often take days to animate, as it needs to be understood and planned out first.

Just like a marathon, you should never just power through it – you must give each step the importance it needs. Also, we are not just *copying* what we see from the real world, as discussed in the previous chapter, so we need to develop a concept of caricature.

This stage is often overlooked when we are in a hurry, but the planning process is very important for the end result. A shot with no planning has a very high probability of turning out poor, because you are leaving things to chance.

There are many ways to plan a shot: drawing thumbnails, shooting video references, acting out the scene in front of a mirror, writing notes, finding video references on the internet, and so on. Regardless of the way (or ways) you choose to plan, what's important is that you get a clear idea of how the character is going to move throughout the shot, as well as the acting choices, expressions, poses, rhythm and everything else that will happen. A good way to know if you're ready to go into the software and start posing is trying to imagine the shot in your head. I tend to think that the clearer can you envisage it, the better prepared you are.

Most of our ideas start out quite abstract, so drawings, videos and so on work as a tool

01

02

03

to make these ideas more concrete. What we are also doing when planning is building a path for ourselves. Since the animation process is long, it is easy to get lost in the technicalities and deviate from the important choices you have made, so anything that can help keep us focused on our original goals is helpful – even just a look at some notes or drawings can remind you of the right path.

> " **Most of our ideas start out quite abstract, so drawings, video and so on work as a tool to make the ideas more concrete** "

PLANNING THE SHOT

To plan for our shot here, I started looking at the character and figuring out who he is. I started by listing a few things that you can notice just by looking at the concept art. He looks self-assured, strong, lazy, devious, and maybe even a bit of a bully. These characteristics are going to impact every decision I make for him here on – even posing and timing. It's very important to figure out who your character is, even on a superficial basis, like I have done here.

The idea of the shot I'm going to animate is very simple. He's in a bar, hanging out, but an annoying fly is getting on his nerves. He grabs a knife that was stuck in the counter and throws it, hitting the fly and pinning it to the wall. With the concept in decided, the next step was to draw a few thumbnails to explore the staging and poses. I'm not great at drawing but that's not the point here, as even very simplified drawings will get the idea across (Fig.01–05).

Once I had these sketches down, I started looking for video references of people throwing knives, looking at how the body works when doing it. The hips, torso, head, arms, hands and feet are all important to review in motion.

With this particular shot, it's not too difficult to figure out the ropes, but in some cases it will take a while before you understand the technique. Imagine, for example, we are going to animate him throwing one of those knives – there a lot of intricate, fast movements involved there.

After looking at the references, I stood in front of my mirror and acted out the shot myself. It's a good exercise to pay attention to what your body does when you execute the movements your character is going to make. I also kept in mind his attitude, character, and the types of poses I had developed for him in my thumbnail sketches. It can be helpful to film yourself doing this but I rarely find the time for that, plus I'm used to planning in this much quicker way.

Once I start I can clearly imagine the scene. I try to make notes and describe what I see, so I don't lose focus of it later. For example:

04

05

• The shot starts out with a slower pace, accelerates during the throw, and slows down again as the character recovers from the movement and settles. The beginning must feel slower than the end, so the rhythm of the shot doesn't feel too symmetrical.

• The character doesn't look annoyed – he's almost oblivious to the fly, but then suddenly hits it. The action is almost muscle memory. This shows he's bad news.

• After the hit, he returns to being idle, satisfied, and as relaxed as he was at the beginning.

• He's a heavy guy, not an athlete, so he should stumble a bit, and although the hit is precise his body movement is not very effective.

Alongside this type of written record, any kind of scribbles, arrows, graphics or notes that can help are a valid exercise, too. Remember the planning is for you – it doesn't have to look pretty, it just has to be useful. Don't plan it just for the sake of it; do things that you think will help you get the ideas out of your head. If you don't know which ways are most helpful for you, try all of them at least once.

INTRODUCTION TO CHARACTER ANIMATION
BLOCKING THE SHOT

BY FERNANDO HERRERA

Blocking is the process in which we build our animation. As the name suggests, we start from a very rough form and go on to refine it.

A lot of people that try their hand at animation find the task of transitioning from blocking to spline very daunting. The reason for this is probably because the blocking wasn't ready for spline, and the software was given too much to handle. The blocking stage is my favorite, though, as it's right here that I build the majority of my animation. I find that from the finished blocking, you should already be able to see everything that's going to happen in the animation.

The way I approach blocking comes from traditional animation, where you had an animator who worked on the shot and an inbetweener (an animator's assistant) that filled the frames, according to what was created by the animator. In our case, *we* are the animator and the inbetweener becomes 3ds Max. The downside of this structure is that the software is not a human being; it will only do the calculations it was programmed to do. On the other hand, we can control the software and direct it to do what we want, which gives us total control and ownership of our animation.

At this stage, I usually work with stepped keys, as this kind of key doesn't allow any software automatic transition, meaning I know that everything I see was created by me. This helps me keep focus on what I'm working on rather than worrying about weird transitions that the software may be doing (Fig.01-02).

In my workflow, I like to end up with a very detailed blocking, leaving very little for the software to do. Every pose, acceleration and timing will be thought of and built by hand. But I want to be clear that this is not the only way you can work; some animators like to work with a less detailed blocking and find more of the movements and nuances later on – it's a matter of preference, but I think the traditional way is easier to teach and tends to be more organized.

At the end of the day, what's best is what works for you, so I encourage everyone to try each approach and see what you are most comfortable with. You will benefit a lot from knowing different workflows. Sometimes, even if you prefer the traditional approach, you will find yourself solving some things in other methods. But for the purpose of our exercise here, let's think traditional.

For a successful shot, we have to create the illusion of weight, so we must stop and think a little about what makes something look heavy or light, and then use that to our advantage, exaggerating and bending the rules. Let's make a little list here of what characteristics are perceived as heavy or light:

Heavy:
• Slow
• Consumes more energy
• Requires more strength
• Greater delay on joints
• Hard to stop
• Hard to change direction

Light:
• Fast
• Effortless
• Requires less strength
• Less delay on joints
• Easy to stop
• Easy to change direction

With this information, we can come to a few important conclusions that are going to help you a lot when blocking a character's movement.

In the examples shown in Fig.03-04, it's clear that when we apply these concepts

we can create the impression of weight. So these are the kinds of things we are looking for in our character.

Since we are animating a human, we have to remember that what makes a human move is its muscles. Once we realize this, we can look at our video references frame by frame and break down the reasons for every part of the body in movement. This is when you observational skills really need to kick in.

You'll probably notice that our body is in constant movement – even when we're in a

stationary position, there's a lot going on. Just breathing, you'll see your arms move a little.

Another thing you'll notice is that our body parts move in arcs and ease in and out of movements. Everything has acceleration and deceleration, so capturing that in our animation will make it feel organic and grounded in reality.

We also need to pay attention to the body's balance and center of gravity. An off-balance pose can easily suck a lot of the believability from your animation (Fig.05).

BLOCKING THE SHOT

To start blocking out our knife-throwing loan shark shot, I'm going to start with a very rough pass. The first poses I build are what we call 'golden poses'; these are the poses that tell the story. A good way to work them out is to think of the shot as if it's a comic strip – what poses would it contain if we were to see it in comic-book form? It usually comes down to just a few.

In our shot there will be four main poses we can use, so that it's easy to understand what is happening: hanging out at the counter, picking up a knife, throwing the knife, and then back at the counter. It's no coincidence that these are the same poses I already explored when I was planning the thumbnail sketches. So I start from those and re-create 3D versions of the poses using the character in 3ds Max (Fig.06-10).

At this point I don't worry too much about the timing. Instead, I spend my time on the poses, as these are going to be the most important ones in the shot. The poses must prioritize the view of the camera, so every silhouette and positioning decision will need to take the camera into account.

We also can't forget about the 3D space that our character is moving in; if we only think about the camera, there's a risk we'll end up with no depth perception, as well as some strange balance issues.

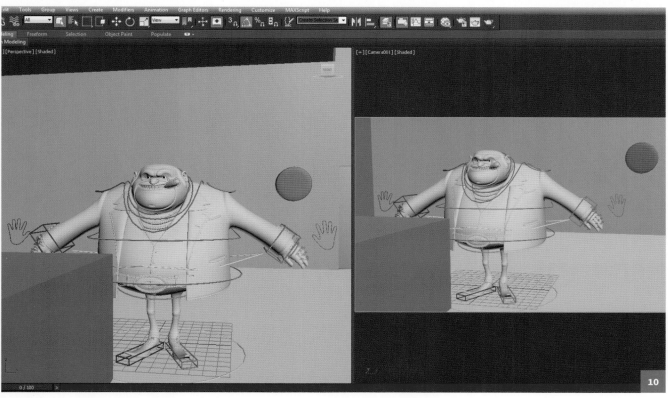

Once I'm happy with the poses I set a rough timing, trying to figure out when each action corresponding to that pose is going to take place. To set timing in 3ds Max, you just select every controller and move each keyframe left or right. After that, I get back to my planning and develop other important poses building on the ones I already have (Fig.11-16).

Up to now, this process is commonly known as pose-to-pose. From now on I'll work in straight-ahead, which is basically building one little adjustment after another – rather than creating two extremes and filling the gap with a pose – and continuing to do that until it's a unified movement (Fig.17-18).

One way to easily understand the nature of straight-ahead animation is to refer to another medium, stop-motion, in which you make a tiny adjustment and then take a picture; this process is then repeated until the full movement has been captured. In our case, we are enjoying the better of the two worlds; we get the organized workflow from pose-to-pose and the organic feel and intuitiveness from the straight-ahead method.

Watching what we have so far, we can see that our movements are starting to make sense, with no particular physics and weight driving them. The way to introduce this is through further detailing, adding transitional poses and ease-in and ease-out poses.

The new transition poses are going to allow us to arc our movements and also create the illusion of acceleration, deceleration and weight. When building these transitions, we are describing how the character does each movement. I don't leave anything till the end, so now is the time to try and make the weight look right.

Since the character is a heavy guy, I know I need to make his limbs look heavy, dragging more than usual and taking longer to settle (Fig.19). You can follow along using the 'LoanShark_ANIM_Blocking. max' file, which can be downloaded from **www.3dtotalpublishing.com/resources.html**.

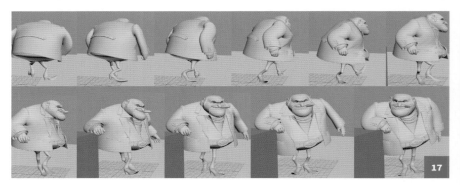
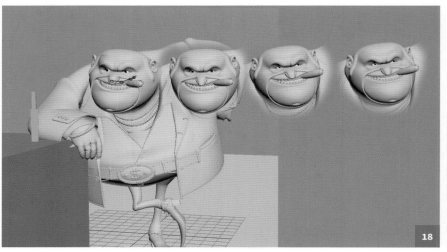

The character design also plays a big role in this process; just by looking at him we can see that his upper body carries a lot more weight than his chicken legs. We can't deviate much from this because our brain kind of has an expectation of how something should move based on the visual masses. What we should also keep in mind is that we need the spectator to relate to our character; they need to feel that the movement matches the personality. So if we are creating a loan shark, we have to connect with the general idea that's playing on the audience's subconscious about how this type of person moves.

With everything in place I make sure the timing and spacing of each part of the body makes sense and is as efficient as it can be at this stage. Another good idea is to make sure there's a degree of timing variation to create contrast and an interesting rhythm throughout the shot.

When I'm done, I usually get keys for every two or three frames. Sometimes I'll get more if it's a long hold and even one frame on fast movements. I try not to think too much about the number of frames, though. It's more important that the movements are nice and detailed, and that I can see the 12 principles in action (Fig.20).

" Make sure there's a degree of timing variation to create contrast and an interesting rhythm "

19

20

119

INTRODUCTION TO CHARACTER ANIMATION
UNDERSTANDING SPLINE ANIMATION

BY FERNANDO HERRERA

To work with 3ds Max Interpolation we must first understand a little about how it works, so that we can make the very best use of it.

To begin, let's take a look at the Curve Editor in 3ds Max and try to understand what it's doing. The Curve Editor is a line graph that shows time on the horizontal axis and movement values on the vertical axis. Interpolation in any software is to create automatic transitions between two points. There are several types of interpolation, but we just need to understand how the three basic ones work.

Stepped is the type of interpolation we were using during the blocking stage. As you can see in the Curve Editor in Fig.01, we see the steps between each keyframe. This means that each keyframe holds its value till the next one comes – or in other words, there is no interpolation between the keyframes.

Linear interpolation traces a continuous straight line between two keyframes (Fig.02). This means that over time (the horizontal axis) an object will move in constant velocity till the next keyframe.

Spline traces a curved line between two keyframes. This means that there can be velocity variation between keyframes. In this mode it's possible to edit the handles to change the curves. This is how we will control our inbetweener, as we discussed in the previous chapter (Fig.03).

01

02

INTERPOLATING THE SHOT

Once we've finalized a nice, detailed blocking we can transition to Spline without much concern. We're going to use the Auto mode in 3ds Max. This mode is basically a Spline interpolation, but with smarter solutions that won't cause weird curves and overshoots (Fig.05-06) .

COMPARISON SPLINE AND AUTO

To transform everything to Spline, we have to make sure that we have keys in every body controller in the same frame, otherwise the software has no way of knowing that there was a key for that controller there and might subsequently interpolate from previous frames. So select the body controllers and mark the keyframes with K on top of each. After that, simply select every body controller, open the Curve Editor, select everything there and click on the Auto button on the top Curve Editor toolbar.

The first thing I do after turning to Spline is to fix any curves problems that may have come up. The objective here is not to make the curves pretty, but to correct unintentional mistakes. In Fig.06 you can see a few examples.

It's important to separate what is a little spacing mistake from what is intentional, or you'll lose details you added in the blocking stage. One good way to do this is to test moving a keyframe on the Curve Editor watching the viewport at the same time and seeing what happens (Fig.07).

" It's important to separate what is a little spacing mistake from what is intentional, or you'll lose details you added in the blocking stage "

03

04

Interpolation on 3ds max auto mode. Notice how the transitions are much more org

05

06

I always start fixing from the main controls – in our case, cog_CTRL. This is important because of the hierarchy: if I change something in the base of the hierarchy, it will probably also change how everything affected by it will look. So the order I will follow is: hips, torso, head, arms and legs.

I then watch the animation a few times, trying to look for every mistake I can find. At this point you can usually spot a number of things, because seeing the animation when blocking has a very different feel than when you watch it in more detail. It's like looking at a photo in low- and high-resolution; when you look at it in low-res, you already see the image and everything it is, but when you look at it in high-res, you perceive much more detail and nuances.

One of the things I found was that I could tweak the timing of some segments. Very often you will notice even one or two frames make a lot of difference. It's not really polishing we're doing right now; it's getting back to the feeling we were aiming for while blocking.

121

I fix the major things and make sure my shot is solid before I add any secondary movements, like the jacket animation.

For secondary animation, like the fabric, hair, ears and so on, I like to work in straight-ahead mode and already on Spline. Since I'm simply reacting to what the body is doing, it's much easier to work this way. I usually mark a keyframe every two or three frames and tweak the reaction.

Once I've finished this pass, I watch it a few times to make sure everything looks nice and realistic (Fig.08-09).

> **" I usually mark a keyframe every two or three frames and tweak the reaction "**

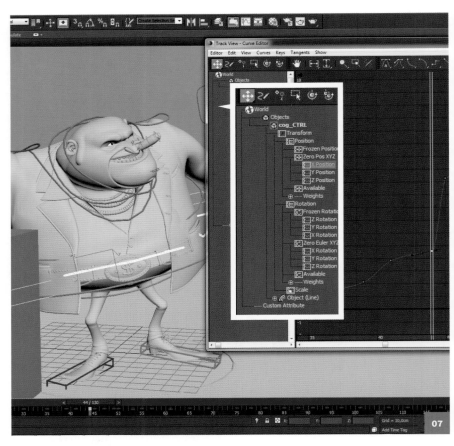

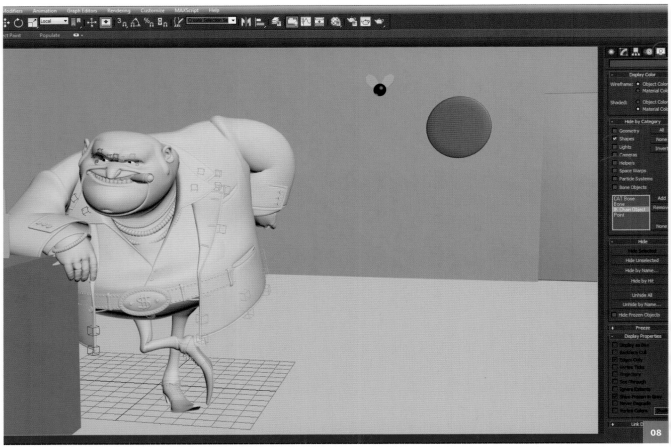

" Figure out where the fly should be in each of the important frames "

After finishing the Spline stage, I go on to animate the fly according to our character's movement. The approach I'm taking is to figure out where the fly should be in each of the important frames, like when the character looks at it in the beginning, then right before the knife is thrown, and then finally it's squashed against the wall.

Once I figured all this out, the fly animation itself was actually very simple. I just loop the wings flapping throughout the whole shot and then animate an erratic movement in the body, making sure it's moving in nice arcs.

In the next chapter we'll go on to our final stage and polish the shot.

INTRODUCTION TO CHARACTER ANIMATION
FINISHING TOUCHES

BY FERNANDO HERRERA

When polishing a shot my main concern is finding every little thing that catches the eye, so it's essential to watch it several times. Sometimes it's also good to give yourself a break so you can return to the shot with fresh eyes and be able to spot more necessary tweaks.

One thing that I always do, regardless of any little mistakes that I see, is to track the arcs and spacing, making sure everything is smooth. 3ds Max has a nice tool for this, called 'Trajectories'; you can find this in the Motion tab. Just select an object, click on Trajectories, and you should be able to see a red line with dots in it. The little squares represent your keyframes, and the small dots the Interpolation. Same as during the Spline stage, we start with the hip control (cog_CTRL) and go on to the other main controls. We then repeat the process of cleaning the arcs and spacing on every control until we are done (Fig.01).

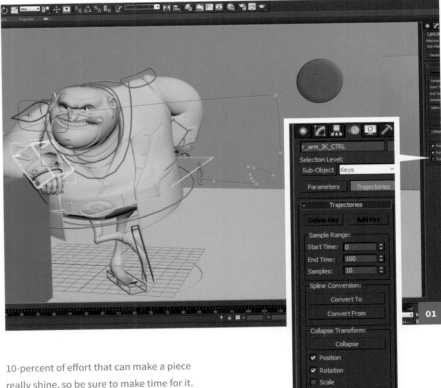

01

> ## " After cleaning the arcs, it's good to watch it through several times again and try to catch more mistakes "

After cleaning the arcs, it is good to watch it through several times again and try to catch more mistakes. It can be a bit tedious, but you'll notice that when you sum up all the little tweaks you've made, the overall look of your shot will improve a lot. It's this extra 10-percent of effort that can make a piece really shine, so be sure to make time for it.

We can also take a look at the contacts. Contacts in 3D are very tricky, and can easily throw off the believability. While on the other hand, having realistic contacts can really sell the realism of a shot (Fig.02).

The face is also extremely important to look at during the polishing stage. Everything we can do to make it more fleshy and flexible can help a lot with the overall look. A good trick is to look at your own face moving in the mirror. Notice which parts move together and affect each other, so you can then simulate these movements on your character's face.

It's also important to take an even closer look at the eyes. Check to see if the shape is good and whether it reacts nicely with the eyelid. The shapes that the mouth makes are also worth paying great attention to. Try to disrupt any symmetry and stiffness as lips are an extremely flexible asset. Finally, be sure to pay attention to the eye direction; don't rely only on the Look At controller you find in most rigs – make sure the character is looking at the direction that it *should* be.

POLISHING THE SHOT

Track the arcs of every limb and the knife to find any places where we can improve, also going back to smooth the movement accordingly. To fix spacing issues you will often find yourself going frame by frame,

which is perfectly normal. Just try to make sure you are indeed at the end of your work on the shot, otherwise it can become a real pain to edit timing and arcs once you've done a frame-by-frame section.

Sometimes we can't avoid this happening, though, because of a client or director. When this happens, I usually delete the tweaks and go back to the original keyframes, change what I need, and then re-check all the spacing.

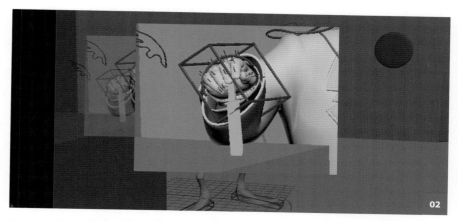

The fly is very important to help the clarity of the story, so I make sure I track its arcs and spacing too, fixing a few points that I felt weren't very smooth (Fig.03).

For the loan shark character, polishing the contacts of hands and fingers is extremely important when interacting with the knife, run a polishing pass on the fingers to make them look more natural.

Finally, do a polishing pass on the face. It's not really our goal here to focus on acting and facial performance, but even a little life added the face can significantly improve the look overall (Fig.04) You can download from LoanShark_ANIM_Spline.max from **www.3dtotalpublishing.com/resources.html**.

THAT'S A WRAP!

Animation is all about observation and decision making. Learning these skills is not an easy path, though; you will realize that a lot of what you have to learn is not exactly concrete. Knowing when timing is wrong or whether something has appeal can be hard to understand at first. What you need to always remember is that in every shot you animate, you will learn something new and your eye will become more and more trained to spot any mistakes.

Your animator's eye is something you should really focus on developing more and more at these early stages. Being able to spot your own mistakes and make good decisions is the most valuable skill you can have, and it's what will make you stand out from the crowd.

My biggest piece of advice for those beginning animation studies is to work hard on doing

exercises. If you don't animate, you won't even know what you have to improve or what doubts you have, and you certainly won't develop your animator's eye without practise. Put yourself in situations outside of your comfort zone as these are where you'll encounter the most difficulties, but also where you'll learn the most. When I'm having a hard time, I always remember that it's a good thing, because I know the experience is going to make me a better animator in the end.

Most artists in this industry love what they do, so studying very often also becomes a hobby. Before deciding to go down this

path, though, make sure that you are dedicated. It's going to be a hard business to succeed in if you are having doubts.

Become a sponge and gather as much knowledge you can from lectures, books, the internet, and from watching animated movies. Animators are often very nice and willing to help one another succeed. And remember: every industry pro was in your shoes once. So don't think of other animators as your competitors; you'll see the community is very open and easy-going. Animation is a team effort: one animator alone can only do so much; a great group of them will make magic.

CLEAN AND EVENLY DISTRIBUTED TOPOLOGY

By Diego Maia

MASTER CLEAN TOPOLOGY TO MINIMIZE DISTORTION AND PREPARE YOUR CHARACTERS FOR ANIMATION

As with all topics and skills there are core subjects that must be considered and understood in order to get the best results. When working in 3D, one of those is topology.

Diego Maia explains some essential retopologizing techniques as he takes you through a detailed account of how he creates good topology for organic characters and hard-surface objects.

CLEAN AND EVENLY DISTRIBUTED TOPOLOGY
AN INTRODUCTION TO TOPOLOGY

BY DIEGO MAIA

In this project, we'll be talking about topology. This is a subject that causes problems for many people and, in most cases, the problem is purely in simple details that can be easily avoided if we plan our modeling and try to achieve clean topology.

There are a large number of issues that are recurrent concerning topology, especially when the models are made for animation. This will be our focus: making good topology for animation. Once you can do this you should be able to cope with anything – even high-poly models for illustrations.

We will also look at how to achieve functional topology, and we'll talk about the theory of edge loops. The tools we'll use to tackle this will not be focused on, though, as it's the principles that are most important. Once you understand these they can be applied to any 3D software.

To begin, it's important to say that when it comes to modeling, there is no single correct way to work. Every modeler should understand the way that works best for him or her, and choose their own pipeline and method. In this project I'll be working with a pipeline that works for me, in most cases, especially for characters. Nevertheless, there is a short list of things that are important to keep in mind.

I'll be demonstrating these points using a character from a personal project (Fig.01). His name is Miranda. We won't focus on the modeling process so we will move straight onto topology. Most tutorials start by teaching the box-modeling technique – it's important

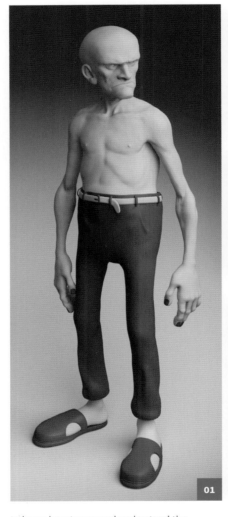

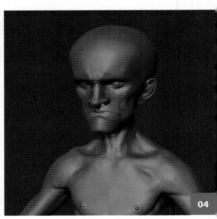

to know how to use and understand the tools involved in box-modeling for the purpose of the retopology process, too.

Retopologizing models allows us to separate the art/sculpture process from the technical one. We can focus on the shapes, gesture and design without coming across technical issues while modeling (a spiral loop or triangles, for example), and then clean we can clean the

topology afterwards. This means that you can create the model in an artistic way first, and then handle the technical part later.

To tackle retopology, you will use tools like the Snap tool in Silo, which allows us to work freely by changing the direction of loops, and delete and create polygons with ease. It's faster to do things this way and means that the result is 100-percent clean

and functional topology. However, this does highlight one of the problems with box-modeling; it means there are many loops and polygons that will appear useless.

These days, the process no longer needs to be linear. We can come and go easily from one program to another to make adjustments using the Projection tool or the GoZ ZBrush plug-in (**http://pixologic.com/zbrush/features/GoZBrush**), for example. In addition, all major 3D programs import OBJ extensions. For this project I will use Softimage for polygonal modeling, ZBrush for sculpting and Silo for retopologizing.

I will be looking at a character that has organic and inorganic forms. We will start the tutorial with a rough base without worrying about the loops, as we just need something to work with in ZBrush to tackle the retopology. Fortunately for us, artists' new tools are appearing all the time that help us avoid the base mesh process, such as using ZSpheres.

So to start with you'll need a rough base mesh to work with – I make my own in Softimage. Note that I don't even have loops for the eyes and mouth (Fig.02).

Once you've created the base mesh, export the OBJ file into ZBrush (Fig.03). The next step is to start the blocking process, which in my opinion is the fun part. As it's not the point of this project, although I won't talk about the sculpting of my image; you can create your own character and then we'll look at the topology of it. To perfect my model, I primarily use three tools in ZBrush: the Standard, Clay and Move brushes.

Fig.04-05 show a few of the stages of my modeling process. Work with your character until you have the shape and proportions you are happy with. Don't forget that things can still be adjusted after you have handled the topology, but we will come back to this later. I work with stylized character proportions: a big head, heavy hands and thin arms (Fig.06-07).

You can see the legs before and after the sculpting process in Fig.08-10. As I already mentioned, the point of this process is

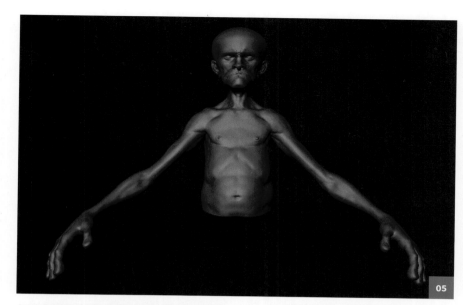
05

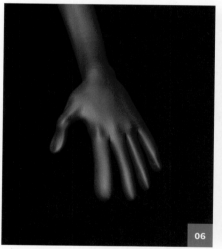
06

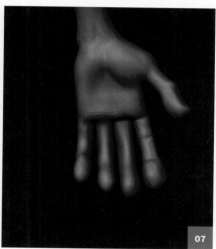
07

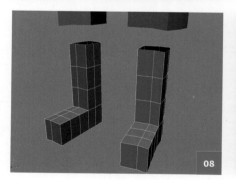
08

09

not to talk about the sculpting process, so let's start working on our topology. I prefer to use Silo (**www.nevercenter.com/silo**) because I really like the way the Snap tool works, but the principles can be followed in other software packages as well.

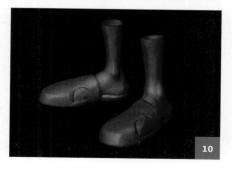
10

I usually start the process by making the high-poly model slightly transparent, as I think it helps with viewing the topology. If you are using Silo you can turn on Ghost Shaded mode and hide the wireframes (Fig.11-12).

Be sure to turn on the Snap tool before starting to retopologize. You can find this tool in all the major software, such as 3ds Max, Maya, Softimage, MODO and so on. Even ZBrush has great tools to do this (Fig.13).

It's very important to make the loops follow the flow of the volumes/shapes and avoid triangles and NGons (polygons with more than four sides). You will come across problems if you use shapes with more sides than four when using Blend Shapes, rigging or even when rendering. Some software doesn't work correctly when rendering displacement maps when using geometry with triangles or NGons.

Start by creating a single polygon and extruding the edges from it. In the beginning the most important thing is to set the direction of the loops (Fig.14-15). I usually work in separate areas and then try to connect them. You can see this at work in Fig.16-19.

Make the loops follow the general flow of the muscle. Knowledge of anatomy helps at this stage. If you don't feel confident doing this, find a reference that will help you to make sure it flows correctly. You will also find that the pieces join together better if you follow this rule.

In Fig.20 you will see a higher density of edge loops at the corner of the mouth. This is quite important because if you were making it for an animation you would need these to make the face smile, speak or even kiss. You can see how the polygons flow around the face and around the neck (Fig.21-23).

In Fig.24 you can see how the direction of the loop follows the collarbone. At the tip of the collarbone we will need to create a circular shape that allows for the rise in the shape of the shoulder.

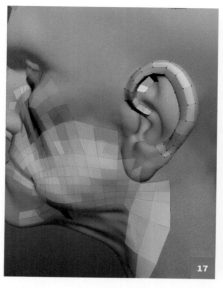

17

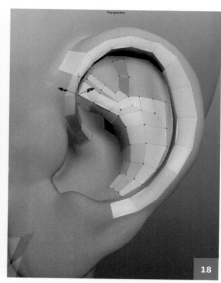

18

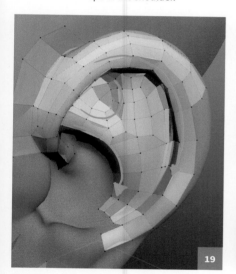

19

20

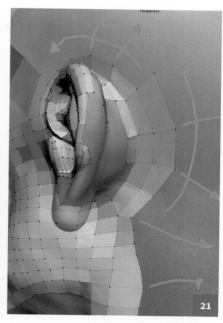

21

22

23

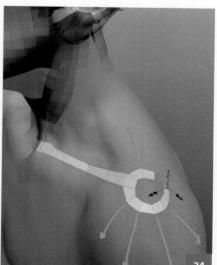

24

" Make the loops follow the general flow of the muscle "

Make the shoulder loop flow down the chest. This will allow the geometry to behave in a similar way to muscles after rigging (Fig.25-26). If you do this correctly you can get good results using simple blend shapes matching the bone's rotation.

Continue to follow the flow of the muscles and forms for the nose and eyebrows, as I do in Fig.27-28. You will be doing this all over your model, matching the flow in the separate areas and then joining them together when the different areas meet (Fig.29-32).

In Fig.33-34 you can see how to fix problem areas in the topology. In **Fig.33** you can see the unwanted triangle and the adjustments made. Each problem area you come across will require a tailored solution. When you browse for shapes that haven't got four sides in the geometry you will come across a few areas where there are problems. Usually this can be solved quite simply by connecting the problem shape with the polygon next to it. This would usually create a square. Another trick is to cut the geometry and make it a quad.

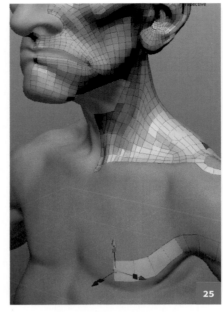
25

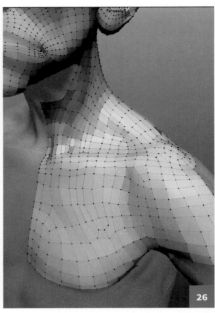
26

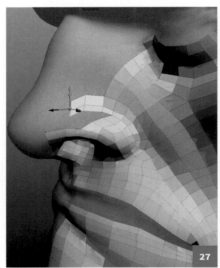
27

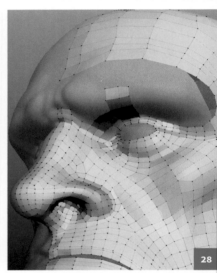
28

29

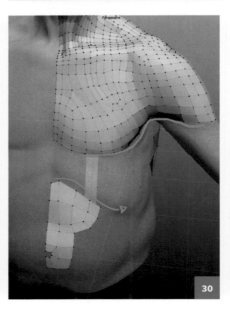
30

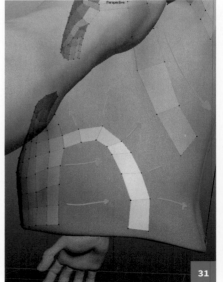
31

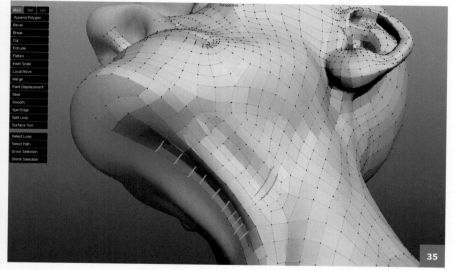

Try to keep the same distance between the loops as much as possible. This will prevent many problems when creating the UVs and textures, and will avoid division problems when rigging and animating Fig.35-36.

Fig.37 is a snapshot of the final head topology. This topology provides enough loops to help the animator to achieve the creases that would be made by facial expressions. In a professional environment, it would be necessary to speak to the rigging and animation team to make sure that you cater for every sort of animation that they would like to do.

When you have done this, you can delete the high-poly base and finalize any of the remaining details, like the inside of the mouth and around the eyes.

CLEAN AND EVENLY DISTRIBUTED TOPOLOGY
LIMBS AND ACCESSORIES

BY DIEGO MAIA

As we have already done the retopology for the head and the torso, now we are going to talk about the arms, hands, feet, pants and shoes (Fig.01-02).

" It's important to control the direction the loops follow "

As I already mentioned, it's important to control the direction the loops follow. Now we will start working on the forearm and linking it to the shoulder.

At this point you can work with larger polygons and add a subdivision later if you want, as this is a bit faster. Just be careful because it can generate loops and polygons that aren't necessary (Fig.03).

You can see in (Fig.04-05) how this way of creating the topology allows you to create loops that follow the contours of the anatomy.

We now have enough loops to create Blend Shapes to inflate or reduce any muscle/volume on our geometry. It is worth pointing out that you need to try to make sure the polygons have an average size and distance. Avoid having tremendous differences between polygon sizes.

The next step is to define the direction of the loops on the hand and fingers. Note that I didn't start from the edges that come from the wrist (Fig.06-08).

01

03

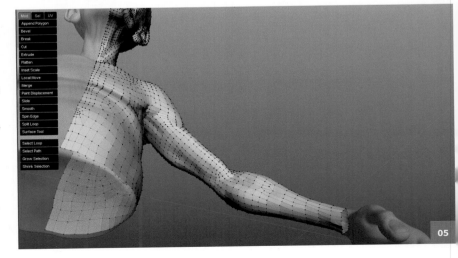
02

04

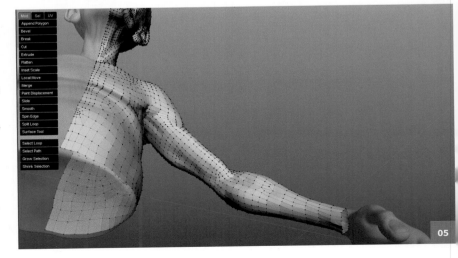
05

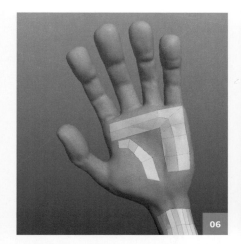

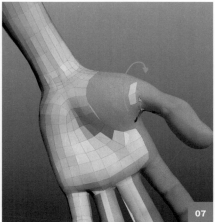

Next we will move onto the pants. You need to follow the same procedure, as stated before. Even though this is simulated cloth, it is worth creating topology that fits the cloth's folds. This is so that these folds can be exaggerated if the character is to be animated. If you are modeling a character that has very detailed topology it is probably not necessary to create these folds in the cloth (Fig.09-10).

In Fig.11 you can see how you should detail the pocket area by following the direction that the pockets would flow in.

When you move on to create the thigh area, extrude a large polygon, then subdivide the points and position them using the Snap tool (Fig.12).

The loop then goes below the knee, which means that we will have the shape of the knee when the leg bends. This means we will avoid the appearance of a bent cylinder. This can be further improved with the use of a Blend Shape to pull the knee out, or even in the folds from the back of the leg.

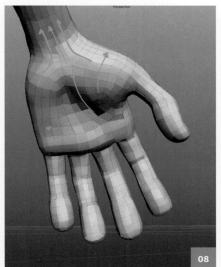

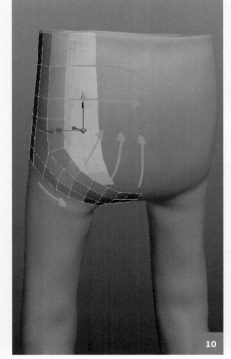

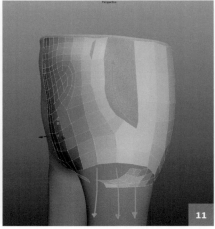

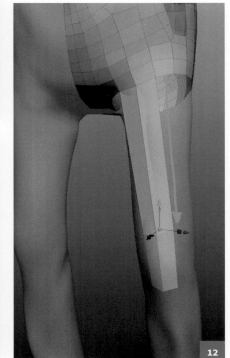

" It's very important to talk to the rigger or director about these technical details before you start "

It's very important to talk to the rigger or director about these technical details before you start, because sometimes it can be done in other ways (such as an animated Displacement or a Normal map) – or could even be unnecessary (Fig.13-14).

For the feet we will do things in the same way as we did the head: create a polygon and extrude its edges to cover the model to create the topology (Fig.15-16).

Although we have two objects here (foot and shoe), the blocking should be done as one SubTool. This kind of choice can speed up the process as we can easily separate the objects later (Fig.17-18).

A common mistake is to keep the amount of polygons in the mesh quite low. This economy of polygons, in most cases, is irrelevant. The idea is to have geometry with sufficient polygons to maintain the overall shape of the character without subdivision, and to not have a big difference between the polygon sizes. Keep the polygons as close as possible to a square shape as well. It's exactly what we did for the head (Fig.19-20).

In Fig.21 we can see the details from the bottom of the pants. It's also nice to give thickness to our geometries. The amount of detail we show here will depend on the purpose of the model. If it's for a production that requires no detail on the mesh they will probably prefer Displacement or Normal maps, or neither. However some objects (especially for close-ups) need extreme detailing. This kind of work without retopology can become a nightmare and last for days, weeks or even months.

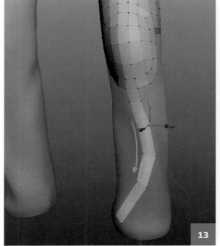

20

21

In Fig.22 you can see how I created the pocket. Create an opening for the pocket as a Blend Shape so the character's hand or anything else can be put into it.

Extract a loop of polygons from the pants to create the belt. This is strongly recommended when overlapping geometry because it allows the upper model to follow the surface of the one below. When box-modeling, it's best to start with a cube and the new parts should be extracted from this topology (Fig.23).

Create the belt fasteners as separate geometry. In most cases this is not a problem, but if you are doing this to be animated and you are unsure, ask the rigger first (Fig.24).

That's our retopology complete now (Fig.25). See how the geometry keeps the shape and design even with no subdivisions?

22

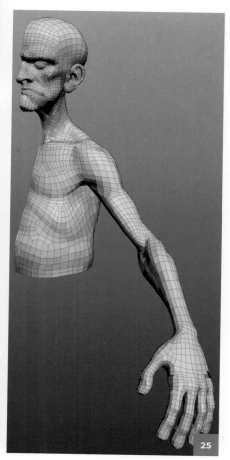

23

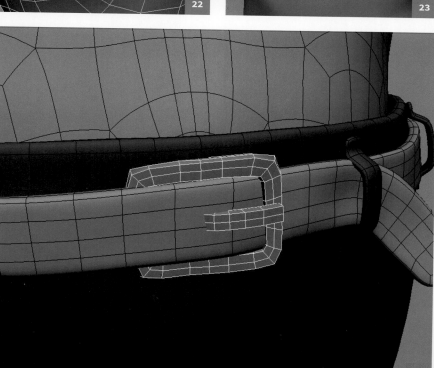

24

25

CLEAN AND EVENLY DISTRIBUTED TOPOLOGY
CLEANING AND ADJUSTMENTS

BY DIEGO MAIA

Now it's time to make some final adjustments to make it perfect for the rigging process. Let's start by making the final adjustments on the head (Fig.01).

We need to build some geometry to create the mouth cavity. I usually pull the inside edges of the lips and form a channel that goes down the neck, but this can be done in a number of different ways. Sometimes I like to make it rounded and close off the mesh inside the mouth. It's up to you, the rigger or director. I'm also used to extruding the inner edges to the inside of the eyes. In some cases we need the model without holes, so it pays to close the back of the eyes, just like the mouth.

Whenever possible, I like making nails separate objects to make the shading easier. This can be done easily if we draw appropriate topology in the retopology process (Fig.02).

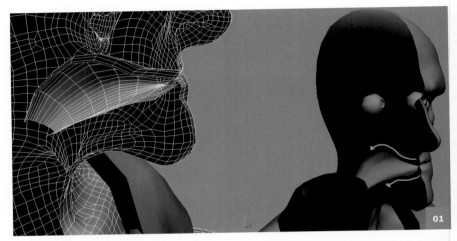

01

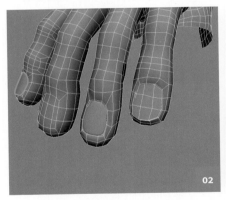

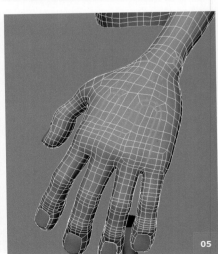

02

03

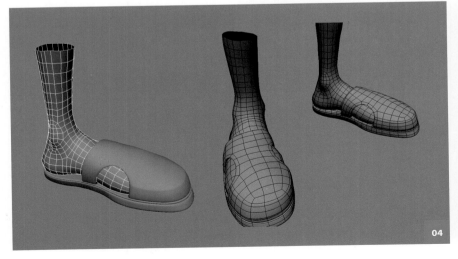

04

05

" Note that some loops make a curve and meet others "

Now it's time to remove all the triangles and NGons from our model. I like to use Softimage for this, because it points out where these are (Fig.03).

The same goes for the shoes and feet (Fig.04).

Note that some loops make a curve and meet others. This is a great solution; otherwise you would have a very large number of edges going up the arm (Fig.05).

Now it's time to re-project the ZBrush details onto your new mesh. This is very easy and fast. Just import the new geometry in exactly the same position as the old geometry, split it with the same number of subdivisions and click ProjectAll in the SubTool palette (Fig.06).

Sometimes this causes some problems at small points, so I usually mask the edges and regions too close to others, such as the corner of your mouth, between fingers and other extremities. This will help us to avoid problems when we're re-projecting (Fig.07-10).

If you still have problems with this you can also make the projection several times, starting in the lower divisions and so on. When ready, you can export your geometry in order to make the final adjustments.

For the geometry of the eyes, it is very common to see a model with one single object for the eye ball, but it is also common to use two models to get a more realistic result: one for the iris and another for the pupil.

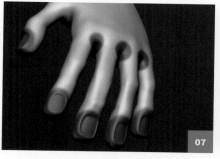

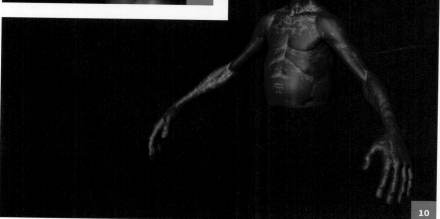

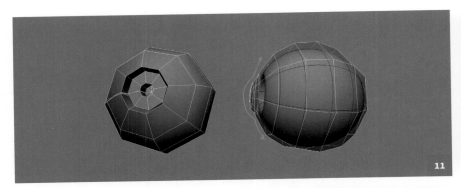

For the inner sphere geometry make two extrusions going inside. Use the second sphere to break up the silhouette by adding the iris bulge. Also give it a very low transparency. The reflections and shading look much more realistic this way (Fig.11). After all the details are set I recommend deleting one side of the model and applying Symmetry, just to make sure that the vertexes haven't lost their positions.

Now let's take a look at the final model (Fig.12-13). On the face we have loops around the eyes/mouth and enough at the folds and places that demonstrate expression, like the forehead, nose and corners of his eyes.

Behind the head we have enough topology to get skin folds when the character lifts his head up. This can be done with Blend Shapes. Such detail can also be worked in several different ways; this will depend on the needs of the model (Fig.14).

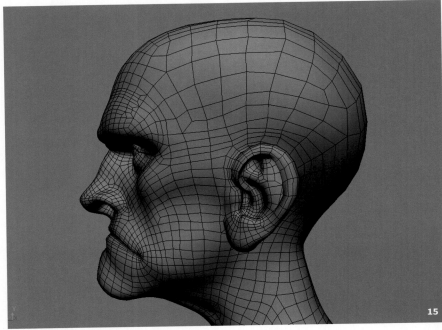

When you have a character that needs to have its head separated from its body (which usually occurs on the collar of a shirt or under some other accessory) the loop should follow right under the item (Fig.15-18).

" It's extremely important to keep in mind where the UV seams will go "

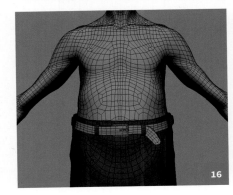

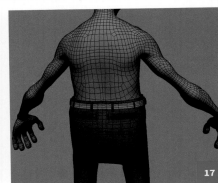

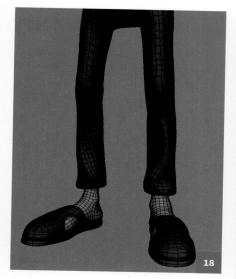

It's extremely important to keep in mind where the UV seams will go. Sometimes as you open the UVs you will realize that you would like to cut the diagonal out of a polygon, but you don't have edge loops for this. It's important that no hole in the mesh is visible from any view.

If you have an overall look at your model you should see regular distribution of the polygons. You should also see that the polygons are a similar size.

" The best way to perfect this is to understand the theory, and practise "

Fig.19 shows the final render of Miranda. And here this chapter ends, but there is a point I would like to make before I finish: Try not to use this guide as a reference to create replicable loops; this can make the process much harder. The best way to perfect this is to understand the theory, and practise.

You will see that after a few hours the process will become faster and faster. The important thing is to work the topology as a non-linear process. You can delete and change the direction of the loops at any time. With practise you can begin to solve these problems faster and figure out new ways of doing it.

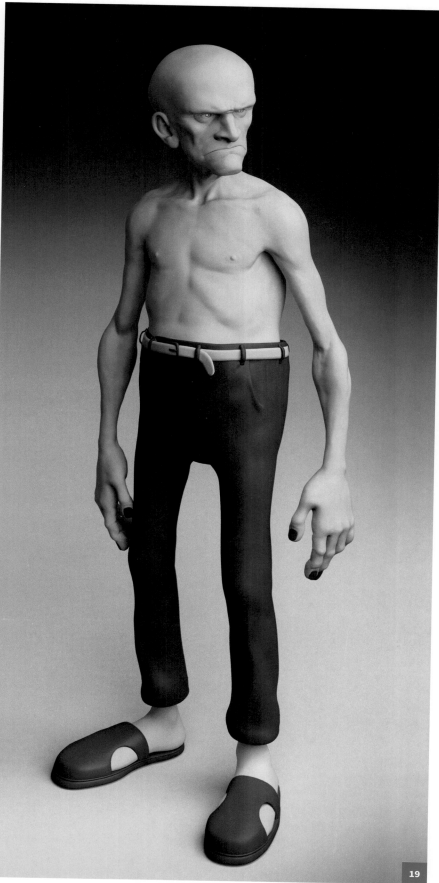

CLEAN AND EVENLY DISTRIBUTED TOPOLOGY
HARD SURFACES

BY DIEGO MAIA

Finally, we're going to be talking about hard surfaces. As I explain the process, I'm going to model a high-tech rifle based on a personal design (Fig.01).

In Fig.02-03 you can see a sketch and a 3D render of the rifle I designed.

For simple forms and objects such as this, box-modeling is very effective in most cases. Usually it is not necessary to use ZBrush, but if the model has an organic design with detailed lines or flat shapes, ZBrush can be very helpful. In this case I will work with box-modeling, but will describe the retopology process.

The strategy here is to draw the topology on a flat model, and when you have done this, correct the loops so we can we extrude the volumes and detail, this will allow us to keep the shape even with no subdivisions.

In order to avoid wrinkles, try to keep the vertices along one axis. Make sure to assess the model from all angles. We're also using Symmetry, since the weapon has symmetrical sides (Fig.04-05).

In Fig.06-07 we can see that the shape of the weapon has begun to appear already, but without any extrusion. I have simply just drawn the outline of the general form and organized my topology on the inner part. Now we have everything in place we can extrude the volumes of the different pieces and start adding cuts to sustain the hard edges (Fig.08-10).

Avoid using the Chamfer tool too much (or the Bevel tool for Softimage

01

02

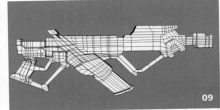

03

04

05

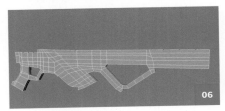

06

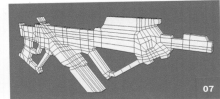

07

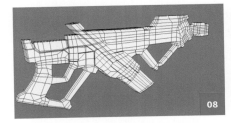

08

09

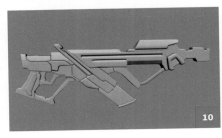

10

11

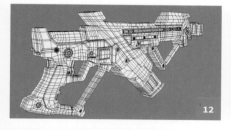

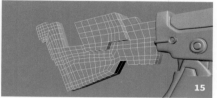

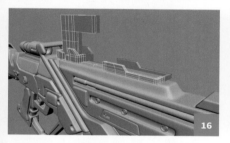

users). Instead, try adding edges, as it allows you to fix details easily.

In Fig.11-12 we can see various screws and small details on the weapon. Try to always make the round forms with six or more sides. Avoid circles with four sides, too, as this is too low when the model's not subdivided.

" Use cylinders to get the geometry for the barrel of the gun and tip "

I use cylinders to get the geometry for the barrel of the gun and tip (Fig.13). This method is much more convenient than using retopology.

Note that even when doing inorganic modeling, I try to keep an average size and distance between the loops (Fig.13). Even if we don't have Blend Shapes we must have the topology well-distributed in order to not have problems with textures and UVs slipping. So, as in previous chapters, let's try to keep an average size and distance between polygons.

Use the same process for the weapon's support (Fig.14-15). Begin by drawing the topology on the flat piece. Then extrude volumes after all the topology is in place. After you have done this you can add even more details, if you want to.

I create the rifle's sight from separate geometry. In this case, we don't need all the pieces in the same mesh. It's important to not be able to see where one set of geometry joins another.

Note that you can use several divisions to keep the round shape, even without subdivisions. In this case our circle would be very low-poly, even with six sides (Fig.16-17).

Here are some close-ups of our final topology (Fig.18-19). You can see the final model rendered in Fig.20.

When learning about topology, I believe that practise improves your ability and optimizes the process. I hope these tips will help you to master your own techniques.

BEGINNER'S GUIDE TO MODELING VEHICLES

By Arturo Garcia

5

HONE YOUR HARD-SURFACE MODELING TECHNIQUES TO CREATE MIGHTY MACHINES AND AWESOME VEHICLES

Arturo Garcia approaches this hard-surface modeling chapter by re-creating a 2D concept and technical drawing of a destructive deforestation vehicle in 3D.

This step-by-step guide describes how to turn 2D drawings and blueprints into accurate and exciting 3D models that will look the part in any scene.

BEGINNER'S GUIDE TO MODELING VEHICLES
MODELING YOUR BASIC VEHICLE

BY ARTURO GARCIA

This project will cover the creation of a complete 3D model of a forest vehicle based on a 2D concept by Yun Ling (http://lingy000.weebly.com) (Fig.01-03).

We will see the model develop from the conception stage, to the placement of our reference/blueprint in the viewport, through to modeling the parts of our vehicle in detail in 3D, such as the hydraulics system.

01

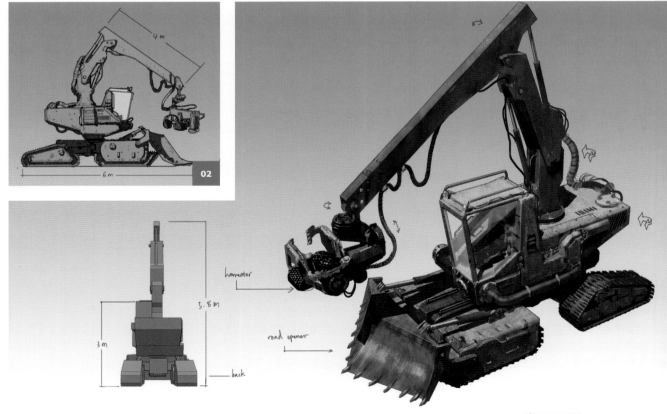

02

03

The first step is to put the reference image into the 3ds Max viewport. For this we need to change our Material Editor to the material named 'DirectX Shader' (Fig.04). This will allow us to see the reference image in high-quality detail.

To load the image, click on the first button in the material parameters rollout and select the effect named 'blend_dxsas.fx' (Fig.05).

To load the reference image, select Top Texture in the Parameters rollout (Fig.06) and choose the appropriate image. Create a plane in the left viewport; in this case I'm using a plane of eight meters wide and six meters high (Fig.07).

Then assign the reference image you loaded earlier to the material for this plane (Fig.08).

> ❝ Create a plane in the left viewport; in this case I'm using a plane of eight meters wide and six meters high ❞

To get an idea of the dimensions of the model I suggest creating a basic reference model. To do this, use a Box that you have turned into an Editable Poly (Fig.09). Assign a material to this Box and set the opacity value to 20 (Fig.10).

Before we move on to modeling and editing the Box, let's look at some of the modes that we will need to use when editing the Box. If you look at Fig.11 you'll see that I've highlighted in green the different tools we will be using, which can be found in sub-object selection mode. Starting from the left and working to the right, the first tool is for editing vertices; the second tool is for editing the different edges on the Box; the third tool is the Edge Loop tool – you will see what that does later in this section of the book; the fourth tool is Polygon mode, which allows you to edit the faces of your geometry; and finally, the last example is Elements mode, which is for selecting and working on separate bits of geometry that aren't welded together.

The next things to consider are the tools that we'll use to edit the mesh. Again, we'll start on the left of Fig.12 and work across. The tool used in the first two examples is the Extrude tool. This tool allows you to pull out (or extrude) edges in the viewport. This is done simply by clicking on an edge and dragging it. The next tool is the Chamfer tool; this one basically chops out sections of your geometry. The final tool is the Connect tool; the Connect tool allows you to adjust the distance and position of different parts of your geometry. You will see this used later on.

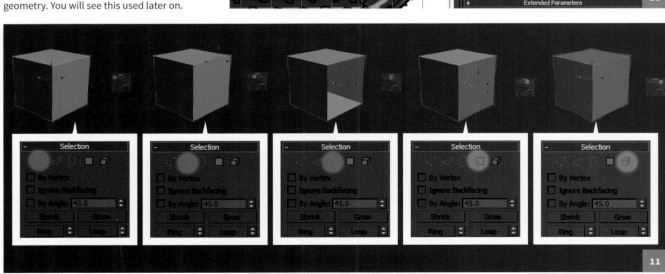

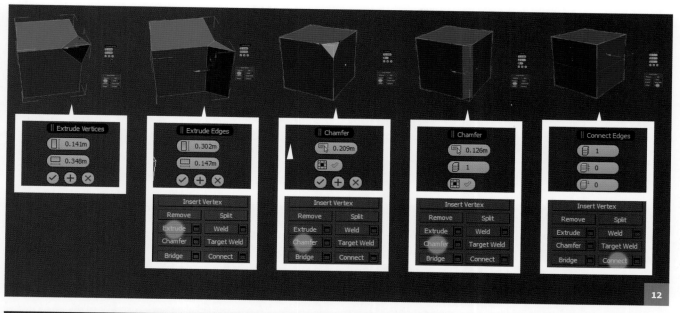

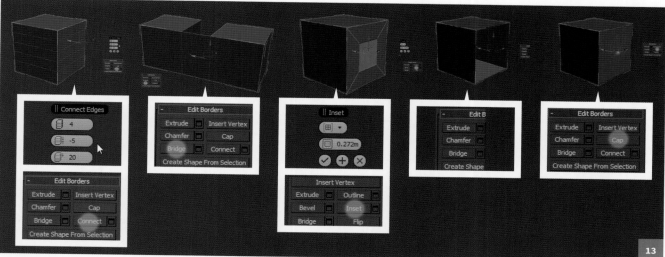

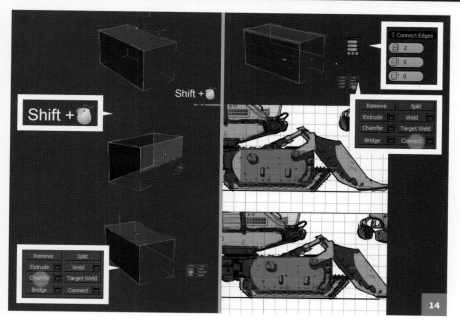

There are a few other tools that we will use too, but not very much. These are the Bridge tool, which helps you to join up two separate edges; the Inset tool, which helps you select sections of the geometry and manipulate them; and the Cap tool, which you use to fill holes (Fig.13).

VOLUMETRIC MODEL

Go to the plane you created earlier and select the top edge using the keyboard shortcut Shift+left-click. Extrude the edges and the shape until it covers the shape of the front track. Select the edge of the plane and divide it into three segments (Fig.14).

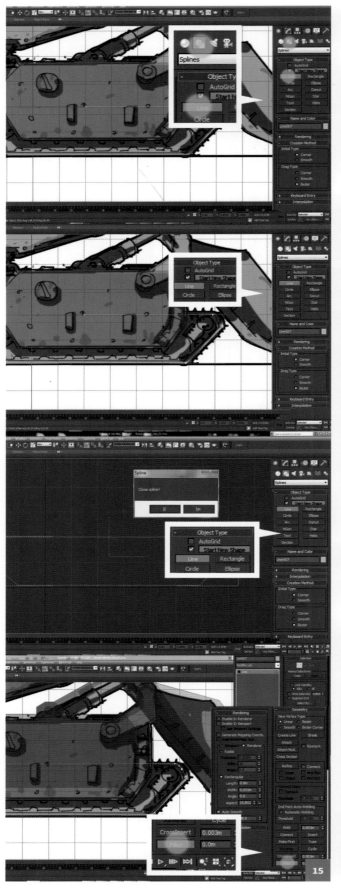

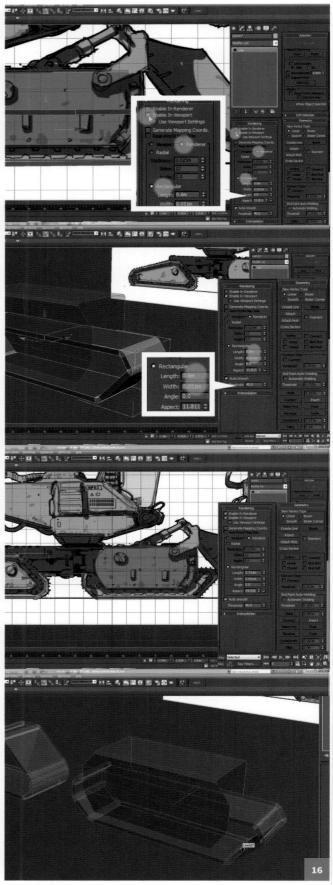

To make the tracks that the vehicle would move on we are going to use Splines. Splines are very much like Editable Polys as they have their own selection parameters that work in similar ways (Fig.15).

Start in one of the corners of the tracks and create a Spline that follows the shape of the track until it ends up back where it began. When you get back to your starting point it will ask you if you want to close the Spline; when it does this, click on Yes. Go into Vertex mode and select the Fillet tool, which you will see highlighted in Fig.16. Also select the Enable the Viewport option and adjust the shape until

you're happy with it. This same procedure can be used to create the rear track, as well.

Continue to use the same technique to create the shovel on the front of the vehicle. Create a plane, turn it into an Editable Poly and refine it to make sure you have the correct shape.

Once you've done this you will have the basic shape of the different elements that make up a large amount of the vehicle. Select the edges of the starting geometry and extrude it sideways, as you can see in Fig.17. You will need to rotate around your vehicle in the virtual space to get a better view of how the model looks when

extruded. Once you've done this, put 0.0 in the X, Y and Z co-ordinates at the bottom of the viewport to return to the standard view. This process will become really helpful later when there are multiple items in your viewport.

With your scoop selected, go to the list of Modifiers and apply the Symmetry modifier on the Z axis. This will create the full scoop shape. With this selected and in Edit Poly mode, use the Extrude tool to pull out the shape that you can see in Fig.18a (see next page). You can rotate around the image to see if this matches the concept. The next step is to create the teeth for the shovel, so let's do that.

18a

18b

Create a new small Box and turn it into an Editable Poly. Extrude one side and adjust it slightly to create a tooth shape, as shown in Fig.18b. Reproduce it until you have five, and then place them on your model.

With the Symmetry modifier on, you can duplicate them to create the other side of the shovel. Finally, attach them to your model.

If you go back to your starting view, the next step is to use the Symmetry modifier to make the complete shape of the vehicle. Once you've done this, create a new plane to create the interior part of the rear track. Extrude the edges of the plane to match the shape in the concept. Once done, select the geometry and then choose the Shell modifier (Fig.19).

The same process will be repeated to create the part of the vehicle that sits behind the front track. Create a plane and turn it into an Editable Poly. Extrude it to match the shape in the concept. Extrude this shape in the same way as you have done for the other elements in the viewport. Do the same for the main body of the vehicle and attach the different elements together (Fig.20a+b) (see next page).

The next step is to create the small cabin on top of the main body of the vehicle. Again, this can start as a Box that is extruded to match the concept. The difference with this piece of geometry is that you will use the Inset tool, described earlier, to select the faces on the top and extract them to create the raised section on top of the cabin. You will also need to use the Cap tool for this section.

Once you've done that you can make two simple circle shapes that can be placed to create the lights on the cabin (Fig.21a+b) (see next page). The final thing to do at this point is to create the mechanical arm. To do this we will use Splines, as it's a complex shape. Use Splines to follow the contours of the shape of the arm. To create the cylinder that sits under the arm, create a circular shape and extrude it into place.

19

20a

20b

21a

21b

To create the various wires, use the Splines and extrude again – but to make it softer and rounder this time, give it more sides so it has cylindrical qualities. The settings for this can be seen in Fig.22a+b. You can also download screenshots for this tutorial section from www.3dtotalpublishing.com/resources.html.

> " With the Symmetry modifier on, you can duplicate them to create the other side of the shovel "

BEGINNER'S GUIDE TO MODELING VEHICLES
DEVELOPING YOUR CONCEPT

BY ARTURO GARCIA

It's time to get some reference pictures now, which is easy with the internet. I found images in a few different places, but particularly at **http://freetextures.3dtotal. com** (search under Industrial). The images are high-resolution and very helpful. Choose some of your favorites and organize them in Photoshop – or any other image-editing program – to make it easier to find the ones you need. Note that, when organizing your images, isolate and crop the specific parts you're interested in; in this case, the important part is the blade (Fig.01).

For the modeling process we will use Editable Poly tools (explained in chapter one) (Fig.02). First select all the edges of what will be the primary face and make a cut near the side of the blade (a). Use the Polygon Selection tool to select polygons close to the edge. Apply Extrude (normal local) to create the desired shape (b). Move to the edge and select the edges of the polygons that you just created and make a cut near the side. Use this to connect edges (c). Select four sides of the selected edge and move them on the X axis to shape to the plow (d).

Now move on to the top edge (Fig.03). Select the edges of the upper part of the blade and make a cut (a); then select some of the polygons that you just created and apply an Extrude (b), turn to the left view (c) and adjust the position of the polygons created (d). Select the edges in Fig.04 and eliminate them.

Now use the Connect and Chamfer tools to subdivide the geometry. Select the edges shown in Fig.05 and apply Connect (a).

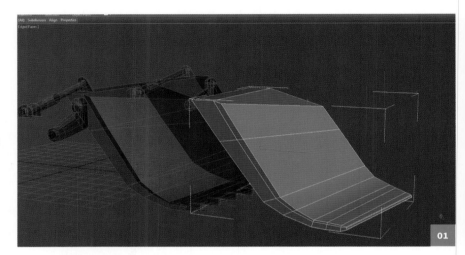

Continue to select the chosen edges of the
geometry and apply Connect again (b).
Continue with the same procedure on another
section (c). Use the Edge Selection tool to select
the edges of the image and apply Chamfer (d).

Select the edges that are displayed in
Fig.06 and apply Connect (a), then move
to the center edge of the model, as shown,
and apply Chamfer (b). Select the bottom
front edges and move them a little (c).

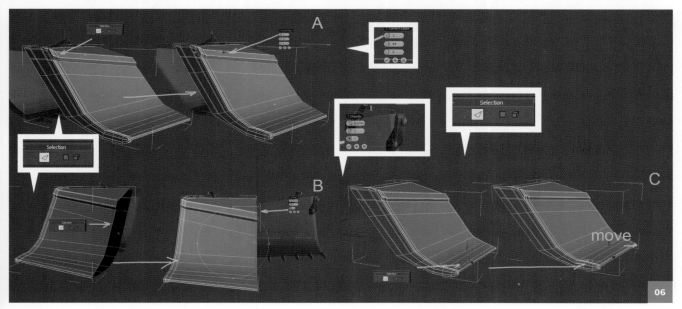

" Use the Edge Selection tool to select the edges of the image and apply Chamfer "

Now turn to the front view to adjust the pivot; this will help you apply the Symmetry modifier, as it will be easier to see the center of the model. To do this go to the Control Panel, select Hierarchy > Pivot and select the Affect Pivot Only option. This indicates that it will only affect the pivot of the object that we have selected. Put the X and Z co-ordinates to 0.0, passed to the front view. Go to the Modifier tab list, select Symmetry and activate it on the Z axis (Fig.07).

Now let's create one tooth of the blade (Fig.08). To do this, start with a simple Box that we can convert to an Editable Poly; select some vertices and move them to give it form (a). Move to Selection mode and select the polys you want to extrude. Select the new vertices that we just created and adjust to give them form (b).

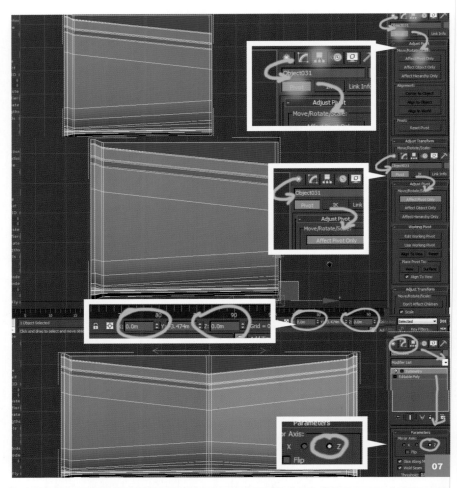

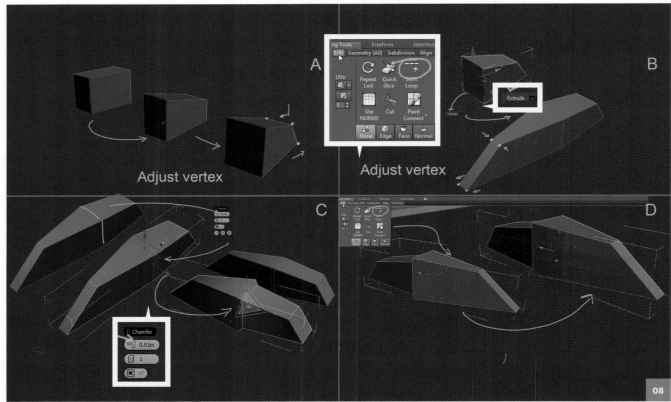

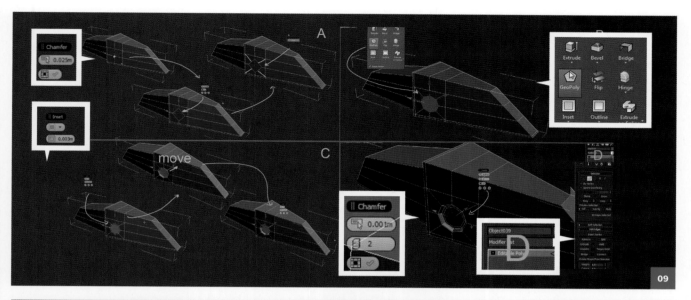

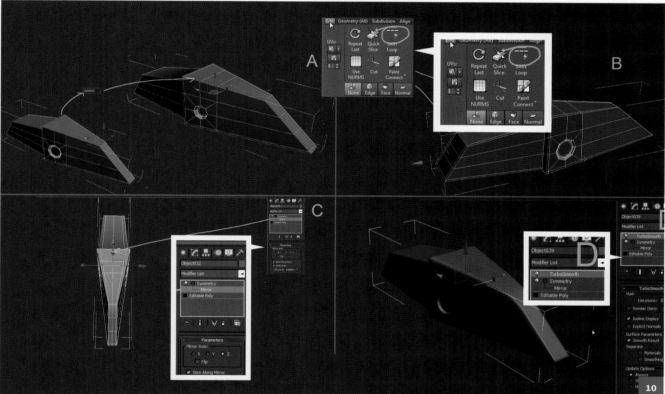

Select the central edges and apply Chamfer, then select the edges of the model and scale it to make it bigger and the correct shape (c). With the Swiftloop tool, make the cuts that are shown in the image (d). You can also do this with the Cut tool or the Connect tool, but the Swiftloop tool is quicker and easy.

On one of the sides select the vertex that is shown in Fig.09 and apply a Chamfer. With the Cut tool, make a few cuts (a), then move

to the Polygons tab and apply the GeoPoly function to give it a more circular shape (b). Then apply an Inset and move a little nearer to the interior before applying Inset again (c). Move on to Selection for the edge and select the edges of the image (applying a Chamfer with two segments) (d).

Go to Select by Polygon mode and select the edges of the central part, then apply Connect with two interactions, as seen in Fig.10 (a).

With the Swiftloop tool, make a few more cuts (b), and then apply the Symmetry modifier on the Z axis (c). Next apply the TurboSmooth modifier with two interactions (d).

Now put the tooth in place and make copies of it. With the Attach tool, attach them to create a single object and apply TurboSmooth (Fig.11).

Now it's time to model one of the hydraulic pistons (Fig.12). For this I'm going to open one of the reference images up (a). Let's start with a cylinder that will be the main part of the piston. First create an Editable Poly and select the edges of what will be the rear; select and remove them. Then select the polygon that we just deleted the edges of and apply Inset (b).

Go to the edges and with the Swiftloop tool, make a few cuts. Move on to Select mode and apply Extrude in the selected areas with different values. Moving to the other section, select the faces of the center and apply Extrude. With these selected faces apply Inset, select the edges and apply Chamfer with two interactions (c).

Now model the part which will house the piston (Fig.13). Start with a cylinder with 10 sides, create an Editable Poly and eliminate the faces displayed in the image (a). Move on to the edges and apply Extrude. Then apply Make Planar on the X axis on the edges that

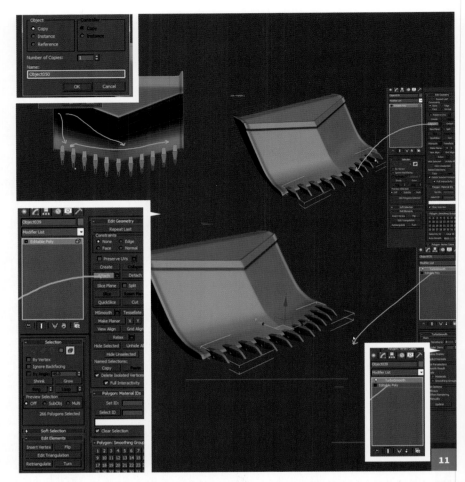

the extrude was applied to (b). Select the edges that are shown in the image and apply Chamfer. Use the same process and apply it to the edges that are shown in **Fig.13**.

Now apply the Shell modifier to give volume to the geometry (c). Make it an Editable Poly and select the surfaces that form a circle. Apply Extrude to the selected edges that are displayed and apply a Chamfer. Apply it to the base again (d).

Weld the vertices that were created so they don't cause problems later (Fig.14). Select another group of edges and apply Chamfer with two interactions (a). Make the cuts that are displayed in the image, and then select the polygons on one side and copy them. Then turn to the left-side view (b). Rotate the element that you just created, select the corners of the model and move them a bit to shape the selected edges of the inner and outer contour. Apply a Chamfer (c), and then weld the vertices and apply the Shell modifier. Make it an Editable Poly and give it volume, then apply TurboSmooth (d).

For the next piece, create two cylinders: one with eight sides and another with 12. Using the Swiftloop tool, make a few more cuts, as shown in Fig.15. Make cuts following the shape of the second cylinder. Take the side of the cylinder and eliminate it, then attach the other

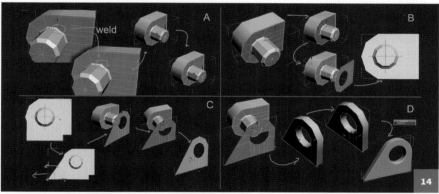

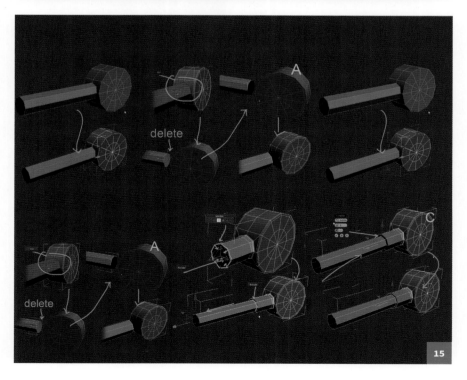

cylinder and remove the faces displayed in the image (a). Select the two edges and apply the Bridge tool, then select the edges where the two cylinders are welded and apply Chamfer.

Select the extreme cylinder ortho and eliminate the face. Move to the edge and move it a bit (b). Select the edge and apply Extrude towards the center, then apply Extrude again. Select the edges in the image and apply a Chamfer with two interactions (c).

Select one of the pieces that you have modeled; copy it and move it to where it will be coupled with the shovel. With this new piece, apply the Symmetry modifier on the Z axis to give you a different shape (Fig.16).

Next create a cylinder with 30 sides (a) and a six-sided cylinder, and make them an Editable Poly. Select one of the six side faces and apply Inset, then eliminate edges that you see in the image and apply Chamfer.

Apply two interactions to the cylinder with 30 sides and apply Chamfer. This will be the base of a bolt head that will apply detail to sections of the piston. Select this and attach it to the six-sided cylinder that we created previously (b). Copy the bolt and place it on the body of the hydraulic piston (c).

Isolate the parts belonging to the base of the hydraulic piston (d). Select the faces of the central part of one of the pieces and copy them. Apply the Shell modifier and make it an Editable Poly. Select the edges of the sides and apply Connect Edges. Place it in position and use Attach, then apply the Symmetry modifier and TurboSmooth to see the result.

Move on to the arm that holds the scoop to the vehicle. Start by creating an eight-sided cylinder. Make it an Editable Poly and eliminate the exterior faces (Fig.17). Copy it and rotate it slightly, then apply Weld and adjust it to create the correct shape. Now select the edge and apply Chamfer (a), and weld the vertices so that they don't cause any problems later. Go on to select the polygons on the edge and apply Extrude, then select the polygons forming a circle and extrude them a little, too. Apply Inset and remove the end faces. Then select the edge

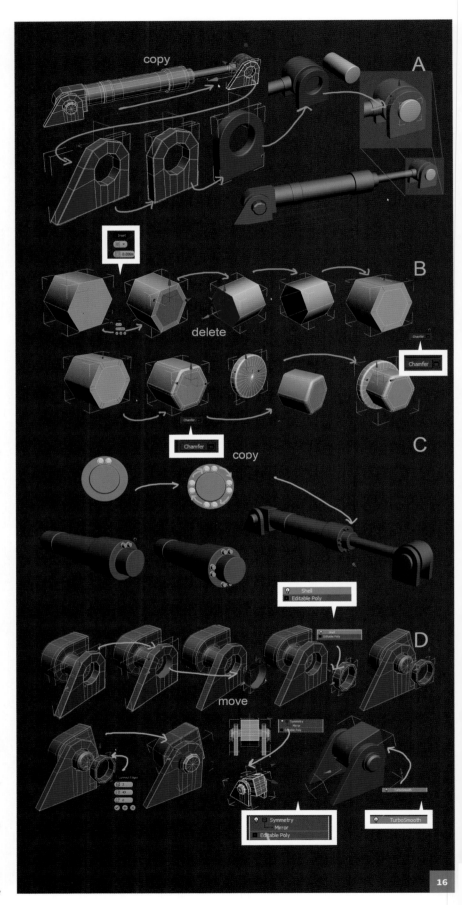

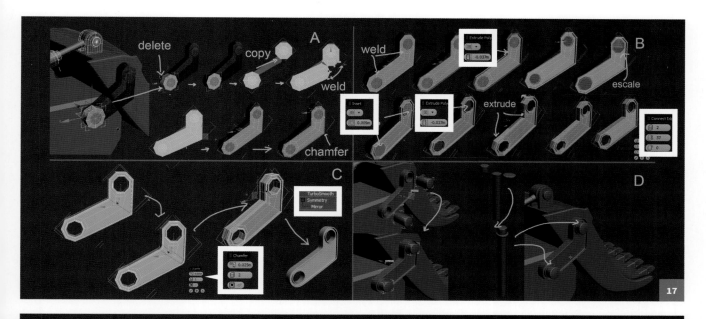

and apply Extrude. Select the different edges shown in **Fig.17** and apply Connect plus two Interactions (b). Select the central edges and apply Chamfer, then apply the Symmetry and TurboSmooth modifiers (c). Place the part in position and create two cylinders with 24 sides. Then place the new piece over the cylinders and add a small screw to hold them in place (d).

Now it's time to create the hydraulic system (Fig.18). The first part starts with a cylinder with eight sides, which you will need to make an Editable Poly. Eliminate the central vertex and apply Chamfer. Repeat the process and select the polygon in the center. Then apply Inset and move on to the center of the piece;

use Inset again. Select the edges and apply Chamfer. You can now apply Symmetry on the Z axis (a). Copy the piece and select the polygons in the image and remove them. Select the edge and Scale and Cap them. Apply Chamfer and three Interactions to the edges (b). Then create a Box and make the cuts you can see in the image (c). Next, select the two central vertices and apply Chamfer. Make a few cuts and apply Bevel, Inset, Extrude, then select the edges and apply Chamfer with two Interactions (c). The last item is a simple chamfered cylinder; put all of the items in position (d). And this concludes the shovel (Fig.19).

BEGINNER'S GUIDE TO MODELING VEHICLES
MODELING DETAILS

BY ARTURO GARCIA

This chapter will continue the modeling of our vehicle. First we'll create what will be the bearings and Caterpillars of the digger; for this we'll take inspiration from some reference images (find some by performing an internet search) and use them to create a sketch for an exclusive piece of this model.

To create this object we will start with a 3 x 3 x 1 Box (Fig.01). With an Editable Poly (a) we make cuts to both ends of the Box, then select and copy the Box faces (b). From the top view, make a few cuts on the faces we copied earlier; once we've done this we can delete the faces that we won't use.

Now make a few more cuts to avoid problems when you subdivide the mesh. Apply Chamfer Edges and make corrections by making new cuts (c); we'll then apply the Shell modifier and

convert to an Editable Poly. Next, select the top faces and apply Bevel, then eliminate the undersides, select all the faces of the bottom edge and copy them. Then apply the Shell modifier and convert to an Editable Poly. Select the edges of the sides and hit Connect (d).

Now we move on to the other side of the piece (Fig.02). Move the faces that belong

to the back part upwards and the front part down, using the Swiftloop tool. Then make some cuts, connect the edges of the central part with the two segments, select two of the new faces and apply Extrude (a). Select the edges and apply Connect.

We see some vertices that we need to give a curved shape to; select the faces of the

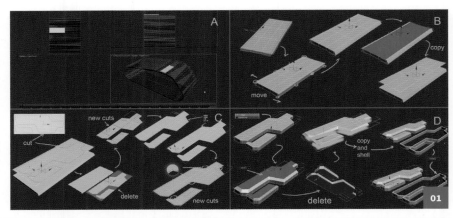

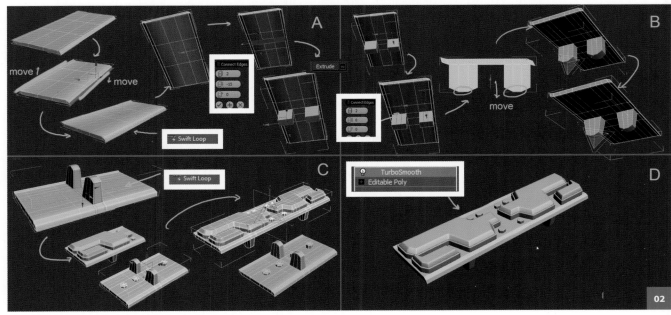

image and extend a little (b), then make some cuts in order to soften it later. Add a few studs in the central part and to what will be the part below. Apply Connect to the elements, then apply a Symmetry modifier (c), and TurboSmooth to see the result (d).

Now we'll make several copies of this piece and put together the front and rear Caterpillars (Fig.03). For this we'll use the Spacing tool, which can be found under Menu > Align > Spacing Tool (Shift+I).

Next, isolate the two Splines that you created earlier for a reference of the Caterpillars (a), select the piece that we will copy and in the options of the Spacing tool menu, click the Pick Path button and select one of the Splines. In Parameters, activate Count and assign a number; this will be the number of times that it repeats the piece – in this case it's 27 (b). As the bottom parts are poorly targeted, select them and rotate 180-degrees locally (c), and then put them in their final position (d).

We will now continue with the bearings of the Caterpillars (Fig.04). Create one Cylinder and two smaller ones that we will use as a guide to make a few cuts. First we eliminate the faces that we don't need and make a few cuts using the smaller cylinders as a guide. Then connect the vertices that were created, removing the edges that aren't needed. Select the sides we want to stay clean and apply Extrude, then Inset, before selecting the edges and applying Chamfer. Select the edge and apply Extrude, moving the edge to give form (a).

Continue with the selected edge and apply Extrude, then select some faces and apply Detach. Select the edges that are left and apply Extrude, then select the edges and apply Chamfer (b). Create another Cylinder, convert it to Editable Poly and apply some of the techniques that we used in the previous step.

Next apply Inset, then move some faces and apply Chamfer. Place a few screws now. We already have one of bearing and, using the same technique, we can create different ones by just moving some faces (c). For the panels of the Caterpillars, make a few

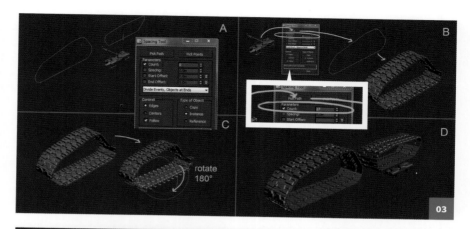
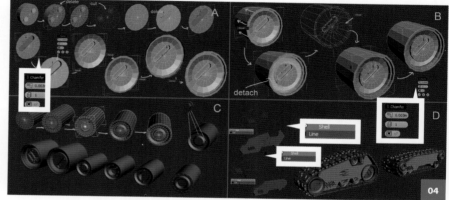
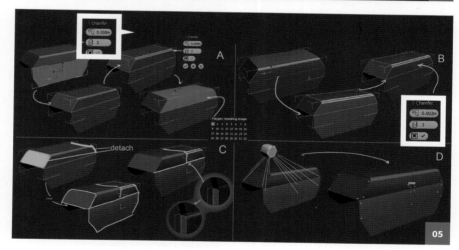

strokes with Splines and apply the Shell modifier to them; with all these pieces we can now assemble the Caterpillar (d).

We'll continue with the front Caterpillars (Fig.05). Take the cover of the base model and make a copy; this copy we can separate from the bottom. Select the four edges of the top and apply Chamfer, then select the faces of the center and apply an Antialiasing group to make that part smoother (a). Take the edges of the central part and apply Connect with one

segment after Chamfer, and separate it into two pieces (b). We then take the front and rear faces and separate them. To give volume to the panels now, select the edge and apply Extrude to five parts, one by one, so you don't miss any vertices that need to be adjusted individually. Select three edges and apply Chamfer with four segments (c), and put some bolts where they are supposed to fix the panels. And with that, we have the Caterpillar's front cover (d).

Now we're going to move on to create part of the chassis and cover the inside of the Caterpillars and bearings. First add some details to the base of the chassis; I won't go into detail on how to make each piece since the techniques we've already covered can be used to easily create these details again (Fig.06).

We take one of the bearings, delete the back and on the base of this apply Extrude Edges twice. Eliminate some of the faces and apply Extrude again.

Then apply the Symmetry modifier and convert to an Editable Poly. Take the edge and adjust it to make the shape and position of the Caterpillars. Remove the sides of the center and edge on the end that is accompanied by the chassis, and apply Extrude. Finally, select the edges of the sides and apply Chamfer. I've also put some bolts on the base (Fig.07).

Now move on to one of the more important parts of the model: the body (Fig.08). First apply Chamfer to some of the edges of the sides and continue by separating parts of the model into panels (a). Select one of the panels – in this case the side – and start making some cuts. Then select some of the edges that form 90-degree angles and apply Chamfer (b). Make a few more cuts and divide the model into three parts, select the edges and apply Chamfer, and then Extrude (c).

This same technique applies to much of the model so there is no need for me to explain each piece. I'm just going to show the separate panels, which we work on individually (Fig.09).

We're going to create a radiator next that can be seen at the sides and on the top (Fig.10). Create a plane and two Cylinders, which we will use as a reference to make cuts and create a pattern. Draw what will be the hole and then clone it; afterwards, weld the vertices to the joining parts (a).

Select the edges at the bottom and Extrude. In one of the sides, draw a circle to locate where there will be screws holding it in place. Clone the entire piece and turn it by 180 degrees, then remove the extra edges and weld the two pieces together (b). Next, select the edge and

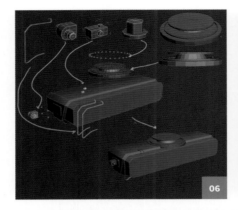

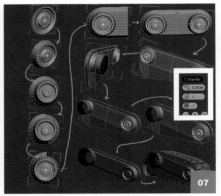

apply Extrude. Also select the edges of the interior holes and apply Chamfer (c). This is the process for other areas of the model (d).

For the base of the hydraulic arm, start with a Cylinder of 24 sides (Fig.11). For the entire shaping process, apply Extrude and Chamfer (a, b). For the gear inside, create a Cylinder of 80 sides, select the edges of the sides, apply Chamfer to them and apply Bevel to create teeth (c, d).

To create the exhaust pipes, assume the Spline will have a basic tube shape, then apply Fillet and convert to an Editable Poly. Adjust the Cylinder Cap to make a slanted shape, apply Extrude inwards, then select the edges and apply Chamfer. The base is now a simple cylinder with a Chamfer on the edge (Fig.12).

Another element that we will need to create is the grating that protects the cockpit. For this we will only use Splines with different values. For the base create two Splines; these will have a higher value of thickness. For the central gate, we create various Splines that will be placed perpendicularly, so they can take the shape of a mesh; these will have a lower value of thickness, though (Fig.13).

Another very simple element to create is the tubing on one of the sides of the cabin. Start with a Spline then continue to an Editable Poly and apply Extrude to get the desired shape. To simulate a flexible hose, select the edges where the flexible section will be located and apply Extrude. The techniques to create the other elements that the tube comprises of have been previously mentioned (Fig.14).

We can now put some rivets on the panels of the vehicle (Fig.15) and with this the modeling of the vehicle is finished (Fig.16).

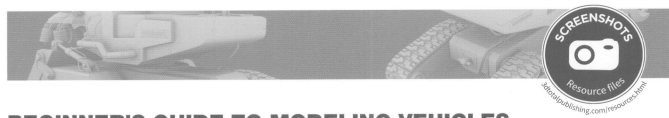

BEGINNER'S GUIDE TO MODELING VEHICLES
CREATING 3D HYDRAULICS

BY ARTURO GARCIA

We continue by creating the base of the hydraulic arm (Fig.01). Starting from the reference model, create two cylinders, which we'll use as guides to make some cuts.

First, we will make circular cuts where the pneumatic cylinders will be, delete the central faces and then apply Chamfer Edges (a). We then apply a Chamfer with a value of 1.0 to the edge, apply Shell and convert it to an Editable Poly. Select the faces we created when applying the Chamfer to the edges and apply Extrude (b). Next, select the faces of the edge of the upper circle and apply Inset and then extrude it. Select the edges of both holes and apply a Chamfer, then connect to the edges of the full body and apply TurboSmooth to see the result (c). The following parts can be created using the same technique (d).

The next section of the arm is created using a similar process, so I will only show a few images to demonstrate this (Fig.02) (a). We select some of the interior faces and we apply Extrude with a small value; apply Extrude again, this time with a bigger value (b). To this we apply Symmetry and TurboSmooth (c), then turn to the first part of the arm and apply the same Symmetry and TurboSmooth (d).

Copy one of the shovel's cylinders twice; put one of them in the base of the hydraulic arm, and the other in the upper part (Fig.03) (a). To create details for this section we add some pieces such as retainers, washers, screws and connections. These are very simple, so I will just use images to illustrate the process (b). Also create bushings to join the hydraulic cylinders to the arm and the wiring for the hydraulic fluid, using Splines (d).

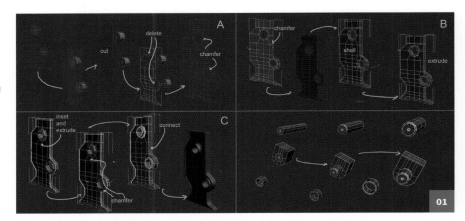

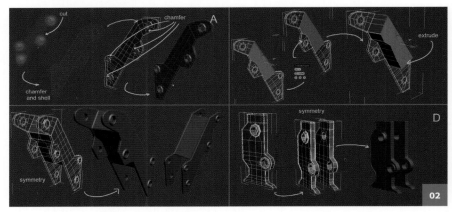

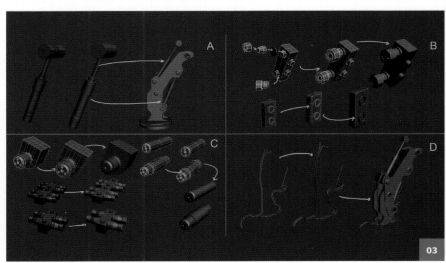

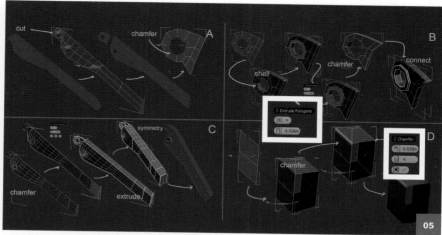

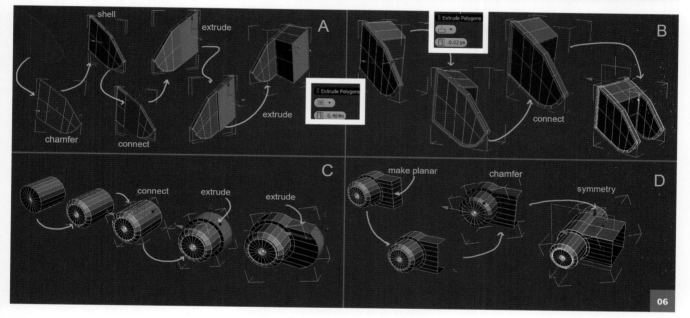

With all the parts that we have previously made ready, it's time to put them into their respective positions (Fig.04).

We now move forward to the third section of the arm (Fig.05). As we did in the earlier chapters, create two cylinders to act as templates, make the cuts and separate into two pieces. Select the first one and apply a Chamfer to the inside edge (a), and to the outside edge. Now apply Shell. Next, simply go to Editable Poly, select the faces of the inside edge and apply Extrude. We apply a Chamfer to the selected edges and then to the edges of the sides, and with the two segments apply Connect (b).

Move on to the next piece and apply a Chamfer to the outer rim. Then select the faces of both edges and some more faces, and apply Extrude. Attach the part that you created earlier and apply Symmetry and TurboSmooth (c).

The next piece is very simple: we only apply a Shell modifier and, with the Editable Poly, delete the faces that are shown in the image. Select the edges of the four sides and apply a Chamfer with four segments. Then we'll select all the faces and apply Antialiasing by groups (d).

The next piece is the part that holds the module combine harvester heads (Fig.06). Take the last piece that we separated in the previous step. Apply the Edge Chamfer, Shell modifier and convert it to an Editable Poly. Select the central edges and apply Connect, then take part of the inner faces and Extrude twice (a).

Select the side edges of the work piece and apply Extrude, then repeat with the next set of side edges. We make a few cuts to the mesh with the Swift Loop tool; apply a Symmetry modifier and TurboSmooth (b).

We start with a cylinder of 20 faces, which we turn into an Editable Poly. First we add details to one end by applying Extrude, and we then connect the edges of the center of the cylinder. Take the faces that we just created and apply Extrude. Afterwards, take the seven faces and apply Extrude by group (c).

Apply Make Planar to flatten the polys and then delete the faces. Select the edges and apply Chamfer, then apply Symmetry and convert it to an Editable Poly. Extrude Edge to help when it comes to assembling the parts (d).

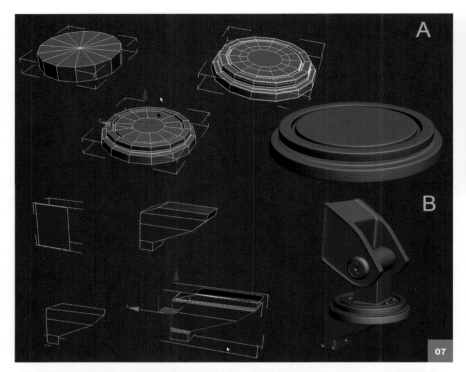

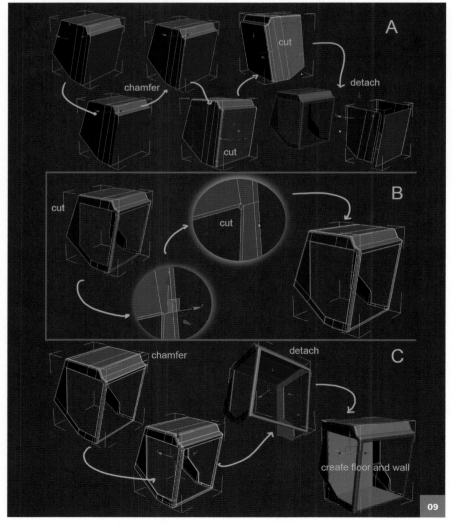

The next part is a very simple part of a cylinder (Fig.07). An Extrude is applied to the 14 side faces, giving it shape, and a Chamfer to finish it off (a). The next part to follow is a plane with some cuts made, and some simple pieces with a Shell modifier applied. Apply a Chamfer to the edges to give them a softer shape, and then add a plaque at the bottom made with a Box, to which a Chamfer can be applied to two of its edges. When we have these pieces placed in position; add some screws and bushing (b).

We can now gather up all the previous parts and we should have a full arm. Add a few connections in the upper part for the extension of the hydraulic fluid arm (Fig.08).

Now we are going to design the cockpit. Once you have a shape similar to what you can see at the start of Fig.09 (a), apply Chamfer to the edges of the sides. Next, cut out areas to determine the location of the windows and separate them with Detach.

Select the cabin and connect the vertices that have been floating about since we made the previous cuts; this is important so that errors don't occur when applying TurboSmooth. When applying Chamfer, apply to all outside edges and the interior. At the corners of the inner edges you might find that applying Chamfer has created a three-sided polygon where the three vertices converge. This can cause problems when applying TurboSmooth, so fix it by making cuts to create a four-sided polygon (b).

Select the edges of the polys in the upper-front edge, apply Chamfer, Shell and then convert it to an Editable Poly. Now we have the external structure of the cabin and the base for the

interior parts. We then select the polys of the interior and separate it; select the inside, then create the floor and rear wall of the cab (c).

Select the polys from the edges of the front and right of the cabin; copy them (Fig.10). To these we apply a Shell modifier and convert them to an Editable Poly. To create the glass for the cabin door, separate the part that will be the opening (a). To this, make a few cuts to create the door frame, apply a Chamfer to the edges and next a Shell modifier.

We make a few cuts to the section of the lock, then separate it and apply Chamfer and Shell. The lock handle is created by extruding a Cylinder of 10 sides to give it shape (b).

To shape the focus point located on the roof of the cabin, take the reference model, separate the front part, select the edge and apply Extrude. Select the edges, apply Connect, select the faces of the edge and apply Extrude. Then select the edges of the edges and apply Extrude, before re-selecting the faces and copying them (c).

Once the light is completed, the lens of the light can be put in place. Then use MeshSmooth and Subdivide, along with Shell, to make the lens fit snuggly (d).

> ## " Use MeshSmooth and Subdivide, along with Shell, to make the lens fit snuggly "

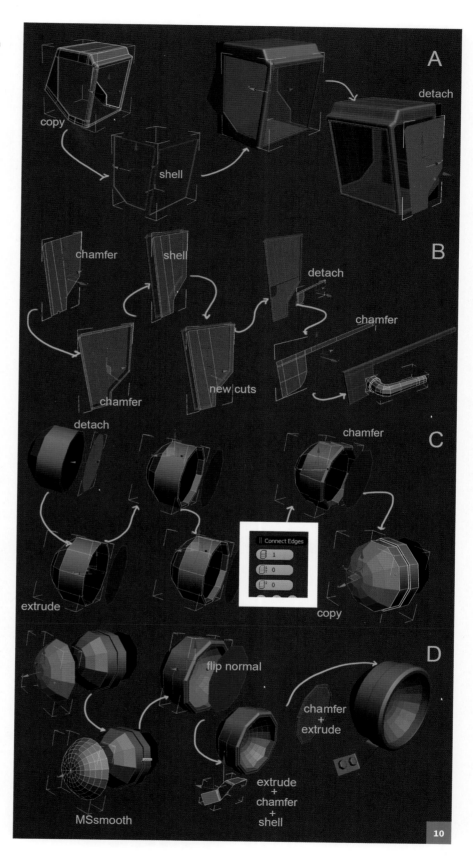

We continue with the modeling of the combine (Fig.11). Start with a Box that we convert to an Editable Poly, and move and cut some vertices. Next we select the side edges and apply a Chamfer (a). Use the same principles as previous parts to form this part: Extrude, Shell and Chamfer (b).

Take the vertices that are shown in the image and apply Chamfer. Then make some cuts, select the central face and, with the GeoPoly tool, create a circular shape. With these selected faces you can then apply Extrude and then Inset. We then place the previously made piece on either side of the object, select the edges and apply Chamfer. Add a cylinder with a plane (c) and apply Extrude, Chamfer and Shell. Create the next piece and attach this one to the front (d).

We'll draw a Spline with the shape that is displayed in Fig.12; add a circle inside. We can now draw a second Spline, which we'll use as a guide; take the first Spline and add the Bevel Profile Modifier. Go to the parameters and click to pick the profile button; select the second Spline and give its volume and shape to the first Spline (a).

Place it together with the pieces we created previously. The next piece will be the toothed roller. We start from a Cylinder of 40 sides, separate the top and bottom caps and give them shape. Then apply Extrude, separate the central part and, with all selected edges, connect the 10 segments. We select all the vertices of the inner part and apply Extrude (b).

" To finish the arm we add some more details, and create the wiring with Splines, connections and fasteners "

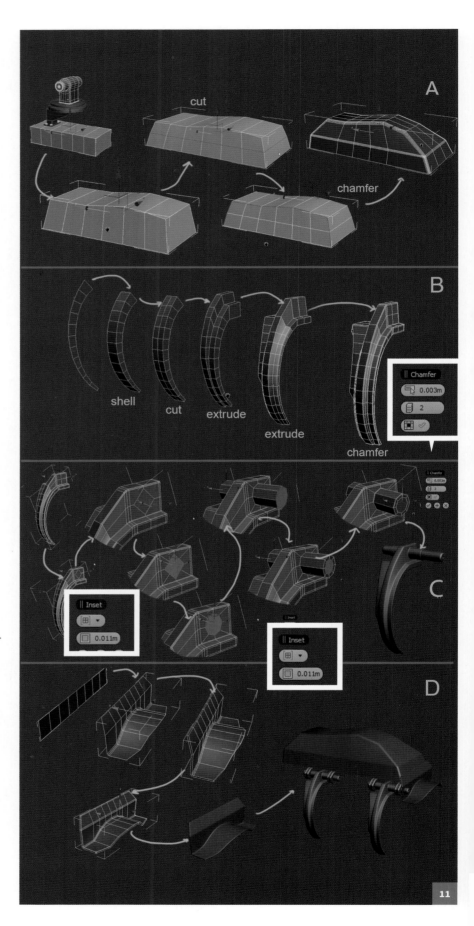

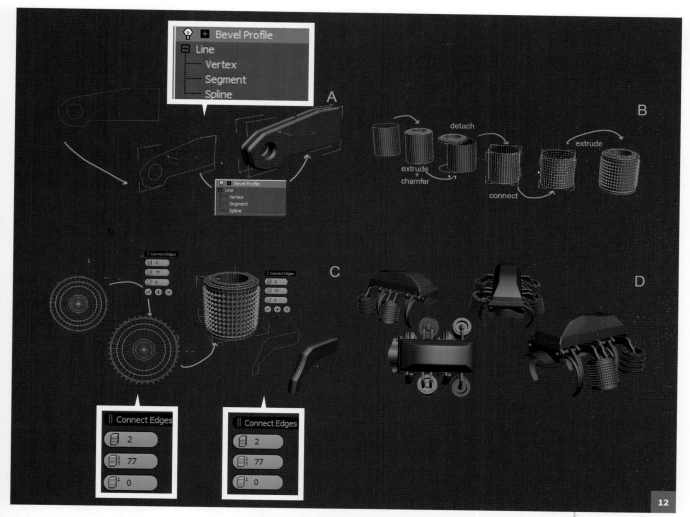

Select the edges of the peaks that we created earlier and connect them to the two segments, add the caps and apply MeshSmooth. Create another Spline with the shape that's shown and apply Bevel Profile (c). Now put all the pieces in place, apply Symmetry to these elements, and add screws (d).

To finish the arm we add some more details, creating wiring with Splines, connections and fasteners (Fig.13).

And with this, the modeling section is concluded! As I've demonstrated, with knowledge of just a few modeling techniques, you can achieve a pretty decent model.

For those interested, a blueprint of this model can be seen in Fig.14-18 and the finished model with all its parts can be seen in Fig.19.

INTRODUCTION TO LIGHTING OUTDOOR SCENES

By Andrew Finch and
Samuel V. Conlogue

6

LEARN HOW TO DRAMATICALLY CHANGE AN ENVIRONMENT FROM A BRIGHT SUMMER'S DAY TO A DARK, FOGGY NIGHT

In this project, Samuel V. Conlogue teams up with Andrew Finch to share some classic lighting techniques and plentiful new tricks.

These two lighting experts have worked together to guide you through building light rigs and render setups to portray different atmospheric conditions, such as fog, sunrise and overcast light. Their step-by-step account of how a base scene can be transformed to portray various environments shares insight into both lighting and rendering exterior scenes.

FREE RESOURCES

Download your free resource pack for this project

www.3dtotalpublishing.com

INTRODUCTION TO LIGHTING OUTDOOR SCENES
FOG/MIST AT NIGHTTIME

BY ANDREW FINCH AND SAMUEL V. CONLOGUE

During this exterior lighting series I will be covering the techniques I used to create various time and weather conditions using 3ds Max, the mental ray renderer and After Effects. I will be concentrating on describing my lighting methods rather than any modeling or texturing that may need to be done. Though I have created as much of the image as I can in 3ds Max, I will also briefly cover my workflow for compositing with After Effects to achieve the final image.

For this first chapter, I will set up a foggy and damp night time atmosphere with the intention of making the viewer engage with the image and want to explore the environment. What's up those stairs? Is there anyone in the houses? What's behind that door? What's the story here? I hope you enjoy reading my tutorial and learn something you can apply to your own work.

IDENTIFYING LIGHT SOURCES

Here is the unlit scene I'll be starting with. (Fig.01). I've highlighted the possible light sources that can be used. The most obvious of these is the lantern illuminating the street, but I also want to have moonlight cascade across the building on the right, and down the stairs spilling through the archway. There are also the many windows and doors that I can use to add life to the scene.

The archway and stairs are central to this image; if lit correctly they will add depth and help to make the viewer want to explore the image as described earlier. In contrast to a

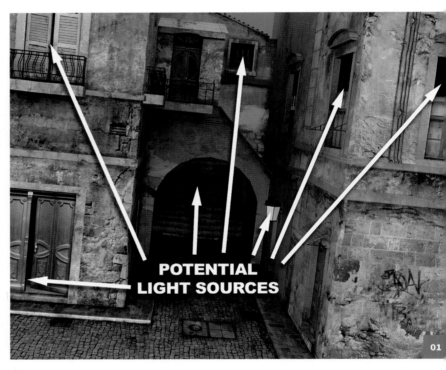

POTENTIAL LIGHT SOURCES

01

daylight scene, the shadows in this scene should be soft so I will use Photometric Area Lights throughout. I could use mental ray lights, but as they lack real-world luminance values and color temperature, I choose to go with the physically based Photometric Lights.

This allows me to light the scene with physically based values, true inverse-square falloff and proper camera exposure values from the start. With all the major rendering packages now offering camera exposure controls and natural light behavior, there is much to be gained from developing an understanding of basic photography terms and techniques.

The weather conditions (a foggy, damp evening) also generate their own light, so I have to take care not to wash the image out.

The addition of fog creates further depth as the light disperses through the fog-created shafts of volumetric light and glowing effects, enhancing the mysterious look I want to achieve (Fig.02). At this stage, I need to concentrate on simply getting the lighting right. I will return to how I create the foggy look later in the tutorial.

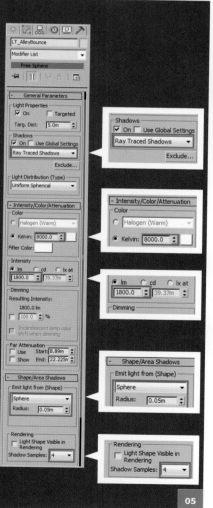

With this in mind, it is important to be sure all file output from 3ds Max is saved in OpenEXR file format at a gamma of 1.0. I have also changed the mental ray Frame Buffer to work in 32-bit mode. This ensures that I have the widest range of color values available for color correction and exposure tweaks. I then enable mental ray Photographic Exposure and apply the settings shown in Fig.04. In newer versions of 3ds Max, Gamma Correction should be enabled by default – if it isn't be sure to turn it on.

NATURAL LIGHTING

The natural lighting for this scene is the moon and some directed bounce light. The moonlight in this image is very important, I used it to help focus the viewer's eye into the center of the image while also adding depth.

I didn't want the moon itself to be visible as I thought it would interfere with the composite of the image, so I kept it hidden behind the buildings. I placed a Photometric Spherical Diffuse Light just behind the archway, about halfway up the stairs to produce our bounce light (Fig.05-06).

By doing this I am immediately stepping away from realistic moonlight behavior, as realistic values could not generate this

SETUP DRAFT RENDER

When lighting any image, you can't expect to achieve the final result first time. In anticipation of a lot of tweaking, one should expect to do many test renders. As this could potentially be very time-consuming, I configure my sampling and Final Gather settings to low-quality, draft settings to expedite my test renders and keep the focus on lighting. Also set all Photometric Lights shadow sampling to a very low value of 4. The default of 32 is much too high for this scene and would slow the rendering to a crawl. I can always use the global Shadow Precision controls to increase sampling if needed.

Firstly, I assign mental ray as the renderer and use the settings shown in Fig.03 for draft renders. It is important to note that I composite my final images in After Effects, utilizing it's very fast and flexible 32-bit capabilities.

level of bounced light without very long exposure and no competing artificial light – it is very important to understand what you are doing when deviating from physically-based light behavior for artistic reasons.

I also add direct moonlight using a Photometric Light set to Spherical Diffuse. I set the color temperature to a cool 8,000 degrees Kelvin, give it a boosted luminance of 30 LUX at 39m – the distance from the light to the wall, to make it stand out. In reality, moonlight would represent about 1 LUX. I then set an Area Light size of 10cm. I position it so it is pointing across the surface of the wall; this also gives me a soft shadow from the roofing tiles and helps to highlight the Bump map, giving more detail to the image (Fig.07-08).

I will also note that because I'm using a Spherical Diffuse light, I am once again stepping away from real light behavior due to the fact distant light sources like the moon and sun cast parallel 'direct light' rays, as opposed to the spherical light's rays that fan out from the point of origin. This affects the shadows produced by the light, but as we don't have a photometric 'direct light' and the 3ds Max's Standard Direct Light lacks soft shadows, I have to choose one or the other.

As you can see, the moonlight cascades down the stairs and through the archway, creating a very soft falloff of light and reflections on the damp cobbled stones. It's very dark and flat around the front of the buildings; even at night you would get some bounce light illuminating the shadowed areas, so I place two Photometric Uniform Diffuse Lights on either side of the front of the scene, just off camera (Fig.09-10). This will emphasize the detail at the front of the buildings.

ARTIFICIAL LIGHTING

The image is still dark and uninteresting, but once I apply the artificial lighting it will add more life to the scene. Artificial lighting was my favorite aspect of this tutorial. For this scene, the most important part of the lighting comes from the street lamp, as it serves as a focal point and plays a big part in creating the illusion of a foggy night.

07

08

09

10

Before I place the light in the lamp itself, I need to set up the lamp object so it interacts correctly with the light once added. I have to alter some of the settings in the glass geometry of the lamp so it doesn't cause any unwanted shadow interaction. To do this I select the glass panel object, right-click and

select Object Properties from the quad menu. In the window pop-up, I need to de-select Cast Shadows and Accept Shadows. I also add a self-illuminating material to the glass to create a backlit, lightly frosted look to add some visual punch to the implied light source.

After making these changes, placing a light inside the lamp object doesn't cast shadows and block out the light being cast on the glass panels. The only shadows that should now be cast are from the lamp object onto the walls and floor, but these shadows should be very diffuse. I add a Photometric Spherical Diffuse Light in the scene and move it to sit inside the lamp object, roughly where a light bulb would normally sit.

Also be sure to disable Affect Specular since the self-illuminating glass will take care of that in the reflections on the walls and stairs. With a Luminance of 1,300 Lumens and a warm color temperature of 3,200 degrees Kelvin, I have now begun to create a contrast of warm and cool light which instantly livens up the image (Fig.11-13).

Looking at the latest render you can see that it still requires more work – there is something

missing. The image still looks a little flat and uninteresting; what is missing is life. In order to bring life into the image I need to apply lighting to the windows and doors.

I do this in two ways: (i) by using textures to create a self illuminating material giving the illusion of light being cast from inside and (ii) from physically carving out the geometry and forming fake rooms behind the windows and doors and using a real light to illuminate the scene.

This technique also gives us the option to add environmental effects such as Volume lighting – further enhancing the life-like look I am trying to achieve. As I use both techniques in this tutorial, I will outline each of them so I can demonstrate the differences.

Let's start with the doors on the left-hand side. Firstly, I need to cut out the door from

the geometry and create a fake room behind it. To do this, I create an open-ended box which surrounds the doorway, making sure all holes are welded and the geometry is solid. This reduces any lighting anomalies that may occur later on in the render.

I want the light to come from inside the fake room and spill out onto the cobblestone road. But I only want this room to emit a small amount of light as I don't want it to be too overpowering and draw the viewer's eye away from the archway. For this reason, I rotate the door 10 degrees inwards to allow just enough light to escape the fake room (Fig.14).

15

I then place a Photometric Spotlight in the fake room and position it so it is pointing out of the door opening. I decide to use a Spotlight for this because I want to focus the light downwards towards the street. (Fig.15-16).

At this stage, I am starting to add more life to the image but it is still missing something so I move on to the windows. For the windows I again carve out a fake room behind and use a real light to illuminate this area. Using the same techniques for the doors on the left, I cut out the windows and create a simple box room (Fig.17). This second fake room also keeps the light from escaping behind the buildings.

Note: I have only cut out the tops of the windows because I want to use the self-illuminating material to light up the remaining window. This will give the effect of something blocking the window from the inside and help create a more realistic fake room. Also, if I cut out the entire window, the light that escapes would overpower the image and ruin the look.

To create a self-illumination map you need to make an edited version of the texture with the desired hue and brightness for the windows but everything else set to black. The edited image is then placed in the self-illumination slot of an Archi-Design Material where you can then set a luminance value.

For the real lights I use two Photometric Spherical Diffuse Lights and place them inside the fake interior space. The settings I use can be seen in Fig.18.

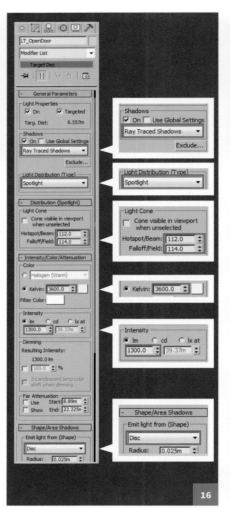

16

17

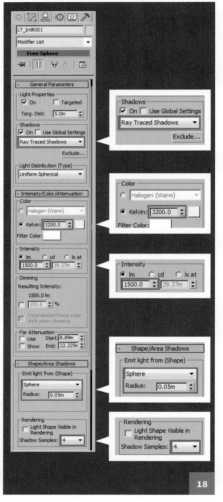

18

19

20

21

22

23

I then use the light from the windows to help define the building on the left and make sure it stands out from the background building (Fig.19). The variation of color difference from the self-illuminated windows and the real windows also give the impression of an actual room with genuine atmosphere inside.

Once the windows are lit in the foreground, the building above the archway seems to lack detail and 'get lost' in comparison with the other buildings in the scene (Fig.20). I use the same methods as before and cut out the window and hollow out a fake room behind, adding a Photometric Spherical Diffuse Light similar to that used in the other fake rooms. I then place the light behind the window (Fig.21).

RENDER SETUP

With the bulk of the lighting complete, it is now time to move on to one last test render and then some weather! I increase the output resolution to 1500 x 1125, and then set the renderer to medium image precision and Low Final Gather settings. With the new settings I am able to see any problems that may occur (Fig.22).

I'm quite happy with the medium render and I can't see any major issues. I feel ready to render the high-quality Beauty pass for this scene, so I go ahead and set up a high-quality render.

The render times for the final render could be quite long, so it's best to plan for rendering your final image overnight depending on how good your PC is. The settings I use to get the final render can be seen in Fig.23.

You should always aim to render your image for printing purposes, just in case your image gets accepted into a magazine gallery or art book. You don't want to have to re-render your image at a later stage and re-do any post work that you apply. I create a large render at 3000 x 2250 – the bigger the image the better. With everything set up, it's time to hit that render button one more time (Fig.24). I then save the image as an OpenEXR with Gamma of 1.0 and start my weather setup.

WEATHER

Now that our Beauty pass is complete, it's time to focus on atmospherics. Fog is fairly simple to create as its look is entirely dependent upon the lighting work we have already completed. There are a couple of ways to create a foggy/misty look, but I prefer to use the Parti Volume Shader that comes with mental ray. The difference between this technique and using something like the 3ds Max Environment Fog effect is that the Parti Volume shader respects shadows and light color, which in turn creates true volumetric tinted shafts of light, just as real particles in the air would.

Our fog setup will involve two parts and introduce our first render pass. A render pass is a render separated or created independently from the Beauty or final render you create in 3ds Max which will later be used in the compositing process to create the finished image in After Effects. I use passes to allow greater flexibility after rendering is complete while speeding up the 'tweaking' process and often render times as well.

I go to the Renderer tab in the Render Setup box and click on Volume in the Camera Shaders section. Then I click in the empty shader slot and assign the 'Parti Volume' shader. I drag this shader into the material editor as an instance and make some adjustments. I could hit render now to get fog, but at this point I really just want my Fog pass, so let's move on to the next part.

To render this as a Fog pass for use later, I go to the Processing tab in the Render Setup box and check Material Override. I then click the empty material slot and assign the 'Matte/Shadow/

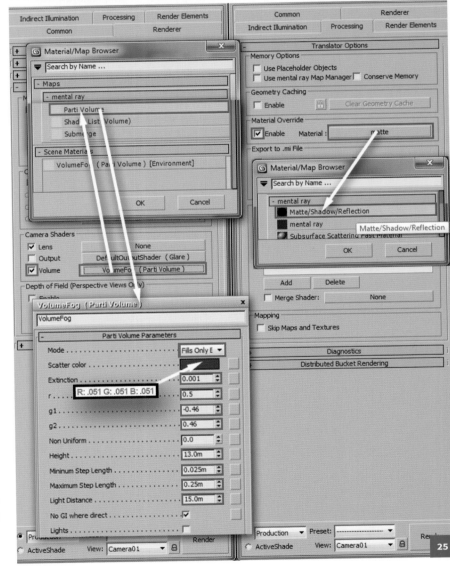

26

Reflection' material. I drag this material into the material editor as an instance and check off any enabled options. This will simply be a black matte so I can isolate the Volume shader for use in compositing. This also dramatically speeds up rendering the volume as opposed to rendering it with the beauty pass.

Lastly I create a simple plane object and place it off in the distance behind the buildings to fill the patch of sky in the scene. This is necessary as the Parti Volume shader only renders volumes over geometry and not empty space. I hide this plane after rendering the Fog pass. The settings for both steps can be seen in Fig.25.

Now decrease the Sampling Quality under the Renderer tab, so that Min is 1/4 and Max is 4 and hit render. (This will speed up the fog render without noticeably reducing the quality) (Fig.26).

The Fog pass contains numerous shafts of volumetric light as cast from the street lamp, windows and moonlight. When composited, this will add a real sense of depth and mystery to the final image. As you save from the frame buffer, make sure to select openEXR as the file type and apply a gamma of 1.0.

ADDITIONAL PASSES

Now that I have my Fog pass, I go ahead to create my last two passes for this scene, the ZDepth pass and Ambient Occlusion passes which will be generated simultaneously. ZDepth is a light-to-dark gradient representing the depth of objects in your scene. This is primarily useful for adding Camera Focal Blur, also known as Depth of Field, but it can additionally be used for faking distance fog among other uses.

27

Ambient Occlusion (AO) is more of a shader trick where you fake ambient 'contact' shadows where faces or objects are close to each other. Areas with soft shadows, or the result of GI solution, can cause a lack in proper contact shadows; the AO pass helps to bring details back into these areas. It's subtle but usually a good idea to have handy for when you need it.

First I reset my sampling so it's higher again (set Min to 1 and Max to 16). I also disable mental ray Photographic Exposure and Final Gather since AO needs no exposure correction or FG. I also make sure to turn off Volume in the Camera Effects section of the Renderer Window. Now I change my Override Material to be a mental ray material

and drop an Ambient Occlusion shader in the Surface Slot. I leave the AO shader alone, aside from bumping the sampling up to 32.

Next I go to the Render Elements tab in the Render Setup Window and add a ZDepth element. I adjust the Min and Max values to represent the overall depth of my scene (Fig.27). Then that's it! I now hit render and get my passes in a flash. Well, maybe not that fast but relatively fast. Again, make sure you save as a OpenEXR with a Gamma of 1.0.

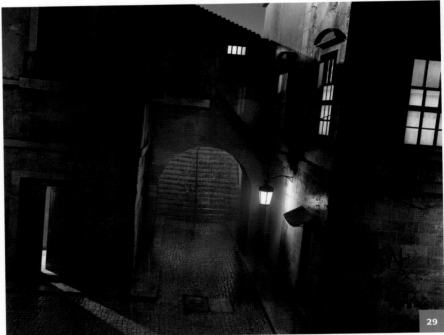

COMPOSITING IN AFTER EFFECTS

Now that I have all of my passes I can quickly assemble a composite in After Effects, before moving on to the fun part – applying color grading, enhancing the fog and other effects.

Assembling a composite is pretty straight forward in After Effects. I first import my Beauty, Fog, AO and ZDepth passes. Then I right-click my beauty pass and hit Create New Comp from Selection. Since I am working with OpenEXR footage, I click the 8 bpc button at the bottom of the Project Panel. I change the Depth to 32 bits, select the sRGB Working Space and click Linearize Working Space.

Now I drag the remaining passes into my composite with the order, visibility and blending modes shown in Fig.28. The assembled composite before any tweaks or FX can be seen in Fig.29. That's it for assembly, now it's time to play around with the composite!

I can now set up my Adjustment Layers and other FX. First I add a layer of subtle Glow above the AO and Beauty passes with a very low intensity of .01. This helps make the light sources 'pop', while giving a slight gauss filter look.

Next, I tweak the rather underwhelming Fog pass to bring it to life. I do this with a little Desaturation, increased Exposure and Gamma, then lastly a little Glow again with a very low intensity. To get the right atmospheric mixture, I reduce the Opacity of the fog layer.

Now I add another Adjustment Layer and apply the Camera Lens Blur effect to generate just a touch of Depth of Field. This is where

the ZDepth pass comes into play, which I should note is set to not visible in the settings. In the Blur settings, I assign my inactive ZDepth Layer as the Blur map and tweak the Blur Focal Distance such that the area around the street lamp is crisp, with slight blurring near to and far from the camera.

Lastly, I apply some grading through three more Adjustment Layers: the first for Color Correction and Contrast via Curves with a slight RGB S-Curve and reduced Red Channel; the second is an exposure boost for the archway using a feathered Mask to isolate the layer's effect; the third is a subtle vignette which is simply a black Solid Layer with a feathered Mask drawn to affect mostly the lower left of and right of the image (Fig.30-31).

I'm quite happy with the end result and I think I achieved what I set out to do. Hopefully it tells a story and makes you want to see

what's behind that door or what's on the other side of the archway. Most importantly I hope you were able to follow this project and learn something from it. I actually learned a lot making it and enjoyed myself too.

> " Add a layer of subtle Glow above the AO and Beauty passes with a very low intensity of .01. This helps make the light sources 'pop' "

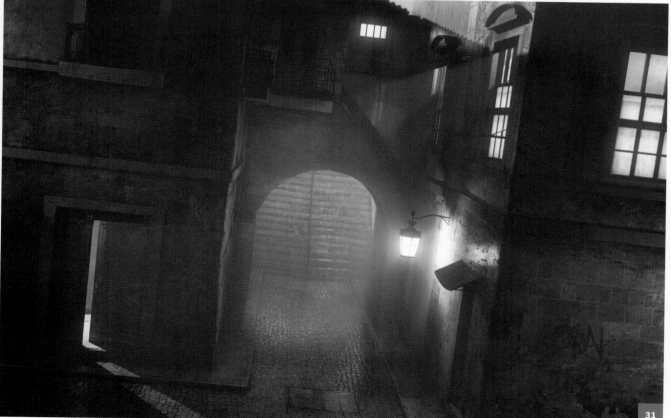

INTRODUCTION TO LIGHTING OUTDOOR SCENES
SUNRISE/SUNSET

BY ANDREW FINCH AND
SAMUEL V. CONLOGUE

Before I start lighting any scene I collect
reference for the type of lighting setup
I want to create. So for this part of the
project, I'll do an internet search for sunsets,
this brings up a lot of images so there's
plenty of reference to get a good end result.

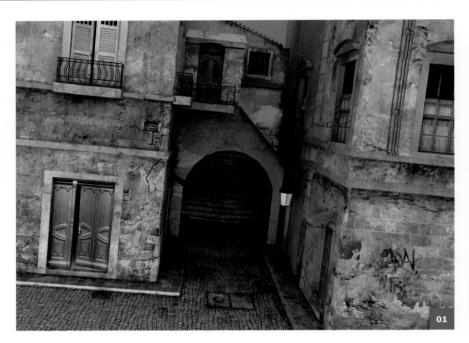

01

> " For a sunset
> environment
> we will need to
> rely on natural
> lighting to
> illuminate the
> scene. This
> means that we
> will need to be
> imaginative with
> the main source
> of light in order to
> create something
> interesting "

I want to create something interesting and
imaginative for this scene. When searching
the internet for sunset images, you will
get a lot of the more traditional golden
Mediterranean-style sunsets. So we need
to refine our search a bit to get something
more interesting. Sunsets can be quite
colorful depending on many factors such
as; time of year, location and weather.

In my mind I'm thinking of deep reds, purples
and blues – maybe something Russian-
inspired. So I do another search for sunsets
in Russia or colder locations. This gives me
a lot of useful references and shows me
the colors I need to get into my scene.

IDENTIFYING
LIGHT SOURCES

For a sunset environment we will need to
rely on natural lighting to illuminate the
scene. This means that we will need to be
imaginative with the main source of light
in order to create something interesting.

There are two places I would expect the sun
to be in this image; the first is behind the
building allowing the sunlight to cascade
down the stairs; the second is from behind
the camera pointing at the front of building.

The first option will give us a nice shadow of
the archway, but the downside of this sun
position is that the rest of the image would
be in shadow, creating an uninteresting
image and allowing all the detail in the
buildings to be lost. Also, this would restrict
us and in the end restrict our creativity.

The second option however would
give us a lot of light to play with and
keep all our detail in the buildings.

You can see the raw scene before any light has
been applied in Fig.01. Since the only direct
light source in the scene will be sunlight, it
is important to be sure the shadows from
the sun are not too sharp, as there will be
no other area lights to soften the look of the
shadows. Ideally, when casting shadows
from distant light sources like the sun, you

want to have a shadow that starts crisp but softens as it's cast into the distance. Also, the sun poses a unique challenge regarding intensity. With these factors in mind I decided to use the mr Sun & Sky system which produces these sorts of shadows and works with properly scaled luminance.

" When lighting any image, you can't expect to achieve the final result first time "

THE WEATHER CONDITIONS

The weather changes the lighting in the environment so we need to think about what kind of weather we want. I want an almost clear sky with thin wispy clouds high in the sky and near the sun. As the sun is behind us, we will get a nice glimpse of blue at the top of the image from the small amount of sky that is visible. This will add a lot to the final image. I will add some slight environment mist to give us some atmosphere and add depth to the image, making the end scene more believable and realistic.

DRAFT RENDER SETUP

When lighting any image, you can't expect to achieve the final result first time. A lot of tweaking could potentially be very time-consuming, so I configure my sampling and Final Gather settings to low-quality draft settings to speed things up. I also set all Photometric Light shadow sampling to a very low value of four. Screenshots of all my draft render settings are shown in the previous chapter, **Fig.03** for reference.

Check the mental ray Frame Buffer is set to 32-bit mode in the Renderer tab of the Render Setup Box. Use mental ray Photographic Exposure, but this time apply a setting appropriate for daytime photography. I use a Shutter Speed of 1/120, F-Stop 5.6 and an ISO of 200. Lastly, I double-check that Gamma Correction is enabled. Now to bring in the sun!

02

SUNLIGHT

For the sunlight I will use the Daylight System built into 3ds Max which can be found in the Systems section of the Create tab of the Command Panel. Once added to the scene, I first change the Sunlight and Skylight modes to mr Sun and mr Sky, which will give us nice soft shadows and ambient skylight. As I've already mentioned, using mr Photographic Exposure is key to properly exposing the daylight. I initially set my Exposure to a Shutter Speed of 1/120, F-Stop 5.6 and ISO to 400.

Next I position the sun, which can be done manually or by selecting a place, date and time of day. Either way, the goal is to position the sun low on the horizon, casting sunlight at a slight angle from left to right across the scene, which I chose to do manually.

Fig.02 shows the position of the light in the scene, and a render with just the default Daylight System applied can be seen in Fig.03.

I can see right away that I will need to tweak the color to get the tones I'm looking for, but more importantly this direct sunlight is too overpowering and the whole scene is washed-out and looks uninteresting.

03

A good way of adding interest to a scene is to add shadows. This serves two purposes; one being that it will break up the mass of light being cast over the scene adding some interest; and secondly, it will create the illusion of an environment behind the camera, further adding realism to the image. This is a very simple process and gives a big reward, so it is well worth doing.

I start by creating two simple boxes and positioning them just behind the camera so they're not rendered – but these must be in front of the main sunlight in order to cast shadows into the alley way. I will then do a quick test render to see what the shadows look like and if their position is suitable.

With some tweaking in the position of the boxes, I am able to get them in a good enough location to cast some nice shadow effects across the front of the building.

The boxes are very simple at the moment, and it shows in the render, so in order to get something a little more interesting I will add some extra faces to the boxes and create a simple silhouette of a typical building shape.

Now I tweak the sunlight color by manually adjusting the Red/Blue value to 0.8 to add a red tint to the direct light. I then go in the opposite direction with the Red/Blue tint value in the mr Sky Parameters by entering -0.7. This will build color contrast between light and shadow as well as help to generate some in-between tones on indirectly lit surfaces. I also turn down the strength of the ambient skylight to 0.2 to darken the shadows, further adding contrast to the image.

Fig.04 shows a perspective view of the whole scene with my fake simple buildings positioned correctly. A test render of the newly placed shadows and light adjustments can be seen in Fig.05.

As you can see, this immediately adds a whole other life to the scene and improves the image so much. Things are looking promising but the image isn't there yet so I move on to the tweaking stage.

TWEAKING

I am pretty happy with the lighting but I feel I could get more out of the details in the scene and that it is too dark overall. For example, the sunlight is too low to really catch the front edges of the cobbled stone street.

As this street texture uses a Normal map for its bump, I know it should respond to light direction properly, even if the geometry is actually flat. To take advantage of this, I bring the sun position up just slightly. Another simple tweak worth doing is adjusting the rotation of the right-hand door of the balcony. Just a few degrees will make it catch more of the sun's direct rays and add a nice strong highlight. Now to test render.

04

05

The test with a higher sun position and tweaked door can be seen in Fig.06. The cobbled stone catching all those beautiful highlights really gives the street some character. I have also brightened the scene by raising the sun position, catching a better highlight on that balcony door. After these couple tweaks I'm ready for a medium test render.

06

07

RENDERING

I set the renderer to medium Image Precision and medium Final Gather settings, then increase the size of the render to 1500 x 1125, as with these settings I am able to see any problems that may occur (Fig.07).

I am quite happy with the medium-sized render and I can't see any major issues. Some color correction, DOF and Subtle Glow need to be done while compositing in After Effects, but this is normal with any image; it adds that extra bit of polish to the art work. I am now ready to go ahead and set up a high-quality render (Fig.08).

As with the other parts of this lighting series I will be generating some additional passes like ZDepth and Ambient Occlusion, but first I'll create my final Beauty render in 3ds Max.

So with everything set up, it's time to hit that render button! The final outcome from the mental ray renderer can be seen in Fig.09.

For the ZDepth (Fig.10) and AO passes (Fig.11), I set everything up just as I did in the first part of this lighting series, as seen in **Fig.26** of chapter one. I also decide to create a very subtle Mist pass to add some atmospherics to the final composite (Fig.12). I use the same settings as I did previously, but I reduce the RGB values of the volume color down to 0.005 across the board as I only need a little bit of misting.

08

09

10

11

12

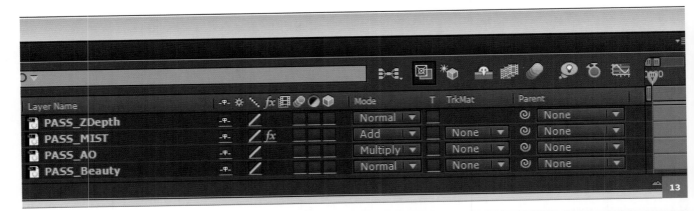

Layer Name						Mode		T	TrkMat		Parent	
PASS_ZDepth						Normal	▼				None	▼
PASS_MIST		fx				Add	▼		None	▼	None	▼
PASS_AO						Multiply	▼		None	▼	None	▼
PASS_Beauty						Normal	▼		None	▼	None	▼

13

COMPOSITING IN AFTER EFFECTS

Now that I have everything, I can import the passes into After Effects and start the compositing stage. I assemble my composite by first importing my Beauty, AO, ZDepth and Mist passes. Then I right-click my Beauty pass and hit Create New Comp From Selection. Since I am working with OpenEXR footage, I click the 8 bpc button at the bottom of the Project Panel. I change the Depth to 32 bits, select the sRGB Working Space and click Linearize Working Space.

Now I drag the remaining passes into my composite with the order, visibility and blending modes found in (Fig.13)

I disable the Alpha channels on all my footage through the Interpret Footage dialog box, accessed by right-clicking on the footage in the Project Panel – this is especially important for ZDepth and AO passes. You can see the assembled composite before any tweaks or FX in Fig.14.

14

With my composite assembled it's time to set up my Adjustment Layers and other FX. Though this is a clear day, I add a touch of atmospheric mist via my Mist pass. I then boost the exposure a bit to accentuate the effect of the pass. You will notice the nice build-up of mist in the archway. Little elements like this are what post-working an image is all about – the details that breathe life into an image.

I always create an Adjustment Layer for color correction tweaks close to the top of the composite. In this case, I add a little boost to the mid-tones with the Curves effect and Slightly cool the scene with a cool Photo Filter effect.

Now I add another Adjustment Layer and apply the Camera Lens Blur effect to generate just a touch of Depth of Field. In the Blur settings I assign my inactive ZDepth Layer as the Blur map and tweak the Blur Focal Distance so that the front of the building on the left is crisp with a slight blurring in the distance.

Finally, I add a simple exposure bloom by adding an Adjustment Layer just below my Color Correction Layer and applying a Gaussian Blur effect, along with a little Glow effect. I then set the Opacity of the layer down to just 5% to get just a hint of bloom (Fig.15).

In the final image I think I have achieved the feel of an exotic and colorful sunset from some remote corner of the globe (Fig.16). I hope you found some useful techniques for your own workflow.

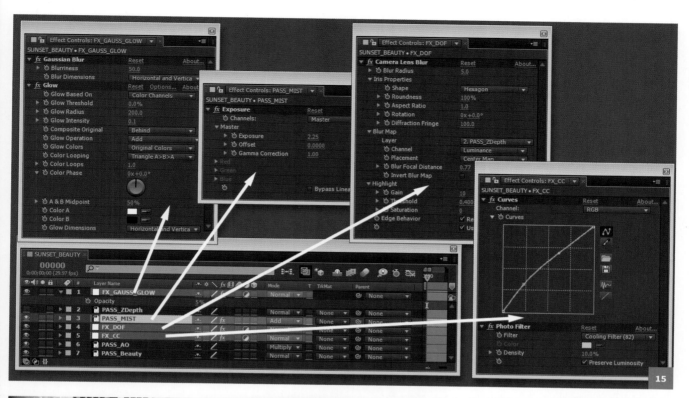

15

16

INTRODUCTION TO LIGHTING OUTDOOR SCENES
MOONLIGHT

BY ANDREW FINCH AND SAMUEL V. CONLOGUE

When I think of moonlit scenes, I automatically think of a full moon with no cloud cover. But for most urban night scenes, you can't just rely on the moonlight to light your image. Looking at the first part of this project, you can see that I used artificial lighting in the buildings and in the alley to help pick out detail within the image and help tell a story – which is the most important step of creating any art work. So, again, I will use moonlight to illuminate the scene, but to add character I will also use artificial lighting.

01

IDENTIFYING LIGHT SOURCES

I want the moonlight to come from behind the buildings and hit the right wall of the alley; this will give me a nice shadow from the roof tiles to add some interest. I could add some fake environment off camera to give me more points of interest, similar to what was covered in chapter one. But this time I want something more organic instead, so I go for tree shadows across the face of the buildings on the left and right.

Because the moonlight is coming from the rear, a natural shadow of the trees would not be possible. To get around this you can use street lights that are again off camera, but give enough light so the tree casts shadows into the scene. For the interior lights I will use the same process as chapter one where I carved out fake rooms and placed a light to simulate an interior light source.

DRAFT RENDER SETUP

The image before any lighting has been applied can again be seen in Fig.01.

As before, you can't expect to achieve the final result first time, so I configure sampling and Final Gather settings to low-quality draft, than set all Photometric Light shadow sampling to a value of 4.

Since the final image will be composited in After Effects, it is important the files output from 3ds Max are saved in OpenEXR file format at a gamma of 1.0. Also, don't forget to check the mental ray Frame Buffer is set to 32-bit mode in the Renderer tab of the Render Setup Box.

Again, I use mental ray Photographic Exposure and apply settings that work well for night

time photography. Like the foggy night scene from chapter one, I use a Shutter Speed of 1/30, F-Stop at 1.4 and an ISO of 1600. Lastly I double check that Gamma Correction is enabled. Now it's time to add light!

ENVIRONMENT LIGHT

I use a Photometric Light set to Uniform Diffuse for the moonlight and point it at the right wall of the alleyway (Fig.02). I set the Intensity to 30 LUX at 39m and enable Ray-traced shadows with a Disc Area shadow shape of 10cm. This will give me hard- to soft-edged shadows the further the light is cast from the occluding object. I then set the color to a cool 8000 degrees Kelvin.

You can see what we have so far with just the moonlight applied in Fig.03.

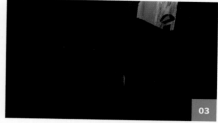

It's not very interesting at the moment but it doesn't need to be, we just need to concentrate on getting the moonlight to look good, then we can fill the scene out and create a nice composition.

For the tree shadows, I use a Photometric Light set to Spotlight. I then enable the Projector Map which allows you to add a texture to the light. I used a black-and-white image of a tree silhouette. The white areas of your image will be lit and the black areas will be in shadow

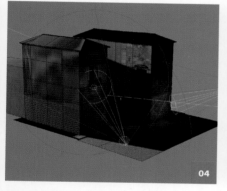

To create this effect, you place the image in the projection map slot located in the Advanced Effects tab of the light settings. I point this light at the wall on the right-hand side and give it an exaggerated cool color of 9000 degrees Kelvin to create the illusion of a very cool mercury-vapor street light. I set a very low Intensity of 110 Lumens as I want to imply that the light is a fair distance away, and to counteract the luminance 'focusing' effect of the photometric Spotlight. I then instance the light and point it at the wall on the left-hand side as well.

You can see a perspective view of the whole scene with my fake tree lights in Fig.04. Fig.05 shows a render of the newly placed tree shadows.

I'm happy with the tree lights and the moonlight but the shadowed areas are a little too dark. With such a strong moonlight and distant street lights, you would get some bounce light in the shadowed areas, so I place a Photometric Uniform Spherical Light higher up in the scene and towards the front of the alleyway. I give this light an Intensity of 1500 Lumens and a super-cool color of 12000 degrees Kelvin. This creates the effect of that cool, ambient light of street lamps and moonlight, with the post-dusk or pre-dawn blue tint of the sky (Fig.06).

07

ARTIFICIAL LIGHTING

I'm now happy with the environment lighting, so I move on to the interior lighting to add life to the image. For this, I use the same methods as described before. I carve out fake rooms and hollow out the window panes so the lights inside can escape the rooms and help to illuminate the street.

I decide that I will light the top floors only for this image, because not only do we have the street lamp lighting the alleyway, we also have the tree projection lights on the walls and I don't want these to get washed out, as they serve the purpose of setting the mood for the image.

I create a simple box that is open ended and make sure it surrounds the window area. I then cut out the window panes using the window texture as a guide. I then repeat this technique for all the lit windows and doors (Fig.07).

I create one Photometric Uniform Spherical Light then duplicate this in all of the other rooms, keeping roughly the same settings for now. All the light intensities fall somewhere between 1200 and 1800 Lumens with the colors ranging from 3200 and 3600 degrees Kelvin, which gives a nice warm tone similar to that which an incandescent light gives off. I give the lights in the rooms on the upper left and right sides of the image the highest intensities at 1500 and 1800 Lumens respectively. The middle window and door share the same intensity at a dimmer 1200 Lumens.

It is always a good idea to vary the intensities and colors of lights in artificially-lit scenes to help add some real-world inconsistency. With this in mind, I decide to add a light above the stairs behind the archway, similar to the one in the foggy scene. But this

08

09

time, rather than faking bounce light from the moon, I want to imply an unseen cool fluorescent light attached to the wall left of the stairs. This will help balance all the warm light cast by the interior spaces and street lamp, while also creating a nice cool highlight down the left side of the alley.

This is achieved with a Photometric Uniform Diffuse Light, aimed slightly toward the wall, with an intensity of 1700 Lumens and an exaggerated coolness of 8000 degrees Kelvin. I set the Area Shadow shape to a 7cm disc to soften the shadow a bit. With all the lights set up, except for the street lamp, let's do a quick render to see how this looks (Fig.08).

For the street lamp in the alley I use a Photometric Uniform Spherical Light set to 1200 Lumens and a medium-warm 4200 degrees Kelvin. I set the Area Light shape to Sphere with a size of 5cm. I also add a self-illuminating Archi-Design material to the lamp glass, making sure to disable Receive Shadows and Cast Shadows in the Object Properties (Fig.09). This helps to add punch to the street lamp and will also play a part in generating a Glare Effect I will create later for use in the compositing phase.

10

RENDERING

I set the renderer to medium image
precision and medium Final Gather settings.
I increase the size of the render to 1500
x 1125. With these settings I am able to
see any problems that may occur.

I am quite happy with the medium-sized
render and I can't see any major issues.

Some color correction, DOF and Subtle Glare
will need to be done while compositing in
After Effects, but this is normal with any
image; it adds that extra bit of polish to
the art work. I am now ready to go ahead
and set up a high-quality render.

The settings used for the large final render
can be seen in Fig.10. As with the other parts
of this lighting series, I will be generating
some additional passes like ZDepth and
Ambient Occlusion, but first I'll create my
final Beauty render in 3ds Max (Fig.11).

For the ZDepth and AO passes, I set
everything up just as I did in the first
chapter of this lighting series. The ZDepth
pass can be seen in Fig.12, and Fig.13
shows the Ambient Occlusion pass.

Now that I have everything, I can import
the passes into After Effects and start
the compositing stage. Well, I have
almost everything – first I'll show you
a cool trick with the mental ray Glare
Shader to generate my Glare pass.

For this shot I decide to add a touch of lens
flare/glare. I do this by using the mental ray
Glare Shader. The nice thing about the Glare
Shader is that it responds to all over-bright
elements of your render, not just the actual
light sources or light positions. So from light
bulbs to glints off shiny metal surfaces and
self-illuminated materials, you get a nice glare.

To render this pass, I will do a little
trick which will help us avoid rendering
the scene again and make generating
this pass almost instantaneous.

11

12

13

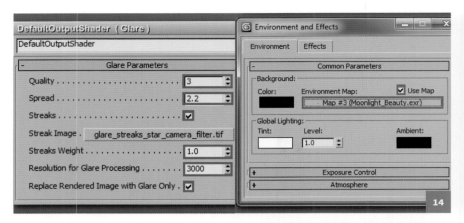

First, open a new instance of 3ds Max, assign mental ray as your render engine if it isn't by default. Then adjust your render settings as though these were the Final Render settings, except here you can disable Final Gather in the Indirect Illumination of the Render Setup Box. Now enable Output under Camera Effects in the Render tab, which already has the Glare Shader assigned. Drag the Glare Shader into the Material editor as an instance so adjustments can be made as needed.

But wait, the scene is empty – how are you going to generate glare from nothing? For this, I am going to re-use the Beauty pass I already rendered to provide the intensity and color information the Glare Shader requires. This is possible only because I have worked in 32-bit mode and saved in OpenEXR format.

I hit number 8 on the keyboard to load up the Environment Box where I click the empty Environment Map slot to load in the Beauty pass I already rendered (Fig.14). I then jump to the material editor and make some quick adjustments to the Glare Shader's settings, before doing my first glare test which will actually be at full resolution with final settings.

I hit Render and in 18 seconds I have a decent Glare pass (Fig.15). I'm pretty happy with the result so I'll save it, again as an OpenEXR with 1.0 Gamma.

If more tweaking were needed, I could have unchecked Replace Rendered Image with Glare Only to see the glare over the Beauty pass for fine tuning. Now I have the last of my passes and can jump into assembling my composite in After Effects.

COMPOSITING IN AFTER EFFECTS

I assemble my composite by first importing my Beauty, AO, ZDepth and Glare passes. Then I right-click my beauty pass and hit Create New Comp From Selection. Since I am working with OpenEXR footage, I click the 8 bpc button at the bottom of the Project Panel. I change the Depth to 32 bits, select the sRGB Working Space and click Linearize Working Space.

Next I drag the remaining passes into my composite with the order, visibility and blending modes found in Fig.16.

It's worth noting that all of the passes will come into the composite with the Alpha enabled. This is not always desirable, so I initially set the Alpha to be ignored (except for the Glare pass) through the Interpret Footage dialog box accessed by right-clicking on the footage in the Project Panel.

The assembled composite before any tweaks or FX can be seen in Fig.17. This looks good but I still have more work to do, so time to move on to finalization!

It's time to set up my Adjustment Layers and other FX. I add a layer of subtle Glow above the AO and Beauty passes with a very low intensity of .02, then set a large Glow Radius of 120 to keep the effect very subtle and atmospheric. Though this is a clear evening, the image could use just a touch of atmospheric depth fog.

To do this, I re-purpose the ZDepth pass by making a copy of the disabled ZDepth layer already present in the composite. I then enable the layer, set the Mode to Screen and hit T on the keyboard to bring up the Opacity and set it to a value of 1%.

As this is creating a foreground fog, I add an Invert effect to flip the White to Black values which cause the fog to build up in the distance rather than close to camera. This is very subtle, but these little adjustments and enhancements are what really add polish to an image.

Now I add another Adjustment Layer and apply the Camera Lens Blur effect to generate just a touch of Depth of Field. In the Blur settings, I assign my inactive ZDepth Layer as the Blur Map and tweak the Blur Focal Distance, so that the cobbled stones at the depth of the street lamp are crisp with slight blurring both near and far from the camera.

I have already dropped in my Glare pass during the assembly phase, but I want to point out how nicely that quick Glare pass sits in the composite – just a hint of glare without overdoing it. An alternative way to handle the Glare Layer is to ignore the Alpha and set the Mode to ADD. This will slightly boost the effect and be more correct mathematically. Also, the great thing about 32-bit workflow is that if I wanted to really boost that glare, I have a ton of color information to work with!

Lastly, I want to do a little directed color correction and add some film noise. For the directed color correction, I essentially create a vignette that will cool and underexpose parts of the image by drawing a V-shaped mask with a large 300-pixel feathering set to Invert, along with some Curves, Desaturation and cooling photo filter effects applied to the layer (Fig.18)

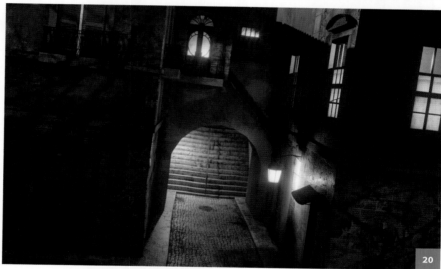

I don't always add grain to my images but anything you can do to avoid the perfectly clean images that renders typically produce is probably a good idea. Though I think most photographers would be baffled by the idea of adding grain rather than trying to avoid it!

To add some film grain I create a new Adjustment Layer at the top of the composite and apply the Add Grain effect. I select Eastman EXR 50D (5245) film and make some tweaks to reduce the intensity and size of the grain. I also adjust the tones affected so that the shadows receive more grain than mid-tones and highlights, as you would observe with real digital and film cameras.

A snapshot of the effects and settings I apply to the composite can be seen in Fig.19, and Fig.20 shows my final composite.

I'm very happy with the final piece. Bringing the image to life by telling a story through contrasts in color, illumination and shadow was the goal and I think I have achieved that. Most importantly, I hope you were able to follow this tutorial and find some useful techniques for your own workflow.

INTRODUCTION TO LIGHTING OUTDOOR SCENES
MIDDAY SUN

BY ANDREW FINCH AND SAMUEL V. CONLOGUE

For midday sun I think of baking hot weather, sunlight bouncing off surfaces creating hot spots on the walls, and windows casting intense light from the sun. Shadows will also play an equally important part in this image: for midday, shadows need to be sharpened and at a steep angle to give the illusion of the sun being almost directly above you.

> " There will be no artificial light in this scene as it is the middle of the day, any interior lighting would be severely underexposed and likely not visible "

I also imagine the sky to be a bright blue with no cloud cover. This blue sky will just show through at the top of the image adding a nice spot of color. A problem that we will need to overcome will be the intense light from the sun washing out the color of the buildings and removing the detail from the textures and bump maps.

IDENTIFYING LIGHT SOURCES

There are two main sources of light for this image. The main one is the sunlight and the

01

02

second one is the ambient light from the sky filling the dark shadowed areas with light. For the sunlight, I will be using the Daylight System to create a realistic-looking sun, and an HDR map to help create the secondary light source. There will be no artificial light in this scene as it is the middle of the day, any interior lighting would be severely underexposed and likely not visible.

DRAFT RENDER

For the draft render, a lot of tweaking could potentially be very time-consuming, so I configure my sampling and Final Gather settings to low-quality draft settings to speed things up. Screenshots of all my draft render settings are shown in chapter one, **Fig.03** for reference.

I check the mental ray Frame Buffer is set to 32-bit mode in the Renderer tab of the Render Setup Box. Again, I'm using mental ray Photographic Exposure, but this time I apply settings appropriate for midday photography. I use a Shutter Speed of 1/250, F-Stop of 5.6 and an ISO of 200. Enable Gamma Correction.

SUNLIGHT

The sun is created using the Daylight System. This is located in the Create tab under systems. When you click on Daylight System you will be asked if you want to change the exposure settings. It's important to click yes, though this sets an EV value rather than manual exposure. I prefer the manual settings I mentioned earlier, so I change them accordingly. In the viewport you click-and-drag a compass, then when you release the mouse button the sun is created and you can position it quite high above the scene to simulate the high midday sun (Fig.01).

If you hit render now you will get an uninteresting image, but we are using the default settings and even shadows aren't yet enabled (Fig.02). We need to alter many settings to get the desired effect; I will start from the top and work my way down the properties of the Daylight System.

I don't really change that much in the Daylight System, but I know I want stronger, sharper shadows, so I make adjustments with that in mind. The settings I used for

the Daylight System is shown in Fig.03. For the Daylight Parameters, ensure Sunlight and Skylight are ticked and choose mr Sun and mr Sky respectively.

Ensure that for Position, Manual is ticked – this allows us to move the sun to where we need it.

For the mr Sun Basic Parameters, set the Shadows to On with a Softness of 0.5 and Softness Samples of 24. The mr Sky Parameters are the same except the Multiplier setting, which is changed to 0.25.

I got to the settings above by tweaking the values and test rendering until I was happy with the shadows, the intensity of the light and bounce light. We also need to change the settings in Exposure Control to further refine the render. This can be accessed by going to Rendering > Environment in the menu or by pressing 8.

In Fig.04, the settings I use for Exposure Control are shown. The Shutter Speed is 1/250, F-Stop is 5.6 and the ISO is set to 200.

In the Image Control section, set the Highlights (Burn) to 0.25 and Vignetting to 4.0.

So with all that done it's time for a medium render and a check for any issues before we start the final large render.

RENDERING

I set the renderer to medium image precision and medium Final Gather settings, then increase the size of the render to 1500 x 1125. With these settings I am able to see any problems that may occur.

Looking at the medium render I can see a problem: the colors are being washed out by the intense light cast by the sun and the red archway doesn't stand out next to the beige and brown walls that surround it. This shouldn't be the case, as the red wall ought to stand out.

The blue shutters (upper left) are also over-exposed in places, washing away the blue color. I think all of the textures could do with some touch-ups in Photoshop. Doing a simple level

03

04

05

adjustment brings out the detail and darkens the texture. Now when the intense light hits the walls the textures won't be lost. You can see a before and after of the textures in Fig.05.

I hit render once more with the medium settings to check that the textures were now displaying correctly. I am quite happy with the medium-sized render and I can't see any major issues. I am now ready to go ahead and set up a high-quality render. The settings used for the large final render are shown in Fig.06.

> " Doing a simple level adjustment brings out the detail and darkens the texture "

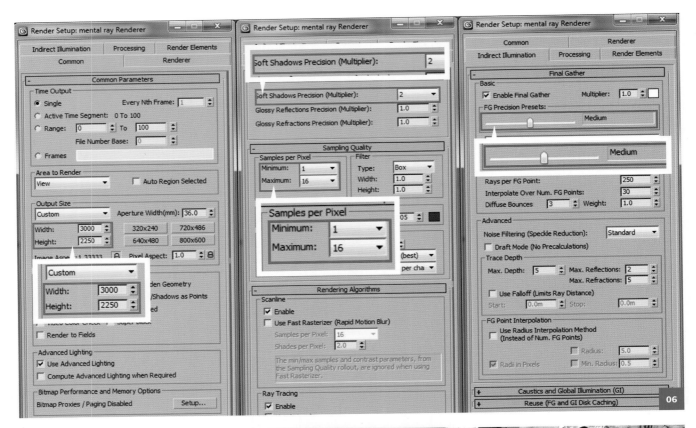

As with the other parts of this lighting project, I will be generating some additional passes like ZDepth and Ambient Occlusion, but first I'll create my final Beauty render with the mental ray renderer (Fig.07).

For the ZDepth and AO Passes, I set everything up just as I did in the first part of this lighting series as seen in **Fig.26** of chapter one. I also decide to create a very subtle mist pass to add some atmospherics to the final composite. I use the same settings as before but I reduce the RGB values of the volume color down to .005 across the board as I only need a little bit of misting.

Now that I have everything, I can import the passes into After Effects and start the compositing stage.

FINALIZING THE COMPOSITE

I assemble my composite just as I have in the previous sections of this lighting project. Since there is not as much post work to do on this image, I'll jump ahead to tweaking in After Effects.

I notice that there are parts of the AO pass creating darkened edges where direct sunlight is falling, which wouldn't happen in the real world, so I create a feathered mask to direct where I want AO and where I don't. Then I add Camera Lens Blur to the DOF layer with the focus being the red archway. Lastly, I add a Gauss Glow setup

similar to what I did in the Sunrise/Sunset scene. This helped to add that touch of glow/glare that occurs in over-exposed images.

The settings for my composite in After Effects are shown in Fig.08, and you can see the final image in Fig.09.

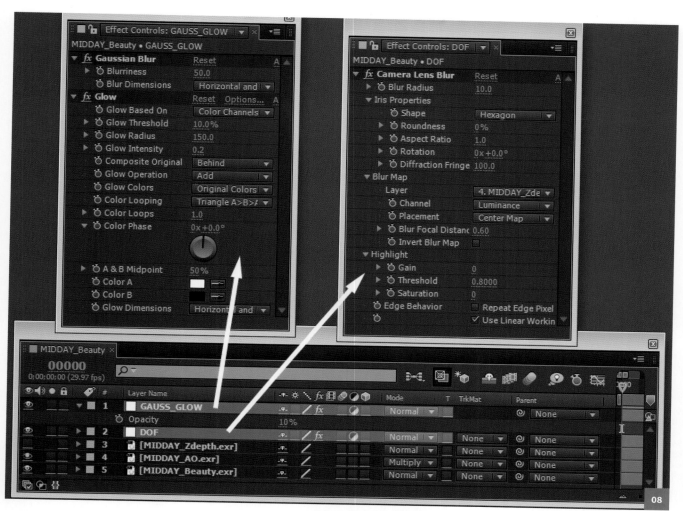

I am happy with the final outcome for this render. I feel I have achieved the effect of a hot sunny day with plenty of hot spots, and was able to keep the color in the textures from being washed out under the intense light from the sun. The blue sky also adds a nice touch to the composition. I hope you have learned something new from this chapter.

INTRODUCTION TO LIGHTING OUTDOOR SCENES
OVERCAST

BY ANDREW FINCH AND SAMUEL V. CONLOGUE

Overcast is going to be quite a hard subject to get a good result from because overcast usually means dull and uninteresting, the lighting will be very soft with no hard shadows to help create depth to the image, and no strong light from the sun to pick out the colors in the textures of the buildings.

So to get a good result we could maybe have a break in the clouds to allow some light through – just strong enough to pick out the detail and create some highlights on the edges of the geometry to pick them out. Because it's dark we could also have one or two interior lights creating some points of interest.

The weather plays an important part in this image. I will use grey clouds that are not too dark because we don't want to make the viewer think it is night time. This would be very easy to do because of the lack of sunlight and because the interior lights are on. I will also add some atmospheric fogging and maybe a rain effect to help convince the viewer it is overcast.

01

IDENTIFYING LIGHT SOURCES

There is usually no direct source of light in an overcast day. The light bouncing around the clouds illuminates the environment from multiple angles, but I want to create a break in the clouds to get some direct light and get some darker shadows, but with very soft edges. Some of the interior lights will be on but won't have enough power to illuminate the street scene, because it is still day time and the interior lights won't

have enough power to make an effect on the surroundings. We will have to use a lot of bounce light to help illuminate the scene from all angles. I am going to use the same lighting system I used for midday sun.

I used the Daylight System to achieve a baking hot day and create bounce light from the blue sky. I will use the same techniques to achieve an overcast day.

DRAFT RENDER SETUP

I configure my sampling and Final Gather settings to low quality draft settings, for speed.

Screenshots of all my draft render settings are shown in chapter one, **Fig.03** for reference. As I did previously, I check the mental ray Frame Buffer is set to 32-bit mode in the Renderer tab of the Render Setup Box.

OVERCAST LIGHT

The overcast light is created using the Daylight System. Again, click yes when you are asked if you want to change the exposure settings as this will give better results in the final render.

In the viewport click-and-drag a compass, then when you release the mouse button

the sun object is then created and you can position this quite high above the scene to simulate the sun (Fig.01).

I will be making many adjustments to the Daylight System, Exposure Controls and adding an HDRI image to use in our Environment slot to add ambient light and our background clouds.

The following settings for the Daylight Parameters are used: the Sunlight is mr Sun, Skylight is Skylight (this will look to the Scene Environment) and Position is Manual (which will allow us to place the sun exactly where we want it).

The mr Sun Basic Parameters are: Sun Multiplier set to 0.7; Shadows set to On; the Softness is set to 30 and the Softness Samples to 28.

The Skylight Parameters have Multiplier set to 3 and Sky Color > Use Scene Environment selected.

It takes many test renders and tweaks to arrive at these settings, but the idea is that pushing the sun's shadows to very soft settings, coupled with boosting the scene environment (our HDRI), would achieve a soft-lit look that was not a drab just flat ambient light. We also need to change the settings in Exposure Control to get a better render. This can be accessed by going to Rendering > Environment in the menu or by pressing 8.

COMMON PARAMETERS:

Check Use Map then load a spherical HDRI map in the map slot. They can be found quite easily if you search for them and download one that you like the look of. Typically, you load an HDRI in with a Gamma of 1.0, in this case I adjust the input Gamma on the HDRI to 0.8 to help Sharpen the muted sunlight to add a little more color variation.

For Exposure Control, in the drop-down menu, select mr Photographic Exposure Control. In the mr Photographic section, select Exposure Control and Photographic Exposure, but uncheck Process Background and Environment Maps.

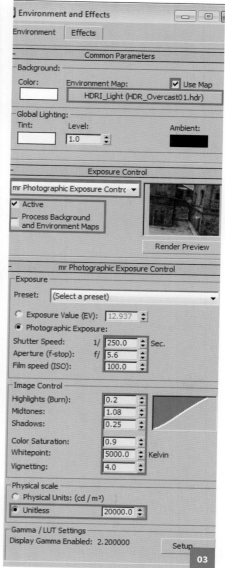

Exposure:
The Exposure settings I use for this scene are a Shutter Speed of 1/250, F-Stop of 5.6 and an ISO of 100.

I also make some changes to the Image Control panel: Highlights edited to 0.2; Midtones 1.08; Shadows 0.25; Colour Saturation 0.9; Whitepoint 5000 Kelvin; Vignetting 4; and in Physical scale check the Unitless setting is at 20000.

Because the HDRI Map in the Environment slot is out of scale according to the real world, we need to scale down the properties so we get a more accurate calculation of daylight. I find a Physical Scale of 20000 works well for this scene.

The settings for my Daylight System can be seen in Fig.02, and the settings for the Environment Window are shown in Fig.03.

"Scale according to the real world, we need to scale down the properties so we get a more accurate calculation of daylight"

With all the setting done we need to change some things with the HDR map. With the Environment and Effects window still open, click-and-drag the HDR map into an empty slot in the material editor and click Instance.

For the coordinates, check Environ and change the Mapping to Spherical Environment. This will wrap the HDR image around the scene.

For the interior lights, I place mr Omni lights inside a fake room on the upper right and upper left where I have carved out interior spaces using the same techniques as

described previously. I give the Omni light an orange tint and a low power (Fig.04).

RENDERING

I set the renderer to medium Image Precision and medium Final Gather settings. I increase the size of the render to 1500 x 1125. With these settings I am now able to see any problems that may occur.

I am quite happy with the medium-sized render and I can't see any major issues. I'm now ready to go ahead and set up a high-quality render (Fig.05-06).

As previously in this lighting project, I will be generating some additional passes like ZDepth and Ambient Occlusion, but first I'll create my final Beauty render in 3ds Max.

For the ZDepth and AO passes I set everything up just as I did in the first chapter of this lighting project. With everything in place, I can import the passes into After Effects and start the compositing stage.

FINALIZING THE COMPOSITE

I assemble my composite just as I have in the previous chapters of this lighting project. First I import my Beauty, AO and ZDepth passes, set the workspace to 32-bit, sRGB Working Space and enable Linearize Working Space to be sure my composite is working at full color precision.

Now to jump into After Effects to complete the look of the image. I feel that the Image lacks atmosphere, so my goal in After Effects is to build up that atmosphere using a number of techniques. I quickly create some fake depth fog by duplicating my ZDepth pass, enabling the layer, adding an Invert Channel effect and lastly reducing the Opacity to a subtle 5%. This really helps add some depth to the image.

Next I add a warm (on the bottom) to cool (on the top) color Ramp effect to a new Adjustment Layer and set the Mode to Color with Opacity of 5%. This creates a sense of hue shift from the ground up into the mist. The last two atmospheric layers are some drizzle via the CC Rainfall effect and a Gaussian Glow Layer.

Now that we have some real weather going on, I add some subtle Camera Focal Blur and a directed Vignette to add a slight under-exposed blue tint to the front faces of the two buildings, via a dark-blue Solid Layer with a feathered Mask and low Opacity (Fig.07-08).

I now feel the final render shows a dull overcast day. I found it quite a challenge to get a good result without the image being... well... too dull! Little effects like slight fogging and rain help to achieve the mood;

also, the lighter grey clouds keep the image from looking like a night time render.

> " **The last two atmospheric layers are some drizzle via the CC Rainfall effect and a Gaussian Glow Layer** "

FX PARTICLES AND DYNAMICS

By Matt Chandler

7

DISCOVER HOW TO EFFECTIVELY USE PARTICLE DYNAMICS TO MASTER CONVINCING FIRE, SMOKE AND LIQUIDS

Mastering particle effects is an incredibly useful 3D skill that can be applicable to both animation as well as when trying to achieve naturalism in successful environmental images, whether realistic or fictional.

In this project, Matt Chandler guides you through some of the most common and popular effects that you can create in 3ds Max, sharing the relevant techniques and settings that will allow you to manipulate objects to create stunning effects.

FREE RESOURCES

Download your free resource pack for this project

www.3dtotalpublishing.com

FX PARTICLES AND DYNAMICS
LIQUIDS

BY MATT CHANDLER

As well as being useful for character creation, hard-surface modeling, texturing, lighting, rigging and animation, 3ds Max is also a powerful visual effects (VFX) tool, capable of creating a wide variety of content.

Generally, it's good practise – and also economical – to try and keep your project work confined to a select number of applications, such as 3ds Max for 3D work and Photoshop for texturing, and so on. However, there are times where the content we wish to create is either limited within our application of choice, or perhaps absent altogether. This chapter is going to look at a beginner to intermediate project that includes some fluid simulation using 3ds Max and RealFlow (**http://realflow.com**).

In the same way that two modeling artists may model the same head, each using different tools and/or methods to create it, effects such as fluid simulations – water, molten lava, paint and so on – can also be created with a variety of techniques. We can usually make a well-educated guess as to which method we should use to complete a particular effect. A typical example of such a scenario would be to create the surface of the ocean. Would we use a simple plane with appropriate deformers and animation to create the illusion of a rolling surface? Or should we simulate a huge data set within fluid simulation software, using a vast amount of system resources, when the end result for both may end up looking the same? This depends entirely on many contributing factors to a VFX shot and sometimes you may end up combining multiple methods to get the job done.

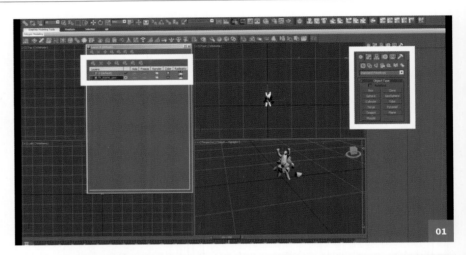

01

02

In a video accompanying this project (you can download free resources for this chapter from **www.3dtotalpublishing.com/resources. html**), I briefly go over some options for pseudo fluid FX directly inside 3ds Max, which may be applied to a wide variety of VFX shots.

There are times, however, where 'faking it' simply won't be good enough, so we must spend time using more complex methods, and even software, to achieve more realistic results.

In this project we'll take a cached scene from 3ds Max and import it into RealFlow to create some believable fluid simulations. RealFlow has become something of an industry standard application for CGI fluids/particle simulations and it allows us to create anything from raindrops to rolling ocean waves.

To get started, open the 3ds Max scene file (Fluid_scene.max) provided with this chapter. This will work with 3ds Max 2010 and

" **The aim is to have a figure rising from the ground; as he does, rocks are pulled towards him, colliding with one another and spinning and falling to the ground – almost as if our character can control his physical surroundings** "

later. The scene contains a low-resolution mesh/figure and some rock geometry. You may need to reload/redirect the point cache file to see the animation. You will find the PC file in the Assets folder.

The aim is to have a figure rising from the ground; as he does, rocks are pulled towards him, colliding with one another and spinning and falling to the ground – almost as if our character can control his physical surroundings. I created the rocks with Rigid-body dynamics, and the figure is an altered and reversed motion-capture file (Fig.01).

Note: It's very important to work at the appropriate scale when exchanging data to and from other applications. To make sure your scene will import and export correctly into RealFlow, be sure to switch the units in 3ds Max to Meters.

Now make a 1 x 1 x 1-meter cube and export it as an OBJ or a RF SD file. Each grid/square in the RealFlow viewport represents 1 meter in scale, so by importing the cube you can ensure your geometry is importing correctly, or you can make some adjustments in your 3ds Max scene to help RealFlow import at the desired size/scale.

You'll want to export the scene as an SD file, as the scene contains both animation and deformation. Under the SD file export settings menu (find this on your 3ds Max toolbar) ensure you've selected the objects you want to export; check Deformation is turned on to auto; make sure the frame range is correct; and be sure you've set a path to export to. Click Export and you should see a progress bar informing you that it has been successfully exported (Fig.02).

Now in RealFlow, import the SD file you've just created. It's good practise to keep the SD file inside the Objects folder that RealFlow will create when you start a new project. Scrub the timeline to ensure the file has come across correctly.

There are many fluid emitters in RealFlow. We'll use the powerful Object emitter to have our character emit fluids from his body. Create an Object emitter from the Emitters menu.

On the left side of RealFlow are the Nodes and Links tabs, which list everything that's currently in the scene and what's affecting what. So far we have rocks, the figure and our newly created Object01 Fluid Emitter node.

Select the node and look to the parameters on the right side of RealFlow. Whatever node or object you select from your Nodes list, the parameters and controls should appear on the right side by default (Fig.03). Leave all the fluid settings at their default values for now, and scroll down until you see the Object tab. We need to add our figure so that particles know where and what to emit from. So click on the object list and add the figure. If you hit Simulate now you will see particles flying out in random directions and lines from the figure mesh. If you don't, ensure there's a value under the Speed tab, otherwise the particles will not appear. Now add gravity to the scene: go to the Daemon menu and select Gravity (Fig.04).

There is a wide variety of daemons within RealFlow, from which interesting and powerful effects can be created when combining them. Note that there is now a Gravity01 file listed under the Nodes tab, and within the Global Links tab. Hit Simulate again and you will see that the particles are now affected by gravity, and fall downwards (Fig.05).

We now need to define the boundaries of our simulation by creating some additional geometry to stop the particles falling and flying off into infinity. You could prepare some geometry within 3ds Max with your scene and import it, or we could create some basic shapes within RealFlow itself.

Create a cylinder from the Geometry menu within RealFlow. Use the Transform and Scale tools to position and resize it. Note the cylinder appears in the Nodes and Global Links tabs.

Whatever objects appear in the Global Links tab do just that; they are all globally linked, meaning that they will all interact and participate in the simulation. The cylinder will act as a ground place and container to the particles. Also note here the options available under Parameters when the cylinder is selected. You can adjust tolerances and behaviors, such as friction and how sticky the cylinder surface might be (Fig.06).

Add a new Daemon called 'K Volume' to the scene. This is a simple container daemon that will further help to keep our particles under control. Any particles that escape boundaries/volume of this daemon are killed off. Use the Translate and Scale tools to move the K Volume Daemon into place (Fig.07). Simulate again.

Fluid is emitted from the figure and interacts with the ground and other geometry in the scene. Now the basic scene is set we can start altering some parameters and refining the fluid simulation. To speed up testing the simulation, select the Object emitter node and, under Resolution, reduce the value to 1 or lower. Resolution is an important parameter that defines how many particles are emitted into the scene. Generally, the more you have, the more realistic and detailed the simulation will be.

05

06

07

Let's add another Daemon called 'Surface Tension'. This daemon will help to keep the particles together and stop them separating too much. Run the simulation again for a few frames to see the results. Also try altering the Emission speed, under the Object emitter node, to get different results. Also enter a value under Randomness to encourage a more random emission pattern from the figure. Set Randomness to 1 and Jitter to 0.6, then hit Simulate (Fig.07).

Now let's animate the Emitter, as we want the figure to stop emitting fluids. By right-clicking on the desired parameter while the emitter is selected, you will bring up a menu where we can add animation keys. To set the speed to 0 at frame 0, right-click on the Speed tab and add a key. At frame 30, set Speed to 2, right-click and add a key. Go to frame 180 and add another key. Then move to frame 190 and set Speed to 0 and add a final key.

Hit Simulate and see how the fluids emit and then stop. You may wish to alter the key frames or values. Right-click on the Speed tab again and select Curves. This opens a typical animation curves rollout/ graph where we can see animation keys and interpolation. Adjust the curves to your liking.

Select the Object emitter again and raise the Resolution to 1. Let's also change the Internal and External Pressure values: set Internal Pressure to 1, or 0.98, and set External Pressure to 3. You may also wish to try different values for Viscosity, depending on the effect you are after. The default of 3 or 4 will behave like water – something like 8 will begin to move much more like slime or lava.

Some of the particles during the simulation may appear to shoot off occasionally due to high speeds/velocities. To keep our scene clean we can add a K Speed Daemon to it. This daemon has some tolerance parameters that will evaluate how fast particles are travelling, and will kill them should they be going too fast. We need to find out how fast our particles are travelling to be able to put a useful value into the K Speed Daemon. So select the Object emitter and, under the Node parameters, look under the Display menu for the total. By default, you will see the velocity, and as you scrub the timeline you can see the particle minimum and maximum speeds (Fig.08).

If your particles have an average speed of 15, for example, enter 20 or more under the K Speed Daemon Max Speed value and hit Simulate. There should be a visible reduction of stray single particles that leave the main body of fluid. The particles' speed is tested and if they exceed the max value, they are deleted.

Other daemons you could add are Drag and perhaps a Noise Daemon. Drag is a useful feature that adds a level of resistance and dampening to the speed of the simulation, as if the particles are being affected by air resistance. The Noise Daemon can be useful in creating some randomness to the shapes and the flow of fluid over time. Again, these daemons can be animated to only affect the particles at the desired time in the simulation.

FX PARTICLES AND DYNAMICS
SMOKE

BY MATT CHANDLER

3ds Max has a wealth of third-party support, which means we have many options for creating effects using scripts, plug-ins and officially supported software that installs and integrates directly.

In the accompanying video to this chapter (video.01 – download resources from **www.3dtotalpublishing.com/resources. html**), I take a brief look at using Particle Flow (PFlow) to create some small, simple smoke effects, and discuss some of the limitations you may encounter along the way.

In recent years, the tool of choice for a plethora of smoke and fluid dynamic behaviors has been the FumeFX plug-in by Sitni Sati (**www.afterworks.com**). This tool allows us to create both fire and smoke effects that range from a small campfire to a volcanic eruptions. It also allows us to create realistic smoke effects while being able to control the appearance and behavior for some amazingly realistic (and impossible) visual effects.

In this chapter we will be using a simple animated character mesh to emit smoke into our scene, creating a smoky figure that leaves a trail of dissipating smoke. It is assumed you already have a fundamental operating knowledge of FumeFX.

Open up the 3ds Max file named 'smoke_scene. max' supplied with this chapter. You'll find a low-resolution character mesh with a Point Cache Modifier. You may need to redirect the point cache to the included point cache file. The included scene file is the file I used when recording the accompanying

01

02

video guide, and contains the final FumeFX scene for you to use and refer to as well.

Start by creating a new FumeFX grid (Fig.01). Study the path of the animated character, positioning and scaling the grid/ simulation box to contain the character.

If the character walks outside of the box, FumeFX will no longer see the mesh and won't be able to calculate any cool smoke (Fig.02).

Now we need to tell FumeFX to see our character mesh and, most importantly, emit smoke from the surface and be influenced by the velocities of the moving mesh. Under the Helpers tab there is a FumeFX menu. In the video guide, I go over a few of these Helpers and describe what they do. In this case, we want to use an Object Src Helper. Select this and drag it out into the viewport.

With the Helper selected you can add the character mesh to the Helper. Then select the FumeFX grid and open up the UI. Under the Obj/Src tab add the Object Source helper. This means FumeFX can now 'see' the figure in the scene and will use it as an emission object.

Before we hit the Simulate button, go to the Sim tab in the FumeFX UI and adjust the Maximum Iterations spinner to something like 90. The default is 200; it's good practise to reduce this for testing, and even for final simulations, to optimize simulation times. Also move the Quality spinner to 6. Almost all FumeFX scenes I've worked on/developed never have a quality value above six or seven.

Since FumeFX can simulate fire and smoke, in this case we want to turn off the fire visibility and fuel emission that drives the fire. (We'll cover fire simulation and effects in another chapter). Disable the fire by unchecking the Simulate Fuel tickbox under the Fuel tab. And just to keep things clean, under the Rendering tab uncheck the Fire checkbox as well. There is now no fuel being emitted into the scene to establish a fire.

Note: To get faster simulations and previews, remember to increase the spacing value of the fume grid; the lower the number, the finer the simulation and therefore the longer the simulation times.

Hit the Simulate button and let the default values of fume simulate out for a few frames (Fig.03). Inside the FumeFX preview window you can see the character mesh emitting smoke from its surface, and the smoke is rising rapidly due to a combination of the temperature values, buoyancy and gravity settings. If you can't see much detail in the preview, try lowering the spacing value back down slightly and re-simulating for a clearer result.

To address the smoke rising too fast – it's better if it trails behind the character and falls to the ground – under the Simulation tab there's a Blocking Sides section; select the Z axis and set it to –Z. Any smoke that has been emitted within the container and meets the bottom will now collide and move across the ground (Fig.04).

> **" Increase the spacing value of the fume grid; the lower the number, the finer the simulation "**

03

04

Let's lower the timescale value down from the default of 1 to something like 0.6. This will help slow the smoke movement and make the simulation appear larger. We can also add more velocity influence from the character mesh by going to the Obj/Src tab and, under the Velocity menu, increase the object's velocity value to something above the default value 1. This means the character's body movements will push the smoke around more forcefully – similar to what happens when you wave your hand through a cloud of smoke.

Re-simulate and look at the results. The smoke is behaving more interestingly, for sure, but it's still rising too fast… There are various ways to address this and control the smoke, so let's try changing the Smoke Buoyancy to something like -20 first. Now when you re-simulate, the smoke still rises, but it's not as buoyant and leaves more of a trail that lingers behind the character. Some of the smoke also now falls around the character's feet and interacts with the ground that we set up earlier by setting the –Z on the fume grid.

Note: Try adding a Gravity Vector Helper from the FumeFX Helpers and adding it to the Obj/

Src menu within FumeFX. You can force the gravity direction with this Helper to get the smoke to travel in a desired direction (**Fig.05**).

One thing you may notice when using a mesh/object as a smoke emission source is that the smoke is emitted from the surface/normal of the mesh. This can result in what looks like a void or empty space inside the smoke. Perhaps this is what you want, as it may be required in some cases. In this example, though, we just want a smoky figure.

A simple way to help eliminate this problem is to edit the mesh object. Select the character mesh, apply a Push modifier and set a small minus value. This modifier pushes or pulls the mesh along its normal, and so setting a minus value causes some weird/ugly areas on the mesh as surfaces intersect with one another.

05

06

07

In this case, this isn't a problem, as we'll not be rendering the mesh. Re-simulate again and examine the results (Fig.06).

We can still recognize a character's form, but since the normals of the mesh are now intersecting – and somewhat noisy – the smoke emission is much more random and we get a much better result.

We are almost ready to run a final simulation now, so after you're happy with tweaking other values within FumeFX – and even animating them (I discuss this and adjusting turbulence values in the video guide with this chapter), lower the Spacing value to something like 0.3, and then hit Simulate.

08

The more powerful your machine/hardware the faster FumeFX will operate. I'm using an 8-core I7 with 16GB RAM, and this scene takes around 10 minutes to solve with a low Spacing value.

Note: In the video guide with this chapter, I go over various options for rendering the smoke, such as using temperature and velocity channels for different looks from the same simulation.

Let's look at the rendering settings for our smoky character. Under the Rendering tab in the Fume UI, there's a Smoke Color box where

we can set a single color or a gradient. Try playing with the Color tab to find something suitable for your project, and also try playing with the opacity curve. Adding points to this and setting unusual curve shapes can lead to cool results. I've selected a dark red color to render out, which you can see at the end of the video tutorial (Fig.07).

Before a final render, we need to add light(s) to the scene, and also add these to the FumeFX UI so it knows how to light the smoke. Create a standard spot light and position it appropriately in your scene. In the spot light

parameters, we must enable Shadows and select Raytraced. Scroll down and under the Shadow parameters tick the Atmosphere Shadows On checkbox. This is an important step, as the fume shader is considered an atmospheric effect, and shadows won't be calculated unless this is enabled.

Finally, we add the spot light to the FumeFX Illum tab. Use the Add button, and then go back to the Rendering tab and enable the Shadow checkboxes to receive and send shadows. Now you're all set for a render. Refer to the video guide to see the end results (Fig.08).

FX PARTICLES AND DYNAMICS
FIRE

BY MATT CHANDLER

Fluid simulation software and solvers have rapidly developed over the last few years, while simulation times have also been reduced by improving hardware. It's now almost standard – and expected – to use a fluid solver for an effect as complex, subtle and explosive as roaring flames.

Like the smoke-themed chapter, we will once again use the FumeFX plug-in in 3ds Max to create some rolling, realistic-looking flames. FumeFX is a powerful plug-in that's capable of simulating huge, large-scale fire and smoke phenomena as well as something as simple as a single candle flame.

Begin by creating a new 3ds Max scene and set the Frame Rate to Film, or your preferred FPS. Increase Scene Duration to 500 frames in length. Then create a FumeFX container by clicking and dragging after you've selected it from the drop-down menu list. The 3ds Max scene units are usually set to Generic, so to start with you should adjust these to Metric.

Make the container around 60 units in length, 60 in height and 30 in depth. We can adjust the Spacing value later (Fig.01). Simple FumeFX sources or object sources can all be used to emit fuel, fire, smoke and so on, but in this chapter we will make use of Particle Flow by passing the particles to the container.

Hit 6 to open the Particle View. Drag out a Standard Flow and align the Particle Flow emitter icon with the center of your fume grid. Make the size of the emitter icon around 30 units in length and 10 in width. The particles will be emitted from the surface area on the

01

02

basic icon. Within Particle View, remove the rotation, speed and shape operators from Event 01 on the particle tree (Fig.02).

Change the Birth operator start and stop to make it correspond with your scene length. In this case it's 500 frames. Also change Emission Amount to Rate; this way particles are emitted at a certain rate per second, and so our fire setup will be easily adjusted and continuous, should our scene later change in length.

If you scrub the timeline, particles will appear upon the icon surface and sit still. Since we removed the Speed operator the particles are simply born and don't travel anywhere. Add a Spawn operator to Event 01 and check the Delete 01 parent box. In the Offspring box, enter a value of 50. This means each emitted particle spawns 50 more and the original single parent particle is deleted.

Next drag a Speed operator out for the depot to create Event 02 with Particle Flow and set its Speed to 0. Also add a Delete operator beneath it and set it to By Particle Age with a Life Span of 8 and a Variation of 1 or 2. You can also change the Display operator to your preference. In this scene, I have set it to Lines to display the direction and velocity of the particles.

If you scrub the timeline, what you see will appear the same. This is because all of the spawned new particles are all exactly on top of one another and currently not visible. Adjust the Divergence spinner in the Spawn operator to spread the spawned particles (Fig.03).

Adjust the speed to a low value, such as 12, with a Variation of 4. Set Direction to Icon Center Out and check the Reverse button.

Now if you scrub the timeline, you will see small bursts of particles being emitted and all firing towards the centre of the icon. We will use these small pulses of particles as a fuel base for the fire effect within FumeFX. We can easily adjust the amount and rate of emission that will fuel our fire with this simple setup.

We now need to enable FumeFX to see our simple particle setup. Go to the Helpers menu and under the FumeFX Helpers select and create a Particle source. Select the Particle Flow system within the Particle Source Helper. Select the fume container and open the FumeFX UI. Under the general parameters be sure to set your desired output path for the simulation.

Fluid simulations can demand a lot of storage space and system resources, so it's a good idea to consider having a dedicated simulations drive.

Under the Simulation tab, change the Spacing value to 0.5. Since this is a fire tutorial – even though FumeFX can also simulate smoke at the same time that's directly influenced and even illuminated by the fire – let's disable Smoke Emission and concentrate on the fire for the time being. Disable the smoke by unchecking the Simulate Smoke box.

Change the Quality spinner to 6 or 7 and reduce the maximum Iterations value to around 80.

We want to introduce a little turbulence to our fire to create some breaking up effects, so also enter a low value of 0.4 into the Turbulence spinner. Under Turbulence Noise enter 5 for Scale and 25 for Frames. Then scroll down a little more and consider reducing the Burn Rate to something around 14. These basic first parameters should be a good start.

Before we simulate, however, we must add the particle emission to FumeFX. So go to the Obj/Src tab in the FumeFX UI and use the Selection tool to select the Particle Source Helper that we created earlier and linked to the particles.

Later in this workflow we'll be adding more detail to the fire by using the Wavelet Turbulence (WT) option. For this to work correctly later on, we need to enable Wavelet Turbulence under the Extra Detail tab now, and also add the Velocity channel to the simulated and exported channels. Extra detail is added automatically when you enable it.

Hit the Simulate button and let it run off a number of frames (Fig.04). You should see flames emitting from the small particle bursts, rising and licking upwards in a realistic way.

Let's improve the preview and forthcoming render by adjusting the flame colors and going to the Rendering tab in the FumeFX UI.

Under Fire you can adjust the flame color by either using solid colors or introducing a gradient ramp. You can download the gradient ramp I've created with the resources for this chapter, from **www.3dtotalpublishing.com/resources.html**. Load it into FumeFX by right-clicking the color swatch and selecting Load.

Now navigate to the Assets folder and load the fire_grad.agt. Feel free to move and adjust the color markers or introduce new ones depending on the look you're after. Increase the Opacity to 3.3 and reduce the Color spinner if the flames begin to look too saturated. Right-click and disable the Opacity curve box, too. You may wish to return to it later to adjust the opacity of the flames, but for now the flames will be controlled by their color and overall opacity (Fig.05).

Let's revise the simulation properties slightly. Decrease the Timescale value from its default of 1 to 0.75. This will help to make the fire look larger in scale as it burns. Reduce the Vorticity to 0.33 and Turbulence to 0.31. Under Turbulence Noise decrease the scale value to around 1; this will help add detail within the flames. Further down the options adjust both Burn Rate and Burn Rate Variation.

At this point, I should mention that these kinds of effects can be adjusted endlessly and frequently, depending on your taste and creativity. Should you want a fast-burning fire, for instance, you should increase the rate and corresponding values.

Increase Expansion to 1.34 next. Expansion means the ignition of the particle fuel being emitted will be a little larger, as if it's eating more oxygen as it burns. To counteract the 'blobbiness' of the fire that can sometimes happen when expansion is increased, go to the Obj tab and decrease Particle Radius to around 0.6.

There are many other parameters you can freely experiment with to obtain the fire results you want. In my case I have increased the velocity slightly, raised the temperature and added higher variation in the fuel emission. These will all help break up the fire and create more realistic variation.

Note: There is a hidden and unsupported method of forcing FumeFX to deal with scene setups differently – and sometimes more efficiently – if you want a larger scale simulation but don't want to increase your fume grid and then have to re-adjust all of your parameters.

Make sure your fume grid is selected and go to MAXScript and open the MAXScript Listener. Enter: $.systemscale =. After the equals (=) symbol, enter a value of 0.4. By default, the system scale is at 1.0; by changing this we're forcing FumeFX to handle scale and the parameters we've entered differently internally. You can change this back by re-entering the script with your desired value (Fig.06).

Now we've adjusted many parameters and even altered the internal scale of the simulation to help get more detail in the fire. Lower Spacing on the FumeFX grid to 0.25 and hit Simulate. Remember to check your Simulation tab for the simulation range if you wish to simulate past 100 and the full length of your 3ds Max scene (Fig.07).

We now have a pretty detailed simulation with long flames rising, licking and breaking apart quite realistically. You can refer to the movie provided with this chapter to see my results (video.01).

This may be a successful result in many cases, but if more detail is required it means

lowering the Spacing even more, perhaps further adjusting parameters and having an even longer re-simulation time. Lowering the Spacing will create more detail, but since FumeFX version 2 there has been a secondary Wavelet Turbulence simulation option. This means that after your main fire or smoke simulation is complete you can add further scale and detail to the effect by switching on WT-P and running a secondary simulation on top of the original cache. Personally, I don't use this option all that frequently, but it can be a great timesaver upon occasion, and it works particularly well with flames.

Go to the drop-down menu Sim mode within the FumeFX UI and select Wavelet. We've now switched the Simulation mode to its Secondary Wavelet Turbulence mode; parameters for this can be seen under the WT-P tab. By default, it's going to double the scale of the grid internally, while keeping our original small grid size and cache intact. Note that the icon for the Simulate button has also changed to indicate we are in WT mode.

Since we're not simulating smoke, we can save some disk space by disabling the Smoke tab. Leave the other settings at their defaults and hit the Simulate button.

After the simulation has finished we now have two caches saved to disk: our initial fire setup and a detailed WT version. We can switch between these two – and even render both, if required – by selecting the cache with the Cache drop-down menu, in the FumeFX UI.

Some final adjustments before rendering would be to lower the Step Size % under the Rendering parameters; this will help reduce any banding or artefacts that can sometimes appear.

You can now render out your fire element as an EXR or another desired format. EXR is very useful as it keeps the effect afloat and is therefore very flexible in the compositing and color-grading stage. I've added some glow and color correction to my final render, which you can see in the accompanying video (video.02).

Note: To gain extra control in compositing and color-correction for your fire, try creating an RGB gradient in the Color swatch for your fire. By carefully adjusting the color sliders, you can position each of these colors from the inner of the flame to the outside edges.

Render this out as a powerful color channel mask for use in compositing.

Selecting a single channel (such as green) from this render allows you to isolate a specific region of the flame render.

Video.03 is supplied as a resource to encourage you to develop this simple particle setup to include object emitters and other burning fuel sources. Have fun!

" **After your main fire or smoke simulation is complete you can add further scale and detail to the effect by switching on WT-P and running a secondary simulation on top** "

FX PARTICLES AND DYNAMICS
SNOW

BY MATT CHANDLER

There can be a lot of variation in the way we add snow to a 3D scene, depending on the weather conditions we wish to portray. There can be dense blizzards, large flakes, sparse sprinklings or the familiar – and somewhat classic – fluttering snowfall, which can add a lot of atmosphere and romance to a scene.

Using Particle Flow and a number of standard Space Warp modifiers within 3ds Max we will add snow to a real production shot, and go over some render settings and render passes needed to add realism later in the compositing stage.

Note: You may need to download and install a plug-in/Space Warp called 'BetterWind', as this is used in the scene file that accompanies this tutorial. This is free to download and has expanded wind control parameters compared to the standard 3ds Max version. You can download the correct version for 3ds Max by going to **www.maxplugins.de** and searching for 'BetterWind' after selecting the version of 3ds Max that you're running.

The finished scene can be opened and examined by opening the scene file, 'Shot_001_ Snow_Track_001.max', which can be downloaded for this chapter from **www.3dtotalpublishing.com/resources. html**. This is a real production scene file from a commercial that my studio worked on. Note the tracking data/markers and moving/tracked camera that walks forwards a little before turning to face another direction (Fig.01).

If you open the Layers manager you can see the tracking information on a layer called

'tracking_ data'. It's important to always keep scene files tidy and organized, even if it's a relatively simple FX scene such as this.

We can reference the marker positions of the tracking data to correctly orientate and place our snow/particle emitters and deflectors. Having it on a separate layer means we can quickly and easily turn visibility on and off. Please feel free to use your own tracking data/camera-tracked scene to add snow to.

Open the supplied scene file, snow_start. max. As previously mentioned, we can find the tracking data in the Layers manager. Click the light-bulb icon to unhide the nulls/markers. We can clearly see the layout of the scene in the top view (Fig.02).

From the orthographic views we can see where the ground plane and walls should/might be from our tracked scene. Scrub the timeline and watch the scene through the

camera view. We can make out walls/sides to the street that the camera is moving along.

Hit 6 to open the Particle View. Drag out Standard Flow to create a default particle emitter with basic functions such as Speed and Shape. Delete the Speed and Shape nodes and change the Display type to Dots. We'll be using forces to add movement to the particles, and will later be instancing custom geometry for the snowflakes.

Select your Particle Flow icon in the viewport and move/rotate it into position above the camera and just out of view. Adjust the dimensions of the emitter to a large area so that when the snow particles are emitted, they fall over a wide area.

Add three Force operators to the Particle Flow. You could add just one, but by splitting all of the forces and influences over more Force nodes we will have finer controls later for getting realistic movement (Fig.03).

If you scrub the timeline, we can see that particles are emitted from frame zero over a default number of frames, but just remain static on the position icon's surface.

Next add a Gravity Space Warp to the scene and then add it to one of the Force operators we added to the Particle Flow tree. Then reduce the Influence % on the Force node to 500. Scrubbing the timeline again, we can see that the particles now fall downwards – but much too rapidly for the behavior of snowflake…

Select the Gravity Space Warp and reduce its Strength to 0.02. The particles will now fall at a slow rate, but appear rather linear in terms of their movement (Fig.04).

Note: If your particles seem to be travelling upwards or in the wrong direction make sure your Gravity Space Warp is orientated to the correct/desired axis.

Next we need to add turbulence and directional wind to add realistic movement to the snow particles. Create two standard Wind Space Warps. Again, pay attention to the orientation/direction of the wind icons and consider the

03

04

05

behavior of the snow you wish to create. This may also be influenced by your scene. In this case we are creating a typically romanticized snowfall with subtle currents of wind.

Set the strength of the first Wind to 0 and enter 0.15 for Turbulence, 1.18 for Frequency and 0.05 for Scale. Consider the direction of the wind in the scene and orientate the Wind nodes accordingly. In this scene they are both simply pointing upwards along the Z axis.

Select the second Wind and set the Strength to 0.09. Change the Turbulence to 0.21, Frequency

to 1.18 and Scale to 0.17. These are the values I chose to use for this particular scene, but feel free to experiment with changing these values and observe the particle behavior.

Add both of these Wind Space Warps to one of the empty Force nodes within the Particle Flow. Adjust the Influence % of the Force node to 900. Then scrub the timeline again. We can now see the particles falling, fluttering, twisting and turning. Change the Display node in the Particle Flow to Lines to see the direction and speed of the particles more clearly (Fig.05).

The particles fall/pass through what should be the ground in our scene. So let's add a deflector to help correct this.

Add a simple plane deflector to the scene and orientate it to the ground using the tracking marker data. Clone this deflector twice more so you have three in the same position. We will use each deflector to give different/varied behavior to the snow that collides with them. For example, some snow will stick and melt/die, while other flakes will continue to float about.

Add three Collision nodes to the Particle Flow. Add one of the deflectors to the Collision node and change the Test True If Particle options to Stop upon Collide. Add a new Display event to the Particle Flow and connect the output of the Collision node to this new Display node.

Scrub the timeline to see the particles fall and then stop and change color upon collision with the deflector. The color change is coming from the new display event; this helps us to see where certain particles are within the Particle Flow tree.

Now add a Spin node to the new Display node and set all the parameters to zero. This will ensure that when the particles have collided they will stop spinning and rotating. This is particularly important as we will be instancing geometry later for the snowflakes, rather than using the dot display.

Next add a Speed By Surface operator, a Rotation node and a Speed node. Set the Speed By Surface node speed to 5 and the direction to Surface Normals. Under the Rotation node set the Orientation matrix to Speed Space and the Z axis to 90. Now we have assigned a more complex behavior pattern to the snow particles that might collide with this first deflector: they collide, stop spinning, slow down considerably, but then rise slowly as if a light wind has lifted them back upwards (Fig.06).

Add the second deflector to the second Collision node and connect a Delete operator to the output of this node. This second deflector will kill the particles immediately upon impact. Then the third and final

deflector to the third Collision operator and set the Collision behavior to Stop.

Create another new Display node now in the Particle Flow and connect this to the third Collision operator. Add a Go To Rotation operator under this new event and enter the following parameters:

- Check Transition Period Ends
 Transition By: Event Duration

- Target Rotation: Constant

- Check Match Initial Spin

- Ease in % to 5.6 and check Stop
 Spinning under Transition End

Add a Rotation node and set it to World Space with Divergence of 60. Under this add an Age test node set to Event age, Greater than Test Value and a Test Value of 25 with a Variation of 12. Now add a Spin node and set it to random 3D.

Finally, add a new display event that's connected to the previously added Age test. Add a Scale operator to this event and set Type to Relative First, Scale to around 30% and Bias to Towards Minimum.

This last collision event we have just built means that any particles that collide with the designated deflector will stop and slowly shrink down, creating the illusion of larger flakes melting. All three of these collision events combined creates some realistic variation for the snow as it collides or comes near to the ground – with some particles blowing back upwards, some melting slowly and some melting/dying immediately (Fig.07).

We can continue to adjust the deflectors, wind parameters and amount of snow by adjusting the scene objects and particles for an infinite number of variations. Adjust the Birth operator within the Particle Flow to a minus value to get some snow already emitted into the scene.

Next we need to make some simple custom geometry to use for the snowflakes. In reality, every snowflake is unique, so the more objects you create to use as snowflakes, the more varied and realistic your snow will appear.

In this scene I've used just two simple objects to represent the flakes, and used the Scale operators within the Particle Flow to add further variation.

You can use any geometry you like for your flakes; I have made two low-resolution spheres, squashing one into a flat shape and re-modeling another into a more random, fragmented shape by deleting faces and moving vertices. Refer to the final example scene to see these (Fig.08).

Group these objects together, add a Shape Instance operator to the Particle Flow and select the snowflakes group. Enable Separate Particles for Group Members.

The particles will now use these custom-made snowflake shapes for their appearance when rendered. Consider updating and adding to this group with more snow shapes if required. To see the geometry in the viewport, change the Display nodes within the Particle Flow from Dots to Geometry and scrub the timeline (Fig.09).

The final thing to add to our particles is a material/shader before we render the scene. Hit M to open up the Material Editor. The material can be extremely simple and is only a white

diffuse color at around 50% self-illumination. To add this to our snow particles, create a Material Static node and add it to the top of the Particle Flow tree underneath the Render node. Drag and drop the white material from the Material Editor onto the Assign Material swatch.

All that remains is to render our particles from the camera view. In some cases, you may wish to render out passes such as ZDepth, Velocity and IDs. In this case, I have rendered the snow particles out with 3D motion blur enabled in V-Ray and a ZDepth pass – enabling me to add

depth-of-field effects later in the compositing stage with my 2D application of choice.

The render will be very fast as there's no lighting in the scene. The final result can be seen in Fig.10 and the final render can be found in the supplied video.01 file.

> ## " The render will be very fast as there's no lighting in the scene "

09

10

FX PARTICLES AND DYNAMICS
LEAVES

BY MATT CHANDLER

Adding falling leaves or petals to a 3D scene can add a great deal of atmosphere and depth to a shot. Using Particle Flow and a number of standard Space Warp modifiers in 3ds Max, we will set up a simple falling leaves scene that can easily be adapted and revised to appear as falling petals or leaves on a much windier day. You can download the final scene from www.3dtotalpublishing.com/resources.html to open and examine, should you have any problems.

Start with a new 3ds Max scene. It's good practise to set your scene/3ds Max environment to your scene scale/unit setup of choice. This can often dramatically affect Space Warp settings and particle behaviors. In this chapter, I'm using the default Generic Units setting.

Start by defining your ground plane. Create a simple plane primitive to represent the ground. As our particle leaves fall they will detect a collision with the ground and settle on the surface.

Create a simple deflector and align it to the ground plane object, matching scale and position. Since our ground is a simple plane, we can use a simple plane deflector to calculate the collisions rather than the geometry.

Let's also create another object in the scene for the leaves to interact with. Create a sphere primitive and position it to your liking. We'll also need to define a deflector for the sphere by creating an SDeflector. Align the position and scale of the SDeflector to the sphere. You may need to increase the

01

SDeflector diameter slightly, so its boundary is just visible around the sphere's geometry. This can be altered later as well, in case the particle collisions need adjusting (Fig.01).

Hit 6 to open up the Particle Flow view. Drag out a Standard Flow from the depot and, within the viewports, position the Particle Flow display icon to somewhere above the ground plane. Our leaves/particles will be emitted from here and fall down to the ground while tumbling and twisting in the air. Feel free to adjust the Emitter Icon shape to get a few different emission results.

The particles aren't doing anything interesting at the moment, so let's make some adjustments to the flow. It is good practise to name your Particle Flow and Particle Flow events that particles are passed into for clarity

and ease of understanding at later dates. I have named mine 'Leaves_petals_falling'. Delete the Speed Operator. Adjust the Birth Operator to Emit Start 0 and Stop to 30. The amount of leaves/petals can be adjusted at any time, so I have left it at the default of 200.

Next, select the Shape Operator, change it to 2D and select Square. Simple planes will represent our falling leaves for the time being, allowing us to see their movements more clearly.

Let's now create some forces to influence our particle leaves. Create a Forces Operator and place it beneath the Position Icon Operator in Particle Flow. Now let's create the Force Space Warps to add to the Particle Flow Force Operator.

Create two Wind Space Warps and one Gravity Space Warp. It's always a good idea to mix at least two Wind Operators together to create more convincing movements and turbulence to drive particle motion.

Select the first Wind and set its Strength to 0. Under the Wind panel, adjust Turbulence to 0.15, Frequency to 1.18 and Scale to 0.05. These values can be sensitive at certain scene scales and produce vastly different results; you may need or want to adjust these to your own tastes later. Select the second Wind; set Strength to 0.09, Decay to 0.05, Turbulence to 0.21, Frequency to 1.18 and Scale to 0.17.

Now add the two winds to the Force Operator within Particle Flow. If you scrub the timeline the particles will blow around, twisting and turning, but we need to encourage a slight amount of direction with some gravity (Fig.02). So select the Gravity Space Warp and change the Strength to a small value like, 0.02. Now add this also to the Particle Flow Force Operator and scrub the timeline to review the results.

Add a Rotation Operator next and set it to Random 3D. Next, add a Spin Operator and change Spin Rate to around 430, with Variation of around 190. Set the Spin Axis to Speed Space. This ensures the particles will spin on the relevant axis according to the speed of the particle direction; adding a more realistic and expected motion.

Now add a scale event and adjust the Scale Variation and Bias to your liking. This operator will be useful later to see the subtle scale differences between leaf sizes.

We now need to add Collision Operators so that our leaf particles can see and collide with the ground place and sphere object. Add two collision events to the bottom of the Particle Flow. We could use just one collision event and add both deflectors to a single operator, but by using two we can create slightly different "resting" behaviors; one for the leaves that rest on the ground and the other for those that rest on the sphere (Fig.03).

"It's always a good idea to mix at least two Wind Operators together to create more convincing movements"

" This zero speed event at the end of the flow will apply zero speed to the particles, freezing them in place "

Select the first Collision Operator and add the SDeflector to its list of deflectors. Under Test True If Particle, change it to Collides and set Speed to Stop.

Create a new event for this collision event to pipe out into by dragging out a new Display event. Name this new event 'rest', as these particles will be resting upon the sphere. Within this new event, create a Spin Operator and set its Spinners to 0. This ensures that any spinning particle entering this event

will stop spinning. Add a Speed by Surface below this and set it to Set Speed Once, with Speed around 4 and 0 for Variation.

Add the sphere geometry to the Surface Geometry tab and change the Direction tab to Surface Normals. This operator will influence the speed of the particles according to the Normals of the sphere geometry, softening the landing.

Beneath this add a Rotation and set it to Speed Space and 90 on the Z axis. Finally, add a standard Speed Operator and set it to zero. This zero speed event at the end of the flow will apply zero speed to the particles, freezing them in place as if they have settled upon the sphere. Scrub the timeline and notice some of the falling particles now come to rest upon the sphere while the remainder continue to fall/blow around (Fig.04).

Let's finish the Particle Flow tree by adding the ground collision object so the remaining leaves

settle. Select the second Collision Operator we created previously and, under Deflectors, add the Deflector Space Warp we created earlier and aligned with the ground geometry. Under Test True If Particle, set Collides Speed to Stop.

Create a new Display Operator and rename the new event containing it to 'Ground_settle'. Connect/wire the output of the second Collision Operator to this new event. If we scrub the timeline now we can observe leaves colliding and stopping on the ground plane; however, they are not lying correctly. We can improve the way they appear to settle by specifying a rotation orientation and adding a Go To Rotation event.

Add a Go To Rotation event and tick the Transition Period Ends box. Change Transition to Event Duration and set Duration to 4 with a variation of 2. Select Constant for the Target Rotation and tick Match Initial Spin with an Ease In value of 5.6. Tick Stop Spinning under Transition End. This

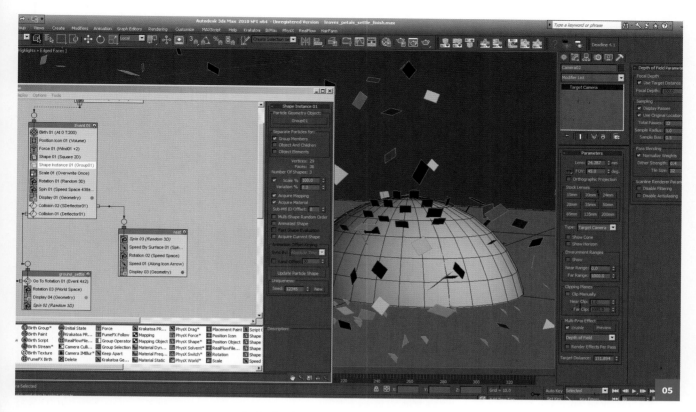

" Include more leaves, more variations, and more wind or petal geometry with less gravity to create a fluttering effect while falling "

operator will ease in to a specified rotation over four frames with a little variation.

Let's specify the settled Target Rotation by adding a Rotation Operator and setting the orientation Matrix to World Space. The XYZ values will vary greatly on the geometry you are using/instancing for the leaves, so you may need to alter the values in this operator until the leaves obtain a satisfactory resting position. In this case, X is -40, Y is -17 and Z is 0.5.

Lastly, add a Spin Operator and set all values to zero (or you could drag and instance the Spin Operator from the sphere resting event).

Reviewing the scene we can see that the particles fall/blow in the wind and settle on both the ground and the sphere object. Try adjusting the Wind Space Warps and gravity to obtain different results (Fig.05) (also see video.01).

Lastly, we need to instance some appropriate leaf geometry to replace the simple squares. Model some simple leaf shapes or merge in the leaf geometry from the example file to use in your scene. Make a few variations in shape and group them together. Back in the Particle Flow tree, add a Shape Instance Operator to the main emission event and select the group of leaf geometry, enabling Group Members and Acquire Materials if you've created a leaf texture on your models. See video.02 supplied with this chapter for a simple render of the resulting particle setup.

Such a particle setup can easily be revised and altered to include more leaves, more variations, and more wind or petal geometry with less gravity to create a fluttering effect while falling. You can also add subtle secondary movement/rippling to the leaf geometry by applying Phasing Noise modifiers and setting the Instanced Geometry modifier to use animated geometry.

FX PARTICLES AND DYNAMICS
FLOCKING

BY MATT CHANDLER

Particles don't have to be literally just particles, such as dust, snow or raindrops. We can instance whatever we like into a particle setup and use simple, out-of-the-box modifiers to create the behavior we need. Flocking birds and gleaming shoals of fish lend themselves well to particle system behaviors, too; their complex, turbulent and patterned movements are always an impressive spectacle.

Let's create a simple particle scene setup in 3ds Max that can be adapted and reused for a number of scenarios, such as birds, fish – or in this case, alien spacecraft.

My studio previously completed some visual effects for a roller-coaster commercial, so in this chapter we'll re-create a scene where a large swarm of alien spacecraft is tumbling and swooping around in the background. We'll also look at how easily the instanced geometry can be switched around to use the same setup for birds with animation upon the wings.

Start a new scene within 3ds Max. Hit 6 to open up the Particle View and drag out/ create a new Standard Flow particle. You can rename the PFSource, if you like – I always like to rename them in case I end up with multiple flows later on (Fig.01). We'll be driving the particle behavior using only some initial speed and Space Warp values, such as Wind and Internal Turbulence. Delete all the operators within the new flow, except for Birth, Position icon, Speed and the Display icon. Switch the display icon type to show Lines. This will make it easier to see the direction, speed and orientation of the particles.

01

02

03

> ## " By creating a negative wind, particles will be drawn towards its spherical center, rather than blown away from it "

In this case, let's emit the particles from a large volume, rather than the default icon point setting. Select the Particle Flow icon in the viewport and inspect the revealed parameters in the Modifier tab to the right.

Change Icon Type to Box and adjust the length, width and height values to your liking. In this case, I've set the size to 20 x 40 x 30. You also have some other basic options, such as whether you wish to see the icon in the viewport. I'm leaving it visible for easy/quick selection later if I want to adjust the volume sizes.

If you scrub the timeline you'll find that you see some particles that are being born and emitted within this box volume.

Let's make some quick adjustments to the Birth and Speed Operators. Set the Birth to emit up to 100 frames and the amount to 2,000. We will have 2,000 ships or birds swarming around very soon! Select the Speed Operator and set a speed of around 90 with 180 variation. Set Direction to Along Icon Arrow and Divergence to around 25. If you scrub the timeline now you will see the particles flying out from all over the box volume with some randomness (Fig.02).

Go to Space Warps; create three Winds and a Drag. Select the first Wind, set its Strength to -0.25 and change it from a Planar to Spherical Force. Within the Particle Flow create a Force Operator and add this to the first Wind Operator. We want the particles to stay together and appear to be following along with all the others. By creating a negative wind, particles will be drawn towards its spherical center, rather than blown away

from it. I've also auto-keyframed its overall Strength value to change slightly over the course of the scene to add some subtle variation, even at this basic first stage (Fig.03).

Create three more Force Operators within the Particle Flow. Add the remaining two Wind Space Warps and the Drag to each of the Force Operators and set a different Influence value in each. I have set Wind 2's Influence to 500, Wind 3's to 620 and the Drag Force Influence to 250. We could add all the Wind and Drag Space Warps to just one single Force Operator, but by separating them we can gain finer and further control over the strengths of each effect and balance them individually.

Select the Wind 2 icon in the viewport and enter some parameters for Strength and Turbulence. For Strength I have entered 0.16, with Turbulence, Frequency and Scale at 0.71, 0.13 and 0.05, respectively.

04

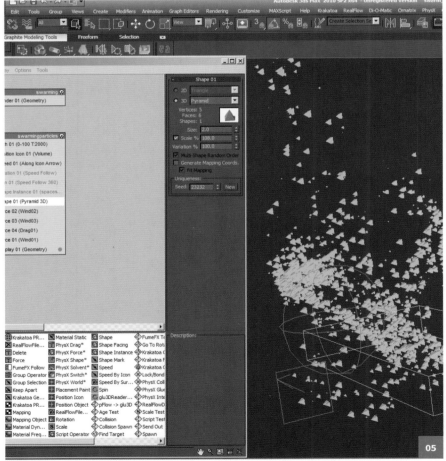

05

Select the last Wind icon and turn the Directional Strength to 0. We'll use just the internal Turbulence values from this one to influence our particle behavior, so set Turbulence to 1.46, Frequency to 0 and Scale to 0.02. Lastly, select the Drag Space Warp and ensure it's switched on for the duration of your scene. Set Linear Damping to 50 on all three axes.

Scrub the timeline once more to see the particles now twisting, turning and flocking together. Almost all of the Force values can be tweaked – or even animated – throughout the scene to create unique swarming and flocking behavior (Fig.04).

The solid, yet flexible, base of the flocking is now set up and ready for detailing with geometry, such as birds, insects or little spaceships.

Let's visualize the particles as geometry to see them clearer. Add a Shape Operator to the Particle Flow and set its shape to 3D pyramid. We'll use the arrow-like shape of the pyramids to see if our particles are orientated correctly to the direction they should be traveling in.

Switch the Display icon to show Geometry and scrub the timeline. As we can see, things look a little strange. The same flocking motion is present, but all of the particles are facing in one direction, and not flowing and turning as expected. We need to amend this by adding a rotational value to the particles so they know which way to face and travel (Fig.05).

Add a Rotation Operator to the Particle Flow tree and set its Orientation Matrix to Speed Space Follow. Set a value of 90 to the X and Y axes and inspect the playback behavior once more.

We have corrected the direction of the particles now so that they travel along the expected axis and orientate correctly to the flow and direction of the flocking pyramids. When you start to instance your own geometry into a system such as this, pay attention to the axis and pivot positions of your custom geometry so you can orientate the Speed Space Follow Axis accordingly.

Lastly, to add even more subtle variation, add a Spin Operator and set the Spin Axis to Speed Space Follow with a value of 1 on the Z axis. As well as twisting and turning, the particles will now spin and turn upon their own axis, as if correcting themselves (video.01).

We can now instance our desired geometry to the particles to finish our effect. In the commercial that a similar scene such as this was used for, simple spacecraft-type shapes were created to match a specified design. I'm supplying a model with this chapter (download from **www.3dtotalpublishing.com/ resources.html**), or you can create your own.

Add an Instance Geometry Operator to the Particle Flow tree and place it above the Force Operators. Then add the geometry (in this case the spaceship) to the Particle Geometry Object slot and adjust the Scale and Scale Variation. For this example scene, I've set Scale to 40 and Variation to 25. Variation values can add a lot of realism to scenes where the particles are organic creatures, such as fish or birds. You can also enable Acquire Mapping and Material here to make sure each particle inherits any textures and shaders from your instanced model. And

06

07

you can add a Material Operator to the Particle Flow tree for further control, of course (Fig.06).

Review the particle setup by scrubbing the timeline or creating a playblast. The complexity and density of your instanced model will affect the performance and speed of the scene, especially if you decide to create thousands of flocking particles (Fig.07) (you can also refer to video.02, supplied with this chapter).

From this basic yet effective core setup, things can be taken further by adding more events and behaviors to the Particle Flow, such as Collision events or Particle Age

Operators that define how each flocking object falls from the sky, explodes or begins a new event. The Instance Operator also supports animated and deforming objects/ geometry (again, be aware of the scene performance), which is ideal for flapping wings, fish fins or other animated effects.

Cache your particles before committing to rendering and even consider baking them to disk using third-party plug-ins such as SuperMesher or XMesh, if you're planning huge, geometry-heavy swarms (also see video.03).

3D
CARICATURES

By Andrew Hickinbottom

CREATE IMPRESSIVE PORTFOLIO IMAGES BY TURNING YOUR FAVORITE FRIENDS INTO STYLIZED 3D CHARACTERS

In this project, Andrew Hickinbottom provides a step-by-step guide that covers every aspect of creating your own stylized pin-up caricature using 3ds Max, ZBrush and Photoshop.

Andrew takes you through the tools and techniques involved in making his latest

protégé, Cara, from modeling through to texturing and lighting, then creating the background and post-production.

Andrew's all-inclusive project aims to provide everything you need to know about the stylized character creation workflow.

3D CARICATURES
PLANNING AND MODELING THE FACE

BY ANDREW HICKINBOTTOM

INTRODUCTION

This tutorial documents the many steps I take to create a stylized caricature image. This first part will cover the initial brief, the development of the idea and the rough treatment of the overall concept. Background info will be given on the subject to help portray my intentions with this piece, and where I plan to go with it.

I will then show how I go about modeling the head from scratch, documenting my progress, giving tips and explaining the modeling methods used. General modeling knowledge is needed to follow this project as I don't have enough space to go into detail regarding my techniques.

I will be using 3ds Max's core modeling tools for this step, with no plug-ins or external programs. Processes such as Cut, Chamfer, Extrude, Connect, Soft Selection and general vertex manipulation will often be employed. If you use another 3D program for modeling, the steps can be adapted for that program if you understand the terminology used.

SUBJECT

I've been tasked with creating a colorful pin-up. I like doing pictures of friends of mine and models I admire, as part of the reward is seeing the reaction they get when completed. I have a friend called Cara that I met while exhibiting at a comic convention in 2012 – she works at an imported sweet/candy store.

She's excitable, bubbly and very colorful due to her clothes, tattoos and colored

> **" Now I have a subject, I need to think about the concept. Usually, I form a picture in my head and work towards that "**

hair. She's curvy, has an interesting face (she's half-Malaysian, half-Australian), is a big fan of Disney, loves sweet, cute and colorful things, and is a fan of pin-ups/burlesque. I think that she will be perfect for this bright and colorful image (Fig.01).

CONCEPT

Now I have a subject, I need to think about the concept. Usually, I form a picture in my head and work towards that, but for the purposes of showing my thought process visually, I've tried sketching out some ideas. I rarely do this as I get frustrated with my drawing skills.

I'm thinking pinks, turquoises (pink and turquoise are her favorite colors), and pastel shades – really vivid, clashing colors. Rainbows, unicorns, candy, mermaids,

cocktails, cupcakes, stars, galaxies, cakes, sea creatures – all that sort of cute, fantastical kind of stuff. I imagine her in an excited pose, being surrounded (or interacting) with these elements.

Some rough sketches give me an idea of the sort of pose and layout I'm heading towards, as well as a written and illustrated list of some of the secondary elements I can include (Fig.02).

ANALYZING THE HEAD

As with all of my character models, I start with the head. Before I start modeling, I collect some images of Cara to see how to approach the stylized likeness. If you personally know the individual you are modeling, it's always handy to take some reference photos yourself, as I did when I asked her for a front and

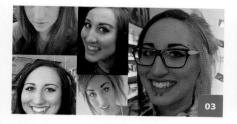

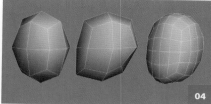

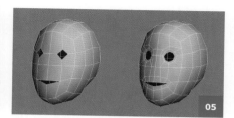

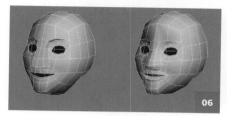

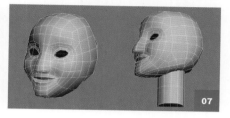

side view of her head after a night out. Cara has a nice, wide, toothy smile, which is the expression I will try to emulate (Fig.03).

She is half-Malaysian, so she has some Asian characteristics such as strong cheekbones and a slightly wide face, which I like. She can be quite sensitive to caricatures, so I have to tread carefully here!

LIFE BEGINS WITH A BOX

Right – here we go. I start with a minimal cube, then subdivide it (with the TurboSmooth modifier) to get a rounded shape with cubic topology. Starting with a sphere primitive is not recommended as it will leave pinched triangular polygons at the poles. I turn the whole modifier stack into an editable poly object and use vertex manipulation to shape the box into a vaguely skull-like profile (Fig.04). Next, I use Swift Loop in the graphite modeling tools section (with Shift held down when I click) to add edge loops while cleverly interpolating the curvature of the object.

If you are not familiar with 3ds Max's graphite modeling tools, you can do this the old fashioned way using Connect in the Edge sub-object tools and then adjusting the new edges to round off the shape, but I find Swift Loop to be quite handy at adding broad loop detail to curved surfaces.

EYE AND MOUTH HOLES

I delete the polygons on one side of the head and use the Symmetry modifier, so I only need to work on one side. I position the eyeline and mouth vertices, and cut holes using Chamfer on the eye vertices (set to Open in the options box), and the Cut tool for the mouth.

Next, I begin rounding out the eye and mouth holes by cutting extra radial edges. The eyes are turned from four border edges to eight using equal division, and the mouth gets

tight corner points, as well as edges near the middle of the face where the nose would be.

The all-important edge loops are established at this early stage by creating a radial band around the eyes and mouth with the Cut tool. Don't worry about untidiness at the moment – you can move, weld and collapse any unwanted points created in the cutting process. Establishing the position of the eyes and mouth early on is crucial, as the main edge loops originate from these points (Fig.05).

Compared to some 3D modelers, my techniques are quite old school. I still prefer to box model with polys from scratch rather than using ZBrush. ZBrush can be very good for quickly fleshing out a shape and playing around with proportions, but I can be quite stuck in my ways and I like to control the topology as I model, rather than do it all later.

My technique when blocking out topology can be a bit messy, but I have shortcuts set up for many of my most frequently used tools so that I can quickly block out the model and tidy things up. Cut, Collapse and Connect are my most-used modeling tools.

DEFINING FACIAL FEATURES

I shape the chin, cheeks and eyes, cutting edges where extra detail is needed. The polygons forming the nose area are extruded out, cleaned up and shaped to form the base of the nose and brow. I make sure I delete the inside polys after the nose extrusion so that the Symmetry modifier will still weld the central

border edges. Next, I start to develop the edge loop structure. It's especially important for her facial expression that I get them right, so that the crease in the corner of her mouth connects with the corners of her nose, so I cut loops leading from her mouth to this point.

The open edges of her mouth hole are extruded in and shaped to form basic lips, making sure that the top and bottom lips form a radial loop of four-sided polygons, rather than pinching into triangles in the corners (Fig.06). There is now no longer a mouth hole – but I'll sort that bit out later on.

SMOOTHING AND ADDING A NECK

Cara's face is smoothed out with the addition of extra edges around her cheeks, brow, nose and chin, and her eyes are shaped more. Next, her jawline is defined by (somewhat messily) cutting edges along the defining line. I then tidy up the stray points, and redirect the topology from the cheeks and chin to naturally flow along and under the jaw and chin, using cutting and vertex moving.

A 12-sided cylinder is added to form the neck, and the intersecting edges of both objects are cut, holed and adjusted so that the points roughly match up. The neck is attached (remember to cut it in half first so that it works with the head's symmetry) and the seam's opposing vertices are collapsed together and smoothed out (Fig.07).

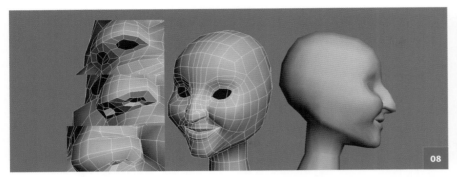

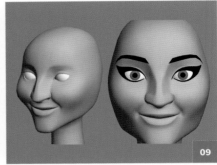

DETAILS AND SHAPING

Now all the main face elements are in place, I spend an hour or two refining and shaping the head to match the photo references of Cara.

First, I tidy up and space out the edge loops. I try to use four-sided polys wherever possible to help get cleaner and smoother subdivision. Extra edges are added (with Cut and Chamfer) to sharpen angled areas like brows and lips.

Speaking of lips, the dividing upper- and lower-lip edge is now split and extruded inwards, then shaped to form the mouth cavity. Nostrils are formed by extruding polys inwards, and shaped by cutting and chamfering where needed (Fig.08).

Finally, the overall posture of the head and neck is improved in the side view to make it look much more natural.

REFINEMENT AND ADDING EYES

Now the mesh has a satisfactory amount of detail, I add a TurboSmooth modifier to subdivide it. In order to further match Cara's likeness, I use soft-selected vertex manipulation to adjust the face shape.

Sphere primitives are added for eyeballs and the eyelids/orbits are adjusted (again, with Soft Selection) to match the curvature of the eyeballs. I spend a while refining the shape of her eyelids to match the photo reference.

Since Cara's makeup plays a large part in her look/likeness, I make simple eyelashes and eyebrows to help see how she will look (Fig.09). The eyelashes are extruded edges from the eyelid borders, and then shaped to form the 'cat's eye' effect. The brows are

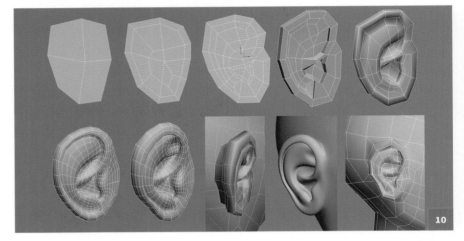

made by detaching the head brow polygons as a clone, then shaping the vertices. Finally, simple sub-object materials are added to the eyes to help visualize the look.

EARS

Realistic ears are notoriously tricky to model. We won't see Cara's ears due to her long hair, but I'll still model some just to show you.

Starting with a four-polygon plane, I gradually shape and cut the main forms of the ear. You can trace the polygonal edges over a background image of an ear if it will help you.

Happy with the flat mesh, I start giving the ear depth by moving vertices and extruding polys to match the ear references I am using. Remember to periodically set all of the whole mesh's poly-smoothing groups to the same number to remove the faceted, low poly look.

Once I am happy with the general detail, I add TurboSmooth to fine-tune the shape, extrude out the back of the ear and then attach it to the head (Fig.10).

EXPRESSION

Usually, I give my characters a 'blank' look, and use morph targets for facial expressions. Cara is going to be a one-off illustration, so I will model her chosen expression now. Using references of Cara smiling her biggest smiles, I use soft-selected vertex manipulation on her lips to move her mouth into a sharp, open smile. Enabling the Edge Distance checkbox with a value of around 10-20 helps restrict the soft selection to the local surrounding edges, rather than the overall mesh.

She needs teeth, so I add some temporary ones in the form of two white cylinders. I can now try to create a wider, more caricatured smile, leaving large gaps at the sides of her teeth, by inflating her cheeks and emphasizing the crease running from her mouth corners to her nose. I also make her lips fuller (Fig.11).

FINE-TUNING EXPRESSION/EYES

I think now it's time to block out some colors on Cara. I give her a skin tone and some lipstick using a sub-object material. The shape of her lips is now clearly defined, helping me to refine the expression some more. I tighten up the corners of her mouth and sharpen the middle peak to make it more stylized.

After looking at many references of Cara smiling, I notice she sometimes shows her tongue a little through slightly open teeth, which is quite cute. I make a simple tongue from a flattened, subdivided cube and position it to get a more appealing mouth. Spheres are added and positioned to form her piercings (Fig.12). I now make her eyes properly by extruding and scaling the top polygons of the sphere inward to create a Death Star-type shape – a sphere with a concave indent where the iris and pupil are. A slightly larger sphere (without the concave bit) is made transparent – this will be the wet, outer part of the eye that will catch the specular highlights when the proper shaders have been applied later.

TEETH BLOCKING

For my simpler, more stylized characters, a basic white teeth strip/half-cylinder does the job, but part of the appeal of Cara's smile is down to her unique, uneven teeth. Imperfections can be interesting and quite attractive, so I try to gently characterize this.

Starting with the cylinders I've already placed, I cut off the excess polys, making two horseshoe shapes. A horizontal line is added using Connect to form the boundary between gum and tooth. Next, I smoothly double the vertical edges by using Swift Loop (while Shift+clicking) like in the first step where I started with a box. These new edges give the extra points needed to create the low poly, zig-zag curvature of the gums and teeth.

Gradually making the teeth from a curved shape is much easier than making the individual teeth and placing them in the mouth (Fig.13).

TEETH DETAILING

Next, I subdivide the teeth, adding edges across the gums and the teeth to tighten up the subdivision. Now that we have

some 'base' teeth, I carefully study some photo references of Cara's teeth to try and match the shape and stylize them.

I chamfer the gums to create the lower pinch points between each tooth, and inset the front-facing teeth surface polys a little to sharpen the subdivision around the edges. Finally, I extend the gums and skew the bite using Rotation and FFD deformers, and adjust them inside the mouth to get a stylized, but pseudo-realistic, look (Fig.14-15).

CONCLUSION

When creating my pin-ups, I often try to get a balance between sexiness, cuteness, appeal and humor. The nature of Cara's personality gives me lots of ideas to play with. When doing images based on people, it's good to not only get the likeness of them, but to try and show the viewer the 'essence' of that person through facial expressions, clothing, mannerisms, poses, attitude and things they are associated with. Strive for a nicely presented and posed model rather than a drab T-pose. The best modeled and lit character is nowhere near as appealing as one that has been brought to life and has a personality (Fig.16).

3D CARICATURES
MODELING THE HAIR AND BODY

BY ANDREW
HICKINBOTTOM

Next, I will be creating Cara's body and hair. Starting from simple primitives, I will show how to shape a simple form to create a torso; adding arms, legs, breasts and hands as I go. The body will be joined to the head I made in the last chapter. Finally, the hair construction will be shown step-by-step – also made from an initial primitive object.

Human bodies come in all sorts of shapes and sizes, and I like to vary my styles quite often. Sometimes I create bodies that are more cartoony and simplistic than others, but in the case of Cara here, I go for a slightly more realistic look.

Whichever approach you go with, the base body mesh has virtually all of the underlying topology you need, so it's possible to adapt the tutorial steps and make a character with a completely different body shape, if

> " **Depending on how different the body is, I sometimes re-purpose existing bodies I have previously made using tools like Push to fatten or make thinner** "

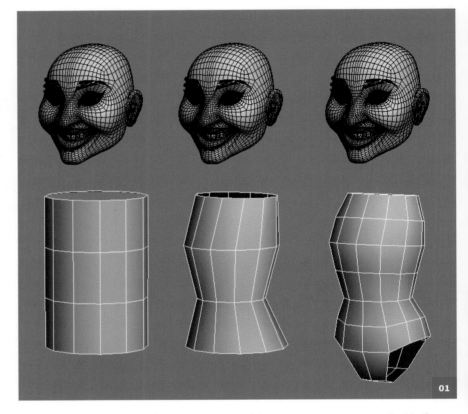

01

you like. Depending on how different the design is, I sometimes re-purpose existing bodies I have previously made using tools like Push to fatten or make thinner.

For Cara, I made the head from a scale reference (see previous chapter), so I begin the body by making a cylindrical primitive with 12 sides and three height sections – this will be the torso (Fig.01). Next, I scale and position the vertical sections to form a basic, blocky female torso.

After that, I use Swift Loop in the Graphite Modeling tools section and Shift-click on the vertical edges to add smoothed edge loops, automatically rounding the torso shape and

giving me more geometry to work with. If you don't have the Swift Loop tool, or have never used it, you can use the standard Connect Edge tool and smooth out the shape manually.

After deleting half of the mesh and adding a Symmetry modifier, the top and bottom cylinder caps are deleted and the hip vertices are moved up at the sides. The crotch edges are extruded downwards and connected with the back-side, forming a shape similar to a toy doll with no legs and exposed leg sockets.

ADDING SHOULDERS AND ARMS

Next, I start to define the origins of the arms and legs (Fig.02). When doing simplified/stylized characters, I try to keep the arms as a manageable eight-sided cylinder shape, so I ensure that there is a cluster of four quad polygons on the shoulder. These polys are extruded, scaled down a little, and then the topology is smoothed out slightly. This leaves me with an eight-edged surface with which to start constructing the arms.

The open edges on the hips are extruded down from the start of the thighs. Separate arms are added and positioned – I make them from eight-sided cylinders with one height section (where the elbow will be), and shape them slightly, with both end caps deleted. When setting the arm length, I always imagine the arm at the side of the body. The palm of the hand should usually be level with the character's groin if the proportions are conventional.

After that, the body's shoulder polygons are extruded again and rotated to roughly match up with the new arm meshes. The four end polys are deleted, leaving a hole.

SHAPING THE BODY

The arms are attached to the body and then joined by moving the vertices near each other, then individually collapsing/welding the end points (Fig.03). Because both the arms and the arm holes have eight sides, the join will be clean and flow with the topology.

The same is done with the legs, but some more manual vertex manipulation is required to keep the flow of the hip topology correct and also retain the volume. The body looks really stiff and unnatural at the moment, so I spend some time relaxing it and making the posture seem more sexy and feminine.

Extra edge loops are added down the center of her body (I need to do this to accommodate the breasts on the next step), on her thighs and anywhere else that needs further definition. I keep it nice and simple for now though, as a needlessly dense mesh can

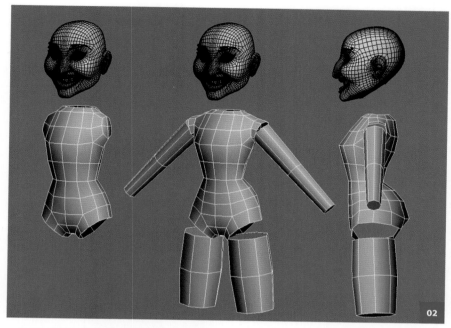

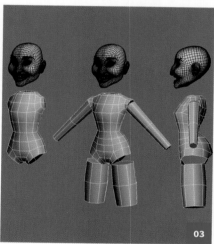

make it fiddly to work with when making broad proportion and shape changes.

The arms are bent slightly at the elbow, and the edges bordering the hole above the clavicles are extruded up a few times to form a neck.

No pin-up is complete without a bountiful bosom! Before I start, I make sure that she has a good chest volume to start with. I select a cluster of four polygons in a logical location and bevel them outwards slightly while scaling them down (Fig.04). I then manipulate the vertices to change the straight, grid-like topology to an eight-point circle. I then extrude the four center polys out again and collapse the vertices to make a single point.

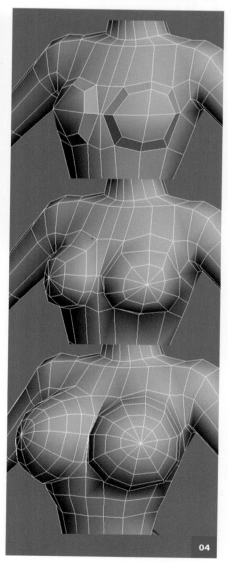

This point should be placed where the nipple tip would usually be. I spend some time shaping the breast and give it weight and volume, adding radial edges to increase smoothness and refine the shape. Vertex manipulation, Relax and the Push modifier (all applied to soft selections) are handy here too.

The overall chest area is now given more volume and curvature, and the breast size is made quite large. This work gives the character model a solid, caricaturized, cartoony, curvy and somewhat idealized result (Fig.05).

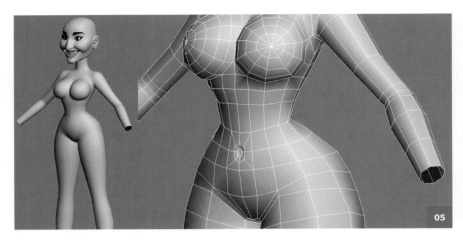

LEGS AND BODY REFINEMENT

Now I have the torso modeled to a satisfactory level, I can define the limbs (Fig.06). First I apply the basic skin material to her body to help visualize it with the head better. The leg edges are extruded downwards and quickly shaped to represent the calf and thigh bulges.

While at this stage, I also take the opportunity to add some details to her torso; namely a belly button (made by extruding polys inwards a few times and collapsing to an innermost point).

Her elbows are defined by adding more edges (at least three ringed edge loops are required for joint deformations) and shaping the elbow bump. Her forearms are shaped by adding edge loops and scaling the sections to form basic musculature, and the skin creases around her crotch are created by chamfering these edges, tidying them up and leading them off around her bum using the Cut tool.

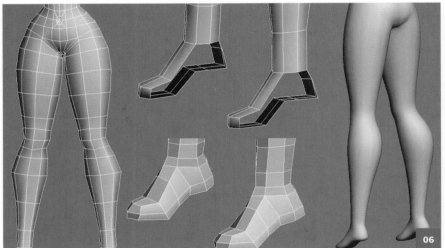

LEG REFINEMENT AND FEET

The leg shapes are refined to get a curvier, chunky look, and her knees are defined in a simplified way (Fig.06). Use photo references to get the leg shapes right – particularly around the knees and calves. Don't worry too much about getting the topology to look amazing and mimicking the musculature of the leg – it's stylized, so a simple cylindrical topology will suffice.

Next, I start the feet by taking the front and back two edges of the end of the leg

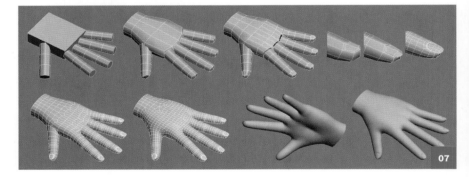

and repeatedly extruding them, forming a silhouette of a foot. Cara will be wearing heels, so I go with a raised foot. The foot 'shell' is shaped and refined before hitting the next step.

The open edges of the foot are filled in by selecting opposing border edges and using the Bridge tool. The foot is refined and edges are added to smooth it out a bit. As she will be wearing shoes, I make it a streamlined shape, rather than adding toes or shaping the foot in an anatomically correct way.

The hands begin with a box and a cylinder with eight sides and three sections to take account of the finger joints. The fingers are copied from the original one as instances, then scaled accordingly so that I need to only work on one of them (Fig.07). The thumb remains a unique object as it will be shaped differently to the fingers.

Using Connect, Cut and vertex manipulation, I shape and smooth the hand parts accordingly. The edge loops forming each finger joint

are increased to three (using an edge loop extrude with no height value) to enable a good deformation when they bend.

The fingernails are made by applying the Inset tool to the upper four fingertip polygons, then extruding them down into the finger, then up, then shaping them to a point before finally extruding the nail tip to the desired length.

The joining parts of the hand are set up so that holes are cut in the hand part with vertices matching the finger ends. The fingers are attached and joined, then tidied up. The hand shape and topology is refined and adjusted, and the palm is fleshed out to get the look I want.

FINISHING THE BODY

Finishing the body is the final step where I can spend as much time as I need to make the body look its best (Fig.08). The hands are attached and joined to her arms. Before doing that, I twist her forearm by 90 degrees to emulate the musculature and to get a less 'sausagey' shape. Clavicles are formed, her head is joined to her neck and I define her bum better, even though you'll never see it in the final illustration. It often pays to make a 'complete' base body so you can re-use and adapt it for future characters. I then spend some time fine-tuning everything and getting the body shape and topology as good as I need.

TOPOLOGY

When creating characters, topology is very important – much like I mentioned in chapter one. There are many ways you can approach the topology on a human body, and I have tried several different methods during my long time as a character artist.

The complexity and 'flow' of body topology can depend on the definition you want to achieve. If the character is muscular or has realistic definition, you need the topology to 'flow' like musculature should. My style is more simplified and cartoony, so I stick to simple, 'tubular' topology most of the time (Fig.09).

However you approach the topology, you must always remember to leave at least

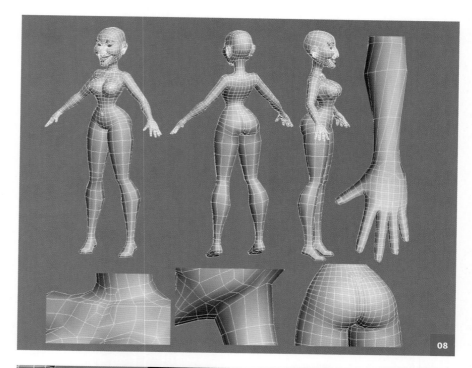

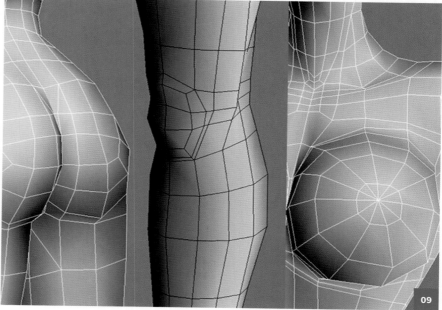

three edge loops around joints such as elbows, knees and fingers, as well as parts that will twist like forearms and the neck.

When working quickly, my modeling style can be quite untidy at first, but I always ensure that I tidy up once I have laid out the rough shape and topology.

When cutting new edges, always try to ensure that the edge forms a continuous loop, or tidily connects in a logical place, leaving the mesh free from triangles or skewed polygons as these can often look ugly when the mesh is subdivided. Try to keep the mesh reasonably consistent in density and avoid long, stretched polygons.

"When moving vertices, the Edge/Face constraint tool can be very useful for changing the topology"

When moving vertices, the Edge/Face constraint tool can be very useful for changing the topology without drastically altering the shape or volume of the model (Fig.10).

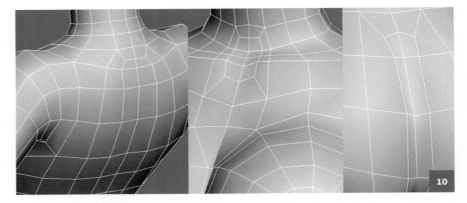

HAIR

It's time to model Cara's all-important hair! Her hair is essential to getting the likeness right, as it is so unique and recognizable. When creating hair, I almost always try to break the geometry of the style down into strips of varying width to mimic the directional flow of hair strands, and to aid the unwrapping/texturing process (which I will explain in the next chapter).

I collect some pictures of Cara that make good hair references, and can now plan how I will approach it. I always like to model chunky, stylized hair, so more sculpted-looking methods can be employed depending on the style (Fig.11).

Because Cara's hair is long, relatively straight and all flowing from a parting at the top of her head, I decide to go with the strip method.

I begin with a cylinder with around 12 sides, and extrude and scale the top polys in order to create the starting step of the parting (Fig.12). The topology is manually cut in a specific way to make the vertical edge rings resemble continuous strips leading to the 'hair root' at the parting. The front faces of the cylinder are deleted to reveal her face.

Next I gradually smooth and shape the hair by adding edge loops (Swift Loop with Shift+click) and adjusting the shape with Soft Selection. Thickness is added using the Shell modifier. The parting is sunken in, symmetry is removed, and it's moved to form Cara's side parting. I then add TurboSmooth, but

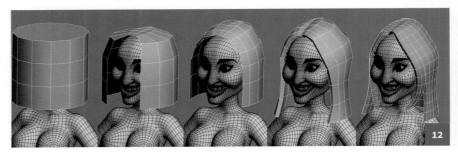

below the Shell modifier in the stack so the edges are (temporarily) nice and crisp.

The two sides of her hair are given material sub-object colors to help visualize it, and the front-most hair edges are split to form her side bangs. The tips of these strips are scaled down and positioned nearer her chin to form points, and the sloping sides of her hair are flattened a bit to create a more interesting silhouette.

Now I have the basic shape of Cara's hair, I can start forming the hanging curls (Fig.13). The

"Be sure to vary the width of the strips and try to get a good, natural, flowing 'rhythm' to the hair"

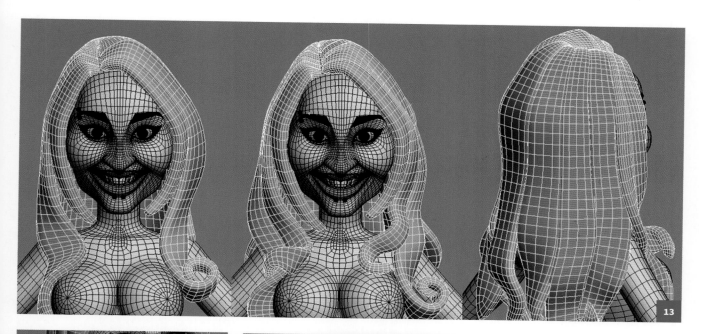

13

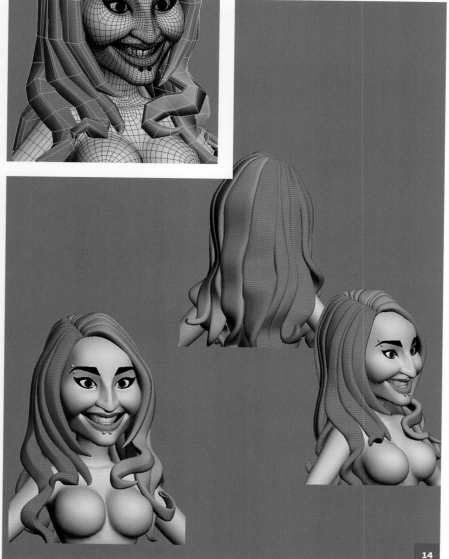

14

vertical edge loops next to the front bangs are split, forming left and right secondary hair strips. The end edges of these strips are repeatedly extended downwards (hold down Shift and move the edge), rotated and scaled to form hanging curls and twists. I then add an extra TurboSmooth to the top of the stack to get a slightly smoother edge than in the previous step – this is just for visualization now.

Continuing the process, I split the hair edges going around the head then shape and extend the tips to form wavy hair strips. Be sure to vary the width of the strips and try to get a good natural, flowing 'rhythm' to the hair.

MAKE IT GLAMOROUS

I continue to split and shape the hair, using photo references of Cara to get the essence of the style just right (Fig.14). At the moment, the Shell modifier gives the hair strips a uniform thickness throughout, which leaves the tips looking chunky.

After ensuring that I am happy with how the hair looks, I collapse the Shell modifier (remember to turn off any TurboSmooths first) and work on it as an editable poly object. The tips of the hair strips are scaled down to a small point, and selected edge loops are raised or chamfered to give occasional sharp edges to the hair and also to tighten it up. Any final adjustments are done with Soft Selection vertex manipulation.

3D CARICATURES
CLOTHING, RIGGING AND UV-MAPPING

BY ANDREW
HICKINBOTTOM

The clothes will be made based on the existing nude body created in the previous chapters. I'll be showing how I created and fitted the rig to the mesh and skinned it with the skin modifier. I'll adjust the skinning envelopes to improve deformations and then document, step by step, how to unwrap the UVs for her body, head, and finally her hair and clothes.

Alongside the general modeling knowledge needed to follow this project, basic familiarity with 3ds Max's biped rig, as well as simple key-framing skills are needed to follow some of the later steps. I'll be using the UVW modifier too, so if you have projected and unwrapped basic objects before, that will help.

I begin with choosing clothes, so it's time to do some research. She often wears colorful, patterned clothes that are retro, glam, cute, trash and/or rockabilly-styled (Fig.01). I want to go along these lines, and maybe push it into an even more 1950s-styled look.

I consulted with Cara and asked her what clothes she likes and to suggest some online shops with visual catalogues where I can look at the many styles and outfits on offer. I can't reveal the websites or show any of the clothing references here, but I'm thinking pencil skirts, tie tops, dresses, blouses, boleros, playsuits, shorts, dungarees and vests with pastel colors and kitsch / retro patterns.

I want to get a nice mix of cute, retro and sexy for Cara's outfit, so I start blocking out some clothes (Fig.02). Starting with the base nude

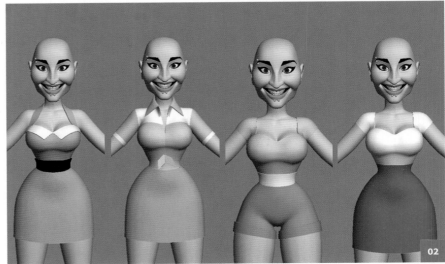

body, I select the polygons that encompass the garment area and detach them as a clone. I apply the push modifier to these new meshes to bring the surface away from the skin slightly and begin to edit the borders of the garments to form the outfits I have in mind. Skirts are made by deleting the central/crotch polys, extruding the gap and smoothing the surface. Collars are extruded from border polygons.

As I wasn't completely sure which outfit I would choose, I blocked out 3 or 4 of them to see which one had the most potential.

I like the shirt with the tied lower part — it has a bit of a 1950s diner waitress vibe, and would look nice with some kitsch patterns on, so I choose that in conjunction with a shortened pencil skirt riding quite high on her hips (Fig.03). The collar and cuffs are changed from the earlier mock-up to look less like a mechanic's shirt and more like a 1950s waitress. The new tapered cuffs and collar also provide room for a nice secondary color for the trim. The shell modifier is added and I start cutting the pulled creases into it, raising and lowering the edges to get the effect I want. The knot is made from a cylinder and a few edited planes with shell on.

ACCESSORIES

I don't intend to show Cara's feet in the final illustration, but for consistency's sake, I'll give her some shoes (Fig.04). Using the bare shoe-shaped foot from the nude model, I extrude some polys out to form a heel, then cut a border dividing the foot into the shoe and skin areas. Extra edges are cut to sharpen up subdivision on the corners and the two areas are colored.

A silver heart-shaped necklace is modeled using a plane, which I place around her neck. Finally, a few torus primitives make ring-shaped bracelets that can be placed on her left wrist. I then prep the model for rigging and skinning as things can go wrong if the model is untidy. I have a strict procedure that I adhere to before skinning my characters to reduce problems.

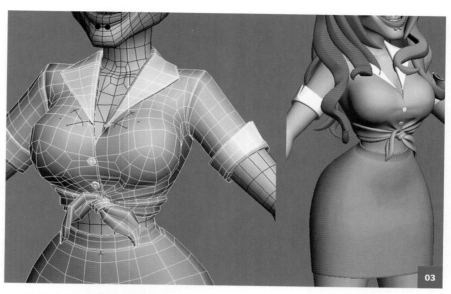

03

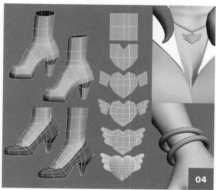

04

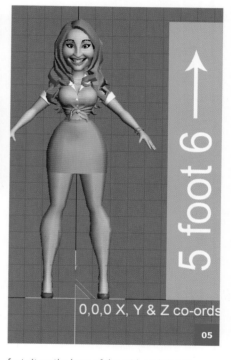

05

" Scale cannot be changed once the character is rigged, so it's best to set the scale now "

RIGGING PREPARATION

Scale cannot be changed once the character is rigged, so it's best to set the scale now. First, I link all of the meshes to a point helper object positioned between the character's feet. Changing the units to feet and inches in the preferences allows me to make a dummy box at the precise height I want, and then scale the point helper (and the objects linked to it) down to the correct height.

Make sure the point helper is at 0,0,0 in the world's co-ordinates, that the character's

feet sit on the base of the grid, and that the pelvis is on the center line from the side view. When you are happy with the scale, delete the point helper and unlink everything (Fig.05).

Mirroring and scaling objects can affect their scale transform values, and this can sometimes cause problems when adjusting the skinning or rotating attached meshes. Firstly, the modifier stacks of all of the meshes are either stripped down or collapsed — all except for the TurboSmooth (that should be deleted, not collapsed). The aim is to end up with an un-subdivided editable poly object — nothing else.

Once I've done this, I go into utilities and do a 'Reset Xform' on every object, collapsing the stacks afterwards. This is an undoable procedure and it collapses your modifier stack, so be careful. Some objects (mirrored ones) can turn black after this process. Simply flip the normals in the poly sub-object tools to rectify it. Once done, I select all objects in need of subdivision and add a TurboSmooth. This applies it to all selected objects as an instance, so I only need to turn it on and off on one object. Now I am ready to skin the meshes.

After prepping, I use 3ds Max's pre-made biped rig to enable me to position Cara (Fig.06).

RIGGING

Hiding the clothes (I put them on a separate layer to make this easier) and disabling the subdivision modifier so I can see the true wireframe representation of the body mesh; I drag out a biped rig from the world's 0,0,0 grid point, and release when the rig's pelvis lines up with the mesh's pelvis. I enter figure mode, set the body type to 'classic' (an old favorite of mine) and begin to rotate and scale the limbs to match the mesh, ensuring that joints are correctly positioned in relation to the mesh's edge loops. Setting the object to 'see through' in the object properties can help you see where the joints are. I add some arm and leg twist links in the rig's structure settings to enable more gradual skinning when I twist limbs.

SKINNING

Disabling figure mode, I key-frame the rig into an extreme pose on frame 10 of the timeline for testing purposes (Fig.07). Freezing the mesh layers in the layer editor can make selecting the rig components easier. Making sure the rig is in figure mode or frame 0, I apply a skin modifier to the nude body and add the relevant bones.

I then do the same for the hair and clothes, linking the eyes, teeth and accessories to their nearest bones so they don't get left behind. By default, the skin modifier doesn't usually do a particularly good job when first applied.

The size and position of the biped rig's bones can drastically affect the boundaries of the skinning envelopes, so I now have

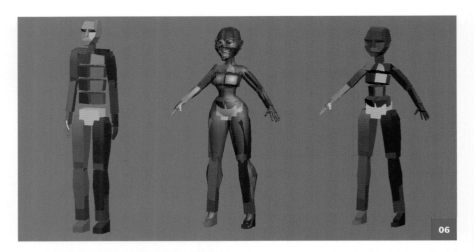

06

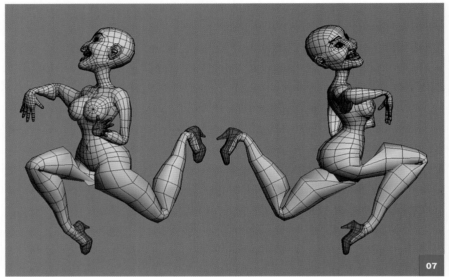

07

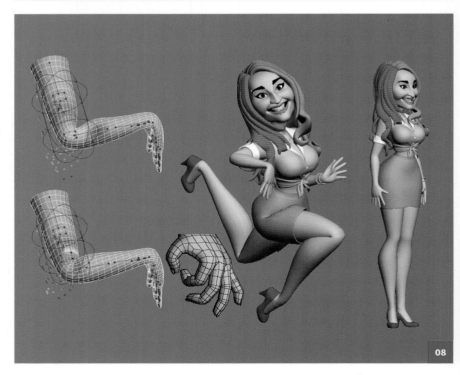

08

to scale them down and space them apart to tighten up the skinning (Fig.08).

I go into the skin modifier, select Edit Envelopes and select a problematic envelope from the list, or in the viewport. I move its end points and scale its inner and outer influence boundaries to get a better deformation. The effect can be noticed in real time when the character is in the test pose. Sometimes I need to use per vertex weighting or paint weights, but that is only usually the case on complex areas, like the fingers.

UNWRAPPING

It's now time to unwrap her nude body for texturing. First, plan how you want to paint your textures. I always like to keep more detailed areas as separate maps, such as the face, hands – and in this case (because of her sleeve tattoos), her arms.

As far as I am aware, there is no tool in 3ds Max that can automatically make UVs symmetrical, though I have a manual method which I have been using for many years.

Unless the model is highly symmetrical, I keep the symmetry modifier on while I UV half of the body to reduce the workload and to ensure both sides of the model have the same UV co-ordinates, which makes things easier when duplicating texture sides (like hands) in Photoshop (Fig.09).

Once I have UV-ed the one side, I collapse the symmetry modifier, select the UV element beneath the current one and mirror it, welding and relaxing the center seam if necessary. Having non-overlapping UVs is important for several reasons, such as if you ever need to bake on any lighting or Global Illumination. Giving all texturable parts of your model their own space in the UV map is a good practice to employ.

I add an unwrap UVW modifier and apply a planar projection to everything, just to get a clean start. The UVs in the display are usually jumbled from the modeling process, so this cleans it all up, making it easier to work with.

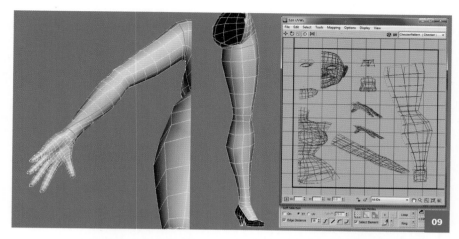

09

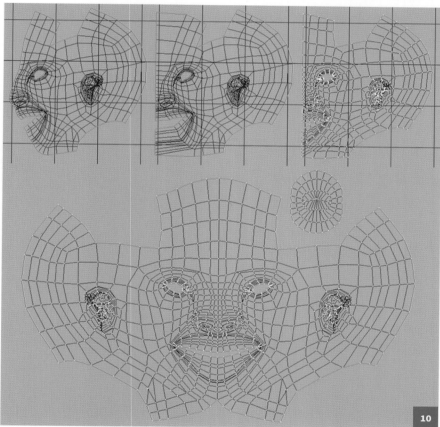

10

Then I select the edge loop boundaries of the planned pieces in the viewport and break them up using 'break' in the UVW editor tools menu (or Ctrl+B). UV seams are displayed in green. These separated elements then have more seams (going from end to end) broken in less visible places (under-arm, inner-leg and so on) and the elements are spaced out.

Next, I select the elements and pick Relax from the tool menu. Setting the drop-down option to Relax By Face Angles' I start the

relaxing process. By breaking the edges in a similar way to skinning an animal (border to border) the Relax tool should automatically unfurl the selected element into a flattened shape (Fig.10). Sometimes you may need to alternate between the face angles and edge angle modes and increase the iterations and amount values to 'bump' it into relaxing correctly, or sometimes you need to manually move some points to help it untangle more complex parts — either way, if you break the correct edges, it should unfurl properly.

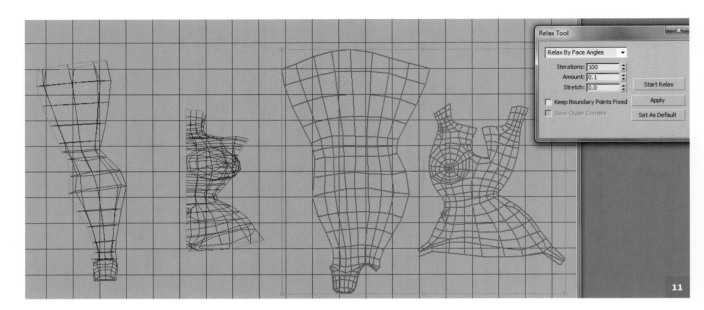

11

" The head is probably the trickiest part of a character to unwrap because of all the holes and varying surface angles "

I do this on all the body pieces, including the head which takes longer. The head is probably the trickiest part of a character to unwrap because of all the holes and varying surface angles. I cut out the inner polygons of the mouth cavity and move them and the other head parts (brows, eyelashes) aside. Some of the scalp edges are broken to ease the 'stress' when relaxing it.

After relaxing the head on a low setting, I then select the edges running down the middle front of the face and scale them down sideways to a single vertical line. The rest of the face (excluding these center points) is then relaxed briefly on a low value, drawing the face points to the straightened center edge naturally.

Finally, imperfections (like the mouth and ear) are manually adjusted, and selected areas (sometimes with Soft Selection) are relaxed locally and sparingly to smooth things out (Fig.11).

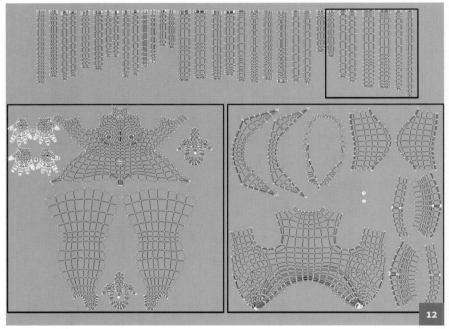

12

The symmetry modifier on the body is collapsed and in the UV editor, the element pieces from the new mirrored side are either flipped, welded and relaxed down the seam (in the case of the body) or positioned logically, such as the left and right legs (Fig.12).

The clothes are unwrapped in the same way as documented earlier, breaking the UV seams where real cloth seams would be.

The hair elements are separated, and then the front and back faces of the strips are broken along the side-edge seams, relaxed and manually straightened into horizontal and vertical lines. This means that instead of drawing a curved hair texture to match the curvature of the hair UVs, the UVs are straightened so the hair texture can be made straight and the UV co-ordinates 'follow' the texture along the hair.

Finally, the laid-out UV square 'canvases' are turned into image files by going to Tools > Render UVW template. Depending on the required size of the texture, I type in a size in pixels and render the UV template to a JPG file so I can use it as a guide when I start the texturing process (Fig.13).

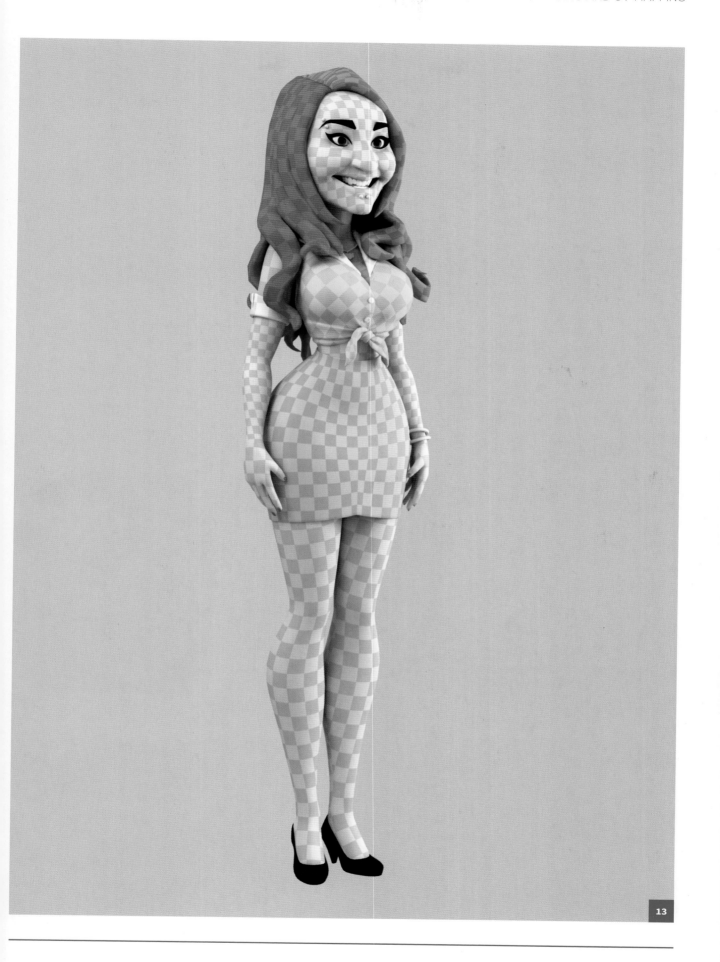

3D CARICATURES
TEXTURING AND LIGHTING

BY ANDREW HICKINBOTTOM

In this chapter, I will be texturing the skin, hair and clothes of the Cara model, applying V-Ray shaders and setting up some basic V-Ray lights. I will be using the V-Ray plug-in for lighting, rendering and shading, but if you are familiar with other indirect illumination renderers such as mental ray, you should be able to adapt the steps to suit your preferred software.

Cara is now correctly UV-ed and ready to texture. To check that your model is correctly UV-ed and free from any distortion, temporarily apply a procedural checkerboard texture to the diffuse channel of a shader and then apply it to all of the meshes (Fig.01). After that, increase the U and V tiling values of the checker, and set it to display in the viewport.

When texturing my characters, I tend to vary the detail of the texture maps depending on the style and artistic direction. More simple, illustrative characters have very basic diffuse textures or maybe no textures at all. More realistic ones have detailed bump, specular and diffuse textures showing blemishes, creases, intricate makeup and shaded areas to boost the depth in skin folds.

Sometimes you can mix them up though, such as giving a really simple character model a detailed texture, or making a more realistic face flat and illustrative by not texturing it at all, and relying on shaders and creative lighting to get the desired effect (Fig.02).

Now we are ready to begin texturing Cara, in Photoshop I load up each of the UV JPEGs that I exported from 3ds Max, and duplicate the background layer. I then invert (CTRL+I) and apply this new copied layer using the multiply blend mode so that it is overlaid on the blank canvas.

The opacity of this layer is then turned down so that it's barely visible. With the background layer filled to one color, I am now ready to start painting textures.

01

02

BODY TEXTURING

For the skin textures, I begin by filling the background layer with a base skin tone, then (using a low-flowing soft-edged brush) apply simple soft areas of tone to enhance the shading for when the model is rendered later on (Fig.03).

Each type of shading is on a separate layer to enable independent control and adjustment. It can also help with the creation of Specular maps if needed.

Darker, browner tones are added to areas requiring subtle shading enhancement such as cleavage, collarbones and skin folds. Redder shading is used to make joints like elbows, knees and knuckles look a little more natural and worn. Lighter, more yellow tones are applied to fatty areas such as the breasts, bum and thighs. As I'm aiming for a simplified, stylized look, I'm not going to worry too much about making it look too realistic – just some simple shading to make the model look less 'plastic' and doll-like.

A rough tattoo is doodled on her arm texture as a temporary placeholder – I'll paint the proper tattoo nearer the end of the project.

FACE TEXTURING

To help visualize exactly how the textures sit on the model in 3ds Max, I temporarily bump up the environmental ambient color to its lightest value. This flattens the viewport shading (providing the textures are set to display in the viewport), showing you exactly what effect your painted texture has on the model, helping you to see any seams that you'll need to address.

To texture the face, a similar process to the body is used (darker nose creases, lighter nose bridge and brow, redder cheeks and so on), except that I also add makeup in the form of lipstick, slight eye shadow and instead of the eyebrows and 'cat's eye' eyelashes being done with geometry, I paint them on after asking Cara how she does her makeup (Fig.04).

A basic Specular map is quickly made by copying the face layer group, desaturating everything, and changing the values

03

04

05

of the separate layers to logically affect the specularity, such as lighter values for glossier lips, darker values for more matt creases, and so on.

HAIR AND EYE TEXTURING

People often ask me about my hair textures, but as long as you create the mesh in a certain way and the UVs are straightened, they are extremely easy.

The hair texture is little more than procedural noise (Fig.05). In Photoshop, I fill a square canvas with black and add the maximum amount of monochromatic noise. I then apply Vertical Motion Blur to turn the noise into fine streaks. I then make it repeatable by going to Filter > Other > Offset and then fix the seams with a clone brush so that it tiles well. This texture is then applied to the hair shader as a Bump map and repeated to a satisfactory value.

06

Diffuse Diffuse Diffuse Diffuse

07

The eye texture is a simple front-projected map comprising of an iris and pupil. A black ring circles the iris, and I sometimes fake the inverted reflection of the ground (the darker bit you often see at the upper part of the iris) with a gradient on the iris part of the texture.

LIGHTING SETUP

Before I begin defining the shaders, texturing her clothes and choosing color schemes, I want to set up some basic lighting to visualize her better, as 3ds Max's default viewport lighting can look a little ugly.

With my renderer set to V-Ray, I add two medium-sized (about 30 x 30) V-Ray lights at opposite sides of Cara. I position them at head height and aim them directly at her (Fig.06).

Once the render settings are defined (in the next step), I experiment with the positioning and scale of the lights to get the effect I want. Larger V-Ray lights with a low multiplier give off a softer, more diffuse light, whereas smaller ones with a higher multiplier create sharper shadows and a more localized effect. Here, I'm aiming for a main diffuse light and a more intense rim light coming from the far side.

ENVIRONMENTAL SETUP

In the render setup menu, I turn on indirect illumination to allow the bouncing of light around the scene. A pink-colored V-Ray floor object is added at the base 0 gridline and made invisible to the camera (but still 'active' in the lighting calculations) by right-clicking and selecting the appropriate button from object properties.

The color of this V-Ray floor is quite important, as it forms the ground bounce light for the

GI Environment (skylight) override GI Environment (skylight) override GI Environment (skylight) override GI Environment (skylight) override
On Multiplier: 1.0 On Multiplier: 1.0 On Multiplier: 1.0 On Multiplier: 1.0

08

whole scene. It might look small in the viewport, but it stretches on to infinity when rendered, hence making it invisible – I don't want to create a horizon on this image (Fig.07).

Generally, the color you choose for the floor will form the subtle up-lighting in your scene if you don't add a modeled environment floor. We will not see the floor in this image, so the V-Ray floor gives us the effect of a 'proper' floor in the scene, without actually having to model or render it.

The final step of this rather technical process is adjusting the environment values.

In render settings, I turn on the GI (Global Illumination) environment override in the

V-Ray tab. This color determines the overall ambient light color independently from the environment background color. The default sky blue value usually works fairly well in most cases, though you might want to tweak the value and see what works best for you (Fig.08).

The environment background color (top menu: Rendering > Environment) will be set to pink for the sake of visualizing the mood of the scene, but this will not affect the ambient light of the scene because the GI override is set to a different color – in this case, light blue.

EYELASHES

Now the boring technical stuff is out of the way, I can start rendering Cara and seeing how the textures affect her.

First though, I'm going to add some spiky eyelashes to her. At the moment, her brows and 'cat's eye' eyelashes are comprised of makeup on the head texture map, so I delete the old geometry ones and make some more conventional polygonal eyelashes instead.

A selected ring of eyelid rim polygons are detached as a clone and the outer edges are extruded out by shift-moving the edges. The radial sections are increased to accommodate the number of required eyelash strands, then the edges are split, the tips are scaled down, and the lashes are lengthened and styled to get the look I want based on some photo references of Cara's eyes (Fig.09).

> ## " I want to get a warm, soft and colorful look in this image, so I'm going to try subsurface scattering "

SKIN SHADING

I make do with a standard V-Ray material nearly all of the time, but I want to get a warm, soft and colorful look in this image, so I'm going to try subsurface scattering.

It's quite a fiddly shader and I don't always get satisfactory results with it. I turn the skin materials into V-RayFastSSS2 ones, and tinker with the settings until I get a pleasing result. It's quite a complex shade, so much trial and error is required (Fig.10).

The base color is defined by the skin textures plugged into the SSS Color slot. The scatter values are tweaked to get the required effect. The Specular map is plugged into the specular slot, and its effects are more subtle than if used on a standard V-Ray material (Fig.11).

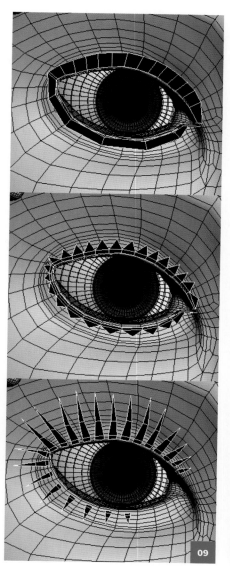

09

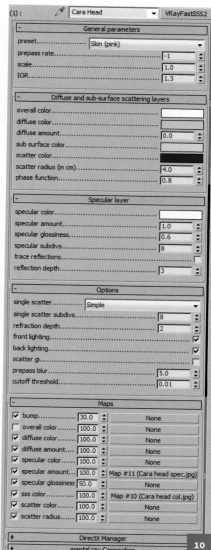

10

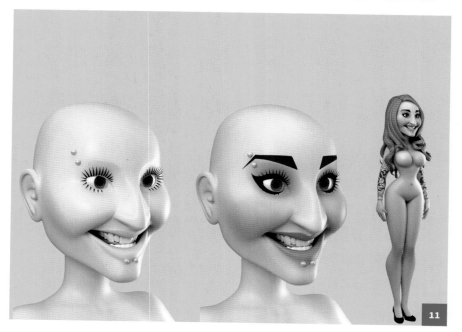

11

CLOTHES, COLORS AND TEXTURING

Choosing the color scheme and patterns for Cara's outfit was tricky. The image will be very colorful and bright, so I have to make sure that the clothes don't clash with the background elements or Cara's hair.

I wanted to give the clothes a retro, 1950/60s look, so I went with pastel colors and kitsch motifs like the flamingos and palm trees on her shirt. I spent time looking at the pin-up/rockabilly fashion websites and shops that Cara recommended in order to get the right look.

I then spent a few hours trying out several different mocked up combinations of patterns and colors until I got the one I liked (Fig.12). I liked the turquoise shirt (and so did Cara – it's one of her favorite colors) from the early modeling steps, so I stuck with that. I chose the mint green skirt with the polka dots and trim. It reminded me of minty ice cream with chocolate chips, which goes with the cute/sugary-sweet theme and looks retro too. The cool greens and blues of her outfit contrasted nicely with the warm pinks of the background and made her stand out.

I decide to go with the blue shirt and mint green polka dot skirt with a black hem.

The shirt pattern is made of two drawn images applied as separate mix maps (Fig.13). Each image controls the distribution of the two color values within the mix map. Doing it this way means that I have complete control over how they are individually positioned and tiled, and so that the colors can be changed easily within 3ds Max, rather than bouncing the texture back into Photoshop for adjustment.

> ## " I really want to get an excitable, happy pose to match Cara's personality and modeled facial expression "

The base layer is a white graphic of a palm tree, and the upper layer is a pink flamingo. Both are repeatable and are tiled at slightly different sizes and angles to get a more randomized look to the pattern. The skirt polka dots are made with a customized procedural gradient ramp set to a radial type and repeated 20 times.

POSING

Now I have a rigged, skinned, textured and lit model, I am finally ready to start giving her some character in the form of an appealing pose.

I really want to get an excitable, happy pose to match Cara's personality and modeled facial expression. I'm thinking tense limbs, energetic body language, raised shoulders, 'glee' hands and excited mannerisms. I key-frame each test pose at 10 frame intervals so I can scrub through the timeline to assess and adjust each one (Fig.14).

I like the idea of her holding or interacting with something sweet or cute like a cake or a cute character, so after some brainstorming I try adding a kitsch-looking cocktail with an umbrella and a slice of fruit in her hand. It was modeled really quickly from a photo reference using a few edited cylinders and a box.

Choosing the right pose for Cara proved to be tricky. My favorite pose involved both of her arms bent, with her palms facing the camera – the excited 'glee' pose. This meant the viewer could no longer see the sleeve tattoo that will be on her right arm. Cara is my first pin-up girl with tattoos, and Cara in real life has many tattoos, so naturally I want to show them off clearly.

I go with a pose that involves a straight arm to create tension, poise and to show off her sleeve tattoo (Fig.15). The forward lean and the inclusion of the kitschy cocktail give it a cheeky, retro pin-up feel, and captures Cara's personality quite well. The chosen viewing angle in the perspective viewport now is turned into a camera by going to View > Create Camera From View.

MAKING THE COCKTAIL

Next, I work on the cocktail model. Using some photo references from a tiki bar we went to (after sampling many different and brightly-colored cocktails), I begin to refine the shape of the glass to match (Fig.16).

A shell modifier is applied to give thickness and a V-Ray material with a high refraction value is also added. The inner liquid is made by detaching some of the glass polygons as a clone, scaling them in slightly with the push modifier and then capping the top and bottom.

The pineapple chunk is smoothed out and the straw is made from a cylinder. The cocktail umbrella is given more detail and textured with a simple hand-drawn floral pattern.

COCKTAIL TEXTURES AND SHADERS

Looking at the photo references, the cocktail is quite opaque, but I don't want it to look solid. I try experimenting with the V-RayFastSSS2 shader again.

Starting with the milk (whole) preset, I adjust the colors and settings to get the bright, translucent result I want. A simple graduated texture is cylindrically mapped to the liquid so it looks like it has depth and a frothy head.

A hand-painted Diffuse and Bump map is applied to the pineapple, a cherry is added on a skewer, and the umbrella paper is made slightly translucent so that the shadows cast by it aren't as dark. The glass material is given a low reflection value and a high refraction value (Fig.17).

This concludes this chapter – in the next, we will look into creating a sidekick for Cara.

3D CARICATURES
CREATING A SIDEKICK

BY ANDREW HICKINBOTTOM

The primary purpose of this part of the project is to show the creation of a secondary character – the mermaid. She will be designed in a different style to Cara – in a simpler, cartoony style. I'll be unwrapping, texturing, rigging and posing the mermaid in the scene with Cara, and I'll then use V-Ray shaders to define the look.

During my thought process for the cute, imaginative aspect of the image, I imagined Cara interacting with all sorts of items and secondary characters. Cara loves sweet things, so I thought about having her holding a plate with a cheesecake on it, maybe with a miniature chunky/chibi pin-up girl sitting on top with some whipped cream on her head. I originally planned to populate the scene with various colorful and cute items and characters, such as unicorns, stars, rainbows, cakes, candy, mermaids, fish, kittens, fairies and such (Fig.01). This would give the effect of Cara's mind bringing all these things to life and surrounding her in a big cute maelstrom of girly glee!

A unicorn sitting on Cara's head was another idea I rejected. Shooting stars or a cat were initially imagined to be emitting the rainbow, and various sea creatures like seahorses, fish and turtles would be surrounding her in some crazy fantasy dream-world. I toned down the ideas and simply settled for the mermaid in the end, because Cara loves them, and it would be able to interact with the cocktail quite nicely.

Thinking how I could compose these elements in the scene without cluttering it, I decide to have just a few elements, thus making the composition much simpler and clearer, and drastically reducing my workload. Cara loves mermaids, so I decide on making a cute mermaid character jump out of the cocktail to fill the space to the right of the image (Fig.02).

THE DESIGN

Cara is more realistic than my usual style. If I make characters that have likenesses of real people, I can inadvertently end up making them more detailed and realistic than I'd like. As a contrast, and to show the fantastical nature of the character, I'm going to make the mermaid really simple and cartoony. Inspired by some 2D illustrators whose work I admire, I imagine her with a simple round head, chunky hourglass proportions and almost spherical, cartoony breasts. The mermaid has to have simple, clear forms that will be easy to read due to its small size.

01

sweets
unicorns
rainbows
stars
fish
mermaids

cats
bears
rocketships
tattoos
pin-ups
anchors

hearts
flamingoes

swallows
fish

02

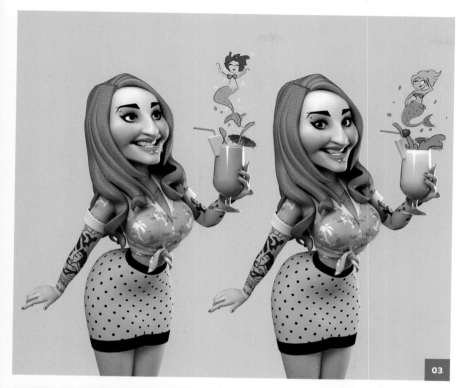

03

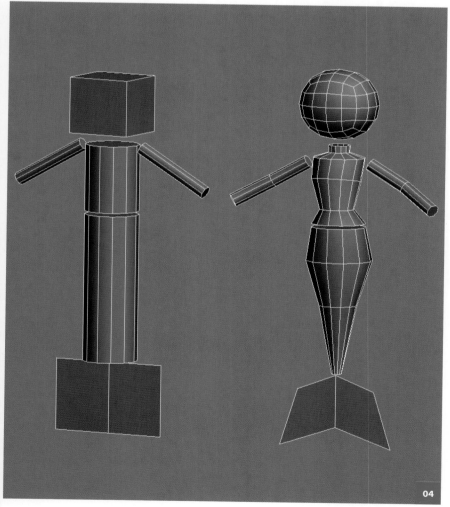

04

> **" The mermaid has to have simple, clear forms that will be easy to read due to its small size "**

Using a render of the Cara scene, I drew a few concept ideas in Photoshop with my Wacom pen to visualize the pose, placement, character style and colors before I start modeling her (Fig.03).

BLOCKING OUT THE PROPORTIONS

Because the mermaid will be quite cartoony and designed in a specific way, I'll start by blocking out the proportions of the whole character using simple primitives. 12-sided cylinders form the torso and tail, two (instanced) 8-sided cylinders form the arms, a cube forms the head, and a sectioned plane forms the tail (Fig.04).

Next, I add vertical sections using the Connect tool to allow me to shape the body. The waist is narrowed and brought forward, and the chest is defined. The torso and tail are also shaped and the start of the neck is extruded from the top of the torso cylinder.

The arms have an elbow section added (using Connect) and are bent slightly. The head is turbo-smoothed by two iterations and collapsed, leaving a sphere with an all-quad polygonal construction – an ideal base for making her simplified facial features. The subdivision process shrinks the volume of the head cube considerably, so I scale it back up to its desired size.

SHAPING THE BODY

With the base components roughly shaped and in place, I start to join and refine them. The bottom poly cap of the torso is deleted, as well as the top one for the tail, and the elements are attached. The seam is then joined by collapsing opposing vertices.

05

06

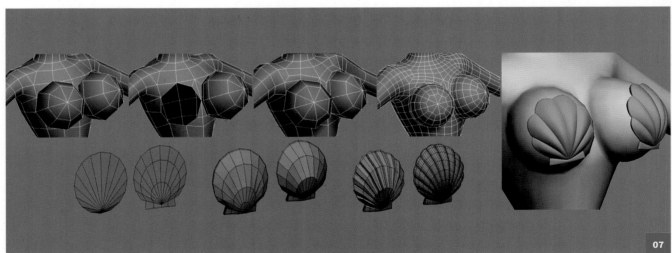

07

I smooth out the waist and tail and shape them some more, and I use the Connect tool to add edge loops where needed.

The arms are given forearm and shoulder sections and the tail has a 'spine' cut along the top where the thicker part of it would be. The head is edited using Soft Selected vertex manipulation to be a little squarer, with a defined jaw that sticks out a little (Fig.05).

I want to really push the proportions here to contrast with Cara's. So the waist needs scaling down further and her hips and bum could do with being inflated using the Push modifier applied to a Soft Selection.

The edges around the shoulders need to be cut to accommodate the arms, so the matching ends can be lined up and joined. By now, you should be working with half of a model with

the symmetry modifier applied, so you only need to work on one side of the model.

Next, I extrude the base of the hand from the wrists and shape it. I then add the required three edge loops (for deformation) to the elbows. More sections need to be cut into the tail to define the shape, and a shell modifier is added to it, making sure there is a central segment in the extrusion (Fig.06).

BREASTS AND SHELLS

To add to the bubbly and simplified cartoon proportions, I'm going to give the mermaid virtually spherical breasts with cute little shells covering them!

I add two spheres with eight segments to both sides of her chest. The intersecting parts are cut away with the Cut tool and the unwanted polys deleted (Fig.07). I then attach the breasts and weld them to the body, making sure that the torso edges trail away nicely without leaving untidy triangular polys.

The shells start out as a disc (the end polys of a cylinder) and I progressively modify and shape them using the Cut, Extrude Edge and Connect tools, as well as Soft Selected vertex manipulation. When the shape is created and rounded off to the same curvature of the breasts, a shell modifier can be added and collapsed, and the fanned edges extruded, giving the ribbed look.

FINISHING THE BODY MODEL

Now I will spend an hour or two fine-tuning the body mesh and getting it to the shape that I want. The simplified 'mitten' hands aren't working, so I make a duplicate of Cara's hand models, remove the fingernails, relax them, shorten the fingers and fatten them up with the push modifier to get a cuter, more cartoon-styled hand (Fig.08). They are then attached and the wrist joins

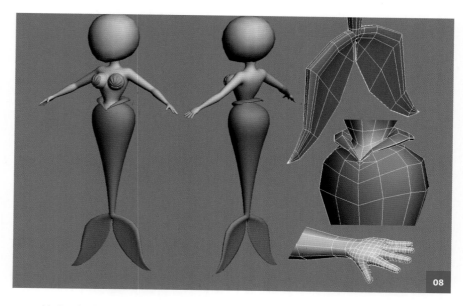

are welded and relaxed. The stomach/waist edges are pulled into a downward V-shape and a fin is extruded from a split in her waist to divide the two halves of her body.

I go on to shape this and give it some thickness with the shell modifier before the modifier stack is collapsed. The tail can now be attached to the body and then carefully welded to it. The shoulders and arms are made chunkier and rounder to enhance the cuteness and plumpness of her body.

HEAD MODELING

Time for the head. The ears are extruded out and shaped first. Modified poly planes temporarily form basic facial features. These are placed to visualize how the face will

eventually look and ensure that I stick to the simple style as I add detail (Fig.09).

Eye polygons are inset and deleted, and the hole is smoothed and the edges extruded inwards before the eyeballs are placed in the sockets. A nose is extruded out and turned into a cuter button nose. The face shape is modified to accommodate the large eyeballs, and the cheeks are raised to give a cuter expression.

The eyelashes are made from poly strips with shell applied; the cheeks are puffed out and the mouth is refined. The asymmetric, cartoony 'banana-shaped' mouth isn't quite working, so I cut a pouting, symmetrical mouth into the geometry and shape it, giving a more 'pin-up' look, while staying simple.

CLEAN UP, RIGGING AND SKINNING

Now the model is complete, I need to clean it up, scale it correctly and add a rig. Ill model the hair later, as it will depend on the pose, which I haven't decided yet.

Given that the mermaid will be jumping out of Cara's cocktail, I scale her down to an appropriate size, strip the TurboSmooths from the meshes and reset all the XForms. (Fig.10).

Next, I draw out a biped rig and match the joints with the body mesh in figure mode. I hide the legs on the rig (we won't need them for a mermaid) and add a bone chain with two forks at the end to act as the tail controls.

The body mesh is skinned to the rig and the envelopes refined, and the separate pieces like her eyes and shells are attached to the appropriate bones.

10

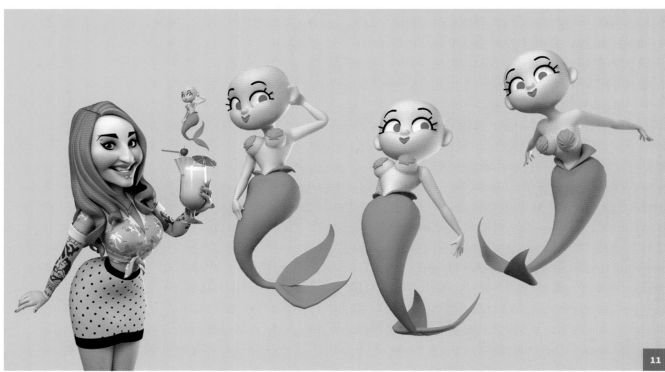

11

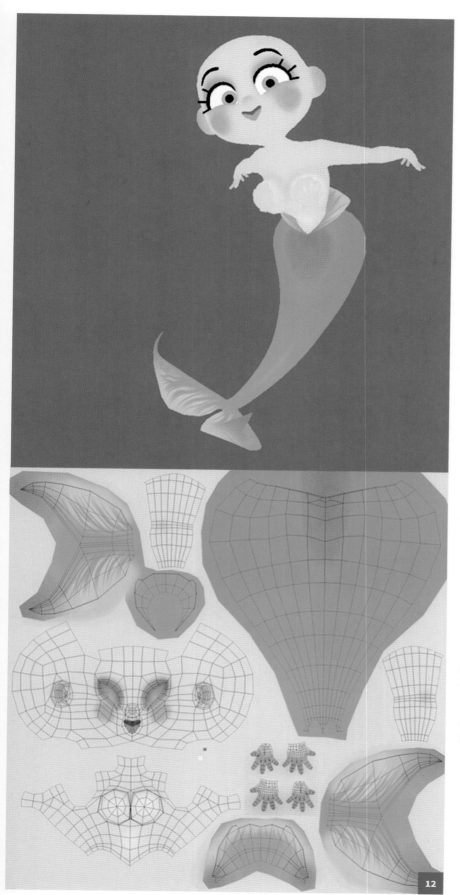

POSING AND UV-ING

Now the Mermaid has been modeled and rigged, I merge her into the Cara scene and position her above the cocktail. I put her in a handful of poses to see which one works. A pin-up-styled one looked quite 'tattoo-like', but too forced, so I put her in a more dynamic and graceful leaping pose with a curved line of action going throughout her body (Fig.11).

Next, I spend half an hour or so unwrapping her for texturing using exactly the same methods described in the last part of the project. This time, I set up the UVs so that the whole mermaid can be textured just from one texture map.

> **" The skin is subtly painted with darker and lighter tones to enhance the shading on parts such as the cleavage and fingertips "**

TEXTURING

In Photoshop, I load up the exported UV map render from 3ds Max and overlay the UV wireframe onto a blank canvas. The skin is subtly painted with darker and lighter tones to enhance the shading on parts such as the cleavage and fingertips. Her lips, eye shadow and cheeks are painted to look rosy and colorful. The fishy parts of her are given vivid aqua colors – purple, turquoise and green in this case (Fig.12). I want her to really 'pop' in the composition and look more cartoony and fantastical than the other elements in the scene.

12

HAIR MODELING

Now I have decided on a pose, I can start modeling her hair. I want the hair to be affected by motion, so I plan on making it follow the flow of her pose and form a simple, elegant shape, much like her body.

Initially, I try the segmented strip approach to her hair (like on Cara), but it proves to be too complex and isn't fitting in with the simple shapes of her body (Fig.13). I decide to start from scratch and apply the bend modifier to a tapered cylinder to get a smooth hair shape coming from the back of her head. This shape is fattened and smoothed out. Side bangs are extruded out and rounded off. The front bangs are made of two shaped planes with a shell modifier applied then collapsed.

SHADING

Her tail needs some special treatment to make it shine and look really 'magical' (Fig.14). I create a fake iridescence by using a falloff map in the diffuse channel. I then plug her painted texture into one channel of the falloff map, and a bright pink color is plugged into the other. The mix curve that controls the falloff distribution is customized to look wavy, so the tail looks really shiny and pearlescent, fading between the texture map and the pink color depending on the angles of the surface.

The hair is shaded in a similar way, but instead of a texture and a contrasting color, the falloff map is comprised of a light and a dark shade of blue to give the hair a shiny look.

SPLASH

For the final step of this chapter, I add a polygonal splash coming up from the cocktail to give some motion and imply that the mermaid has just leapt from the glass.

Firstly, the cocktail umbrella is moved aside and lifted out of the glass to look like the splash has made it airborne.

A box primitive is placed on the top of the cocktail liquid and extruded upwards several times, being shaped with each step. The TurboSmooth subdivision will round off the boxy geometry, so I work on

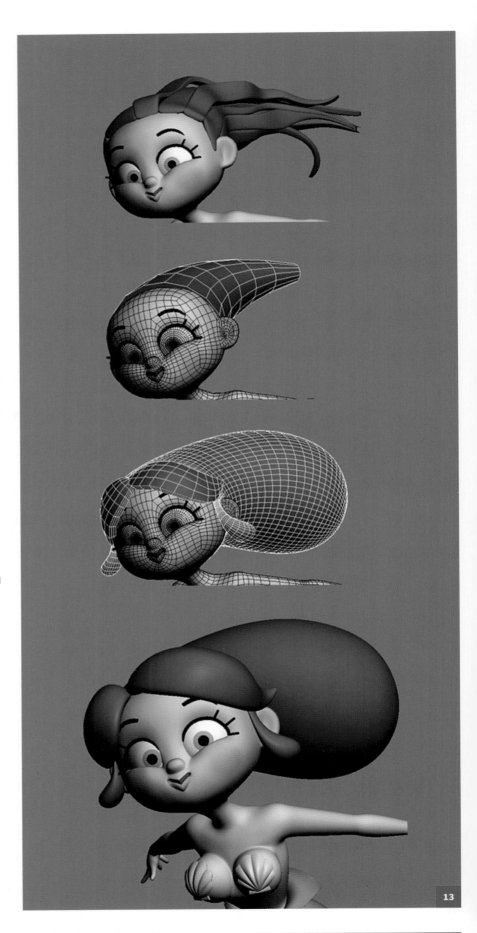

13

the base mesh with the end result being shown in the modifier stack. Pieces of the box shape are separated to form additional droplets and splashes – one of which is flicking off the mermaid's tail tip. (Fig.15)

Rather than use the opaque, translucent SSS material that the main liquid uses, a reflective material is added to get some nice specular highlights on the splash and droplets.

Generally, the best advice I can give is practice! I've been doing 3D modeling for a long time (since the Amiga computer days in the early/mid 90s) and I've lost count of the times I have made hands, ears, faces, bodies and other parts from scratch. Every time you make a similar object from scratch, you learn something about it and find ways to improve. It sounds obvious, but whether it's the topology, the shape, the creation method or the style; repetition pays off in the long run. There is no easy or quick way to better yourself other than persistence and practice.

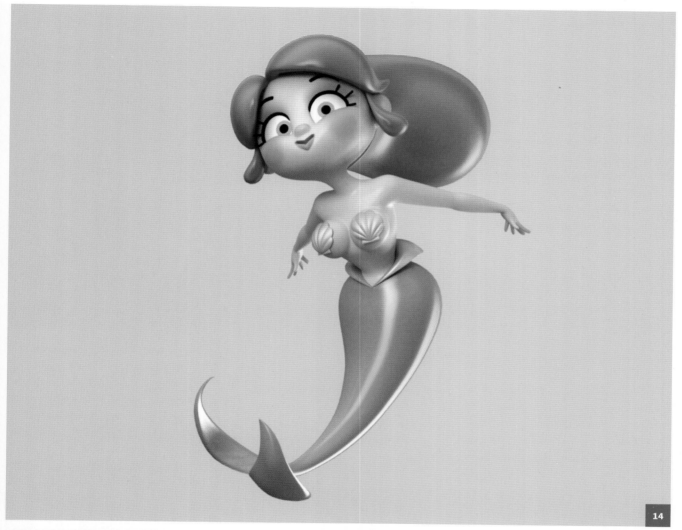

14

15

3D CARICATURES
PERFECTING YOUR PIN-UP

BY ANDREW HICKINBOTTOM

In this last chapter of our project, I'll be showing the final steps of the image, beginning with the design and painting of a sleeve tattoo in Photoshop. I'll be improving shaders and lighting using V-Ray, then using basic modeling skills to shape up the mesh in places to suit the chosen pose.

The cloth meshes will be imported into ZBrush where I will sculpt creases and export Normal maps for added detail. The background will be created in a separate scene, and each of the final elements will be rendered out and then composited in Photoshop to create the completed image.

For the first and only time in this project I'll be using ZBrush, so core knowledge of its interface and sculpting tools will be needed, though not essential as this step is optional depending on whether you want to add the extra detail or not.

01

TATTOO DESIGN

Now Cara is mostly finished, and the mermaid and cocktail are completed, it's time to do her sleeve tattoo properly. Until now, I've used a roughly-drawn temporary tattoo comprised of a pin-up, some fish, a cake and some nonsense squiggles.

I want the proper tattoo to be really colorful and have cute characters relevant to Cara's interests all over it. I'm thinking stars, moons, sea creatures, a cake, a unicorn and a mermaid at the center. I asked Cara for some photos of her own sleeve tattoo to give me some ideas. It is formed of multiple Disney characters, so for copyright reasons I decide to stay away from this and make it from original characters.

Taking the exported arm UV image into Photoshop, I overlay the wireframe on top of the canvas so I can see the extent of the arm. I then sketch out the various elements using my Wacom pen. Each is drawn on a separate layer so I can position them around and check how they look in the 3ds Max scene.

My drawing skills aren't as good as I'd like, so I place an early render of the mermaid on there to use as a guide. With the rough elements positioned nicely, I draw a second draft with more detail, including a fish, a seahorse, a cake with a ribbon and a banner, a shell with

02

a water splash and some planets above. I also paint some basic colors on a layer underneath to see how it will look on her arm (Fig.01).

Next, I carefully draw the final outlines on a new layer, using the faded rough sketch layers underneath as a guide. It's good to keep saving the texture and switching to 3ds Max to see how the texture looks on her arm and what parts of it can be seen from the chosen camera angle.

I trace the mermaid by hand to create an accurate line portrayal of her. Once I am happy with the outlines, I start to paint the solid colors, keeping the outline layers above so I don't go over the lines. I want the tattoo to be predominantly blue, with the ocean, sky and galaxies forming the background (Fig.02).

I apply shading to the color layers with selection masks and a soft brush at low flow. I then gradually erase some areas to make the skin color show through and create lighter areas. Once I'm happy with the shading, I make a blurred copy of the outline layer and apply it at a lower opacity to get the softer look that you get with tattoos.

I apply the color layer to the skin using multiply to get a darker, more faded look

that blends with the underlying skin texture, then color correct and desaturate this slightly to make it look more akin to a tattoo and the pigments they use (Fig.03).

IMPROVING THE SHADERS

Next, I improve the shaders. Adding a falloff texture to the diffuse channel for the skirt and shirt materials creates the impression of the slight fuzz you see when viewed from an acute angle. The existing diffuse textures

are put in both channels of the falloff texture and one channel is mixed with a white color.

The mix curve is edited to make the white part stronger at the edge, giving the cloth a slight glow to make it pop. I also apply a falloff map to the hair using a more randomized mix curve to control light and dark hair colors and give it a glossy look – an effect you can really see on the lower curls (Fig.04).

POSE AND LIGHTING

I tweak her pose slightly; tilt her head a little, raise her left pinky finger and reduce the upward angle of her right hand for a less forced pose. Next, I spend an hour or two improving the lighting. I double the number of lights in the scene to give more refinement and control.

I now have four lights. A large, rear V-Ray rim light is placed to the side of Cara's face to give her hair and cheeks a border rim. A small, side-fill V-Ray light brightens up the cocktail and adds a nice reflection to the edge of the glass. On Cara's right side, a large V-Ray light illuminates the back of her head and bum, and the smaller light nearer the camera is the main fill light, softly brightening up the whole scene (Fig.05).

FIXING FLAWS

Now that I am completely happy with Cara's pose and no further texture or modeling work needs to be done, I will iron out any flaws caused by the skinning. I collapse the skin modifier, turning the previously posable Cara into a static editable poly object. Sometimes I use an edit poly modifier on top of the skin modifier, but this can occasionally be unstable and corrupt the mesh.

Now Cara's pose is frozen as a mesh, I spend a while fixing anything that looks odd, such as her right wrist deformation and left elbow volume. Generally, if you are skinning the skirt to the legs rather than using a cloth simulation, you will nearly always need to edit the mesh when the legs are brought closer together. To fix the lumpy, pinched mesh in this area, I straighten and space out the skirt hem topology to make it look tighter fitting.

Using edge constraints when editing vertices will be useful here, 'sliding' vertices to one end of the edge, then to the other helps to 'average' out the vertice position without forming lumps in the surface. I notice her bum sticks out a bit too far, so I use Soft Selection to smoothly move the vertices to get a slimmer, more streamlined shape from the angle it is viewed from (Fig.06).

SCULPTING CREASE DETAIL

I think her clothes need a little more detail, and I find the best way to get this without worrying about ruining the nice, clean topology

is to sculpt the creases in ZBrush and export a Normal map. I export the unsubdivided skirt and shirt meshes as OBJ files and import them into ZBrush as separate SubTools. The imported meshes are subdivided until the faceted look disappears. Using the DamStandard brush (obtained from the Lightbox menu if you are using an older version of ZBrush), I start sculpting crisp, simplified creases, using photo references of tight skirts and shirts. The standard, smooth and pinch brushes are also used in the process (Fig.07).

APPLYING CREASE DETAIL

Once I am happy with the crease sculpting, I drop the subdivision on both the shirt and skirt down to the lowest level (still in ZBrush here), then select 'create Normal Map' from the Normal map menu and then export it as a PSD from the texture swatches.

In Photoshop, I turn the PSD into a maximum quality JPG (the same file format as all of my textures) and fix any orientation issues. Back in 3ds Max, I apply the Normal map to the bump channels of the skirt and shirt materials as a normal bump, adjusting the value and doing test renders until I am happy with the intensity of the creases (Fig.08).

SELECTIVE LIGHTING

A happy accident in some early test renders resulted in the cocktail glass catching a really nice graduated reflection running down the length of it, but this reflection was lost when I re-worked the lighting. I try to

replicate the reflection by adding an extra V-Ray light near the camera and telling it to only affect the cocktail glass mesh by using the 'exclude' menu in the light options.

Selective lights like these can be useful for boosting the illumination of certain objects or giving a specific object a reflection that is not seen on other reflective objects, such as the glass here. I move the light around and do test renders until I find the sweet spot that creates the reflection I want (Fig.09).

RAINBOWS

For the background, I thought I'd add a
rainbow above Cara to frame her and create
an interesting, colorful shape leading the
eye to the cocktail. I make a bent poly-plane
using the bend modifier, then give each
poly-strip running along it a different sub-
object material color. I make the materials
('standard' ones, not V-Ray ones) 100%
self-illuminated so they are completely bright
and unaffected by any lighting. I also apply
a custom gradient to the opacity channel
to enable it to fade in and out (Fig.10).

BUBBLES

As well as rainbows, Cara also likes bubbles, so
I add some sphere primitives of varying sizes to
the bottom of the scene, shrinking as they rise.
I experiment with several different material
setups for them. Transparent, reflective
bubbles prove to be too distracting and take far
too long to render with V-Ray. More illustrative,
non-raytraced bubbles don't look very good,
so I go with a simple solid 'blob' look instead.

I'll make these look nicer and integrate them with the image in Photoshop using some blend modes later. Finally, I use a three-step radial gradient map as the environment map to create a central glow to attract the eye. This is always a simple, useful starting backdrop for character-focused renders (Fig.11).

RENDERING

All the elements are in place now, so it's time to begin the render. I adjust the V-Ray render settings to produce good quality renders with minimum noise. V-Ray is a very powerful renderer. My overall knowledge of V-Ray is quite limited, but I know enough to make it work for my benefit.

> " **To make compositing easier and to enable control over the separate image pieces, I break the image down into renderable layers** "

The main things I have found that affects the image quality (mostly the amount of noise) and render time are the DMC sampler values in the render settings. The Global subdivs multiplier should be set to 0.5 or 1 for quick test renders, then bumped up to 2 or 3 when rendering out at best quality. The Noise threshold also matters a lot too. A value of 1 (the lowest quality value) gives the fastest result, whereas a value of 0.01 or even 0.001 provides the smoothest results (Fig.12). I recommend trial and error to see what settings work for you.

MANAGEABLE RENDERING

To make compositing easier and to enable control over the separate image pieces, I break the image down into renderable layers (Fig.13). The background gradient is rendered out first, followed by the rainbow, the background

bubbles and finally Cara, the mermaid and the cocktail as one. All layers are rendered out at 3182 X 4500 pixels and Cara's layer takes just under three hours to complete. I make sure to save the final render elements as a 32-bit TGA file with a pre-multiplied Alpha, so that I can use the Alpha channel to cut out and place the renders in the final composite.

ADJUSTMENT LAYERS

In Photoshop, starting with the pink background layer, the other render elements (with Alphas) are opened up, then added to the pink background image by creating a new layer for each and going to Image > Apply Image, choosing the relevant source and Alpha masking options.

The very slight white fringe around each render element layer is easily removed by going to Layer > Matting > Remove White Matte. After some experimenting with the look, I add a yellow gradient glow to the bottom of the image. The bubbles (which have been blurred to make them look softer) are applied using the Hard Light blend mode.

Above the rainbow layer I apply a slight white radial glow to make Cara 'pop out' of the image slightly. Above Cara's layer, a masked selective color Adjustment Layer makes the neutral colors warmer in tone. This makes the shadows less grey and helps to make Cara look more like she belongs in the bright environment (Fig.14).

FINAL TWEAKS

After completing the image and showing it to people, a friend mentioned that her thumb looked a bit short. This was due to the foreshortened angle it was viewed at. It bugged me, so I adjusted the thumb angle and shape to make it more readable, then re-rendered the hand and re-composited it.

I'm really happy with how the final image turned out, and Cara was over the moon with it, which is the best feedback I could get! It turned out a little more realistic and detailed than I had planned, but that is often the case when I try to capture someone's likeness in 3D. The mermaid character was a nice contrast to Cara's more realistic look, so I'm happy I

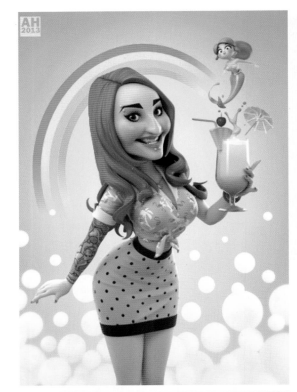

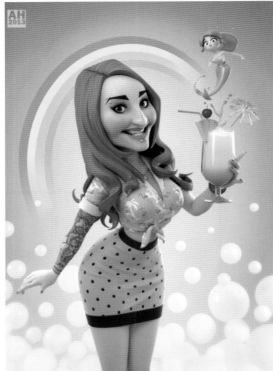

was able to explain the process of creating two differently-styled characters, as well as the overall image and the many processes it involved. I hope you have enjoyed this behind-the-scenes look at how I made 'Cara', and that you are inspired and hopefully a little wiser!

BLENDING 3D AND PHOTOGRAPHY

By Andrzej Sykut

9

LEARN HOW TO CREATE CONVINCING CYBORG IMAGES BY MERGING 3D MODELS WITH DIGITAL PHOTOGRAPHY

Mixing 3D and photography is an art in itself, and you've probably seen it attempted with varying results.

In this project, Andrzej Sykut will showcase the techniques he has mastered in order to achieve a perfect blend of 3D and photography. And he'll be tackling one of the greatest subjects for it: cyborgs.

When approaching a task like this, there's lots to consider. You must think about the photograph and the lighting you want; you must consider how you'll create the 3D elements; and once you have all this you need to ensure you have the same lighting on the 3D aspect as in the photography. This project will guide you through the entire process.

BLENDING 3D AND PHOTOGRAPHY
PROSTHETICS

BY ANDRZEJ SYKUT

In this project I will be sharing the techniques used to create an image composed of 3D and photography. I have divided the process into five stages: concepts, photography, 3D modeling, 3D layout, and rendering and compositing. These stages will overlap quite a bit as I will be doing shader tests while modeling and bits of compositing at the same time. Nevertheless, separating the different processes will make it easier to organize the information.

CONCEPTS

My starting point is to think of a cybernetic addition to the hand. All kinds of images start to come to mind when thinking about this kind of thing, such as the robotic hand of *The Terminator* character, which was covered in bloody tissue; Luke Skywalker's burned prosthetic; and Robocop's face (it's the only place where you see the flesh-metal boundary). Most of the time, the fusion of human tissue and metal looks brutal. I want something slightly different.

I begin with some research on modern prosthetics, which are rapidly growing more and more impressive as time goes by. There are mind-controlled limbs that provide tactile feedback – a bit like things you see in science-fiction. One thing that most modern prosthetics share in common, though, is the material. They are very rarely made of metal in reality, and are usually made of some kind of composite polymer. And while modern prosthetics can already do truly amazing things for people, they don't currently look all that fantastic, aesthetically speaking.

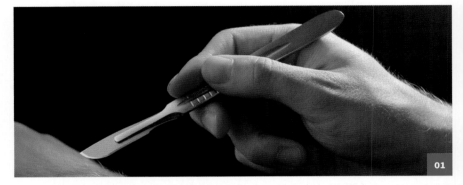

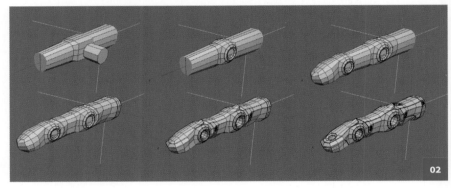

Following plenty of research, my ideas start to hatch. How will these prosthetics look in a few years when the technical issues are solved and aesthetics start to become important? Carbon fiber is already in use because of its practical and mechanical qualities, but it also has quite a cool aesthetic as well. Just take a look at modern super cars, for example.

With all this in mind, I'm going to create a hand with high-end carbon-fiber fingers – mildly futuristic, somewhat elegant and potentially possible all at once. I want to emphasize the precision and dexterity of the prosthetic fingers, so the hand will be holding a scalpel.

PHOTOGRAPHY

With the help of my brother, I start by setting up a very simple shoot in a dark basement (to get the almost black background I wanted). The main light was behind and above my hand; the fill was provided by an overhead fluorescent light (pretty weak); and there was a silver reflector on the right side (Fig.01). That was basically it for this simple setup.

There was plenty of trial and error to find a nice pose and position for the scalpel, and so on. After playing around with this for a while I achieved some usable photos. I simply selected the best one, flipped it horizontally, cropped and recomposed the photo very slightly, cleaned up the scalpel (using the Spot Healing brush in Photoshop) and enhanced the reflections a touch.

For the photography, an old manual 50mm lens was attached to a Nikon DSLR, giving it approx.

75mm focal length. And while I could have created some HDRIs for reflections and lighting, I decided to skip that stage as the light setup used was quite simple and should be easy to recreate by eye. However, if I had been shooting outdoors I would have tried to capture as much environmental information as possible.

3D MODELING

This stage happened simultaneously with planning the shoot. It's pretty straightforward: I use box modeling in Wings 3D to do the groundwork; Fig.02 shows the progress of the model. Some slight tweaking helps to match the human fingers in the photo, mainly by shortening the middle segment.

At the end of the modeling phase, I import the model into 3ds Max, set up a very simple shader and start to throw some lights at it. It's a great way to see if there is any additional detail needed, if the surface curvature is right, and if the reflections are working nicely.

3D LAYOUT AND RENDERING

I'm using a combination of 3ds Max and V-Ray for the layout and rendering. The first important step is to match the camera and object positions. For this image I am doing it by eye, mainly because there isn't much for camera matching software to work with. There are no three-edged corners and no planes, so this is the only option. Of course this wouldn't work if it was animated, but for a single still image, it's good enough.

I do know some of the parameters, like the camera focal length, so I type that in. I then try to place the camera roughly in the right position in relation to the finger. I tweak the finger orientation and rotate the segments to match the pose from the photo. To make this job easier, the finger segments have pivots aligned with the real pivot locations, and they are parented into a simple FK setup.

From this point it's an iterative process; tweak the camera, tweak the fingers, and then tweak the camera again. You'll need to go through this process until the tweaks diminish and it starts to look good. For a simple scene like this it shouldn't take too long, though.

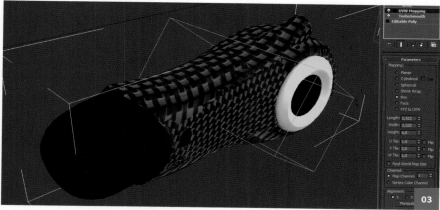

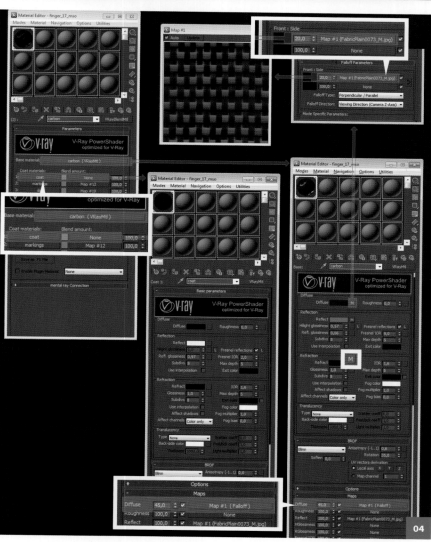

With the camera and fingers positioned, I create some simple geometry to represent the human hand and scalpel, and to provide some shadows and reflections on the CG fingers. It's all invisible to the camera, of course. While doing this, I also work on shaders, textures and lights. One great shader is the carbon fiber material. I build it like real carbon, with a base layer of carbon weave and strong bumps to bring out the fabric detail. There is also a shiny, reflective, clear coat with another top layer for the text and markings (Fig.03). I try just a simple box-mapping for the texture, and it turns out that if you resize and rotate the gizmo, the texture placement looks very similar to real-life carbon fiber (Fig.04). This

is one of the very, very few cases when UV seams and texture-stretching are of any use.

The light setup is quite simple and you can see it at work in Fig.05. Firstly there is the key light (1), above and behind the hand; it actually acts as a rim light as well. Then there is a fill light (2), which is positioned to match the lighting from the photo. There is a little trick you can use here: create a sphere roughly in the center of the image and use the Place Highlight tool to put the light in the right place, corresponding with the specular highlights on the skin. This way, matching things like the warm light on the tip of a middle finger, becomes an easy job (3).

Finally there's an additional rim light for the left top-facing parts of the fingers (4-5). All the lights are mapped with gradients, either linear or radial. This way the reflections they produce look more studio-like. I use GI and a diffusely-convoluted HDRI map to provide additional fill lighting, and a high-resolution HDRI to generate nice reflections.

I rotate the reflection map so the reflections show up in the right places. Color-mapping is set to Exponential, so it doesn't blow out the highlights. To see the progress, take a look at the sequence in Fig.06 – see if you can spot the changes between them.

Now happy with the preview renderings, I'm going to started work on a high-resolution render. I have a bit of a setback here because, in full-size, a slight lack of surface detail becomes apparent. I fix this in two ways: firstly, I add another layer of dirt to most of the materials, with a fine texture of spots and scratches; I also add to, or increase, the strength of the bump mapping in places. The second way is to use another render pass containing three various textures in the R, G and B channels – occlusion, spots and anisotropic specular, modulated by tiled scratches. All can be added in compositing. All in all, these are subtle changes, but important when you look at the image when it is large and at full size.

COMPOSITING

There are many little steps involved with compositing this image. The first one is masking. I use a layer mask in Photoshop to

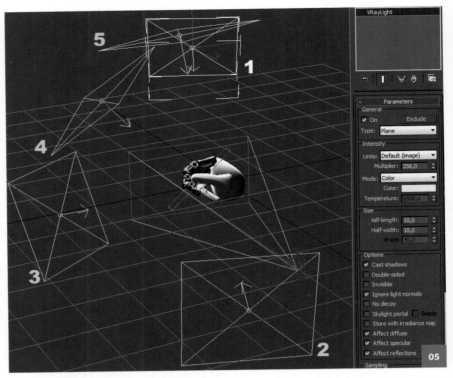

hide parts of the CG fingers that should be occluded by photographic elements. For a still image this is the fastest way, but it's not the same case for an animation. I also use the Clone Stamp tool to remove the portions of the real fingers visible behind the CG ones.

The next crucial step is matching the brightness and contrast levels in both the photo and CG elements, and also matching the colors. This can be done using Curves adjustment layers in Photoshop. I simply add some contrast to the photo and boosted the shadows on the CG a bit.

Another important thing is matching the depth of field. Although subtle, blurring is still present and needs to be taken into account. I render a ZDepth pass and feed it to the Lens Blur filter. It takes a few tries to get the blur amount just right, but after some trial and error it matches up well. The same treatment is necessary for the V-Ray Reflections pass, which I add on top to make the reflections 'pop' a little better.

Now for some polishing tweaks, like adding some blurred smoke in the background, adding a bit of glare in the top-right corner and removing skin-toned finger reflections from the scalpel. I also add an orange logo to the handle – this is just to tie the photo and CG in better, since now both have strong orange accents.

I add the additional rendered dirt and specular passes to the CG fingers and paint in some shadows – mostly the shadow of the scalpel on the CG fingers and darkening the bottom finger behind the scalpel. Finally, I paint in greenish fringes/glows on the edges of the CG parts.

To tie both parts together, I take a look at the Channels palette and discover there that there is quite a bit of noise present in the blue channel of the photo. I add something similar to the blue channel into the CG part, too. You really wouldn't notice this unless you look into the Channels, but I can see that it's definitely there. I also add some grain over all the Channels later on.

The boundary between flesh and prosthetics is a challenge. I don't want anything unpleasant, just a clean joint (it's important for me that the cyborg addition looks comfortable). Luckily, the boundary is quite small in relation to the rest of the image. Still, the best way to make it work is to find an existing feature that I can use to 'anchor' the prosthetic; in this case, a skin fold in the middle of the first finger segment.

Now it's just a case of darkening the skin in the whole area and painting in some shadows and highlights on the skin and on the CG render. The boundary doesn't draw too much attention to itself, which is what I want. This method is practically useless for animation, but very fast and efficient for still images.

Global color correction is the final touch – a subtle modification of Curves, with the blue curve shaped into a very shallow S-shape. This adds a hint of color to the highlights and shadows separately. I also add vignetting to darken the corners of the image (Fig.07).

07

BLENDING 3D AND PHOTOGRAPHY
IMPLANTS

BY ANDRZEJ SYKUT

In this chapter I want to try a workflow that has only become possible in recent years. The task is to add a mechanical element to a photographed face. This can be approached in many ways, but all these ways have one thing in common: you have to carefully match the camera and geometry. This is a hard thing to do and usually takes a lot of time. But it doesn't always have to…

Here is my idea: while shooting the base plate for the project, why not shoot a few more snaps, every 5-10 degrees around the head and feed them into the Autodesk 123D Catch app (www.123dapp.com/catch). By doing this, we can create magic: we get a 3D model of the face with textures derived from the photos, and what's most awesome is that we get properly positioned and matched cameras for each snapshot too, which means the whole job became much easier to do with this technology. So let's take a look through the steps involved.

CONCEPT PHASE

Since cyborg faces have been done to death I wanted to try something not too glamorous, but perhaps a little more practical in real life. Hence the glasses, particularly as they present their own challenges due to reflections and refractions. Glasses don't *make* a cyborg, but some implants do. I found it hard to come up with a decent-looking idea for the implants, but they should turn out okay.

THE SHOOT

I asked my brother to (once again) take some photographs of my face for me. We used a long lens to create a nice blur in the background. We also used a big piece

of almost-white Styrofoam to serve as a reflector to fill in the shadows a bit.

As well as the main plate we shot even more photos, moving the camera around my face in 5-15 degree increments. We also did the same from slightly higher and lower heights for more coverage. The trick for the model is not to blink or move (the photographer can blink all he wants, though). If you find photos where you have blinked afterwards, just delete them. That's why it's good to capture a lot of photos, in case some turn out unusable (Fig.01).

These additional photos are essential for the 3D reconstruction of the face and camera position. Capturing them only takes a few minutes, but

it can save you hours of camera-matching and even more hours of modeling the subject's face.

The workflow described should help you avoid these problems, but it's not guaranteed to work in *every* situation. If you're working with shiny, reflective items you are out of luck, unfortunately; the 123D Catch software doesn't really enjoy with those types of surfaces.

Another thing worth capturing is an HDRI environment. I do this the rough-and-dirty way, using four fish-eye snaps with bracketing that I quickly stitch together manually in Photoshop. It's nowhere near perfect, but it will do the job. I also prepare a diffusely convoluted version for lighting purposes (Fig.02).

03

04

RECONSTRUCTION

This part is simple. Open the software and upload the photos to the 123D Catch. Once the mesh is created, inspect the low-res mesh. If you wait a little longer it will create a high-res mesh as well, which should be exported as an FBX file (Fig.03). Simple, right?

After importing the FBX into 3ds Max, rotate the whole scene so the face is orientated properly. This is mainly for convenience. Since the mesh is very dense, use the Optimize modifier (be careful, though, as it destroys UVs – ProOptimize may be a better choice) and clean it up a bit, removing unseen parts.

Find your plate and use it to camera-map the plate photo onto the geometry. Why not use the reconstructed UV textures, you might ask? Well, this will work in some cases, but not in this one. The reason is resolution and averaging. A 4K camera map will give sharper details than a 4K UV texture. That 4K texture is averaged from all those photos, which results in loss of detail. It's not a big deal, except for on the eyes. It's hard to keep the eyes exactly the same all the time, even if you were trying not to blink. So all the little inconsistencies resulted in a blurred area where the eyes are supposed to be.

The camera map solves this problem easily. The face uses a 100% self-illuminated material, and serves mostly to provide refractions, reflections and shadows, as well as some Global Illumination (GI). In V-Ray, the properties will be set to Matte Object and the Alpha to -1.0.

LIGHTING/REFLECTION AND ENVIRONMENT RECONSTRUCTION

This part takes a lot more manual work. I use 50-percent gray and glassy spheres as a visual aid and try to roughly match the light positions and HDRI intensities. Simply slapping the HDRI into an environment map slot won't do. Use a V-Ray HDRI instead of a 3ds Max default bitmap; this works much better.

The most important part is to type in the proper horizontal rotation. This is so the map is oriented correctly in relation to the face model. This is not an exact science, so do it by eye and to make it easier display the environment in the viewport. Do this for both the reflection (the high-resolution map) and illumination

(diffusely convoluted, blurred-looking one). Then put them into the appropriate override slots in the V-Ray render settings. I play with the multiplier parameters right until the final render, but these are all just small tweaks.

HDRIs will provide the fill/environment lighting, but the sunlight needs to be simulated by a direct light. I use a VRaySun placed to match the position from the photo. It acts as a nice rim light. I also add a big area light to simulate my Styrofoam reflector and one more from the top, just to accentuate the up-facing parts of the glasses. I also add one more rim light (Fig.04). The lights you choose will all depend on the photo you started with.

MODELING

This phase is pretty quick. The design of the glasses is based on some modern sports eyewear, and since they are simple it's a pretty straightforward job. One thing worth noting is the way I create the glass piece: I make a plane with a lot of divisions, draw the shape of the lens using a Spline and use Shape Merge to cut the plane to shape.

Then I remove the outer polygons, do some cleaning up (Shape Merge is messy; it leaves a lot of vertices that can cause problems later) and use two Bend Modifiers to give the lens a proper shape. I also use a Shell modifier to add some thickness. The rest of the glasses consist of simple box-modeled shapes.

The implants are tricky. I do the basic mechanical shapes in Wings 3D and take into 3ds Max. The area immediately around the implants has to be altered as well, so I export a piece of the head geometry to ZBrush and model some scarring, bruising, and generally mangle the skin a bit. I also use ZBrush for some basic texture layouts (Fig.05).

SHADING

Since I don't want the glasses to be perfectly clear, I prepare some dirty maps – fingerprints and all – and use them in various channels of the shaders (Reflection Glossiness, Refraction Glossiness) and as a mask for another layer on top of everything. The glass itself uses Fog to tint it slightly.

The nose piece is just a transparent material with lots of Refraction Glossiness and the side pieces are similar, but less glossy. They too use Fog, so they're not too transparent. It's all pretty simple, but it takes some time to get right.

The implant uses a metal and carbon fiber shader, plus some VRayDirt here and there. The flesh around the implants is a bit more interesting: I use a VrayFastSSS2 shader with the Skin (pink) preset, with custom textures for SSS color and bump (Fig.06). To add some detail to the flesh I use the Render Surface Map function and render Dust and Cavity maps. I also alter the Scatter radius a

bit, since the reconstructed scene is scaled differently from the real world. Actually, it is quite easy to match the skin to the photo.

RENDERING AND COMPOSITING

I render the glasses and the implants separately as they are added in slightly different ways. As usual, I render a beauty pass and a few V-Ray passes (of which I only use the V-Ray Wire Color as a selection mask and the V-Ray Total Lighting to tweak the side pieces a bit) plus a Shadow and Ambient Occlusion (AO) pass. Both deserve some attention anyway.

I render a black-and-white mask for the shadow of the glasses on the face and apply it to the plate before rendering the final images; this way the shadow is taken into account when

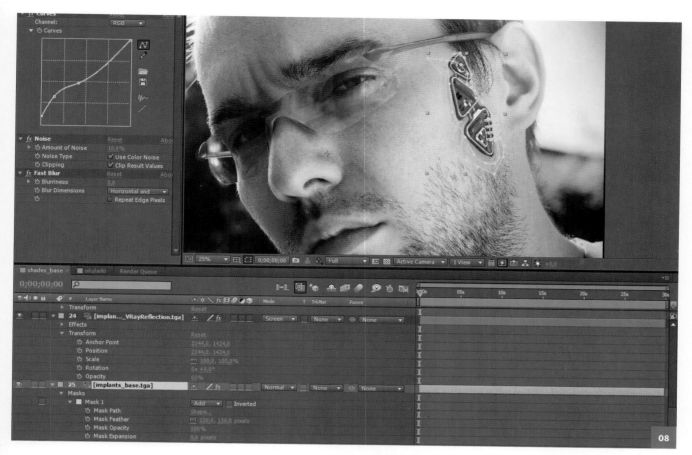

08

09

creating refractions. The way to apply the shadow is not by multiplying it, but by using it as a mask for Curves and color correction. Multiplying it will only produce horrible effects.

The AO is approached differently: I render the AO viewed through the glasses to be composited on top of everything. Again, this is to be used as a mask for color correction. Both passes are only used for the glasses and need some cleaning up in Photoshop as the 3D geometry from the 123D Catch is somewhat messy in places (Fig.07).

Facial hair also proves troublesome while I'm compositing the implants. I have to remove a lot of hair from underneath the 3D section. Fortunately, the Spot Healing Brush and the Healing Brush tools in Photoshop make this part easier, though.

I usually render my images with Exponential color-mapping, but this time I use Linear Multiply to preserve the real colors and brightness from the photo materials. This means I have to be careful with light intensities

(it is easy to get overblown whites), but it saves me a lot of color correction later on. Compositing isn't especially complex; there is a bit of masking, some color correction, some blurring, adding some noise, and so on.

The rendered images fit quite well, even before any alterations, especially on the flesh part. The implants need to be brightened a bit to match the black levels, though. They

also need some hand-drawn soft masks so they blend well with the real skin (Fig.08).

Finally there are some overall enhancements like color correction, vignette, glows, that kind of thing. I prefer to do all of this in After Effects (Fig.09).

BLENDING 3D AND PHOTOGRAPHY
POWER SOCKETS

BY ANDRZEJ SYKUT

The back of the head is a pretty obvious place for an implant – or at least it has been since *The Matrix* came out. It can have some interesting uses; for a start, it makes the owner of said implant look vulnerable. When you combine that with a machine that connects to the socket (particularly a pointy and dangerous-looking one), you get a nice base for an image. That's exactly what I did here.

The general workflow is very similar to the one I described in the previous chapter, but it's a bit trickier this time. So rather than repeating myself, I'll focus on the differences and various difficulties we'll encounter.

PLATE PHOTOGRAPHY, CAMERA & GEOMETRY RECONSTRUCTION

Since using the 123D Catch to track the camera proved to be a good idea last time, I want to use it again. But since I'm doing the shoot in my basement, and there isn't a lot of space in there, I am only able to capture a few additional angles, aside from the main plate photo (Fig.01). Nevertheless, it works quite well again. The model and texture have some artifacts, but nothing major. The texture streaks don't matter as the geometry is to be camera-mapped anyway, and the model errors are easy to fix by deleting some faces.

This time I don't capture HDRIs as there is nothing to see really, just a dark basement. Since I know that there will be a lot of metallic parts in the scene, I'll need a better Reflection map anyway. For lighting

01

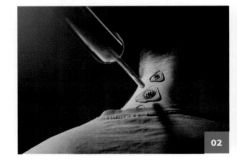

02

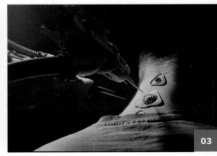

03

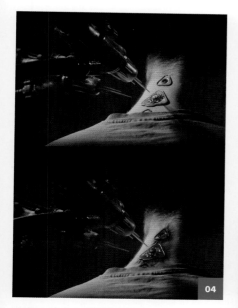

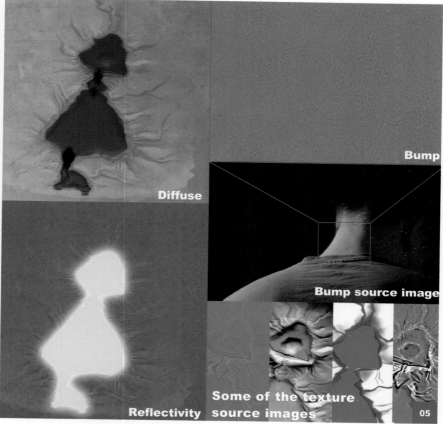

Diffuse

Reflectivity

Bump

Bump source image

Some of the texture source images

05

04

purposes, I decide that duplicating my setup, consisting of one strong light, will be easy enough. I don't like the composition of the plate photo and it needs some cropping, but I'll leave it for the compositing stage so that it's easier to line things up.

MODELING

For the sockets I'm going to re-use some models from the previous project and add some simple geometry, which is quick and easy. For the needle-type things, I do some research on pipe connectors and the like, and then model the shapes in 3ds Max and ZBrush (I just used ZBrush for the welds using the ClayTubes brush with a round alpha). For the hoses, I use Hose advanced primitive, which is very handy, as all the ridges are procedural and easy to tweak.

The scar tissue around the sockets are sculpted in ZBrush using the DamStandard, ClayTubes, Rake and hPolish brushes. Rake is especially handy for stretching the skin; the ClayTubes brush with a round alpha proves to work nicely on the veins, too – I just need to smooth the ends a bit. Essentially, this is all similar to the last project.

LAYOUT AND COMPOSITION

After tracking the camera, I quickly import my socket models and mock up the scene (Fig.02). I also roughly match the lights. The

asymmetrical black letterbox is a cropping guideline. In line with my inspiration, I do a basic color correction towards a green hue, crush some shadows and add some vignettes, just to see how the image will look.

After modeling the needle devices, I replace the mockup objects and, again, do a test render and test compositing (Fig.03). I do this after every major addition to the scene, tweaking the shaders and lighting constantly (Fig.04). It's easy to spot potential problems this way.

LIGHTING AND RENDERING

While doing the mockups and tests, everything seems to look right. But once I import the sculpted scar and do the first tests with the skin shaders, it turns out to be not-so-right after all. I go back and re-do most of the lighting, focusing solely on the skin and hoping the rest fits in.

It takes a lot of tweaking, adjusting light intensities and texture colors to even roughly match the look of the real skin. The base

texture is sampled from the plate photo and made tileable, then blurred to get rid of the detail. I then add detail with PolyPainting in ZBrush and some Surface Map renders from 3ds Max, and so on. It's not perfect, but I'm able to get it to the point that it just needs some post-production and color correction to blend in.

Match the bump of the skin by running a High Pass Filter on the plate, cropping it to the neck area and using the Healing Brush to repair blurred parts. The shader is a modified VRayFastSSS2; the texture is in Fig.05.

" The base texture is sampled from the plate photo and made tileable, then blurred to get rid of the detail "

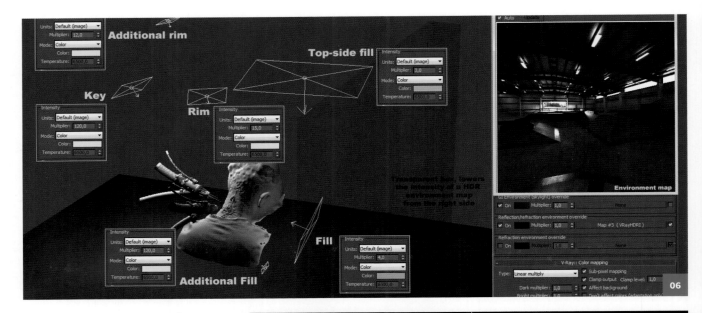

> ## " Fortunately for the skin, it works well, and it's good enough for the metal parts too. It seems there's a lesson here: match the skin first and the rest will follow "

I have to play with the scale parameter a bit to compensate for the random scaling of the scene from 123D Catch.

The light setup is shown in Fig.06. Fortunately for the skin, it works well, and it's good enough for the metal parts too. It seems there's a lesson here: match the skin first and the rest will follow.

As always, I render in V-Ray, with the GI turned on. I use Linear Multiply color-mapping so the colors from the photographic plate are not distorted, but this means I have to be very careful with light intensities, as it's so easy to get nasty, burned-out whites.

I render the various parts of the image separately for better control in the compositing process (Fig.07). I also render a ZDepth pass,

Multi Matte Elements (great for creating masks for various objects in one go), and some other Elements passes. Not all are used, but it's better to be prepared with images like this.

COMPOSITING

Compositing is pretty straightforward, but even here I have to employ some tricks. For example, I want to add some out-of-focus smoke behind the character, and some pipes in there as well.

So I need a way to quickly extract him from the background. There's a magic feature in After Effects called 'Roto Brush' that does just that – and does it quickly and easily. Double-click on a layer you want to mask and look for the Roto Brush tool icon on the toolbar. Paint a bit in the foreground and, with Alt key pressed, paint on the background (Fig.08). This feature works well, but it can be unstable and occasionally crashes when used on a moving image.

08

The smoke itself is a blurred photo of real smoke, and some solids with feathered soft masks. The pipes in the background are modified, needle-like tools from the foreground that have been scaled, rotated and extended. The parametric nature of the hose objects comes in very handy here.

Depth of field (DOF) and blurring effects are done using the Frischluft plug-ins (**www.frischluft.com**), which I find typically work better and faster than standard After Effects' functions.

The main color correction is done using Curves, individually shaping the RGB curve and every one of the Channel curves, as well as giving them a subtle S-shape. I reduce the reds and blues, and boost the greens. It's handy to keep these corrections separate so you can turn them on/off.

The piece that requires the most attention is the skin. It has to be masked out, blended

09

with the real skin and color-corrected to match. It involves trial and error to get the things like the subtle red-tinted shadow edges right. The final touches then consist of adding some grain, vignettes and subtle texture overlays. After sleeping on it, I also

apply some Dodge/Burn in Photoshop, which brightens the carbon fiber parts of the sockets and darkens some shadows. It's much faster to do it this way, rather than messing around with masks and layers in After Effects. The final image can be seen in Fig.09.

BLENDING 3D AND PHOTOGRAPHY
MILITARY SNAIL

BY ANDRZEJ SYKUT

While this project is nice and straightforward (and lots of fun), working on a small scale presents certain challenges that I'll try to describe in some detail.

CONCEPT

As futuristic and strange as it sounds, remote-controlled bugs with cameras on them are actually a reality. You may remember a spying cockroach in *The Fifth Element* (and its sad demise). Well, it's not restricted to sci-fi anymore; they are actually used in military research. The internet provides plenty of photographs and general information about this and how it's done, so finding references is easy. I've decided to keep it crude and give it a rough prototype look. I also want to add a little humor to it – hence the snail. Let's face it: a snail is useless where the military is concerned.

SHOOTING

Photographing small animals, like insects, is hard; it can also require special equipment – macro lenses, infrared flash triggers and so on – particularly if you're after in-flight images. More sedate images are easier to obtain, although I always find any bug seems to have a sixth sense and will fly away a millisecond before I press the shutter button…

Even the snail I'm using for this project wouldn't stay still – and snails aren't exactly renowned for their speed. So this rules out using things like 123D Catch, which proved very useful in previous chapters. What's left is just shooting the best photo with the resources available and doing the rest in the old-school (hard) way.

01

My resources for the photo comprised of a Nikon D70, a cheap zoom lens and some golden sunshine – and a snail, of course (Fig.01).

SCENE RECONSTRUCTION

Due to the mostly organic nature of the subject, camera-matching has to be done by eye – and there is little to help. There are no three-way corners, no square shapes and no converging lines. All I have to work with is the focal length from the image data stored by the camera (70 mm, which should probably be multiplied by

something due to the sensor being smaller than the full frame, but I thought of this too late), and the wooden fence post on which the snail was sitting. The post is more or less cylindrical, so I can roughly match the cylinder in 3D. All this doesn't really matter, though; because there are no 90-degree corners in the image, the match doesn't have to be perfect.

I model the rough shape of the shell, camera-map everything with the plate photo and assign some VRayObjectProperties (Matte object: on; Alpha contribution: -1; Direct

light: Shadows) – and that's it, as far as scene reconstruction is concerned (Fig.02).

LIGHT MATCHING

The lighting in the photo is pretty nice; a beautiful sunset, which was quite easy to match. I use a VRaySun and VRaySky as the GI Environment override. I have to crank up the Turbidity to match the warm colors of the photo. For the reflected environment I use a map from **Openfootage.net** depicting a sunset, as it matches the image well (Fig.03). I use GI with almost default settings (with the Irradiance map quality set to very low; a good setting for high-res stills). This allows for nice, ambient sky light.

MODELING

This part is easy as the shapes I need are quite simple (Fig.04). I use Wings 3D for some parts and 3ds Max for all the rest.

TEXTURES, SHADERS AND SMALL DETAILS

When working at a small scale, just matching lighting and shaders is not enough. At this scale you notice the small details that disappear when looking at something from a distance. You can see things like little variations in the material's surface, specks of dirt and other detritus, small bumps, manufacturing flaws, and so on. At this point it comes down to observation; what's the level of small details on the base plate? In this case the snail's shell was covered with specks of mud or dirt.

The mud is a bit thick in places, breaking the silhouette of the shell, so to replicate that the texturing alone won't do. At the same time, the dirt is dull, not shiny, and it breaks the specularity of the surfaces adding a lot of variation. I will approach the problem in two ways...

The first approach is on the texturing side. Almost every material in the scene is a VRayBlendMtl, with one of the two layers of dirt added on top of a base material. One of the layers uses VRayDirt as a mask (essentially an AO shader) to simulate dust buildup in the corners, and the other simulates tight spots. This looks pretty good, especially on the dark

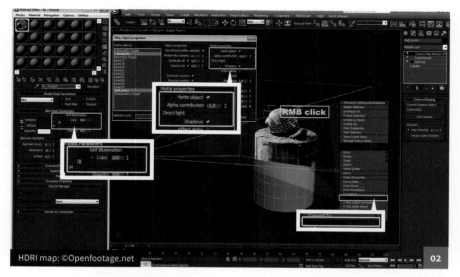

plastic parts (on some objects, like the lens housing, this is implemented in the Diffuse slot, which works in almost the same way). The second layer uses a texture made up of mud specks mapped in the second UV channel, so the objects can have their usual UVs for

normal texturing and another set of UVs for the dirt. I use box-mapping, scale and move, and rotate until the dirt is in the right place.

I've always found that it's much faster using a generic map and freely transformed UVs

> ## " Another trick is to use the dirt specks from the texture as a guideline for placing the dirt objects "

than properly unwrapping and painting every speck of dirt into place (Fig.05).

The second part of the solution uses geometry; tiny objects to simulate the dirt particles. I (very quickly) model a few variations of the mud specks in ZBrush, optimize them with the Decimation Master and import them into 3ds Max. Then, using one of my favorite scripts, Advanced Painter (**www.scriptspot.com/3ds-max/scripts/advanced-painter**), I start placing the specks over my model. It involves some trial and error because it's easy to overdo it, but it seems okay in the end (Fig.06).

The trick is to put a few of the specks in places that mean they break the silhouette slightly (marked red in the image). Another trick is to use the dirt specks from the texture as a guideline for placing the dirt objects (since they use the same material as dirt layers they blend well – marked in green). Yet another trick is building the specks from a lot of smaller ones, with varied scale and rotation (marked blue). It's not an exact science; do it by eye – like almost everything else in this project.

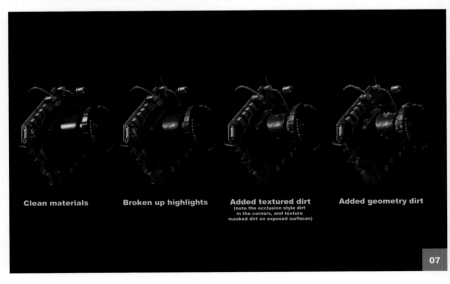

Clean materials Broken up highlights Added textured dirt
(note the occlusion style dirt
in the corners, and texture
masked dirt on exposed surfaces) Added geometry dirt

Even underneath all the dirt the base shaders cannot be left clean and shiny. Surprisingly, I find that I can often leave the Diffuse and Bump channels alone. The ones that make the difference are Reflection Glossiness and, to a lesser extent, Reflection Color. Both are mapped with various grunge and metal textures, and edited using the output curves to get the right contrast. This results in nice, broken-up highlights – and that's what matters here. Fig.07 shows the progression of the added details, up close.

RENDERING AND COMPOSITING

I usually render the shadows cast on the plate separately and apply them in post-production. This time, though, I just render the plate with the shadows applied using the V-Ray Matte object (it looked good enough this way, because the shadow was applied in the shade area, not in direct sunlight). This is something of a happy coincidence because adding shadows over the highlights can be tricky.

My rendered layers consist of: the plate with shadows; the beauty pass of the circuit board; and the Reflection, ZDepth and other V-Ray

elements. This way I can match the DOF blur and overall softness of the circuit board without affecting the plate, which is quite important, especially on such a small scale (Fig.08).

I also do some color-matching, add some highlight glow (using the VRayReflection elements), some cropping, vignetting and add some light spots – all of which is pretty simple.

The 3D is pretty well-matched, even straight out of the renderer. The biggest challenge is masking out the snail's eyestalk; otherwise

compositing is a relatively simple job. I use After Effects for this (Fig.09), as it's very handy if you need to re-render the image. You just reload the sources and the composition will update. Unfortunately, you can't easily do that in Photoshop. I highly recommend exploring After Effects as a software for your compositing toolbelt, if you're not already using it in your workflow.

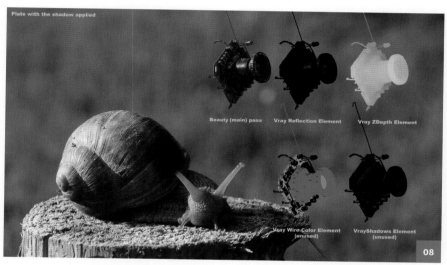

Plate with the shadow applied

Beauty (main) pass — Vray Reflection Element — Vray ZDepth Element

Vray Wire Color Element (unused) — VrayShadows Element (unused)

08

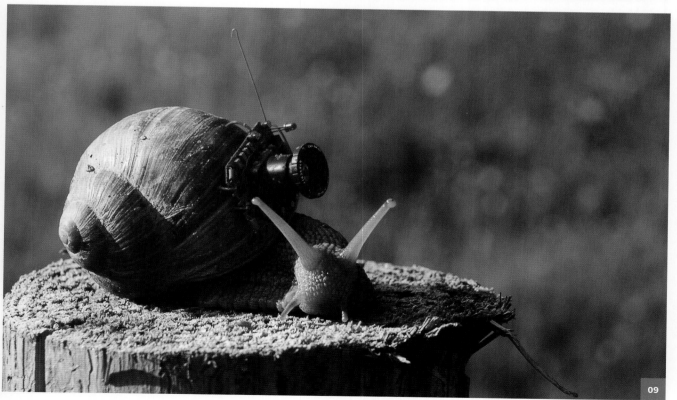

09

FEATURED ARTISTS

THE PROJECT AUTHORS

Each of the authors featured in *3ds Max Projects* is a practising professional 3D artist. We highly recommend checking out their personal websites for even more practical advice and inspiring artwork!

FERNANDO HERRERA

Animation Director at Z-Axis 3D Studio and Co-Founder at Blue School, Brazil

www.fhra.blogspot.co.uk

JAHIRUL AMIN

CG Generalist and Associate Lecturer in Computer Animation at NCCA, UK

www.jahirulamin.com

ANDREW HICKINBOTTOM

Freelance Character Artist, UK

www.andrewhickinbottom.com

MATT CHANDLER

Founder and Director at Analog Studio, UK

www.analogstudio.co.uk

DIEGO MAIA

Freelance Visual Artist, Brazil

www.maia-art.com

SAMUEL V. CONLOGUE

CG Artist at Infusion Studios, US

www.infusionstudios3d.com

DMITRY SHAREYKO

Character Artist at Crytek, Ukraine

www.shardcg.cghub.com

ANDREW FINCH

Environment and Lighting Artist at Codemasters, UK

www.andrewfinch.carbonmade.com

ANDRZEJ SYKUT

Freelance Artist, Poland

www.azazel.carbonmade.com

ARTURO GARCIA

Freelance Designer, Mexico

www.dessga.cgsociety.org

SEID TURSIC

3D Character Artist, Bosnia and Herzegovina

www.behance.net/seid

INDEX